W9-BJV-908

C

## DATE DUE

| | |
|---|---|
| | |
| | |
| | |
| | |
| | |
| | |
| | |
| | |
| | |
| | |
| | |
| | |
| | |

*The Art of Black American Women*

# The Art of Black American Women

*Works of Twenty-Four Artists
of the Twentieth Century*

*by*

ROBERT HENKES

McFarland & Company, Inc., Publishers
*Jefferson, North Carolina, and London*

**British Library Cataloguing-in-Publication data are available**

**Library of Congress Cataloguing-in-Publication Data**

Henkes, Robert.
    The art of Black American women : works of twenty-four artists of
the twentieth century / by Robert Henkes.
      p.  cm.
    Includes bibliographical references and index.
    ISBN 0-89950-818-9 (lib. bdg. : 70# gloss paper) ∞
    1. Afro-American art.   2. Afro-American women artists—Biography—
History and criticism.   3. Art, Modern—20 century—United States.
I. Title.
N6538.N5H45   1993
704'.042'09730904—dc20                             92-50955
                                                       CIP

Manufactured in the United States of America

*McFarland & Company, Inc., Publishers*
  *Box 611, Jefferson, North Carolina 28640*

# *Table of Contents*

# *Preface*

My purpose in writing this book is to promote an awareness of, and perhaps a deeper understanding of, the rich if under-appreciated contribution of African American women to the world of art. Conscientious and repeated attempts were made to contact all living black women artists whose names could be found in a great variety of sources, formal and informal, throughout the United States.

The 24 women discussed in depth in the following chapters are prominent and highly regarded in African American circles and among university, museum and other artistic groups. Much of my research involved their representation in major galleries and museums. They deserve renown throughout the world.

In the case of some artists, my letters and phone calls went unanswered, or yielded responses that were too late for inclusion. A few artists I approached for inclusion preferred to decline, believing they should promote their art universally rather than as the product of ethnic sensibilities. It is, however, a recognition of this universality that I hope to foster. Promoting African Americans, or women, as themselves before discussing their art as part of a mainstream may in fact enhance their acceptance as artists. The few who chose exclusion must nevertheless be honored, anonymously, for their viewpoint on a difficult issue.

Black women have much to say; one powerful way they can choose to "speak" is through the medium of visual art. I sincerely hope that the following accounts will awaken the sensitivity of the American public to a heritage easily sidelined, and bring about the well-deserved artistic recognition of the American black woman. I have attempted to discuss the nature of each artist's work rather than the artist herself, for it is the work that best reveals the integrity and vision of the artist.

# *Lois Mailou Jones*

Born in Boston, Massachusetts, in 1905, Lois Mailou Jones has come full circle. She has been honored in several countries including France, Haiti and the United States. Four honorary degrees enhance her reputation. Her decades of inspiring potential young artists while a professor at Howard University have caused her works to take on a humanitarian sensitivity toward life. Even after her retirement, her works continue to enliven the scenes she portrayed. Such an example is *Le Chateauneuf de Grasse* (1989), a detailed study of a French village nestled in the mountains. Beauty is found in the lush colors given to the scene. Rather than executing several sketches of the scene and then rendering a final copy, Jones captures the fleeting moments under ideal conditions. In *Le Chateauneuf de Grasse,* human structures succumb to the natural beauty, yielding a total compatibility.

The viewer observes the French village as the artist has recorded it. Yet, it is more than a recording; it is an embellishment of nature, not in the sense of extraneous elements but rather a magical charm unique to the artist herself. Color is fresh and pure. Nature glows and shimmers in brilliant color. Extraordinarily, objects recede without a loss of vibrant energy.

Quaint, roadside homes, while adjacent to the erupting spring foliage, retain their centuries-old character. Trees of varying degrees of color speckle the terrain. There is joy and hope in Jones's landscape.

The boating scene witnessed in *Across the Sound, Menemsha, Massachusetts* (1980) is a pure delight. Calm serene waters unaffected by social injustices surround the wharf, boats and homes of the summer residents. Boats are moored awaiting their owners. Jones has established a water base upon a frontal plane with the eventual horizon line attached to the distant sloping mountainside. Details are tenderly added. Life is nonchalantly and quietly inserted as the vacationers prepare for a long awaited sailing trip. Her fluid rendering of watercolor is as convincing as her acrylic rendering of *Le Chateauneuf de Grasse.* Because of a thorough knowledge of the technical considerations of painting and of color relationships, Jones has a distinctive awareness of color. Her ability to use different coloring under different circumstances is apparent in *Across the Sound, Menemsha, Massachusetts.* The several compositions residing within the single composition are deftly handled and elegantly exposed. If each segment of the painting were enlarged, several paintings would be the result.

A lone sailboat rides the blue-green waters as four vacationers man the deck. In spite of the tightly knit shack huts and accumulation of stored goods and equipment, there remains a definite looseness

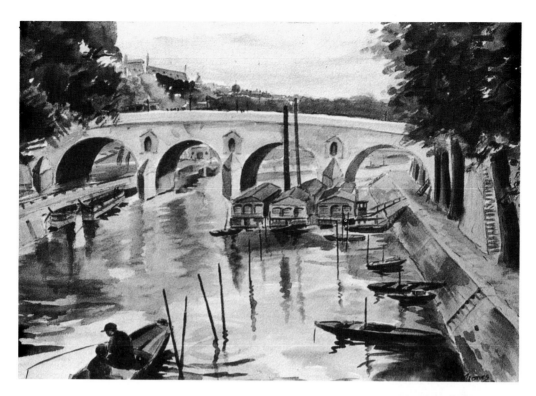

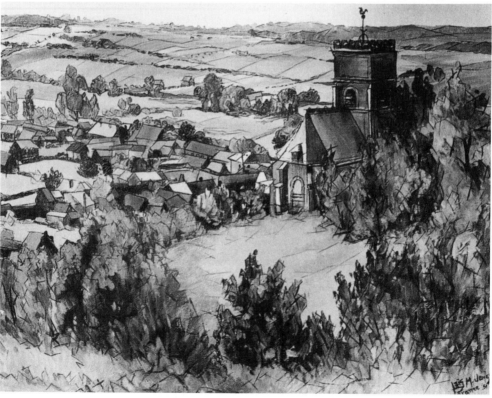

*Top:* **Lois Mailou Jones.** *Pecheurs sur la Seine, Paris* **(1937). Watercolor, 23×19 in. Courtesy of the artist.** *Bottom:* **Lois Mailou Jones.** *Ville d'Houdain, France* **(1951). Oil on canvas, 36×28½ in. Courtesy of the artist.**

that sustains the fluidity of her work. The horizontal planes are made compatible by the establishment of vertical posts and poles projecting skyward from the water.

Jones's scenes of Paris are fresh and dance with energy. In *Pecheurs sur la Seine, Paris* (1937), an added dimension is the certain calmness and peaceful union between man and nature. The Seine enables a fisherman with his son to calmly enjoy the tranquility of an early morning sunrise while contemplating inner frustrations. *Pecheurs* is a traditional painting, an objective visual capturing of a peaceful Parisian scene. One views a customary bridge spanning the Seine, boats moored along the shores. The horizontal bridge is counteracted by tall trees and subordinate dock posts. The four circular entry ways of the bridge are positioned in the upper central segment of the painting to form the focal point.

*Ville d'Houdain, France* (1951) is an exquisite example of the oil technique executed by a master technician. Jones's masterful technique contributes to a quietly elegant display with richly imbued yellows and greens enhanced with compatible umbers and siennas.

Again, the human condition is ignored in favor of the richly endowed natural setting. The visual perspective reaches miles as acres of land lie adjacent to each other in the distant horizon. The small French village is adjacent to the centuries-old Catholic church surrounded by a forest of trees. A lonely weathervane is perched atop the church. *Ville d'Houdain* is a recording and a reporting, but also an expression of love and compassion. The subdued color is due partly to climatic conditions and partly to the emotional circumstances of the event.

There is a loneliness about the scene. Jones, in a manner similar to many French painters, works on establishing the purity of nature's beauty. Jones never looks objectively for ways to improve her observational powers because she instinctively senses the most appropriate locales for witnessing the intrinsically beautiful spots.

*Les Pommes Vertes* (1938), one of her few still life paintings, has the charm and convincing manner of a Cézanne. A crusty, heavy technique reflects a powerful brush. The lightheartedness revealed in her Paris watercolor scenes gives way to a solid, secure, stabilizing technique which favors the strong craftsmanship of the artist. Even though traditionally posed for exercise purposes, the still life affords the spectator a pleasant view. The fruit bowl perched upon a chair and draped with material folded appropriately to meet compositional needs, presents a commonplace theme with commonplace objects, but in a highly personal manner.

Jones has an artist's approach toward the strong application of pigment. One enjoys not so much the theme itself, but rather the paint quality and color, and its crusty, textural make-up. Although the arrangement of the stimulus is traditional, one relishes the richness of a limited palette.

*Speracedes, France* (1948) is a view from the air of a typical French village with two- or three-story apartment buildings surrounded by cypress trees. Jones prefers the quiet stillness of the landscape rather than human activity. However, in a sense there is activity in nature when seen from an aerial perspective. Jones leaves little room for rest as the viewer is treated to a landscape jammed with architectural activity and surrounding foliage.

*Speracedes* also seems to show the Cézanne influence of a heavy palette knife technique and thickly applied pigment that makes for solid, secure buildings which seem to stand proud in their habitats. Even though the frontal plane consumes the area and the sky has left the scene, the sharp shadows upon the building sites reveal that sunlit skies hover above. And even though Jones preferred to paint directly at the locale, preliminary sketches seemed essential to a final composition with *Speracedes*. The juxtaposition of the several buildings and the insertion of tree foliage suggests a more complex approach than the usual instinctive response. One is dazzled by the

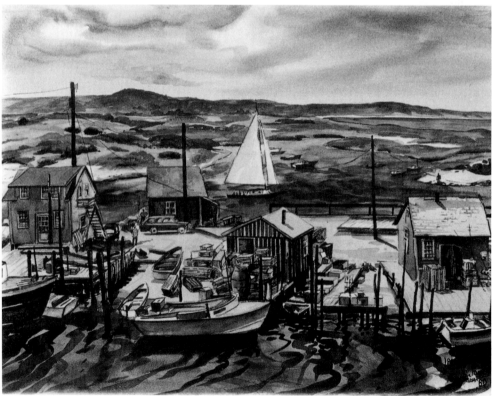

*Top:* Lois Mailou Jones. *Le Chateauneuf de Grasse* (1989). Acrylic on canvas, 25¹/₂×19³/₄ in. Courtesy of the artist. *Bottom:* Lois Mailou Jones. *Across the Sound, Menemsha, Massachusetts* (1980). Watercolor, 22×18 in. Courtesy of the artist.

overlap and interweaving of buildings and roadways and the never-ending parade of activity. It would seem that *Speracedes, France* is a slice of life severed from an ever-expanding landscape and then enlarged by the artist. Details are limited to the windows and chimneys of the apartment houses and echoed in the distance with a sprinkling of miniature spruces.

*Old Street in Montmartre* (1932) possesses a definite French flavor. Not only do the buildings reflect a typical French origin, but the influences of Vlaminck, Gauguin and Cézanne remain. The curvature of the hillside, ironically, enjoys its oppositions in the attempts made to avoid the obviousness of its shape. A handcart is positioned overlapping a curve at the hill's crest. The inactivity of the circular form and the assortment of windows and shutters accompanying the hillside buildings diminish the presence of the uphill curve.

To the painting's extreme left are three humans engaged in business. Residents are also noted in a café, which adds to the viewer's enjoyment. Jones has attempted to realize a quaint Parisian scene common to those American artists who found it beneficial to paint in the style of the French. Jones has succeeded in recording the French color, the centuries-old decor and the influence of her French predecessors.

Unlike the visual compactness of *Speracedes, France*, the *Old Street in Montmartre* allows both the sunlit skies and its effects upon the environment to be seen. Brushstrokes are crude and assertive, and have a nervous touch, a sense of haste to record the scene. An old street is not without extraneous tidbits which needed expunging during the process of recording essentials.

Jones has maintained the quaint beauty of Montmartre while injecting personal magic onto the surface of the painting. In *Coin de la Rue Medard, Paris* (1947), Jones exhibits a rare masterful touch. Lush color vibrates. Even streets and sidewalks, generally considered rest areas in a painting, become alive with

human activity. Brushstrokes of color spread upon the appropriate surfaces bounce with life. Centuries-old buildings are vitalized by the surrounding activity. There is a carefree, yet determined attitude to the Parisian populace, one that is enjoyed by the viewer as well as the artist who performed the work.

Both Impressionist and Expressionist in style, *Coin de la Rue Medard* is a painter's painting. Neighborhood events occur throughout the painting. Segments could be extracted and developed into major works. The window shopper, the violinist, the aged vendor, the saleslady and the young lady in shadow exemplify the nonchalant, *laissez-faire* attitudes and life-styles of the Parisians.

There is an ancient look about *Coin de la Rue Medard, Paris* made obvious by the crusty appearance of the architectural environment. It is also a charming painting, one which defines the old traditional manner of life that needs resurrection frequently in order to preserve one's sanity in the current world.

*Place du Tertre* (1962) sustains the French flavor Jones experienced during her stay in Paris. Buildings that are close together form an intimate relationship, but in total contrast is the vast space occupying the center of the canvas allowing the French patrons the freedom of movement.

*Place du Tertre* is painted in an intuitive style following an objective arrangement of subject matter. Diligence and care are seen in the details adorning the buildings. *Place du Tertre* is an affirmative painting, an expression of a positive statement, but nonetheless loneliness prevails. Jones has created a sincere approach to a commonplace theme and has injected a sense of loyalty and pride.

Thus far Jones's discussed works have centered upon Parisian landscapes and still life images. Emotions intensified with the introduction of her Haitian and African paintings. There was a profound concern for her subjects. Her watercolor Parisian landscapes seemed to fulfill a different need, a need to enjoy and engulf

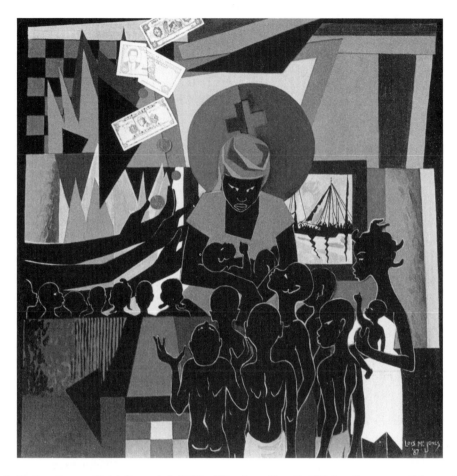

**Lois Mailou Jones.** *Haiti-Demain?* **(1987). Mixed media, 43×43½ in. Courtesy of the artist.**

the French landscape. There was a freedom to explore, a freedom to enjoy life.

Suddenly, the economic problems, the poverty and starvation, the daily deaths due to sickness and malnutrition erased that joy for life, that happiness that seemed to flow from her watercolor paintings. Now art had become an essential part of her life, in fact, life itself. No longer could Jones fulfill the needs of only herself. She now felt the strong desire and need to fulfill her destiny of assisting those in dire need.

Her Haitian paintings are not only a record, but an eternal expression of the death of a spirit that stubbornly fails to succumb to man's inhuman negligence. In her painting *Haiti-Demain?* (1987), Jones portrays the dilemma of an entire race of people. Devout religious beliefs

provoke procreation, but the lack of economic prowess and mechanical ingenuity forestalls any anticipated progress. Instead, disease and hardship and death continue to rack the country. Perhaps the poorest of all nations, Haiti remains in the clutches of mounting physical casualties, a momentous occasion for artistic reporting and expression.

Lois Mailou Jones found in the Haitian people a reason to extend her talents, a need to refurbish her prior trials, to put aside any racial or economic injustices, and to finally concentrate on a single people. *Haiti-Demain?* is indeed a question mark. It is essential that Jones re-create the poverty of this worn-out nation. Her painting declares a continuous line of births met with a continuous need for support and aid. It is a carefully con-

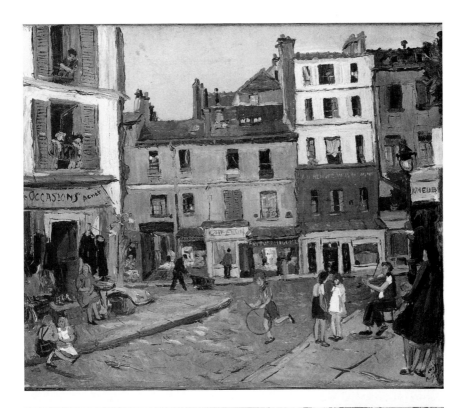

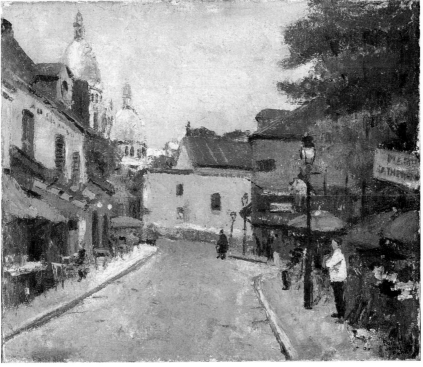

*Top:* Lois Mailou Jones. *Coin de la Rue Medard, Paris* (1947). Oil on canvas, 22×18 in. (55.8× 45.7 cm.). Courtesy of The Phillips Collection, Washington, D. C. *Bottom:* Lois Mailou Jones. *Place du Tertre* (1932). Oil on canvas, 22⅝×18½ in. Courtesy of The Phillips Collection, Washington, D. C.

ceived composition, one in which cause and effect dominate the canvas.

The overpopulated isle of newborns is received by a single woman surrounded by a halo symbolizing sainthood. The halo incorporates the cross symbol suggesting the image of their Savior, Jesus of Nazareth. Jones acknowledges the profound faith of the Haitians and applies its symbolic presence in her work. Strong, pleading arms reach out to assist in the everpresent population crisis. One may question her stylized workmanship with such devastating problems at hand, but nonetheless there exists a compassionate plea in the naked images of those pleading for aid.

The colorful geometric environment adds to the intensity of the scene. The outstretched arms of the recipients gather in the much needed currency which seems to fall from heaven. This symbolic gesture of financial aid has become an everpresent need for the Haitian people. This diligently executed painting incorporates the traditional representation of human figures with an abstract environment into a compatible unity. Jones had always considered Haiti and Africa similar in terms of deprivations and injustices experienced in daily life.

Her painting titled *Symbols d'Afrique II* (1983) is a montage arranged geometrically. Dominating the frontal plane, African females occupy the central band of color which is part of a symbolic cruciform. Traditional African symbols are juxtaposed in a manner similar to that applied to the works of the famous semi–Abstract artist Stuart Davis. *Symbols d'Afrique II* also reminds one of Josef Albers's optical illusions of the early fifties. Because of its abstract nature and its flatly applied color, *Symbols d'Afrique II* holds less meaning about the hardships of the African people. The three heads consuming the vertical panel are realistically rendered and thusly hold a prominent position. All other areas of the painting are flatly covered, which would ordinarily create confusion. Yet because of color control, the painting sustains a compositional unity throughout. There is a pleasing distribution of color in spite of recessive and advancing color, seemingly contradicting the rules of nature.

*Symbols d'Afrique II* illustrates Jones's mastery of composition. The deliberate inclusion of conflicting color relationships and the satisfying and compatible results indicate an underlying strength that is not as readily apparent in the subjective portrayals.

Another strictly symbolic painting is titled *Dahomey*, executed in 1971. Its three pronged composition is simple and direct, and avoids the overlap of color and form obviously expressed in her later African works.

Animal forms reminiscent of early cave drawings monopolize the canvas. A subtle juxtaposition of environments is the backdrop for animal-like figures resembling the turtle, bison and bat. The chosen colors resemble those of the American Indian and the Aztec civilization. Circular shapes seem like targets occupying each of the three segments. They alternate in color and are well integrated parts of the three segments.

Again, *Dahomey* appears as an exercise in color and shape. Yet, the need to convey specifics was evidently strong enough to enable Jones to impose a bit of discipline, which is so essential to the creative process.

The brilliant sunshine of the Haitian islands is forever witnessed in the colorful dress of the Haitian people. In a painting titled *Street Vendors, Haiti* (1978), the magic of this natural haven of exotic beauty becomes evident in spite of the devastating hardships. One cannot erase the divine beauty which remains unscarred. It is this divinity, this creation by the omnipotent being that Lois Jones is obsessed with expressing in concrete form. Even though Jones avoids the three-dimensional nature of the inhabitants, visual perspective is obvious in her juxtaposition of figures, buildings and the sailboat flirting with the horizon. *Street Vendors, Haiti* is an eloquent

*Left:* **Lois Mailou Jones.** *Symbols d'Afrique II* **(1983). Acrylic on canvas, 37×37 in. Courtesy of the artist.** *Right:* **Lois Mailou Jones.** *Dahomey* **(1971). Acrylic on canvas, 40×54³/₈ in. Courtesy of the artist.**

example of the innate beauty inhabiting the isle.

Jones has declared and recorded the beauty of landscape, and humans were removed from the scene. There are bits of influence via Jacob Lawrence and Romaire Bearden. Whether or not such influences existed matters little since Jones injected her work with her own style. There exists a spatial transference of darks and lights which tends to defy Josef Albers's theory of recession and advancement of color. The white sailboat hovering at the top of the canvas remains at a spatial distance in spite of its advance to the forefront. There is also a subtle blending of color creating nuances which offset any controversial color relationships.

*Street Vendors, Haiti* is basically a pleasant experience in color, theme and composition. A unique distribution of vertical and horizontal planes brings

about a compatibility that marks Jones as a master of styles.

An equally compassionate portrayal of Haitian life is witnessed in *Marche Haiti* (1963), a portrait of the Haitian people who continue to tote their goods overhead which illustrates Jones's superb compositional dexterity. In spite of the numerous positions and various objects involved, confusion is avoided by the interest maintained between the subjects. Jones portrays the recessional parade of events by depleting details as they recede into space and by diminishing figurative sizes.

Again, the attainment and maintenance of compositional props contradict the color theory of advancing colors intensifying and receding colors diminishing in intensity. *Marche Haiti* is an exquisite example of Haitian color applied to the native tasks of employment. Although objectively portrayed, each figure

**Lois Mailou Jones. *Marche Haiti* (1963). Polymer, 29⅞×33¾ in. Courtesy of the artist.**

joins forces with each other to form a single unit and thus suggests an aspect of subjectivity. There is still a sense of Cubism, the Cézanne influence, permeating the scene.

Jones slips in and out of the subjective approach depending on artistic needs. The crowded village of dilapidated shacks adjacent to a statuesque church illustrates the congestion and poverty of the starving nation of Haiti. Titled *Eglise Saint Joseph (Croix Bassale) Haiti* (1954), the overcrowding is typical of the overpopulation of this small isle.

The viewer is brought into the painting as the natives stand and look to the viewer as if a stranger had intruded upon their privacy. There is a confusion of sorts caused not by the artist, but by the nature of the scene. Cluttered huts of

**Lois Mailou Jones.** *Eglise Saint Joseph (Croix Bassale) Haiti* **(1954). Oil on canvas, 28½×23½ in.
Courtesy of the artist.**

busy activities add to the complexity of
the design. Several compositions reside
within the whole, and if enlarged would
produce several major paintings.

One of Lois Jones's major works is
*Meditation (Mob Victim)* (1944), a por-
trait of universal significance because of
the injustices visited upon the African-
American race. The highly subjective ex-
pression of her subject illustrates her pro-
found concern for the underdog, perhaps
because she herself has been a victim of
white supremacy and bigotry. It is unfor-
tunate that her productions did not in-
clude more themes of social injustice.
*Meditation* is also an appropriate title
because Jones blends the divine with the
human. The need to pray for future
miracles is registered in the eyes of the
victim; the resignation to death is wit-

nessed in the glance heavenward; the
symbolic tree branches in the background
form an arch which peculiarly hints at a
hanging tree; in the distance is a church
tucked into the hills but nonetheless sig-
nificantly evident in the scheme of things.

Jones projects her feelings unmistak-
ably to the viewer in a daring but essen-
tial plea for tolerance. *Meditation* shows
in a single sweep the social injustices of a
system that ironically prides itself on
the principles of freedom and justice for
all.

Of lesser significance but worthy of
deliberation is the theme of a portrait
titled *Jennie*. It pictures a maid in the
midst of cleaning fish. The subject is
surrounded by objects of china and
glassware. In so doing, Jones avoids an
inner loneliness which is readily iden-

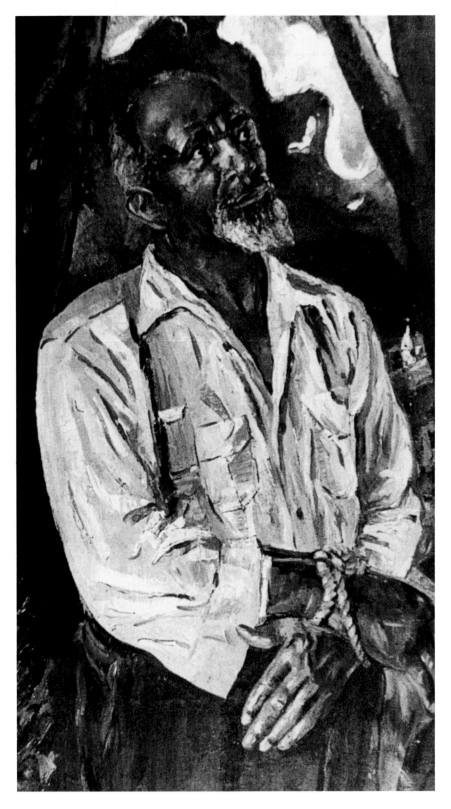

**Lois Mailou Jones.** *Meditation (Mob Victim)* **(1944). Oil on canvas, 25×41¼ in. Courtesy of the artist.**

tifiable with the literal circumstance. The viewer must divide visual and emotional attention among the several items and Jennie. *Jennie* may well be a self-portrait, a common practice among artists.

The collage was never a major source of expression for Lois Mailou Jones, but in *Challenge* she objectively portrays a wide range of exploits. A complex manipulation of tribulations proves exciting for both artist and viewer. Executed in 1969 during the era of anti-war and civil rights riots and student protests, *Challenge* depicts personalities and events of America. Overlapping and interpenetrating are such famous personages as presidents Kennedy and Johnson, Martin Luther King, Jr., Einstein and Washington. References are made to Lyndon Johnson's "Great Society," NASA, the cause of peace, the Mississippi scandal, segments of the Gettysburg Address and the Bill of Rights. The word "America" looms large in the forefront overlooking the events of history, but particular letters of the word are obliterated; images of the American eagle and Abraham Lincoln partially block out key letters of the word as if to dispel any hope for social justice.

The design reads like an American history book used to recall events of turmoil caused by racial uprisings. Artistically, *Challenge* is an articulate, objective rendering of shameful national problems the solutions to which would ease the pain of racial bigotry. It is a diligent record of personalities and events which helped to shape the standards of America's social system.

The word "America" is split into two colors, the last three letters of the word in black. This subtle disbursement of color recognizes the position of blacks in America. There are no violent images in *Challenge,* only a recording of those who wish to create a better America for all humans through the application of the Bill of Rights.

In a similar vein is the oil-collage titled *Vévé Voudou II* (1963), a painting of African symbols. Similar to her other African works, *Vévé Voudou II* completely dominates the frontal plane, thus ignoring the visual perspective of receding or advancing objects.

Spatial considerations are dealt with in terms of three-dimensional color relationships. Overlapping of objects determines their spatial placement onto the working surface.

Jones's shifts in style would appear disconcerting, but to her the directional changes afford a deeper understanding of media and composition. Her landscapes, still lifes and figurative paintings adhere to a sense of freedom, a technical freedom, an opportunity for change within the process itself.

However, *Vévé Voudou II* and similar works demand attention to compositional needs. Planning is essential to avoid instinctive or impulsive change. The complexity of design of this painting is easily seen in the final product. The development of a symbolic abstract work demands further considerations in terms of color and space relationships. African symbols are justified only if used to create a meaningful abstract (in terms of color and space).

*Vévé Voudou II* is an intellectual approach to painting. One questions the success of such works, which were perhaps essential to Jones's personal growth and development. But it is her landscapes that excite the viewer and that this author believes will maintain her status in American art.

An exquisite composition is presented in Jones's watercolor *French Scene* in which boats are anchored in the Seine. The amazing overhead bridge protects the boats from the brilliant sunlight as shadows divide the canvas into dark and light areas. The sunlit waters compete with the shadowy underlying bridge span. To add to the intriguing design, Jones inserted the human element with the persons interested in the fishing game. The partially circular shape enclosing the objects of activity and the humans is textured to avoid a monotonous surface rendering.

Jones's use of color is exhuberantly displayed in a Haitian painting titled *Marche Haiti* (1965). A painting of 1963 with an identical title was discussed earlier. The 1965 rendition is a horizontal panel consisting of a team of nine vertically structured figures dressed in colorful garb. The attire reflects the continuing Cézanne influence. The apparent monotony is salvaged by the strong color relationships and the semi–Abstract structure of the foreground.

Jones reveled in the Haitian color and hastened to use it full force. Even though objectively arranged, each colorful figure is a single link to the whole. The nine figures add up to a single unit and thus *Marche Haiti* is viewed subjectively. Since the final result is a compatible team of nine figures rather than single figures each painted separately and in a procedural order, a compositional unity prevails.

*Ubi Girl from Tai Region* is a highly decorative, symbolic rendition. Realism is found in the upper right head which is partially covered with a white mask. The mask image is duplicated to the lower segment of the canvas, but the complexity of design and the overlapping of planes make *Ubi Girl from Tai Region* an exquisite painting. There is a definitive sequence of spatial perspective, not in the sense of receding vanishing points but rather in the advancement of design. Jones has reached into the past to express her African heritage. There is a definite departure from her American images and even a deliberately different style. More tightly knit and disciplined in a design sense, *Ubi Girl from Tai Region* was well conceived before the paint was applied. In her landscapes a looser style enables a freedom and flexibility which is absent from her African-American portrayals. The switch from the Expressionistic technique to calculated compositions is noteworthy but her true strength and power of conviction stems from her earlier works of the thirties and forties.

*The Lovers* is a highly decorative piece with strong African influences. The two lovers, engaged in a visual and mental dialogue, occupy a major portion of the painting. In spite of the obvious concentration on each other's flirtatious looks, the romance is visually hampered by the ornate design of the environment. The background is echoed in the female's necklace and its geometric design is reflected in the male's upper attire.

Although the lovers are positioned in a sexually suggestive situation, the ornately designed background interferes with the intimate relationship. The contour lines serve to strengthen the form of each lover and unite the composition. *The Lovers* is a montage of faces, bits of design, geometric shapes and color paying tribute to Jones's African heritage, which she has celebrated through her work. The double portrait illustrates Jones's exposure to black culture on a world-wide basis.

During the thirties while studying African culture, Lois Jones painted *Les Fetiches, Paris* (1938), a display of African symbolism which incorporates the mask image found in the African culture. A large, eerie and mysterious mask dominates the canvas accompanied by secondary masks below and adjacent to the focal point.

Jones has utilized a circular composition in which bands of color monopolize the canvas surface. Her African culture motivates decorative design even though a magical, unexplainable mystery emerges. Glimmering highlights and brooding shadows envelop the head shape resembling a king's crown.

In spite of a calculated design, there is the freedom of abandonment which prevails throughout the painting. Sharp, angular, geometric shapes are counterbalanced by seemingly frivolous gyrations of color (à la Kandinsky). In a sense, *Les Fetiches* is subjective with its interpenetrative shapes even though the work is objectively executed.

In Lois Mailou Jones's *The Ascent of Ethiopia* (1975), the new and the ancient blend into a fascinating montage of cool mystery and magical ritual. The loneli-

ness of the natural landscape and the towering urban skyscraper emerge into a single undulating design of life. Two spheres house unusual images: The lower orb contains Egyptian pyramids and successive stars of David, while the upper sphere incorporates images of the current fine arts agenda, namely, art, music and drama. Each medium of communication sustains its own environment.

A bright star shines down upon the earth and its occupants who kneel in ritual assembly. Jones's elaborate design provokes an emotional response. Divergent lines inspire a complex study of the African root images. The artist's combination of Egyptian and Ethiopian imagery is rooted in the African civilization and Jones does well to express this unification.

In *Initiation-Liberia* (1975), Jones interprets an initiation ritual. The prospective member is blindfolded, thus participating in a ceremonial role. The social system into which she is initiated becomes more potent than the person herself. The strong facial image is echoed in the dual profile adjacent to the frontal view.

*Initiation-Liberia* is another example of remarkable composition. Its combination of Realism, Abstract and Op art blend effectively into a unified composition. The duplication of pattern is exquisitely balanced throughout the work. Line and solid shapes coexist in a highly calculated and complex expression.

Executed a year earlier is *Petite Ballerina* (1974) a painting utilizing a composition similar to *Initiation-Liberia.* The young female figure is also an initiate whose companion represents a past generation. Although unlike *Initiation-Liberia* whose female initiate is masked, *Petite Ballerina* pictures an unmasked initiate whose headdress consists of cowrie shells and monkey hair. Similar geometric designs reside in the background. The image of the early African sculpture becomes the link to the current generation.

Lois Jones's residence in Haiti and her study of the Haitian culture has resulted in several colorful masterpieces. Her painting titled *Vévé Voudou II* ex-

plores the Haitian religious culture. Several vévé symbols occur upon a black background. Color and shape are juxtaposed in a delicately rendered and complex calculation. Jones's Haitian and African images are precise and flatly painted and become extremely intricate in design.

Intricacy had become a strong factor in Jones's paintings and is potently expressed in *Magic in Nigeria* (1975). Each overlapped image is exquisitely detailed and rendered in flawless fashion. The jewel-like appearance reflects her intense concentration and devotion to a limited working surface. In spite of each isolated subject, the combination of the individual images results in unification of all parts.

And yet, this manifestation of African masks has created a freedom from a caste system deeply rooted in the African culture. The muted background acts as negative space thus enhancing the positive aspects. The presence of a negative background is essential to the whole because to consume the entire canvas with positive elements would smother *all* elements and destroy the effects of the initial message.

Jones's articulation and obsession in seeking a democratic society in African cultures, such as she has experienced as an African-American, suggests a devotion to her origin.

Jones also has a devotion and love of painting which is well illustrated in her landscape paintings. The talent needed to include numerous buildings in a work is witnessed in Jones's panoramic view of a French city, and is an example of her keen observational power and diligent executions. Appropriately titled *Panorama of Grasse, France,* this 1952 production scans the French city and introduces a spiral rooftop as the focal point from which develops a variety of rectangular shapes overlapping their way to the distant sea.

A subjective view of a single building coupled with the routine shoppers is found in the painting titled *Quai Montebello, Paris* (1967). Narrow streets and

intricately designed shops monopolize the scene as pedestrians casually roam the limited space allowed by the artist. Quaint old buildings, rustic shutters and hanging flower baskets dominate the facade of the work. In spite of the material and human activity, there is a quietness that permeates the work. *Quai Montebello, Paris* is a significant work which has a more definitive nature than her earlier works of the thirties and forties.

Aside from her detailed and colorful landscapes, Lois Mailou Jones has excelled in subjective portrayals of individual personalities. Similar to *Mob Victim* of the forties are two paintings titled *Jeanne, Martiniquaise* (1938), and *The Pink Tablecloth* (1944). Both are contemplative themes relying on audience reaction for full interpretations.

The work titled *Jeanne, Martiniquaise* portrays a simple female personality. The roughly textured application of pigment is in contrast to the meditative spirit of the subject. There exists a direct communication between the subject of the painting and the viewer who resides outside the painting. The spread of horizontal planes in the background add to the depth of the contemplative environment. *Jeanne, Martiniquaise* is a spiritual intercourse between artist and viewer. In spite of the unique subjectivity of the scene, there is a spacious sense of fulfillment.

Likewise, the painting *The Pink Tablecloth* reflects the somber mood of the subject; whether caused by an overindulgence in cognac or by a visualization of a fatal destiny remains for viewer speculation. *The Pink Tablecloth* is a deceptive title. It suggests a joyous occasion rather than the pathetic, tragic lifestyle the transient represents.

*Les Pommes Vertes* (1938) displays Jones's classical approach. Because of the unusual composition in which the commonplace drapery serves as an enhancement to the focal point of interest *Les Pommes Vertes* has an intensity usually lacking in still lifes. One is attracted to the advancing and receding spatial elements of the drapery which absorbs an equal share of the canvas. The dramatic palette aids in the intensity of a rather commonplace subject matter.

Although nearing the end of a long and successful career, Lois Mailou Jones continues to assist the younger generations through teaching and her work, which continues to exalt her cultural origin. In this case, pride and humility are totally compatible. She is humble about her achievements but proud of her ancestry and of her contributive nature regarding educational and artistic philosophies. Her zest for life has tremendous influence on her students and is reflected in her colorfully lush French and Haitian landscapes, and in her adopted African settings.

During her long and devoted career, from her early disciplined still lifes to her loosely expressionistic French landscapes, to her colorful and festive portrayals of Haitian culture, and finally to her African symbolism, Lois Mailou Jones has never relinquished her joy of painting. Her enthusiasm and dedication of purpose has never seemed to flounder, and there was never an indifferent attitude but always a cry to be answered. Jones is a devoted disciple of her heritage, but more importantly, she is intensely in love with life, and her art is a mirror of that life. She believes in the education of the young as witnessed in her tireless years of teaching. And in spite of life's usual deterrents, her work always reveals a deep respect for the art of painting.

Whether painting personal portraits of life or panoramic landscapes, Lois Mailou Jones has sustained a consistent level of excellence throughout her illustrious career.

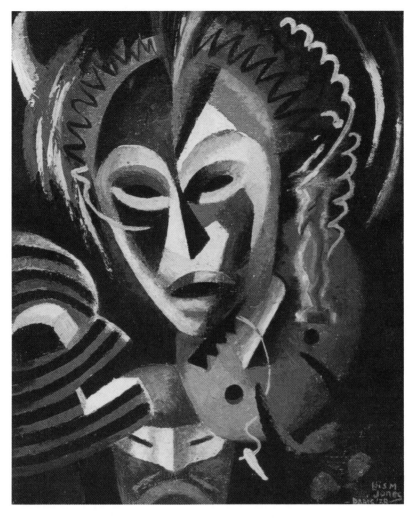

**Lois Mailou Jones.** *Les Fetiches, Paris* **(1938). Oil on canvas, 21×25½ in. Courtesy of the artist.**

# *Career Highlights*

Born in Boston in 1906.

## Education

Boston Museum of Fine Arts; Boston Normal Art School; Harvard University (summer); Columbia University (summer); B. A. degree from Howard University, Washington, D. C.; Boston Designers Art School; Académie Julian, Paris, France; École des Beaux Arts, Paris, France; studied in Rome; studied under Philip Hale, Jules Adler and Joseph Berges.

## Awards

Boston Museum of Fine Arts, 1927; Robert Woods Bliss Landscape Award in Oil Painting, Corcoran Gallery, 1941; Lubin Award, 1947; National Museum of Art, Washington, D.C., 1947; Haitian Government Decoration & Order of Achievement in Art, 1954; Washington Society of Artists Award.

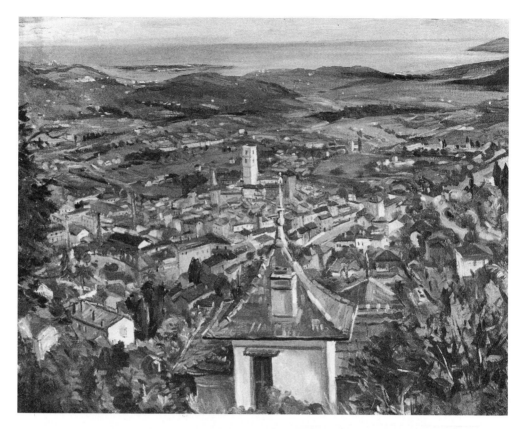

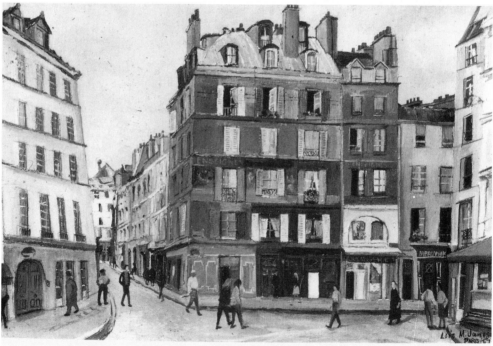

*Top:* Lois Mailou Jones. *Panorama of Grasse, France* (1952). Oil on canvas, 26×22 in. Courtesy of the artist. *Bottom:* Lois Mailou Jones. *Quai Montebello, Paris* (1967). Oil on canvas, 40×30 in. Courtesy of the artist.

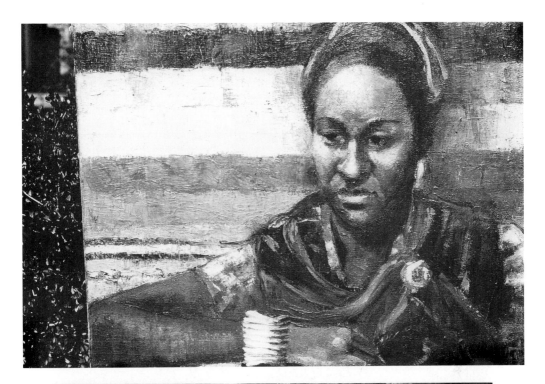

*Top:* Lois Mailou Jones. *Jeanne, Martiniquaise* (1938). Oil on canvas, 28⅝×23⅜ in. Courtesy of the artist. *Bottom:* Lois Mailou Jones. *The Pink Tablecloth* (1944). Oil on canvas, 28¾×25 in. Courtesy of the artist.

## Selected Exhibitions

Salon des Artistes Français, Paris, France, 1929; Corcoran Gallery of Art, Washington, D. C., 1931; National Academy of Design, New York, 1932; Pennsylvania Academy of Fine Arts, Philadelphia, Pa., 1935, 1936; Harmon Foundation, 1935; Trenton Museum, Trenton, N. J., 1936; National Gallery of Art, Washington, D. C., 1938; Baltimore Museum of Art, 1938; Albany Museum of History and Art, 1939; American Negro Exposition, Chicago, 1940; Whyte Gallery, Washington, D.C., 1940; Smithsonian Institution, 1940; Barnet Aden Gallery, Washington, D. C., 1941; Institute of Modern Art, Boston, Ma., 1941; San Francisco Art Museum, 1941; Seattle Art Museum, 1941; Phillips Collection, Washington, D.C., 1941, 1942, 1943; Boston Public Library, 1942; Smith College, Northampton, Ma., 1942; Hampton Institute, Hampton, Va., 1943; Fisk University, Nashville, Tn., 1945; United Nations Club, Washington, D. C., 1946; Dillard University, New Orleans, La., 1946; State Armory, Wilmington, Del., 1947; Pan American Union, Washington, D.C., 1947; Lincoln University, 1947; Grand Central Art Gallery, New York, 1950; American University, Washington, D.C., 1952; Xavier University, Cincinnati, Oh., 1962; Smith-Mason Gallery, 1968; Boston Museum of Fine Arts, 1971, 1972, 1975, 1976.

## Solo Exhibitions

Howard University, Washington, D.C., 1937, 1948, 1972; Vose Gallery, Boston, Ma., 1939; Whyte Gallery, Washington, D.C., 1947; Haiti, 1954; Galerie International, New York, 1961; Soulanges Galérie, Paris, France, 1966; Boston Museum of Fine Arts, 1974.

# *Bibliography*

## Books

Atkinson, J. Edward, ed. *Black Dimensions in Contemporary American Art.* New York: New American Library, 1971.

Boning, Richard A. *Profiles of Black Americans.* Rockville Centre, New York: Dexter and Westbrook, 1969.

Bontemps, Jacqueline. *Forever Free: Art by African-American Women, 1862–1980.* Alexandria, VA: Stephenson, 1980.

Burroughs, Margaret. "To Make a Painter Black." In *The Black Seventies,* edited by Floyd Barbour, 133–34. Boston: Extending Horizons Book, 1972.

Butcher, Margaret. *The Negro in American Culture.* New York: Alfred A. Knopf, 1973.

Chase, Judith. *Afro-American Art and Craft.* New York: Van Nostrand Reinhold, 1971.

Dannett, Sylvia. *Profiles of Negro Womanhood.* 2 vols. Negro Heritage Library. Yonkers, N. Y.: Educational Heritage, Inc., 1964.

Dover, Cedric. *American Negro Art.* Greenwich, Connecticut: New York Heritage Society, 1960.

Driskell, David. *Amistad II: Afro-American Art.* New York: United Church Board for Homeland Ministries, 1975.

————. *Hidden Heritage: Afro-American Art, 1800–1950.* Bellevue, Washington: The Art Museum Association of America, 1985.

————. *Two Centuries of Black American Art.* New York: Alfred Knopf, 1976.

Dyson, Walter. *Howard University. The Capstone of Negro Education: A History.* Washington, D. C.: Howard University Press, 1941.

Fax, Eldon Clay. "The American Negro Artist, 1968." In *In Black America: 1968—The Year of Awakening,* edited by Patricia Romero. Washington, D. C.: International Library of Negro Life and History.

————. *Seventeen Black Artists.* New York: Dodd, 1971.

Fine, Elsa. *The Afro-American Artist: A Search for Identity.* New York: Holt, Rinehart & Winston, 1973.

Franklin, John Hope. *From Slavery to Freedom: A History of Negro Americans.* New York: Alfred Knopf, 1960.

Gaither, Edmund Barry. "Black American Art." In the *Black American Reference Book,* edited by Mabel M. Snythe, 839. New Jersey: Prentice-Hall, 1976.

Gordon, Edmund. *Black Artists in America.* New York: Horace Mann Lincoln Institute, 1972.

Grigsby, Eugene. *Art and Ethnics: Background for Teaching Youth in a Pluralistic Society.* Dubuque, Iowa: William Brown, 1977.

Heller, Nancy. *Women Artists: An Illustrated History.* New York: Abbeville, 1987.

Jones, Lois M. *Lois Mailou Jones, Peintures, 1937–1951.* Tourcoing, France: Presses Georges Frère, 1952.

Krantz, Les. *American Artists: An Illustrated Survey of Leading Contemporary Artists.* New York: Facts on File, 1985.

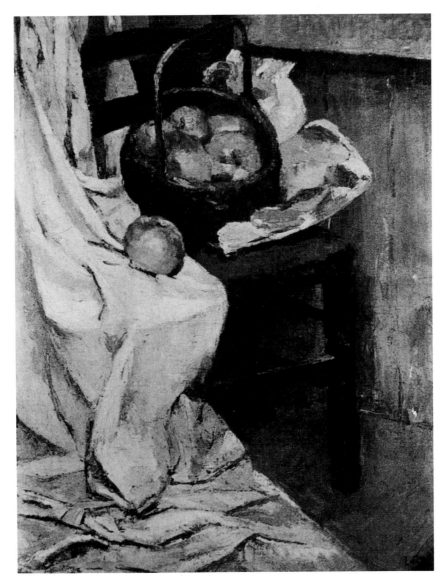

**Lois Mailou Jones.** *Les Pommes Vertes* **(1938). Oil on canvas, 28¼×36 in. Courtesy of the artist.**

Lewis, Samella. *Art: African American.* New York: Harcourt Brace Jovanovich, 1978.
_____, and Ruth Waddy. *Black Artists on Art.* Los Angeles: Contemporary Crafts, 1969.
Locke, Alain. *Negro Art: Past & Present.* Washington, D. C.: Associates in Negro Folk Education, 1940. Reprint. New York: Hacker Art Books, 1968.
Logan, Rayford. *Howard University: The First Hundred Years 1867–1967.* Washington, D. C.: Howard University Press, 1969.
"Negro Artists Gain Recognition After Long Battle." In *The Negro in Music and Art,* edited by Lindsay Patterson, 256. New York Publishing Co., 1967.
Peterson, Karen. *Women Artists: Recognition & Reappraisal from the Early Middle Ages to the 20th Century.* New York: Harper, 1967.
Phillips, Marjorie. *Duncan Phillips & His Collection.* Boston: Little, 1970.
Ploski, Harry, and Ernest Kaiser. *The Negro Almanac.* New York: Bellwether, 1967.
Porter, James Amos. *Modern Negro Art.* New York: Dryden, 1943. Reprint. New York: Arno, 1969.
Rubinstein, Charlotte. *American Women Artists from Early Indian Times to the Present.* Boston: G. K. Hall, and New York: Avon Books, 1982.

# Periodical Articles

"Artist in Transition." *Essence* (November 1972), pp. 45–47.

"Artist of Sunlit Canvases." *Ebony* (November 1968), pp. 136–41.

"Our Cover Artist: Lois Mailou Jones." *Design* (January 1958), pp. 95.

"In the Galleries: Lois Mailou Jones." *Arts* (March 1961), p. 52.

"Art Throughout America: Washington—Results of an Art Contest." *Art News,* November 23, 1961, p. 15.

"Washington Moves Across the Tracks." *Art Digest,* February 15, 1940, p. 15.

"Survey of the Month: Lois Jones Exhibits in Paris." *Opportunity* (January 1938), p. 28.

"African Influences in Contemporary Black American Painting." *Art Voices* (Jan.-Feb. 1981), pp. 15–22.

"Portrait of an Artist: Lois Mailou Jones." *Museum School News* (Winter-Spring 1988), pp. 1, 2, 3.

"Lois Mailou Jones: American Painter." *Museum & Arts* (July-August 1988), pp. 42–45.

"The Grand Dame of Afro-American Art: Lois Mailou Jones." *Women's Art Journal* (Fall-Winter 1987–88).

"Lois Mailou Jones: Portrait of an Artist." *New Directions. The Howard University Magazine* (July 1977), pp. 5–23.

# Catalogues

Atlanta University. "Contemporary Art Collection." Atlanta, Georgia, 1959.

Atlanta University. "Exhibition of Paintings by Negro Artists of America." Atlanta, Georgia, 1942.

Baltimore Museum of Art. "Contemporary Negro Art." Baltimore, Maryland, 1939.

Barnett-Aden Gallery. "Paintings by Lois Mailou Jones." Washington, D. C., 1946.

The Boston Museum of Fine Arts. "Reflective Moments: Lois Mailou Jones." Boston, 1973.

The Harmon Foundation. "Negro Artists: An Illustrated Review of Their Achievements." New York, 1935.

North Carolina Agricultural and Technical State University. "Fifteen Afro-American Women." Greensboro, North Carolina, 1970.

Winston-Salem Alumnae Chapter. "Reflections: The Afro-American Artist." Winston-Salem, North Carolina, 1972.

# TWO

# *Shirley Woodson*

The works of artist Shirley Woodson have over the years generated an appreciative audience with her continued search for new means of expressing her cultural heritage. Her works of the sixties included the images of entertainers such as Aretha Franklin and Tina Turner, and although her later works have omitted such portraitures, the rhythmic pattern nonetheless has been sustained.

Although such identifiable entertainers no longer reside within her canvas confines, a musical crescendo appears throughout as colors rise and fall in intensity in relation to compositional balance. During the sixties, Woodson's palette was one of pure color confinement. Instead of the simple arrangement of the pure color spectrum, in the seventies Woodson resorted to a complexity of nuances, a breaking down of the pure color barrier with an expansion of options. Shadows and reflections became a factor in the choice of secondary colors. Because of the additional color exposure, compositional complexity resulted. Thus, the color distribution influenced and was also influenced by the positioning of ideas. Intuitive response became an essential segment of the creative process. Woodson succumbed to improvisation, thus avoiding a reliance upon traditional, entrenched philosophies of the art process.

The change of tactics has resulted in a series of paintings called *Journey,*

executed during the seventies. In her painting titled *Ode to Wifredo Lam* (1982), Woodson has kept the subjects and animal-like images as subject matter for the foreground while the background consists of plant life. Woodson has resorted to strong contrasts through the use of intense colors. The three forms occupying the frontal plane are further identified with strong, deliberate contour lines. There is a purposeful avoidance of facial identity, and details lean toward a semi–Abstract appearance. The background incorporates leaf-like organisms which seem to be overseeing the proceedings of the trio.

In a sense, *Ode to Wifredo Lam* is a highly personal work, and in spite of its deliberately objective positioning of images, it maintains a subjective sensation. The total use of space does not allow negative space to act as an accent for the positive aspects.

A painting titled *Within* (1982) reveals a trio of isolated figures, recognized in spite of the Abstract nature of the surroundings. Again, the foremost figure is outlined while the two adjacent figures blur into the background. Woodson has manipulated acrylic, a water base paint, with an oil pastel for this work. *Within* is an intuitive response to an idea, but it is also a painting in which the process of creation allowed transformation of notions impulsively into alien ideas. It transfigures what appear to be underlying

images into positive statements. And yet, because of the elements of overlapping and interpenetration, the viewer is open to speculate.

The medium of oil pastel superimposed upon the acrylic color enables Woodson to freely express new notions which occur to her during the artistic act. With the addition of a second medium, Woodson is further freed to correct or alter notions which offer a decisive character to the work.

*Within* seems a continuous performance which beckons for additional insights, insights which need to be satisfied. Musical performers seem to inhabit *Within*, and it is the tempo which sustains the painting through color and texture.

There is a reluctance to identify certain personalities in order to universalize her ideas. In both paintings, *Ode to Wifredo Lam* and *Within*, Woodson has avoided total recognition of her subjects. In a third work titled *The Three of Us* (1982), the artist has purposely avoided facial identity of one of the figures of the trio. Woodson has again utilized the contour or outline to differentiate her three subjects. The trio of heads are highly decorative but in an impulsive manner.

*The Three of Us* combines both flat and decorative planes which tend to enhance each other. Flat colors adjacently positioned to highly intermixed areas create both a compositional balance and a mysterious and inquisitive awareness of the unexpected and the unknown.

There is a sense of joy emanating from the features of the three figures although the middle figure mysteriously lacks individual identity. There is also a sense of oneness existing between the foreground and background as well as in the rendition of the trio itself.

An Abstract Expressionist approach is obvious even though the composition is well conceived. There is an immediacy reigning within *The Three of Us*, a spontaneous expression of color, shape and line. And yet, the placement of subject matter is calculated well in advance of any instinctive response to the idea.

Woodson has sustained a freshness, a newness stemming from a controlled emotional response. Given a limited working surface, which in itself forces the artist into a bit of restraint, Woodson is able to paint and suggest human emotions and keep them under control without sacrificing the explosive power of spontaneous painting. *The Three of Us* seems a joyous celebration. The rhythmic patterns of color registered in both the forefront and the background continue throughout her work.

Another painting of the same period titled *Flight into Egypt II* (1982) is objective in concept but subjective in the product. It seems that the outcome was inevitable once the idea was formulated and established upon the working surface, and that the artist had fully envisioned the work before the creative process was completed.

*Flight into Egypt II* incorporates elements of Realism and Abstract Expressionism. The subject matter, registered as positive aspects in the foreground, is objectively conceived and portrayed. The background is blended into the foreground to create a oneness, a singularity of unity between two opposing techniques. What may appear obviously different in style or technique in the original concept is soon altered to become similar to that of the later concept. In other words, the artist is sometimes forced to accommodate an alien impulse in order to serve the broader purpose of satisfying the compositional whole. There can be no isolated areas of satisfaction that simultaneously distract from the whole. The contents of a painting must maintain a singularity of purpose, a union of all its parts in order to become one. This is Woodson's motive. *Flight into Egypt II* is

*Opposite:* **Shirley Woodson.** *Flight into Egypt II* **(1982). Acrylic and oil pastel on board, 44×28 in. Courtesy of the artist.**

a fine example of compromise in order to create a satisfying oneness.

Woodson seldom loses sight of her original concept. Figures, although maintaining anonymity, are continuously highlighted as if to guarantee their presence amid a jungle of swirling shapes of color. In her work titled *Journey Fifteen,* figures seem to appear and disappear at will as if a mystery is about to unfold. It is this constant turmoil in a highly organized inner structure that intrigues the viewer.

In the Abstract Expressionist style, *Journey Fifteen* (1982) appears at an initial glance as a chaotic image of uncontrolled emotions, but further study proves otherwise. The complex overlap and interpenetration of images serve both literal and compositional needs.

It is the seemingly erratic that blends and mends what may appear to be disruptive forces. The advantage of a multimedia expression is the ability to salvage alien elements by improvisation and the superimposition of secondary notions. It is the secondary idea that may become the primary idea. In other words, the Abstract Expressionist thrives on uncertainty and the results of impulsive actions. Therefore, what appears as truth may shift into hypocrisy, and what suggests uncertainty may result in a definitive answer.

*Journey Fifteen* is an endless journey, a travelogue of intrigue with undetermined destinations. A sense of a mysterious sequence of events is ever present. Emotions explode within boundaries, a difficult task for the Abstract Expressionist, yet Shirley Woodson succeeds in *Journey Fifteen.*

Shirley Woodson, noted for a brilliant palette, fulfills a gigantic assignment with a panoramic view in her work titled *Talking Interior II.* One is reminded of Gauguin's Tahiti series when viewing Woodson's paintings of the eighties. The partially hidden figures found in the foreground and background are mysteriously isolated within themselves. Each form remains a general figure without a definitive identity. Facial features are absent, bodies are interwoven with aspects of the intricate background. Woodson has combined the purity of color with the subtle nuances of an expanding palette.

*Talking Interior II* is an intuitive masterpiece, a seemingly chaotic visual expression which is truly an exceptionally organized composition. The positioning of the visual aspects is diligently calculated, but it is the execution of the composition, the application of pigment that has created the spontaneous appearance. The brushstrokes of color maintain the suggestivity of impulsiveness while meeting compositional needs.

Woodson's deliberate attempts at suggestion allow the viewer several options in the reception of the work. The nature of Abstract Expressionism is to exploit the unpredictable and to alter the predictable so that a meaning is never clear-cut. The anticipation of the unknown in a work of art is at times as frustrating as it is exhilarating. Whether the viewer responds in the same manner as the artist or to the same degree of remorse or gratitude is never known. Most likely, there is a vast difference.

Woodson's paintings of the eighties have this ingredient of uncertainty, mystery and unresolved dilemmas. The painting itself is successfully rendered as a total composition, but the viewer is positioned at the receiving end. The manner in which the work is received and the degree to which it is accepted depends upon the aesthetic position of the viewer, determined by his or her intellectual, emotional and spiritual intensities. Woodson creates such a platform for audience participation.

A remarkable series of paintings have been referred to as Shirley Woodson's journey home, her pilgrimage of renewal. This group of outstanding works has been labeled *Shield of the Nile,* and this approach to painting is firmly rooted in her understanding of African art in relation to the love and affection expressed in the nostalgic echoes by African Americans regarding their cultural heri-

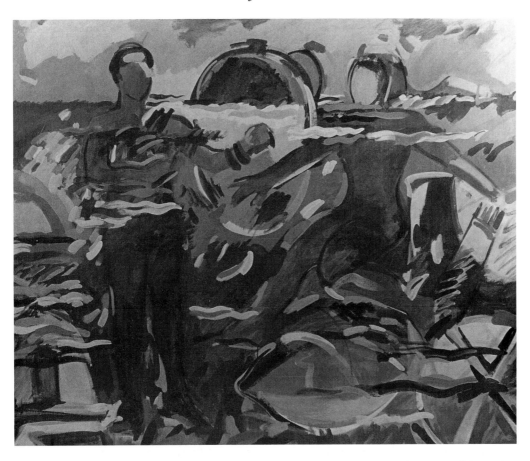

**Shirley Woodson.** *Shield of the Nile #3* **(1984). Acrylic on canvas, 68×56 in. Courtesy of the artist.**

tage. In this series of powerful paintings, Woodson has continued the use of symbolic images.

In the explosive, fiery portrayal titled *Shield of the Nile* (1984), the first of several masterpieces executed during a five year period, figures frolic in the symbolic waters of the Nile. Not only has water served as a compositional element in her work and as an environmental concern in life, but also as a symbol of purity. Figures emerge from unexpected sources. A complete image never exists but there is enough to evoke a query. Bits of color speckled about the river's waters take on facial features allowing the viewer to assume that the greater portions of the bodies reside beneath the watery surface.

Segmented bodies also occupy the open air. Perched on a cloud or enve-

loped in smoke, Woodson's images sprout from weird origins. *Shield of the Nile* is a dramatic exploitation of sea and sky. Brushstrokes are vivid and aggressive thus recording an event of spiritual purification and sustenance. Woodson's underwater figures are seen as complete only by the viewers' imagination. The artist's segmented creatures are attempts to create a visual dialogue between herself and her audience. The deliberate exclusion of facial features on the human forms is an attempt to include the viewer's own body in the watery fray. By allowing a blank face to survive, the viewer is offered the option of substituting oneself in place of the faceless creature.

Another version titled *Shield of the Nile #3*, also painted in 1984, presents a horizon line created by the juncture of

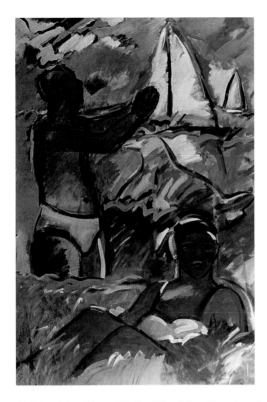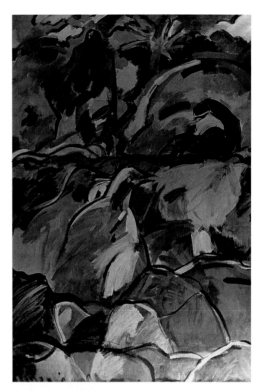

**Shirley Woodson.** *I'll Be Watching You* **(1987). Diptych, left and right panels, each 43×70 in. Courtesy of the artist.**

sky and water. Human figures are totally submerged in the water except for the heads of two major subjects. Again, human forms are left unidentified to allow for viewer participation.

Ripples of color activate the Nile while severing particular segments of the human bodies. Figures seem to be in motion, but one questions the cause of the anatomical agitation. Thrusts of color surrounding the contours of the figures create the illusion of physical activity.

Woodson has utilized the symbolism of the Nile as a purifying agent by immersing the figures into the deep waters. The narrow slit of sky residing behind the submerged figures accents the depth and the significance of the Nile.

In *Shield of the Nile #3,* the figure to the right seems a calculated creation, energized by the addition of color swatches, while the figure to the far left seems intuitively created. In the latter,

linear definition is added to a seemingly random application of color.

As stated earlier, *Shield of the Nile* is a journey home, a voyage of renewal. It is this exhilaration that is recalled and recorded by the artist. Those who participate in playful activity in the pure waters of Woodson's Nile are in essence renewing their spirituality. One's emotional, intellectual and physical makeup is revitalized, a new life is born, and according to Woodson, a purpose is reestablished.

In her painting titled *I'll Be Watching You* (1987) symbolic meandering exploits the human condition. A figure stands knee-deep in the purified waters, hands folded in a baptismal gesture, and an adjacently positioned female lounges in the Nile. The female peers outside the picture plane seeking viewer participation, an invitation commonly extended by the artist. A fantastic horse image jubilantly gallops across the canvas,

seemingly floating in space and reminding one of a Chagall magical journey. Sailboats, remnants of civilization, float aimlessly and freely against a vibrant sky.

The right segment of the two part painting resembles the left section by color similarity. The Nile scene is abruptly changed to one of land birds on a rocky terrain. Nonetheless, there is the oneness which is forever present in Woodson's paintings. Regardless of size, subject matter or technique, Woodson's Abstract Expressionist approach never fails to provide a panoramic view of life while maintaining a wholeness and a oneness.

In a large scale work titled simply *Nile Figure #1* (1989), Woodson focuses on a closer view, a detail of a single figure which appears to be clutching to life. Yet as Woodson explains, the Nile with its symbolic purification of the spirit, acts as a divine stimulus. Whether the human form is clinging to a physical life or preparing for a divine excursion is not a problem for Woodson. Again the viewer is invited to interpret according to one's own inclinations.

*Nile Figure #1* exhibits a single being under water except for a head and a hand which rises above the watery surface. According to Woodson, the raised hand represents acceptance of a divine will.

The slashing strokes of color found on the Nile's deep blue waters seem to ride the waves instead of being essential to its constitution. And yet, in spite of its apparent randomness, the streaks of color serve as a soothing element to the compositional whole, and indeed echo the artist's intuitive responses to her subject matter. Streaks of color were arbitrarily positioned due to impulsive reactions to the composition. Although primarily on the watery surface, Woodson has hastened to add similar brushstrokes to the sky above.

A series of paintings with similar compositional formats feature subjects which confront the viewer. In each of the works, *Poets #2* (1985), *The Poet and the Singer* (1985), and *Night Bird* (1985), the foreground and background become a single environment; that is, in order to prevent a visual separation of front and back planes, Woodson has advanced aspects of the back plane into the front plane and repeated frontal aspects in the background. This procedure is called interpenetration. It is a habitual technique of the Abstract Expressionist.

Woodson admits that ideas motivate her work and they are established upon the working surface before color is added. However, during the process of painting, ideas change, color is altered, images are extinguished, reconsidered and recreated. The concern is for the total expression. Shapes eliminate other shapes, lines discover new shapes, colors contrast and ideas succumb to new ideas. The painting is unpredictable and is governed by emotional impulses which are controlled by the intellect. Woodson's technique is one of constant and continuous discovery, and the excitement of the process creates an exciting product.

Woodson has introduced during the late eighties an unusual but successful medium in a series of religiously oriented paintings. Using oil and plaster on rice paper, the artist has effectively applied the scratch board technique to create highlights and shadows. Completely avoiding visual perspective, Woodson has projected her images on a frontal plane thus adhering to the freedom of placement. In her work titled *As He Lay Sleeping,* images, including a camel, glide through space. By creating a sense of eternal space, Woodson was able to transcend the physical world to that of the spiritual. Furthermore, the dream-like quality of subconsciousness transports her message beyond academic and traditional boundaries. Her images become universal in character adhering to no particular school of thought, individual stylization or acclaimed regionalism.

*Night in Tunisia,* another 1989 example of scratchboard technique, highlights the camel and brightly shining stars. The positioning of color and the ensuing surface scratching is a less intuitive project than her earlier works. The environment

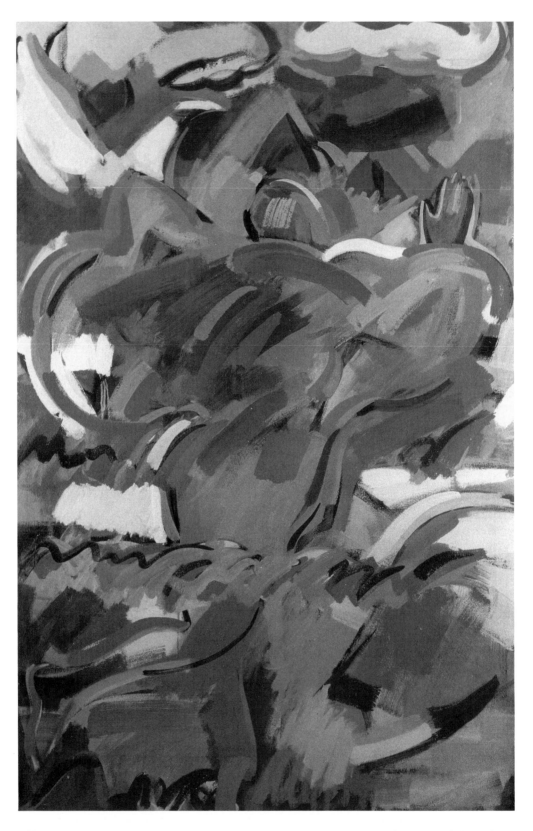

**Shirley Woodson.** *Nile Figure #1* (1989). **Acrylic on canvas, 42×66 in. Courtesy of the artist.**

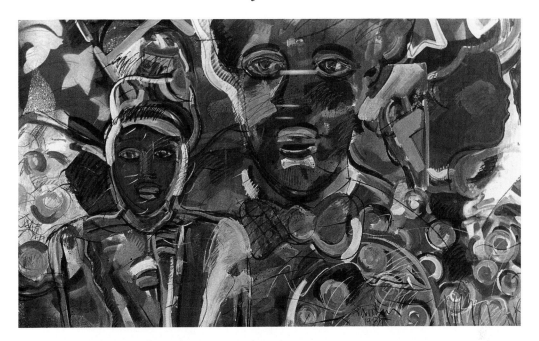

**Shirley Woodson.** *Night Bird* (1985). **Acrylic and oil pastel on board, 49½×34½ in. Courtesy of the artist.**

remains untouched as figures appear to lurk in the darkness. Outlines identify the contours of both figures and objects.

The spiritual mood is similar to that witnessed in *As He Lay Sleeping*. The richly textured environment is created by the subtraction of color, or by colors transformed from other colors. There is a majestic quality to the camel's stature as if she were playing the role of a heroine.

*Voyage,* a 1987 painting, is a dramatic concoction of swirling slashes of colors merging to create images of disasters encountered during the journey. It is an exhilerating example of intuitive responses to an idea conceived and executed on an uninterrupted voyage.

Where breaks in the continuity occur, quickly applied strokes of paint fill the gaps and close the slack. The choppy appearance is due to a series of interruptions which demand bits of contemplation before the voyage is continued. The undetermined destination creates a finality, and the last of the breaks dictates the end of the creative process.

*Voyage* is not essentially a quick rendition of a given idea. Its totality and its completion relies on several moments of idleness as well as action. As chaotic as *Voyage* may appear at first glance, its inner structure is logical and strongly reflects the Abstract Expressionism school of thought. If alien ideas creep into the expression, the painting may shift along the lines of the new ideas or the foreign elements may quickly be obliterated by newly discovered notions. Ideas need not be figurative or objective in nature, but may be represented by abstract shapes.

*Journey One* (1973) is a highly stylized semi–Abstract painting of figures in a rhythmic pattern. The distribution of highlights and shadows creates an eerie environment, one replete with African symbolic images. An obviously calculated composition, it differs considerably from her works of the eighties which are intuitively motivated. Yet, its complexity of design, its unusual blend of line, color and shape, and

**Shirley Woodson.** *Night in Tunisia* **(1989). Oil pastel on rice paper, 31×43 in. Courtesy of the artist.**

its peaceful mood seem to indicate a pleasant journey, a voyage from the physical world to a spiritual existence. *Journey One* is a joyful trek unlike those works of the eighties in which slashes of color seem like obstacles to physical pleasures. Although the palette is subdued, it is justified by the rich mellowness emanating from the background.

Excitement is found in Woodson's paintings of celebrities. Her work titled *Aretha in the Homeland* (1982) is alive

with color and people as entertainers seek the viewer's approval. In Woodson's entertainment series there is a hint of her later intuitive responses to life. Aretha Franklin's stage presence as viewed in Woodson's painting is potentially explosive and the artist's recording of the entertainer's personality is indeed enthusiastic. Colors overlap, intermix and interpenetrate to create a gala event.

Woodson's use of the contour line to

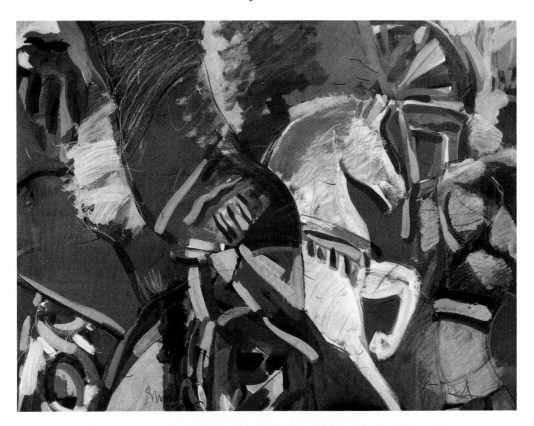

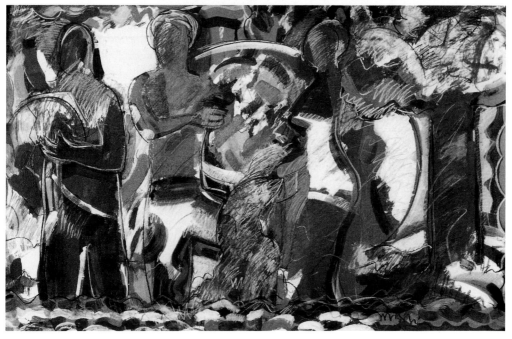

*Top:* Shirley Woodson. *Lilt* (1985). Acrylic and oil pastel on board, 44×28 in. Courtesy of the artist. *Bottom:* Shirley Woodson. *Pouring* (1985). Acrylic and oil pastel on board, 44×28 in. Courtesy of the artist.

separate positive aspects from a negative environment is partially evident in *Aretha in the Homeland.* Typical, however, is Woodson's obsession with the oneness of life, a merging of planes, an elimination of visual perspective in order to unify the composition.

Amid the several paintings completed during the eighties, Woodson veered from her Abstract Expressionist movement to a more traditional form in a religious painting in honor of St. Stephen. The mural approach features the cultural and spiritual roots of black Americans, and it portrays the religious heroes and heroines who helped African Americans survive the brutality of slavery.

Even in its traditional and formal style, there exists a rhythmic pattern of portraits which parallel her Abstract works of the eighties, and strangely enough, each facial image is individually identified. The *St. Stephen Memorial* (1988) became a labor of love. In fact, it became a welcomed disciplinary task which not only served a humanitarian and spiritual purpose, but contributed to the artistic growth of the artist.

The two figures occupying the foreground of her painting *Destiny* represent the fact that blacks are both African and American. Woodson has written:

> There are a lot of things about our African heritage and how we look at life in America that get overlooked in the dominant culture. But we are both Africans and Americans and this represents that duality.

*Destiny* is a boisterous painting, full of slashing colors which intermix to create a frontal plane. Seldom is visual perspective considered in terms of recession and advancement of positive images. In fact, initial concepts of negative space are eliminated during the creative process as Woodson's theory of interpenetration operates. It is this pulsation of color that recedes and advances, not for the traditional visualization of images, but to make the canvas surface appear as a single vertical plane.

Other paintings of note, *Lilt* (1985) and *Pouring* (1985), are examples of her mixed media of acrylic and oil pastel. Because of the opposing makeups of the two media, Woodson was able to justify both the intellectual and intuitive application of media. Woodson has succeeded in blending the two opposing media with satisfying results. Although *Pouring* is small in composition, it presents an expanded feeling, an ever present and never-ending lineup of figures. *Lilt* exhibits a segmented version of the theme.

Woodson's explosive technique is nonetheless intellectually and physically controlled, and her instinctive responses are conceived beforehand. In spite of any laboring efforts, there is a freshness in appearance that Woodson has succeeded in presenting to her audience. In expanding and deepening her ideas of life she has been consistent with her chosen medium rather than relying on numerous techniques which too often fail to satisfy the search for truth.

# *Career Highlights*

Born in Pulaski, Tennessee, in 1936.

## Education

B.F.A. degree from Wayne State University, 1958; M.A. degree from Wayne State University, 1965; Masters degree studies, Art Institute of Chicago, 1960; independent study, Rome, Paris, Stockholm, 1962.

# Awards

MacDowell Colony Fellowship, 1966 and 1967.

## Selected Exhibitions

Michigan Artists Exhibition, Detroit Institute of Arts, 1960; Four Afro-American Painters, Oakland University, Rochester, Mi., 1967; Childe Hassam Foundation Purchase Exhibition, Academy of Arts & Letters, New York City, 1968; Second World Festival of Black and African Art and Culture, Lagos, Nigeria, 1977; National Conference of Artists, Automobile Club of Michigan, Administrative Headquarters, Dearborn, Michigan, 1979; Historical Roots: The Black Artist in Michigan, Detroit Historical Museum, 1980; Forever Free: Art by African-American Women, 1862–1980, Illinois State University (traveled to museums in United States), 1981.

## Solo Exhibitions

Arts Extended Gallery, Detroit, Mi., 1963; Wayne State University, Detroit, Mi., 1966; Collaboration: The Painter and the Poet, (Poet–Dudley Randall), Arts Extended Gallery, 1969; "Kings & Queens," Gallery Seven, Detroit, Mi., 1970; Automobile Club of Michigan, Administrative Headquarters, Dearborn, Mi., 1982; Howard University, Gallery of Art, Washington, D. C., 1975; McGregor Library, Highland Park, Mi., 1973.

# *Bibliography*

## Books

Bailey, Leonard. *Broadside Poets and Artists.* Detroit: Broadside, 1974.
Bontemps, Arna Alexander. *Forever Free: Art by African American Women, 1862–1980.* Alexandria, Va.: Stephenson, 1980.
*Directory of Afro-American Artists.* Boston: Boston Public Library, 1973.
Fox, Elton. *Black Artists of the New Generation.* New York: Dodd, Mead & Company, 1977.
Igoe, Lynn Moody. *Two Hundred and Fifty Years of Afro American Art.* New York, London: R. R. Bowker, 1981.
Kostelanetz, Richard. *Assembling III.* New York: Assembling Press, 1972.
Patterson, Lindsay. *The Negro in Music and Art.* Washington, D.C.: International Library Series, 1967.
Woodson, Shirley. *Black Women in Michigan History: 1700–1985.* Detroit: Detroit Historical Museum, 1985.

## Periodical Articles

Charleston, Lula. "Profile of an Artist: Shirley Woodson." *City Magazine,* 1986.
Demerson, Bamidele. "Vivifying Power: The Nile as Metaphor in the Art of Shirley Woodson." *International Review of African American Art,* 9, no. 2 (1990).
Parks, Carole A. "The Broadside Story." *Black World* (January 1976).
Patterson, Lindsay. "African-American Audiences and the Arts." *Upscale Magazine,* 1991.
Williams, Kelly. "Michigan Watercolor Annual." *Art and Artists* (April 1964).
Woodson, Shirley. "History of Black Art in Michigan." *City Magazine* (March 1987).

## Catalogues

Automobile Club of Michigan. "Analysis." Text by Charles W. Finger, 1982.
Beach Institute/King-Tisdell Museum. "Walter O. Evans Collection of African-American Art." Text by Charles W. Finger, 1991.
Calvin College. "Figuring It Out." Text by Charles W. Finger, 1988.
Detroit Institute of Art. "Shirley Woodson: Dialogues: New Works." Text by Helen Shannon, 1980.

Flossie Martin Gallery, Radford University. "Coast to Coast: Women of Color: National Artists Booth Project." Text by Charles W. Finger, 1990.
Michigan Council for the Arts. "New Intiates: Five Michigan Artists." Text by Charles W. Finger, 1989.
Pontiac Art Center. "1983–84 Grant Recipients Exhibition." Text by Charles W. Finger, 1984.

# Reviews

Albert, Sara. "Art to Figure Out at Calvin Center Gallery." *Grand Rapids Press,* October 30, 1988.
"Art News." *Negro Digest,* May 1969.
Britt, Donna. "National Conference of Artists Convene." *Detroit Free Press,* April 1979.
Bruner, Louise. "Black Artists in America." *Toledo Blade,* September 13, 1970.
Camp, Marla. "New Generation of Black Leaders." *Detroit News,* February 2, 1989.
Canter, John Carlos. "Dreams Hold Fast in Afro-American Exhibit." *Ann Arbor News,* February 21, 1988.
"City Gallery Features Work of Two Michigan Educators." *Dearborn Times Herald,* June 28, 1990.
Colby, Joy. "Art in the Park—and On It Too." *Detroit News,* August 7, 1986.
_____. "Art Review." *Detroit News,* February 1990.
_____. "Black Experience Show Hugs Tightly to Convention." *Detroit News,* July 1979.
_____. "Celebrate Black Heritage—The Cultural Link." *Detroit News,* February 17, 1989.
_____. "Exhibit Features Forgotten Artist." *Detroit News,* March 17, 1988.
_____. "The Last Frontier: Commitment from Black Collection Sparks Renaissance of African American Art." *Detroit News,* January 9, 1989.
_____. "Quartet." *Detroit News,* February 26, 1988.
de Ramus, Betty. "Art Feature." *Michigan Chronicle,* October 1962.
Edmonds, Patricia. "Letter Says Yes, But City Says No." *Detroit Free Press,* April 1, 1986.
Findsen, Owen. "Focus 1988 Showcases the Works of Midwestern Artists." *Cincinnati Enquirer,* November 3, 1988.
Hakanson, Joy. "Art in Detroit." *Detroit News,* May 27, 1957.
_____. "Art in Detroit." *Detroit News,* May 25, 1958.
_____. "Art: Woodson-Randall." *Detroit News,* April 1969.
Iden, Shirlee Rose. "Diversities Spotlight on Women Artists." *Observer & Eccentric* (Southfield, Mich.), March 14, 1985.
Ingraham, Ken. "Art for People's Sake." *Michigan Chronicle,* April 1979.
"Khoury/Woodson Paintings." *Dearborn Press & Guide,* June 28, 1990.
McDonald, Elizabeth. "Exploring World of Art." *Battle Creek Enquirer,* February 7, 1990.
Maher, Mark. "Art Expression." *Detroit News,* October 9, 1990.
_____. "Showcasing the Works of Black Artists." *Kalamazoo Gazette,* February 20, 1990.
Meilgard, Mahon. "Artists Call." *Metro Times* (Detroit), November 18, 1987.
_____. "Year in Review—Art." *Metro Times* (Detroit), 1989.
Merkle, Karen. "Art: Woodson World of Color." *Erie Sun Times,* December 5, 1985.
Miro, Marsha. "Commitment Ties Collector Robert Perkins to Detroit's Black Artists." *Detroit Free Press,* February 17, 1991.
_____. "A Rich Sense of Color and Composition." *Detroit News* and *Detroit Free Press,* July 1989.
Rather, Ruth. "Black Artists: Interview with Shirley Woodson/Alvin Loring." *Detroit Tribune,* Summer 1968.
Shannon, Helen. "A Season of Afro-American Art History." *Detroit Focus Quarterly,* September 1983.
Siwala, Barbara. "Richard Mayhew/Shirley Woodson." *Focus Quarterly* (Detroit), Fall 1989.
Slowinski, Delores. "Perspective in Contemporary Black Art." *New Art Examiner* (Chicago), May 1985.
Tall, William. "Art in Detroit: Collaboration." *Detroit Free Press,* 1969.
_____. "Art in Detroit: Shirley Woodson at Gallery 7." *Detroit Free Press,* March 29, 1970.
Young, Harriet. "Legacy Painting Depicts History and Development of Church." *The Christian Recorder* (Detroit), February 6, 1989.
Young, Helen. "Saint Stephen Unveils Art Celebrating A.M.E. Roots." *Michigan Chronicle,* 1989.

# THREE

# *Howardena Pindell*

Born in Philadelphia in 1943, Howardena Pindell has altered her artistic direction each succeeding decade. Her method of painting figures in the sixties gave way to field color explorations in the seventies. Small circles of color dominate her paintings of this decade in which she explored the Abstract Expressionist school of thought. Finally in the late eighties and nineties she has chosen to utilize collage materials to execute mixed media works.

In a painting appropriately named *Untitled* (1984), Pindell creates a sense of foreshadowing and anxious moments of anticipation. She calls it a freedom, a release from the psychological shenanigans occurring at the time. The overlapping of positive pallets of color creates a three dimensional environment. Although optical illusions occur sporadically throughout the painting, receding and advancing colors adhere to the general rule of visual perspective. Although no particular plan is followed, an overall pattern becomes obvious as each succeeding spot of color fills a spacial vacuum as well as preparing for the next brushstroke. A light color partially placed over a dark color immediately sets the stage for the following overlap. The procedure continues as negative space gradually diminishes causing the original background to become the foreground or the positive space.

There are moments of pause which become focal interest points since the positioned colors differ in intensity or texture from those colors adjacent to it. Viewing *Untitled* is a conceptual process: The intellect dictates the formation of the positive aspects after the initial instinctive response.

Monotony of form is avoided by varying the colors of the hundreds of circles which make up the painting. Although the final product appears subjective, typical of the Abstract Expressionist school, the process by which it was achieved was objective.

Pindell's travels in America have motivated such works as *Skowhegan Series: Lake Lilies for Kim* (1980–81). In the series, small tempera paintings depicting fishing boats and fishermen during serene early evenings are grouped with a collection of flower scenes.

The shores of Skowhegan are integral segments of this mixed media work. With a wooden board as a background, small paintings, glitter, nails and thread form the distinctive work of Howardena Pindell.

Each segment of *Skowhegan: Lake Lilies for Kim* is different, and the entire work initially appears to be in chaos, but after close study the viewer is able to see an integrated and organized composition. Nails tacked to the outer edges of the composition serve a utilitarian need by anchoring strands of thread. The nails

also perform an aesthetic role as they visually enhance the informal balance of the other objects.

A work such as *Skowhegan Series: Lake Lilies for Kim* has several points of possible completion. At any time during the creative process, the work may reach one of these points. Sensing these points sometimes results in the continuation of the instinctive process. Once a new medium is employed, a new beginning is initiated and the continuation of the newest ingredient is determined by the artist. Any medium that is overplayed could cause the disintegration of the collage painting.

Strands of thread overlap the small paintings, creating a visual experience enhanced by the two tiers of expression. This work suggests an ongoing creation.

Periods of physical idleness allow for a renewed interest in intellectual considerations, and *Skowhegan Series: Lake Lilies for Kim* may well be the result of such an interest.

Pindell's extensive travels through Europe and the Far East have also resulted in an exciting series of collage paintings. A 1983 product of her Far Eastern travels is Pindell's extraordinary piece called *East-West: Waterfall*. Again, a small painting executed in tempera and watercolor media is arranged upon a broad working surface. Postcard images of waterfalls, pen and ink sketches of Oriental religious services, mythical animals painted in tempera and landscape scenes are sliced, perforated and overlapped onto a muted background to form an irregular montage of travel events.

Pindell has created realistic and naturalistic scenes and composed them into an exciting Abstract pattern. By considering individual compositions and adjusting them in relation to adjacent segments to form an organizational unit, a complex expression has resulted. Although there is a best angle from which

to view *East-West: Waterfall*, its unique composition still allows viewing from all angles.

Oriental images are found in several rectangular paintings which share various types of waterfall and other natural landscape scenes. The waterfall image is witnessed in various sections of the montage painting.

The irregular surface of the work is echoed by the jagged perimeters. There are also three-dimensional effects as colors and textures recede and advance in an undulating fashion. The outer edge not only mimics the work surface but also creates a contrast between the vibrant creation and its muted background.

Segments of the outer edge resemble Japanese and Chinese fans. Other symbols of Oriental philosophies and beliefs infiltrate much of the total collage.

In a sense, Pindell has continued her exploration of the color-field theory of the Abstract Expressionist school of thought. *East-West: Waterfall* is both a simplified and complicated blend of this theory. There are fewer segments to the whole, but each segment is more involved than those works of the sixties. In *East-West: Waterfall*, Pindell creates her own complexities.

Pindell's collage paintings are novel in that they incorporate several smaller paintings with the montage application occurring after the paintings have been positioned and arranged. Other montage artists such as Rauschenberg and Bearden reversed the process. The appropriate positioning of each segment sometimes necessitated brushstrokes of color to force one area into submission or propel another area into prominence.

In 1987 Pindell began a series of works patterned after personal activities and experiences. In *Autobiography: Earth/Eyes/Injuries* (1987), the artist has retained her Abstract Expressionist interest. An irregular circle encompasses

---

*Opposite:* **Howardena Pindell.** *Skowhegan Series: Lake Lilies for Kim* (1980–81). **Tempera, watercolor, gouache, glitter, nails and thread on board. 24×14 in. Courtesy of the artist.**

**Howardena Pindell.** *Autobiography: Earth/Eyes/Injuries* **(1987). Acrylic, paper and polymer-photo transfer on sewn canvas, 78×88 in. Courtesy of the artist.**

symbolic images related to autobiographical experiences. Several eyes and pairs of eyes, some encased in sockets, others free and exposed, engage in a visual hide-and-seek. The eyes are scattered seemingly at random upon a working surface covered by miniature animal tracks. In some cases, the eyes are placed directly onto the plant-like background while others are inserted in such a way as to appear to be looking out from underneath the work's surface. This circle which symbolizes the earth's surface also incorporates

*Opposite:* **Howardena Pindell.** *East-West: Waterfall* **(1983). Acrylic, tempera, gouache and postcards, 32×27×6 in. Courtesy of the artist.**

**Howardena Pindell.** *Autobiography: Water/Ancestors/Middle Passage/Family Ghosts* (1988). Acrylic, tempera, cattle markers, oil stick, paper, polymer-photo transfer and vinyl type on sewn canvas, 71×118 in. Courtesy of the Wadsworth Atheneum, Hartford. The Ella Gallup Sumner and Mary Catlin Sumner Collection. 1987.17.

eyes which are socketed into eerie animal heads.

An Oriental hand fan folded in its customary fashion pictures a full length skeleton, a symbol of injury. Other segments are occupied by auto accidents and references to an earlier subject matter.

Autobiographical in its presentation, Pindell's work is profoundly personal and Abstract both in literal and technical portrayals. Segments of *Autobiography: Earth/Eyes/Injuries* suggest calculation and planning by the artist, but the work taken as a whole seems subjective, suggesting an impulsiveness in the creation process. Her collage painting encounters new directions by referring to earlier works. The figures of the sixties, the colorfield expressions of the seventies, and the Far Eastern travels of the early eighties participate in her works of the late eighties and early nineties.

In her series of autobiographical works, Pindell carries symbols from one work to another. In *Autobiography: Water/Ancestors/Middle Passage/Family Ghosts* (1988), symbols are of a personal nature, and thus their meaning may elude the viewer. Consequently, such works as Pindell's collages are evaluated on aesthetic criteria, although one cannot avoid the mysterious charm that permeates her work.

Executed in acrylic and tempera paints and various other materials and tools, the final work is sewn into canvas. Painted heads are scattered throughout the work. The left side echoes her earlier works as if style must show proof of prior existence to be used. There are emotions concealed from the casual observer while a search for details uncovers seemingly insignificant images. The positioning of facial features serves both literal and emotional needs as well as compositional demands.

An upright figure with outstretched arms reaching heavenward occupies the central area. Because it is not easily detected, the body of the figure is overlooked until the figure's head is observed.

Its eyes continue to stare at the viewer, provoking an emotional response whether justified or not.

The thrill of seeing the personal memoirs of another often eludes the viewer unless, of course, similar memories occur in one's own life. Pindell's autobiographical series is remarkable in that its diversified media result in haunting but charming excursions into the unknown. The central figure (perhaps Pindell herself) is surrounded by memories of past events.

The painted faces are reminders of the various personalities each person possesses, symbolic perhaps of all the other changes in life. Pindell's insertion of facial features is also reminiscent of Frederick Franck's use of mirrors to identify oneself with the agony of a tragic event.

Pindell expands her versatility in a 1989 production titled *Autobiography: The Search/Chrysalis/Meditation/(Positive/Negative)* in which areas of dark and light are more pronounced as a dual personality emerges from an intricately detailed background.

Aside from the well-defined heads which act as focal points of interest, the bodies of the figures are disguised or hidden from initial views. A concerted effort will eventually lead to a recognition of the graceful motions of a ballet performer.

Words relating to past disappointments occupy the lower right corner of the work. The dark corner is balanced by smaller appropriately positioned dark areas. The beauty of Pindell's work is not so much the technique itself, but more the result of her technical skill. It is the haunting, eerie charm that comes from various parts of her work and the ever-present mystery that provokes the viewer to search continually for answers to unanswerable questions.

Pindell's mixed media work *Autobiography: Through a Looking Glass* (see color insert) is a myserious mixture of personal symbols of yesteryears. The human form in the center is surrounded

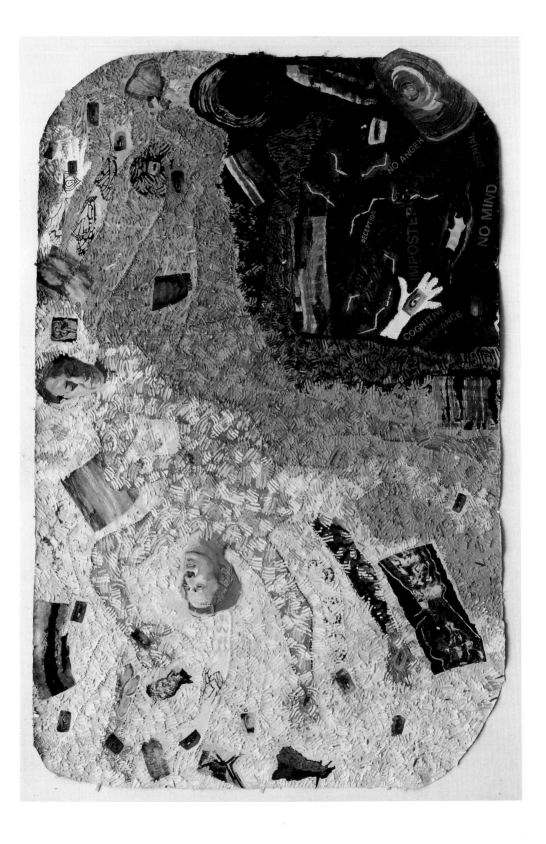

by reminders of earlier days. Compositionally, the circular painting is equally divided into negative and positive environments. Informal balance is maintained with the insertion of positive shapes into negative space and negative shapes into positive areas. Texture and color are heavily used in Pindell's works and especially in *Through the Looking Glass* in which the circular composition suits the subject matter.

Pindell's autobiographical series is puzzling but in a fanciful way. Although serious in intent, there is a flexibility of emotions, a framework for the contemplative as well as the riotous. Yet, in the final analysis, there is a joy, a thanksgiving and a gratefulness that touches the viewer.

Travel is a significant part of Pindell's autobiography. She continues her dialogue with the viewer in *Autobiography: Japan (Hirosaki: Nebuta Festival and Kyoto: Gion Festival. Yasaka Shrine 1981)*, painted in 1989 with acrylic and tempera paint on museum board.

In essence it is a miniature panorama of delights encountered during her travels in Japan. It has a personal touch, a feeling of love between the Far East culture and herself.

A vertical panel titled *Autobiography: Kanazawa (Japan 1981)*, painted in 1988, again records in aesthetic fashion Pindell's travels. Three major events are depicted, and because of their personal nature, one is again forced to forego knowing the meaning in favor of compositional criteria. In her works Pindell has combined several media into a unified composition, each medium becoming a challenge in and of itself; and although they are incompatible with each other at times, Pindell transforms the opposing media into unique works of art.

*Autobiography: Egypt (Chapel of Hathor, Deir el Bahari)* (1989) depicts a beautiful architectural work. The panoramic vertical planes are a compact travelog. Brilliant sunlit slabs of concrete are balanced by dark shadows as the architectural parade is halted only by the limits of the canvas. Pindell has used architecture in an artistic display of color and shape in space. Azure skies anchor the upper segment of the painting.

The interaction of horizontal and vertical planes makes *Autobiography: Phoenix: Road to Casa* (1990) an exciting abstraction. The overlapping of alien aspects in a completed natural landscape adds mystery to a visually acceptable image. The upper and lower segments of the painting are equally balanced in shape, tone and texture. The atmosphere of the painting is injected with strange vertical objects which act as focal points of interest.

Pindell has created certain optical illusions. Whether intended or not, the subject matter contributes to a dual observance. Within the textured landscape are stacks of rock formations typical of the Southwest. Her travels have been recorded in frequent works of mixed media. Pindell has avoided the risk of overindulgence. Her choice of media has enhanced her travelog landscapes.

Pindell continued to use her autobiographical work throughout the eighties. In her collage painting titled *India: Suttee* (1986–87) (see color insert), she creates on a large scale an exquisite example of the color-field theory of the Abstract Expressionist school of thought. A figure, only slightly defined, emerges amidst a sea of color. Breaking the monotony is a splash of brilliant yellow, appropriately positioned in the upper portion of the vertical panel. Colors blend, but also remain distinct. Blues, reds and yellows fuse into shades of purples and oranges, yet they retain individual identities.

Autobiographies generally focus on

*Opposite:* **Howardena Pindell.** *Autobiography: The Search/Chrysalis/Meditation (Positive/Negative)* **(1988–89). Acrylic, tempera, cattle markers, oil stick, paper, polymer-photo transfer and vinyl type on sewn canvas, 112×72 in. Courtesy of the artist.**

both tragedy and joy. Pindell has eliminated episodes of a more personal nature by including the element of travel in a series of works. The autobiographical segments become a way of recording more objective events, like travel, rather than a way to exploit the dramatic events of one's life.

The creative nature of Pindell's work is evident more in the approach than the structure of her work. It is indeed contemporary, which is a considerable factor in the judgment of a piece of art, while the personal nature of her work gives an illusive quality to her art which frequently lures the viewer into a more profound study.

In spite of the unusual technical approach to her subject matter, Pindell has not yet reached the fullest potential. Her continual and persistent experimentation has opened new doors in the creative process. The presence of photography in painting is not new, but its use as a companion to painting has been challenged for decades. Although currently acceptable, its exploitation now becomes a challenge for artists such as Pindell (whose use of photos incidentally differs little from those who engage in painting nature on the scene).

Pindell alters the landscape upon the photograph itself rather than recording the original landscape on a working surface. By so doing, she uses the photograph as a springboard for expanding ideas originated from the photograph as well as creating new ideas by blocking out segments of the photograph and replacing with alien images. By removing particular elements and replacing them with opposing notions, the artist exploits all the photograph's potential and creates new aesthetic boundaries.

However, Pindell is an intellectual painter, one of quietude and poetic charm. If protest and unrest prevail, they tend to remain personal and introverted. To portray the inner personalities, she rejects the visual reality of the world in favor of intimate fantasies. Pindell's collage paintings are personally innovative, leaning toward the Abstract and the Surreal.

Pindell's academic background justifies her unusual approach. In her work titled *India: The Storm* (1984), Pindell brings together symbolic and religious imagery of the different Eastern faiths. In a sense, a travelog emerges from this montage of visual pleasures. Mosques, rituals, sacrifices and representations of the Indian culture merge into a panoramic view of personal preferences.

Compositionally, the shape of *India: The Storm* is in itself a unique approach, with an oval placed onto a rectangular horizontal surface. The montage of events is thus confined while resting upon a mute background. Aside from the travel aspects, Pindell incorporates personal desires which can elude the uninformed viewer. Her sewn images are positioned adjacent to each other and seldom overlap. Delight occurs when one observes the recorded events. Howardena Pindell has developed a unique approach appropriate to her personality and academic background.

# Career Highlights

Born in Philadelphia in 1943.

*Opposite:* **Howardena Pindell.** *Autobiography: Egypt (Chapel of Hathor, Deir el-Bahari)* (1989). Acrylic and tempera on museum board, 19×8½×2 in. Courtesy of the artist.

# Education

B.F.A. degree from Boston University, Boston, Ma., 1965; M.F.A. degree from Yale University, New Haven, Ct., 1967.

# Awards

National Endowment of the Arts Fellowing for Painting, 1983; National Endowment for the Arts–USA/Japan Friendship Commission Creative Arts Fellowship.

# Selected Exhibitions

Recent Acquisitions: *Curator's Choices,* Metropolitan Museum of Art, New York, 1982; *American Women in Art: Works on Paper,* United Nations International, Womens Conference, Nairobi, Kenya, 1985; *Howardena Pindell: Odyssey,* The Studio Museum in Harlem, New York, 1986; *Language, Drama, Sources and Vision,* New Museum, New York.

# Solo Exhibitions

A.I.R. Gallery, New York, 1983; Harris/Brown Gallery, Boston, Ma., 1986.

# *Bibliography*

## Books

Campbell, Mary Schmidt, and Lucy Lippard. *Tradition and Conflict: Images of a Turbulent Decade 1863–1973.* New York: The Studio Museum in Harlem, 1985.
Davis, John. *The American Negro Reference Book.* Yonkers, N.Y.: Educational Heritage Inc., 1966.
Driskell, David. *African American Artists: Selections from the Evans-Tibbs Collection.* Seattle & London: University of Washington Press, 1989.
Rubinstein, Charlotte Streifer. *American Women Artists.* Boston: G. K. Hall & Company, 1986.

## Periodical Articles

Kirwin, Liza. "The Papers of African American Artists." *Archives of American Art.* Washington, D.C.: Smithsonian Institution Press, 1989.
Wilson, Judith. "Howardena Pindell." *Ms. Magazine* (May 8, 1980).

## Catalogues

Douglas Art Gallery. "Fragments of Myself/THE Women." Text by Wendy McNeil, 1980.
G.R. N'namdi Gallery. "Howardena Pindell." Birmingham, Michigan, March 1, 1991.
Metropolitan Museum of Art. "Recent Acquisitions: Curators Choices." New York, 1982.
New Museum, Solo Exhibition, A.I.R. Gallery. "Language, Drama, Sources and Visions." New York, 1983.
The Studio Museum in Harlem. "Howardena Pindell: Odyssey." New York, 1986.
United Nations International Women's Conference. "American Women in Art: Works on Paper." Nairobi, Kenya, 1985.

*Opposite:* **Howardena Pindell.** *Autobiography: Phoenix: Road to Casa* **(1990). Acrylic and tempera on museum board, 37×8½ in. Courtesy of the artist.**

# FOUR

# *Vivian Browne*

Not only as an artistic activist but also as one who utilizes art as a political tool, Vivian Browne rates high. Her search for truth continues in light of sustained domestic dilemmas that face America. She feels that it is essential to make known the evils of society before answers can be found. This concern is evident in her exciting *Seven Deadly Sins* (1967). Regardless of one's personal stand for or against the portrayal of sin, one must acknowledge the artistic merit of *Seven Deadly Sins*. Beauty does reside in the ugliness that Browne so vividly exposes.

The technical mastery of *Seven Deadly Sins* is seen in the beauty of its color, its composition, its technique and finally in its purpose, for indeed a lofty purpose diminishes the ugliness of sin. Rouault became famous for justifying his portrayals of prostitutes in the same style as the passion of Christ.

*Seven Deadly Sins* is a portrait of humanity engaged in sins of lust, envy, pride, greed, sloth, anger and gluttony. Browne paints the evils of sin and its physical effects upon the human condition, but even more significant is the loss of a spiritual mainstay. The experience of sin creates a lonely life. In spite of momentary pleasures and even amid an engaging crowd, emptiness gnaws at the soul until eventually peace evaporates into nothingness.

Browne's human beings turn demonic, becoming obsessed with the earthly pleasures of the seven deadly sins. Lacking the grotesqueness of a Bosch ritual or the gruesomeness of a Cadmus portrayal, Browne's version is on the brim of spilling over into the decadence of eternal Hell. The fleeting pleasures of Browne's earthly delights will eventually result in death. *Seven Deadly Sins* is a powerful painting, yet it is softened slightly by the hope of spiritual reorganization of one's soul.

In *Seven Deadly Sins*, Browne uses the human image to communicate, acknowledging the viewer as an integral part of the creative act. If there is no response to a work of art, the process is incomplete and the product will die. Perhaps one day it will be received by a segment of the population, thus finally reaching its completion.

In *Seven Deadly Sins*, Browne has acknowledged the evils of sin and its mental and physical effects upon mankind. She has illustrated the consequences of the evil doings with her images of distorted humans and of the pitiful state of the victims. The artist is not only a recorder of truth but also a recorder of punishment by merely acknowledging the atrocities that one brings upon oneself. The sins of lust, anger, envy, sloth, gluttony and pride are identified by Browne. Frequently, hope will reside amid the despair and chaos found in the painting. The artist does not have to beg for aid. Perhaps the painting

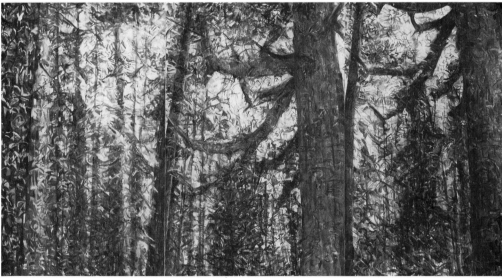

*Top:* **Vivian Browne.** *Seven Deadly Sins* **(1967). Oil on canvas, 120×60 in. Courtesy of the artist.**
*Bottom:* **Vivian Browne.** *Metasequoia* **(1987). Oil on canvas, 132×70 in. Courtesy of the artist.**

itself is enough to stimulate humane assistance by those of society who view the work and are emotionally aroused by it.

The artist is not an answering service. Browne has revealed the evils of sin through art in the hope that the audience will respond with positive attitudes and possible assistance. Regardless of the assistance, or lack of it, the artist remains free to exploit

humanity for the purpose of artistic expression.

An etching executed two years later, titled *Getting Out* (1969), ironically identifies with the theme of sinfulness. Whether Browne intended it or not, *Getting Out* seems reminiscent of *Seven Deadly Sins*. A face, unidentified, moves forward in the picture plane. Art has always been a private experience for the viewer. Interpretations vary considerably

even with the most obvious of themes. *Getting Out* may be just such a painting. The blackness of the background may hint at the title; or perhaps gradual recognition in current society or general acceptance of the underprivileged, or perhaps a personal experience that is known only to the artist, explains the title. All works of art are not necessarily open to interpretation.

Another etching of the same year titled *Peopled Mountain* (1969), is even more abstract. Again, the title grants a clue to the definition. Sharp tones of darks and lights, geometrically shaped, clamor for attention. Background and foreground emerge as a single entity.

The mountain reflects the unsolved social problems existing in America. Yet aside from literal interpretation, one can readily appreciate Browne's sense of design. Geometric shapes which overlap and interpenetrate contribute to a unified and pleasant visual experience. Regardless of Browne's intent, *Peopled Mountain* remains a textural pleasure to view and appreciate.

Vivian Browne's remarkable transition from painting a single aspect of nature to painting a unified composition made up of different aspects indicates her versatility. In her exquisite painting titled *Gigantea II* (1989), the viewer is treated to a rare example of nature: Looking skyward Browne has utilized a basic element of nature, a tree, and painted it from an unusual angle, thus creating a subjective/objective picture.

According to Browne, the view of the tree is enhanced because of the angle from which it is painted. The earth below the tree is not a part of the painting, thus allowing the negative space of sky to become the environment in which the tree exists. Browne has also brought forward the textural aspect, allowing for a subjective appraisal as well as exercising an objective technique.

Although the sky serves in a negative sense as the leftover space, it simultaneously identifies the tree as the positive aspect of the painting. There is

well-defined *and* suggestive imagery, again serving the objective and the subjective. The artist has avoided the obvious upward movement by diminishing the tree's skyward progress. Branches extending outward from the tree's structure and appropriately positioned on the vertical scale lessen the viewer's visual ascent. Even though objective details reside within the tree, they are blurred images, blended together to form a unique textural surface.

Aside from its gripping presence, *Gigantea II* provokes varied interpretations. Ignoring the literal, there exists an artistic, thoroughly Abstract beauty to Browne's portrait. Line, color, shape, texture and space are well coordinated to form an exquisitely uniform composition.

In *Metasequoia* (1987), Vivian Browne uses her talent to incorporate several single aspects of nature to form a unit or team. Again, Browne has avoided the usual baseline or ground surface, and instead has moved the viewpoint upward to incorporate the glistening sky. By so doing, she has captured a rare view of a pleasing scene—the sky mingling with various twigs which seem to dance to the sunlight.

Not only has Browne capitalized on nature's most precious gems, but she has the ability to position herself to witness and to express. *Metasequoia* is also a panoramic view of nature's treasures which extends beyond the confines of the canvas surface. Browne is able to contain the beauty by avoiding the everpresent peril of monotony. *Metasequoia* is a beautiful painting of a commonplace theme. She has succeeded in portraying nature as a precious reminder of life's continued existence. Browne's accomplishment is different from that of the photographer who sights and records the beauty of nature. She has enhanced God's creation with her own personality. Even though many proclaim that divine creation is already perfected, it is the artist's touch that humanizes it and brings it into the reach of humanity.

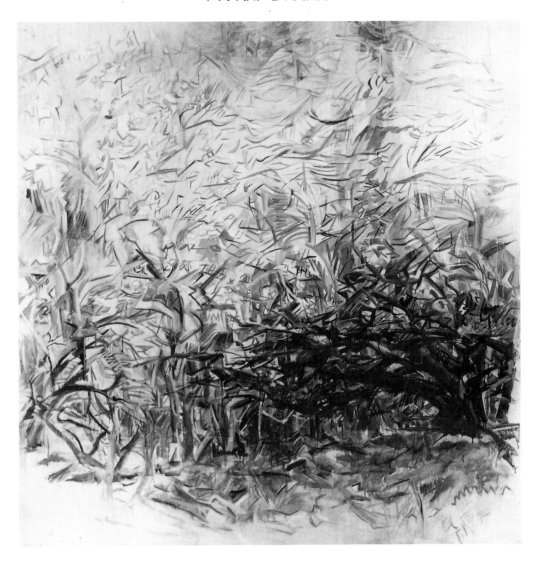

**Vivian Browne. *Trees, Not Flowers, Not Words* (1984). Oil on canvas, 57¾×59½ in. Courtesy of the Havana Fine Arts Museum, Cuba, and the artist. Photo by Ken Showell.**

Even though *Metasequoia* is an intricate web of differing aspects of nature, it thrives on the total compatibility of all its parts. There is a continuity, and yet particular aspects tend to be outstanding, demanding the viewer's attention as especially pleasing images. The common theme is nonetheless excitingly different, with a variety of shapes and spaces resembling Persian draperies.

This continuity of life is again portrayed in *Trees, Not Flowers, Not Words* (1984), a painting in which nature seems

destined for an abstract transformation. Browne's title emphasizes the trees, asking her audience not to confuse the painted images with words and flowers. And yet, it is precisely the unidentifiable nature of her subject matter that is so intriguing. Browne's transition to Abstract Expressionism is a successful change.

In spite of what appears to be an instinctive response to an idea, the artist's preplanning becomes obvious after thorough study. Unlike other Abstract Expressionists who unleash swirls of color

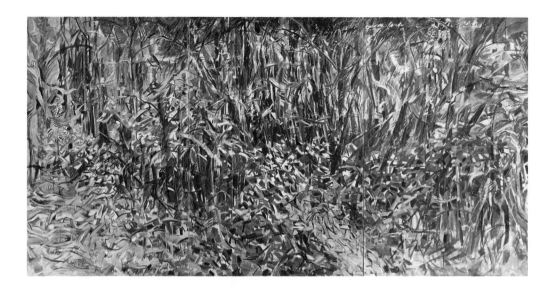

**Vivian Browne. . . .*collisions, rumblings and waters* (1984). Oil on canvas, 126×56 in. Courtesy of the artist. Collection of Dr. June Christmas and Walter Christmas. Photo by Nick Levine.**

with little or no regard for an idea, Browne carefully considers the idea, and with an intuitive technique, applies pigment in a seemingly reckless manner but with controlled brushstrokes.

Trees seem to grow within a static environment. The foreground trees are well-defined while the background trees are less so. The vitality is everpresent and the entire composition ignites with verve and vigor.

The senses of sight and sound are both addressed in . . .*collisions, rumblings and waters* (1984). Tree branches and twigs have turned to banners and ribbons. No longer are there sharp outlines and heavy trunks. Visual depth is achieved by altering the color tones. Details are consistent throughout the painting thus avoiding well-defined forms within the upper picture plane.

Browne removes the usual and generally most acceptable theme of trees by employing a symbolic title. There is a collision of color, rumblings which are the undercurrents that precede collisions, and waters which symbolize the needed nourishment that causes the collisions and rumblings in the first place. And yet,

perhaps Browne's title holds little relevance. Her paintings are of nature's delights, yet her approach to painting these delights not only gives the paintings more profound meaning but expands that meaning beyond its natural habitat and certainly beyond the visual comprehension of the viewer.

Despite the density of the subject matter, there is an amazing display of highlights and shadows. The overlapping of forms creates an Abstract visual experience, accomplished by Expressionist means and resulting in an Impressionistic appearance. Browne's control of details is a result of merging of emotional and intellectual faculties into a simultaneous function. To consistently display a uniform blend of the intellectual and emotional upon a large canvas surface is a tribute to her physical control as well.

The unusual angle in *Tuolumne* (1985) resembles an Abstract approach to a single aspect of nature. Browne has taken a simple item of everyday life and transformed it into a thing of beauty. The angle has created an exaggerated height. One reacts psychologically to the

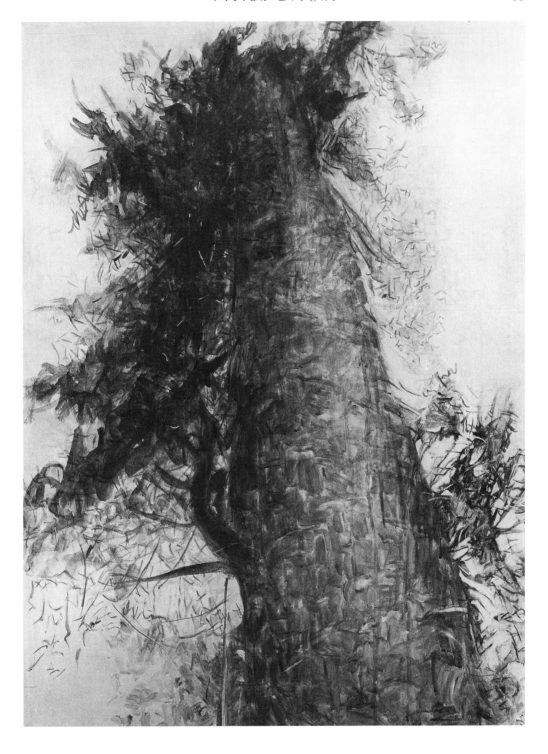

**Vivian Browne.** *Tuolumne* **(1985) Acrylic on paper, 22×30 in. Courtesy of the artist.**

Vivian Browne. *Bald Ring* (1987). Acrylic on canvas, each section 14×20 in. Courtesy of the artist.

upward surge. Brush and branches occupy the space surrounding the tree. Details are abundant at the base of the tree but diminish as the tree moves upward. Trees have been frequently recorded by artists whose concerns were more emotional than visual, and Browne's version is a highly emotional portrayal.

A series of three paintings titled *Bald Ring* (1987), *Burning of the Bush* (1987) and *Global Warming* (1987) deals with the threat that global communication has on natural resoures. In *Burning of the Bush*, a work consisting of two physically separated segments, one segment shows a giant tree while the adjacent segment is of a gigantic steel communications tower. Each has its own life and each is treated as a single aspect.

In the second painting of this series, titled *Bald Ring,* pieces of the communications tower fall upon the tree while at the same time the tower retains its strength. There is a visual similarity between the natural and the man-made. Slowly and insidiously the thorns of man's materialism creep into nature. Although physically separated, the two segments blend into a single idea. Two opposites merge, the divine creation with the human invention, and the future lies in the eventual destruction of nature by man's greed.

Perhaps this is not the message of the artist, but it is one logical interpretation. It is the unusual nature of Browne's ideas and the rare approach to her theme which opens the doors for speculation. The third of the series, *Global Warming,* suggests that greed is on the verge of consuming nature. The inventions of man have intruded upon nature to the point of nature's eventual total destruction.

Browne's ability to sustain a relationship between two segments is noteworthy. In the three examples discussed, there is a companionship, an artistic relationship resulting in a single expression. A message is constantly being transmitted, its completion dependent upon the recipient's ability to view the segments as one.

In a large triptych titled *Pinacea* (1987), Browne has created a work which displays both density and clearance. In the left panel the viewer finds many towering sequoias in a compact space. Flickers of light seep through the dense foliage, and one is convinced that an escape is futile.

The feeling of futility is diminished in the middle panel as a clearing is developed, allowing the viewer an entrance to freedom. Additional sunlight enters the scene suggesting a direction. The final panel has diminished the presence of the giant sequoia considerably, and by soaking the area in sunshine the artist has created a scene of total freedom. Whether one accepts the psychological premise of *Pinacea* matters little since the work is judged solely on its artistic merits.

An untitled drawing (apparently a precursor to her 1987 series of trees and roots as witnessed in her 1987 production, *Metasequoia*) resembles both the roots and the branches of a plant. The presence of squiggled lines represents the spread of life. The roots of a great redwood expanding without boundaries, or the branches reaching heavenward within a limitless firmament, symbolize the beginning and the end. Each inhabits a different plane: The roots are fed from underneath the earth's surface while the branches rely upon climatic conditions above the earth's surface. Browne's drawing represents one of two things—the beginning or end of life, or the fullness of life.

If the untitled drawing became a painting, the habitat would depend upon the color of the background. The color blue would represent the sky, and the color brown, the earth. There would be no middle life, only the start and the finish, the joy of anticipation or the joy of full bloom.

Browne's artistic approach is unique in that it thrives on the unusual. Reality becomes Abstract because of the angle

Vivian Browne. *Pinacea* (1987). Triptych, oil on canvas, 168×60 in. Courtesy of the artist.

**Vivian Browne. "Untitled" (1987). Oil on canvas. Courtesy of the artist.**

from which it is expressed. Nature is recorded from seldom seen vantage points and thus received in a new manner. Using the entire frontal plane as the working surface, Browne has avoided visual perspective as seen in her forested landscapes. Browne projects shooting upward from the base of the tree a power which seems infinite in its journey skyward.

The ability to take a single aspect of nature and around it create and develop an entire exhibition is witnessed in Browne's journey into the forest. The single tree becomes an entire universe, or segments of several trees, although different, form a union.

Browne is alert to monotony and in order to avoid it, each brushstroke is carefully considered before application. Just as the monotony of repeated forms and shapes is avoided, so too is the confusion caused by a congestion of parts. The intersection of twigs and branches, represented by lines of varying degrees of thickness, is purposely created to energize an otherwise bland background; but an overactive area which leads to confusion is avoided by an intense concentration on the area under scrutiny.

Browne's Abstract drawings illustrate the possibility of the extinction of the great redwood and its surrounding environment, replaced by man's greed for commercial advancement. In a sense, Browne has incorporated man into her paintings: Although absent from her works, the human being becomes responsible for the decline of nature's beauty.

Not only has Browne continued to artistically record the beauty of the forest, she has also introduced the actions of man whose greed will lead to the eventual destruction of the earth's natural structures. Man-made edifices now compete with God's miracles and if left could result in eventual decadence and ruin of God's earthly kingdom.

Rather than depicting the results of man's greed by picturing man-made interferences, it would profit the artist to introduce humans into the painting as the perpetrator of disaster. Yet Browne's

recordings of nature are beautiful, unaffected by man's greed, and thus there are no humans or man-made structures in her nature portraits, but they are found in one segment of each of the dual paintings. The nature halves exist alone as testament to nature's beauty, but when placed adjacent to man's halves, human intrusion is symbolically mirrored upon the surface of the tree.

It is this connection that explains the need for the dual painting. There is not a mixing of nature and man within a single segment. Each painting exists on its own merits and each is successful in its isolated purpose. It is this teamwork which defines the total work and continues to attract the viewer because each segment of the dual painting is important and can be understood and appreciated as a separate work of art.

The artist's exploitation and expansion of a single aspect of nature results in an unusual and unique approach to artistic expression, and although its merits are applauded, Browne's depiction of the suggested effect of man on nature is not only agonizing to behold, but its flow of energy initiates communication between artist, subect and viewer.

A charming, semi–Abstract portrait titled *Benin Equestrian* (1972) stirs the imagination. A pleasant, decorative work of the seventies, it represents a fluid use of the oil medium not unlike the techniques used by the Americans Max Weber and Jack Levine. Injected into colorful, broad brushstrokes are piercing lines of varying widths, guidelines to the unification of the composition.

Vivian Browne's works of the late sixties perhaps best illustrate her compassion for the human condition. Similar to her fabulous work *Seven Deadly Sins* are such paintings as *Two Men* and *Dancer* (see color insert). The extreme distortion in both pieces is magnificently rendered. The viewer is forced to acknowledge the physical distortion and to offer compassion and hope. Browne's style of the late sixties is strong and persuasive, and the fluid style and figurative subject matter

**Vivian Browne.** *Benin Equestrian* **(1972). Acrylic on canvas. Courtesy of the artist.**

would have translated well in the follow-
ing decades.

An artist seldom changes direction
or style deliberately. Most often, a change
occurs without the artist's awareness.
Browne's obsession with the natural stim-
uli of trees and foliage and her preoccu-
pation with the intrusion of technology
upon the earth's surface was a substantial
growth in artistic achievement. But is it
conceivable that one's strongest work is
in the past? The need to be different or
the need to change should occur only in
terms of strengthening one's current
style. Browne's work of the late sixties
could have reached panoramic heights.
Her work of the eighties is excitingly
poetic, and even though visually absent,
mankind remains a part of her current
production.

# *Career Highlights*

Born in Laural, Florida, in 1929.

## Education

B.S. degree from Hunter College, New York; M.A. degree from Hunter College, New York; post graduate work at University of Ibadan, Ibadan, Nigeria.

## Awards

Huntington Hartford Painting Fellowship; Research Council Grants, Rutgers University; MacDowell Colony Fellowship, New Hampshire; Achievement Award, National Association of Business and Professional Women; Guest of Honor, NYFAI, Women's Center for Learning, New York.

## Selected Exhibitions

Museum of Modern Art, New York, 1968; Brooklyn College, Brooklyn, N.Y., 1968; Carnegie Institute, Pittsburgh, Pa., 1972; Mt. Holyoke College, 1972; Southern Illinois University Gallery, Carbondale, Il., 1972; New York Cultural Center, New York, 1973; City University of New York, New York, 1978; Soho 20 Gallery, New York, 1980; Illinois State University, Normal, Il., 1981; California State College, 1982; Kenkelba House Gallery, New York, 1983; Gallery of Art, Howard University, Washington, D. C., 1984–85; The New Muse Museum, Brooklyn, N.Y., 1984–85; Clark College, Atlanta, Ga., 1984–85; Louisiana State University, Shreveport, La., 1984–85; Museum of African and American Art Antiquities, Buffalo, N.Y., 1984–85; College Art Gallery, New Paltz, N.Y., 1984–85; Hebrew Union College, New York, 1985; Soho 20 Gallery, New York, 1985; Associated American Artists, New York, 1986; Bergen County Museum, New Jersey, 1986; Museum of Contemporary Hispanic Art, New York, 1986; Hampton University, Hampton, Va., 1986–87; Squibb Gallery, Princeton, N.J., 1987; Goddard Gallery (Riverside Community), New York, 1987; Intar Gallery, New York, 1988; Black Art Festival, Atlanta, Ga., 1988; The Jane Voorhees Zimmerli Art Museum, Rutgers University, New Brunswick, N.J., 1988; Museum of Modern Art, New York, 1988–90.

## Solo Exhibitions

Rhode Island College, Providence, R.I., 1973; Artist House, New York, 1974; Soho Gallery, New York, 1982; Franklin & Marshall College, Lancaster, Pa., 1983; Western Michigan University, Kalamazoo, Mi., 1984; Soho 20 Gallery, New York, 1984; The Bronx Museum, New York, 1985; University of California at Santa Cruz, 1985; Soho 20 Gallery, New York, 1987; Shifflett Gallery, Los Angeles, Ca., 1987; Soho 20, New York, 1989; Virginia Tech University, Blacksburg, Va., 1990.

# *Bibliography*

## Books

*Afro-American Art: Annotated Bibliography.* New York City Board of Education, 1972.

Boning, Richard. *Profiles of Black Americans.* Rockville Centre, N.Y.: Dexter & Westbrook, 1969.

Cedarholm, Therasa Dickason. *Afro-American Artists: A Bio-Bibliographic Directory.* Boston: The Boston Public Library, 1973.

Dannatt, Sylvia. *Profiles of Negro Womanhood.* Yonkers, N.Y.: Negro Heritage Library, 1964.

Dyson, Walter. *Howard University: The Capstone of Negro Education. A History.* Washington, D. C.: Howard University Press, 1941.

Fine, Elsa. *The Afro-American Artist: A Search for Identity.* New York: Holt, Rinehart & Winston, 1973.

Heller, Nancy. *Women Artists: An Illustrated History.* New York: Abbeville, 1987.

Igoe, Lynn Moody. *200 Fifty Years of Afro-American Art.* New York: R. R. Bowker, 1981.

Lewis, Samella. *Art: African American.* New York: Harcourt Brace Jovanovich, 1978.

_____, and Ruth Waddy. *Black Artists on Art.* Los Angeles: Contemporary Crafts, Inc., 1971.

Locke, Alain. *Negro Art: Past and Present.* Washington, D. C.: Associates in Negro Folk Education, 1940. Reprint, New York: Hacker Art Books, 1968.

Logan, Rayford. *Howard University: The First Hundred Years.* Washington, D. C.: Howard University Press, 1969.

The Printmaking Workshop. *Graphics Portfolio.* New York: Attica, 1973.

# FIVE

# *Norma Morgan*

Norma Morgan is a versatile artist of the highest level excelling in painting, etching and engraving. A student of masters Hans Hofmann and Stanley Hayter of the famous Art Students League of New York, Morgan learned early in life to fulfill her artistic needs. She learned color from Hofmann, and to offset her methodical painting she learned from Hayter the techniques of etching and engraving.

Morgan, born on the East Coast, has shared her time and talent with Woodstock and New York City. She claims that her art goes beyond the black experience and the feminist movement. She believes in social protests and the civil rights movement, but she refuses to expend her energies in physical protests and parades. She feels that a God-given talent should be used to right the wrongs of society, that one uses the tools of combat that not only suit one's personality, but that best serve the cause under discussion or active consideration.

There is in Norma Morgan's watercolors a fluidity of color that creates an emotional response to her subject matter. *Friends & Sisters* (see color insert) is a prime example of color flow of an Abstract nature coexisting with the controlled technique of Realism. The two figures prominently displayed in the central portion of the painting are accompanied by an equally realistic animal image.

Realism and Surrealism are seldom compatible, but Morgan makes it believable. The ethereal environment, reflecting Morgan's fluid style, seems an appropriate habitat for the women. The friendly animal appears equally inviting.

*Friends and Sisters* is a simple triangular composition in which each of the three images rely upon each other. Its simplicity complements the free-flowing background. There is a slight lean toward Abstractionism as eloquent misty clouds interpenetrate the lower portion of the foremost figure. The background is an eruption of beauty as the forest blazes with color; it could be a shimmering glow of an early sunrise or an autumn sunset.

In her engraving titled *David in the Wilderness* (1955–56), the star player David rests upon a mountain ledge, made not of rock, grass and trees, but of humans and collapsed man-made structures. The unusual composition of positive and negative areas diminishes the person of David as he becomes a part of the landscape. The positive aspect of the composition is of a triangular shape creating a similarly shaped environment. Amid the rubble are fragments of facial features and demolished ruins of once elaborate buildings. There is the Hayter influence seen in the sharp, angular shapes, strong contrasts and suggestive Abstractionism.

Her association with the homeless and city slums and her acquaintance with

the mountainous regions of west and upstate New York have resulted in works similar to *David in the Wilderness* which can well be described as examples of social erosion.

For *A Cave Interior* (1967), like *David in the Wilderness,* social erosion is indeed a possible theme. The central portion, set ablaze with fiery light, casts reflections upon the eroded landscape while images of a semi–Abstract nature flutter about the composition. Swirling acrobatic figures are scattered throughout the work and create a Surrealistic environment. Resembling a World War II tank stalled in the midst of a battlefield of wounded soldiers, *A Cave Interior* depicts a sky full of demonic angels swooping down upon its victims. Whatever the artist's intent, interpretations of *A Cave Interior* will vary considerably from viewer to viewer.

A 1968 etching titled *Dunstanburgh Castle* reveals a well-defined example of the English moors. The castle, the focal point of interest, is silhouetted against a brightly lit horizon threatened with stormy skies. Birds of prey swoop about the swirling clouds. Surreal clouds of mist and fog descend upon the land.

Again, an eerie sense of possible peril creates the mysterious theme of the unknown. This dramatic effect is due partly to the artist's subconscious recall of the moors of England. *Dunstanburgh Castle* is a masterpiece of suspense, a drama threaded with anticipation and uncertainty. The clinging mist of the foreground matches the shadowy configurations found in the sky.

In *Character Study* (1957), an upper male torso is Realistically shaped but semi–Abstract otherwise. Resembling a battered pugilist, the semi-controlled medium slips and slides into appropriate niches and crevices to form a dramatic male image. Working wet-in-wet, Morgan has allowed the pigment to flow at ease but has nonetheless controlled it in order to define the recesses and highlight advancing areas.

A similar technique occurs in her painting titled *Badenoch, Inverness* (1958).

Morgan's habit of diversifying certain areas of a simple composition is evident in the foreground and background. In artistic terms, the foreground is positive and the background is negative. However, in *Badenoch, Inverness,* both segments are treated in a positive manner; that is, the sky which is usually the background area is as thoughtfully handled as the low lying moors of the foreground. In spite of the differing textures, the two segments form a perfect union. The rhythmic pattern of the moor landscape is echoed in the swirling clouds above.

In a similar lonely theme is the desolate but beautiful *Castle Maol, Isle of Skye, Scotland* (1972), an exciting painting with four points of interest residing in an environment of swirling masses of snow-like material. Two imaginary figures erupt through the billowy snowdrifts while above, in a web-like network of radiant clouds, two birds gracefully fly. Meanwhile, the fourth point of interest, only partially distinguishable, pierces the foreground crust.

Morgan's amazing technical skill in copper engraving has never been more masterful than in *Castle Maol, Isle of Skye, Scotland.* The same technical skill is witnessed in *A Portrait of My Grandfather* (1972). The biographical sketch sums up a lifetime of achievement, not material gain but spiritual gain, the acquiring of the spirit of man and the determination to buck the odds. The portrait is strong and simple, and transmits a powerful message of endurance and the transcendence of barriers to the advancement of one's culture.

One is reminded of the great stone faces of Mount Rushmore. The set jaw, quizzical eyes and wrinkled cheek bones display a firm commitment to the spirit of man but a spirit steeped in the religious search for the truth. Humility and strength is portrayed by the powerful simplicity. There is a purposeful look to the future, a visual prayer seen on a humble face and a prayer of thanksgiving stemming from a grateful heart.

Similar to *Friends and Sisters* is the

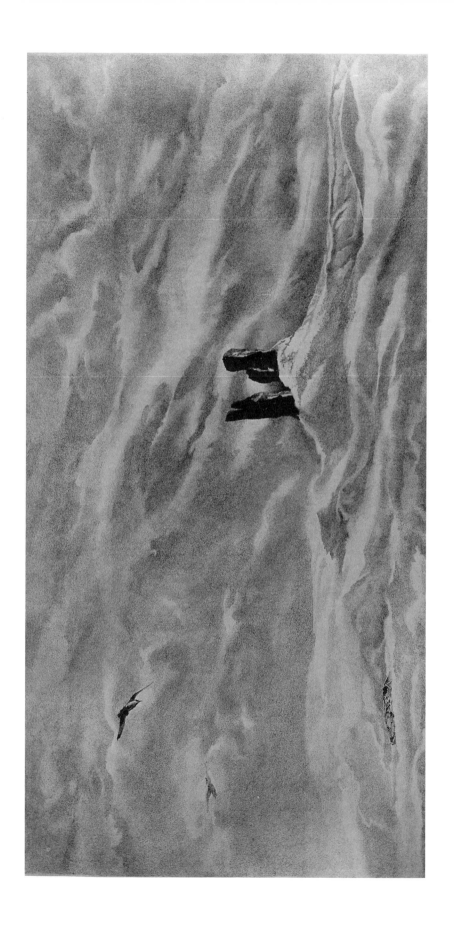

equally engrossing painting titled *Ethel—Portrait of My Mother* (1974). The artist's mother is nestled in a forest of color reminiscent of autumn's fiery blaze of foliage. Habitat and foreground blend in perfect unison. The artist has sustained the painting's dream-like quality both in the mother image and in the highly suggestive environment. In spite of the compatibility of the foreground and background, there appears to be two distinct styles. The background, subjective in its technique, leans toward the Abstract Expressionist school of thought, while the mother figure relies on the Realistic school of art. But Morgan's unique style brings together the two extremes by softening the outer contours of the central figure as they meet the surrounding areas.

Morgan enjoys the injection of fantasy symbols, and one is never quite sure of the existence of such imaginative creatures. After witnessing several of her works, and after close scrutiny, one is obligated to assume the presence of unreal demons or angelic phenomenan creeping about the environment.

*Ethel—Portrait of My Mother* is a pleasant depiction of a commonplace theme, and yet, Morgan places it at a poetic level.

*Through Pagan Eyes* (1978) exploits the Abstract Expressionist style of painting as highly suggestive images inhabit the entire composition. Morgan has used a vertical flow of paint to create an eerie environment. The limited palette further dramatizes the work as subtle images emerge from broad brushstrokes. Morgan allows the paint to run at will in appropriate areas while other segments of the painting are more controlled.

Abstract Expressionism is a most difficult technique to master because the outcome is never predictable. It is an excursion of uncertainty, unpredictable from one move to the next. Ideas emerge from what often appears as a chaotic entanglement of Abstract images.

It is from this apparent chaos that order is restored, whether it be a unified flow of color remaining Abstract, or an emerging Realistic image. The result depends upon the course of action determined by the artist. The Abstract Expressionist movement dictates no end results or definitive products. The creative process may end when the intellectual, emotional and physical faculties make that decision.

*Through Pagan Eyes* is a free flowing painting of weird creatures that occupies the frontal plane, thus avoiding the usual foreground and background.

Morgan's joyous venture in the troll world is seen in her watercolor titled *A Winter Troll* (1982). Similar to *Through Pagan Eyes* in style, the artist again creates a Surreal environment by opening up the background immediately behind the troll. The positive and negative aspects of the painting are not separated even though the composition of each is distinctly different. The two aspects blend together by virtue of color and technique. Even though the troll is detailed, the use of watercolor maintains a similarity between the troll and its Surreal environment.

Morgan's *A Catskill Troll* (1972) is another watercolor in which the ugly face wears a glaring stare that has sinister implications. Because of its nature, the miniature size tends to avoid a subjective portrayal. However, the complete lack of background forces the viewer to accept the image as it is. In fact, the negative space surrounding the image loses its identification and one is forced to totally respond to the positive image.

Whether the troll image is a valid artistic expression or not, Norma Morgan excels in portraying the legitimate attire and customary surroundings. In a sense, *A Catskill Troll* is an enticing bit of artistry.

*Opposite:* **Norma Morgan.** *Castle Maol, Isle of Skye, Scotland* (1972)**. Engraving on copper, 33¹/₂×17¹/₂ in. Courtesy of the artist.**

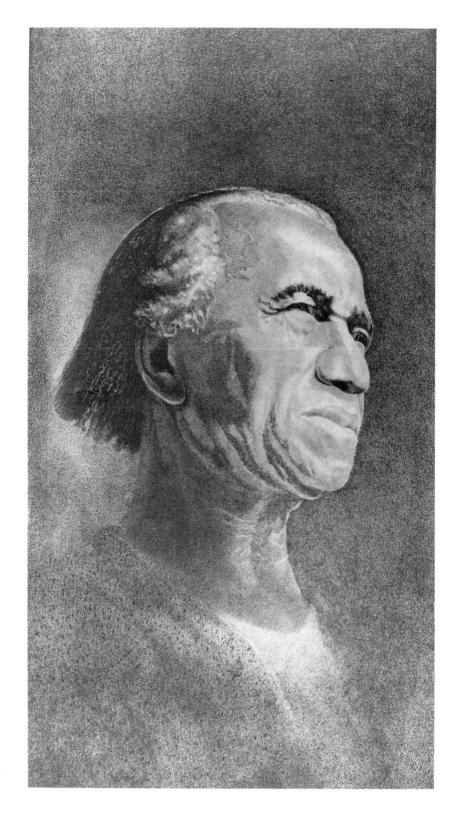

**Norma Morgan.** *A Portrait of My Grandfather* (1972). **Engraving on copper, 17½×30 in. Courtesy of the artist.**

Discussed earlier, *Castle Maol, Isle of Skye, Scotland,* transcends reality. One is reminded of Alexandre Hogue's Dust Bowl Series of the thirties. Sand dunes caused by drought covered the lands of the Southwest. The barren land free of greenery and laden with the remnants of dead cattle and barbwire fences is similar to Morgan's *Castle Maol, Isle of Skye, Scotland.*

A lifeless landscape, Morgan's portrayal reflects the unknown as it responds to the anticipation of the unpredictable. It is a dead world, yet the subtle textures the artist brings into the deceased areas create a hope for survival. *Castle Maol, Isle of Skye, Scotland* has to do with life, not death. It is the environment itself which becomes the subject matter. The romantic sense of quietude and desolation is no longer eerie, but an awareness of ethereal belonging. *Castle Maol, Isle of Skye, Scotland* is a world undisturbed, unspoiled and free of man's neglect.

Morgan's technical mastery of her medium results in poetic imagery. Underlying geometric shapes emerge gradually as softly moving clouds. Advancement and recession of color nuances move in an unending change of geometric shapes. The flow is so gradual that the changes go unnoticed.

Interpenetration of subject matter and its surroundings perhaps best describes Norma Morgan's engraving titled *Alf, Man of the Moors* (1964), in which the subject seems consumed by the environment. The subject is a male form, of which only the head and hands remain totally positive.

The male is surrounded and bombarded by miniature demonic creatures that absorb both the foreground and the background. And yet, he appears content with his surroundings. Perhaps the fantasy relates more to the artist than to the subject matter.

It is noteworthy that Morgan seeks the unusual and tries to further activate the unreal with personal imagery. There are those who transform the usual to levels of fantasy, but Morgan's basic subject matter is atypical and to build on that usualness is indeed artistically rewarding and not at all ghoulish as one would suspect. Instead, it is a charming look at creatures which seem caught up in a gigantic celebration, the hero being Alf, the man of the Moors.

There is a third world which exists between the reality and the Surreality of life. Morgan has magically portrayed her images in a sort of limbo, departing from the earth but not yet arriving in heaven as a supernatural being. Morgan has transformed the earthly images to a level of existence which enhances reality to the point of idealism, a form of existence which carries human emotions beyond the point of anguish.

Morgan claims not to be an idealist; she is more the artist who prefers to soften the marks of frustration and despair which envelop the world. And yet, the entire world is made up of individual personalities who cannot be lumped into a single classification. Each is destined to an individual problem and an individual solution.

Norma Morgan survives with her art and by her art. She resolves earthly problems by the therapeutic use of her artistic media and in so doing not only heals her own wounds but also those of an appreciative audience.

Defined as a magic–Realist, Norma Morgan explains her position as follows:

> A world of fantasy awaits any painter who longs to explore hidden subjects that do not meet the eye at first glance. With each visit to this unique world of the moors, for example, unusual forms are revealed. I am especially attracted by erosion and objects affected by it. I feel also that individuals strongly influenced by life which has worn itself into their character make the best subjects to portray on canvas. Erosion seems to me to be another dimension of the visual scene. Old buildings, hills and the like all yield a good source of exploration.

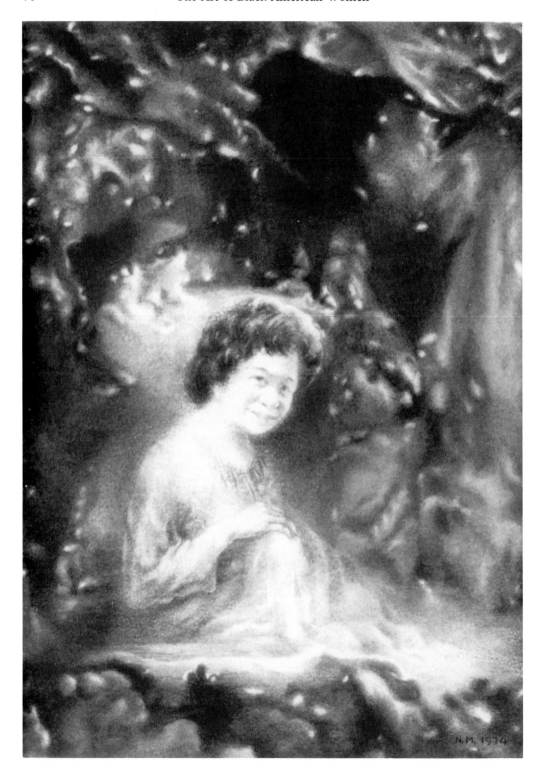

**Norma Morgan.** *Ethel—Portrait of My Mother* **(1974). Watercolor, 12½×16½ in. Courtesy of the artist.**

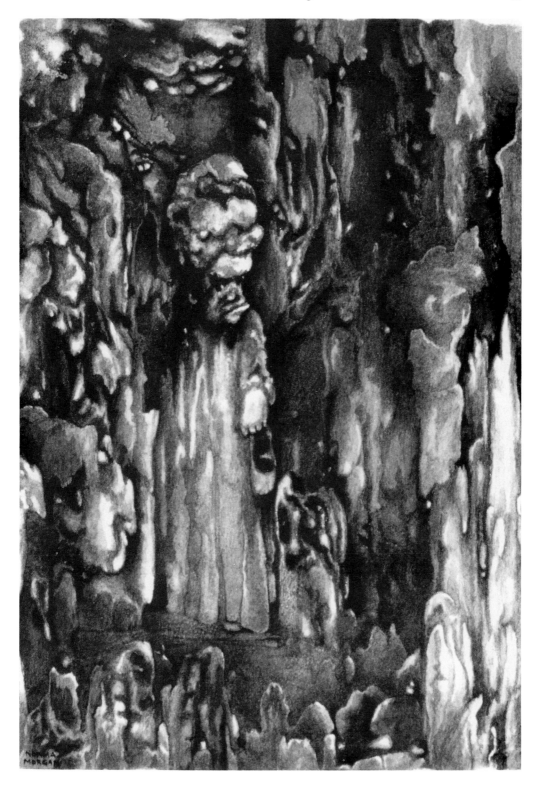

**Norma Morgan.** *Through Pagan Eyes* (1978). Watercolor, 11×15 in. Courtesy of the artist.

This quotation refers to the artist's preoccupation with the Scottish moors. And it is the moor landscape that creates for Morgan that third world which seems to elude the viewer.

Morgan has proven the theory that isolation is essential to the creative process. She supports the civil rights movement, but has refused to march on Washington or Selma acknowledging instead her God-given gift of artistry.

Morgan has experienced the hardships of poverty and homelessneses. In a letter to this author she states,

> What I am inspired to paint and to engrave doesn't seem to camp on the doorstep of the inner city, but I can assure you, I have had my share of problems living in a dying building with all the problems associated with it. I see homelessness every day in the city. I call it social erosion.

In order to satisfy her artistic urges, Morgan has isolated herself from urban problems and concentrated instead on Scotland where she has found an ideal environment, a habitat for humans capable of recording and exploiting the erosive powers of the Scottish moors. She regards her scenes of the Scottish landscape as an escape from the turbulence of the inner city.

**Norma Morgan.** *A Winter Troll* **(1982). Watercolor, 7×15 in. Courtesy of the artist.**

# Career Highlights

Born in New Haven, Connecticut, in 1928.

## Education

Hans Hofmann School of Fine Arts, New York; Art Students League, New York; Whitney School of Art, New York; Stanley Hayters Atelier.

**Norma Morgan.** *A Catskill Troll* (1972). **Watercolor, 11½×14½ in. Courtesy of the artist.**

# Awards

John Hay Whitney Fellowship; Louis Comfort Tiffany Foundation Grant; John F. Stacey Foundation Grant; Philadelphia Museum of Art Award; Washington Watercolor Club Annual Exhibition Bainbridge Prize; Gold Medal Graphics Award of National Academy of Arts & Letters; Gold Medal of the American Arts Professional League, Smithsonian Inst.; Gold Medal of Honor, New Jersey Society of Painters; David Rose Award.

# Selected Exhibitions

Pachita Crispi Gallery, New York, 1954; Smithsonian Institution, Washington, D.C., 1954; International Exhibition of Graphic Arts, Yugoslavia, 1957; Museum of Modern Art, Kassel, Germany, 1959; Association of American Artists Galleries, New York, 1962; United States State Dept. Show, Soviet Union, 1963; Brooklyn Museum of Art, Brooklyn, N.Y., 1965; Market Place Gallery, Keighly Museum, Yorkshire, England, 1965; Prints from Twenty Nations, Yugoslavia, 1965; First World Festival of Negro Arts, Dakar, Senegal, 1966; Woodstock Gallery, London, England, 1966; Ball State Teachers College, 1969; New York Cultural Center (Fairleigh Dickinson University), 1970; Whitney Museum of American Art, New York, 1971.

# *Bibliography*

## Books

Dover, Cedric. *American Negro Art.* New York: New York Graphic Society, 1960.

Driskell, David. *African-American Artists.* Washington, D. C., Smithsonian Institution and Seattle, University of Washington Press, 1989.

Fine, Elsa. *The Afro-American Artist.* New York: Hacker Art, 1982.

Lewis, Samella. *Art African American.* New York: Harcourt Brace Jovanovich, 1978.

————. *Art: African American.* Los Angeles: Alan S. Lewis & Associates, 1991.

————. *Black Artists on Art.* Los Angeles: Contemporary Crafts, 1971.

## Periodical Articles

Bowling, Frank. "Discussion on Black Art." *Arts Magazine* 43 (April 1969).

————. "It's Not Enough to Say Black Is Beautiful." *Arts News* 70 (April 1971).

Coffin, Patricia. "Black Artist in a White World." *Look,* January 7, 1969.

Exler, E. "Romanticism & Printmaking." *Journal of the Print World,* Summer 1990.

Gaither, Edmund. "The Museum of the National Center of Afro-American Artists." *Art Gallery* 13 (April 1970).

Greene, Carroll. "Perspective: The Black Artist." *Art Gallery* 13 (April 1970).

Kay, Jane. "Artists as Social Reformers." *Art in America* 57 (January 1969).

Killens, John. "The Artist in the Black University." *The Black Scholar* 1 (November 1969).

Kramer, Hilton. "Black Art & Expedient Politics." *New York Times,* June 7, 1970.

————. "Black Experience and Modernist Art." *New York Times,* February 19, 1970.

# SIX

# *Elizabeth Catlett*

Elizabeth Catlett, noted for her powerful lithographs, is not only a master technician but also a conveyor of strong messages. The strength of these messages rests in the affirmative force of the human condition. Catlett believes in the Afro-American search for total freedom; the persistent and diligent pursuit is registered in the well-chiseled features of her works' personalities. Hope seems victorious over despair, but one cannot remove the stain of slavery. There is an open plea *and* a sense of achievement.

Catlett is a painter and lithographer of the African-American scene rather than the American scene. Her subjects are Americans but of strong African heritage. And yet, there is no conflict. Catlett believes in the American dream with the realization that one day a Oneness will result. Catlett's statements are clear-cut, direct and honest. Her work portrays a people in search of a way of life acceptable to the truths of the American Bill of Rights.

In her lithograph titled *These Two Generations* (1987), the sweat and tears have long been absent from the faces of the older generation but the scars remain. Catlett has depicted the young and the old side by side, a universal study of the past and future, a figure of dignity, a figure of vast human experience who peers into space and deeply feels the anguish that faces the younger generation.

Catlett's simplicity captures the soul of a human race who accepts God's plan and who prays for a brighter future for the young. A straightforward commitment to a difficult medium becomes an honest statement. Shadows and highlights reflect a questionable future. Catlett's source of light is flashed upon the pensive faces of victims of a nation steeped in greed, avarice and gluttony.

One questions the mood of Catlett's characters. Are they trapped in a social system that ignores their wants and needs, or are the two generations patiently awaiting ample opportunities for future happiness? One does not see despair in Catlett's portrayal. There is a resolution, a firm determination to fight for a cause, a belief. *These Two Generations* is a basic clear, simple statement, and because of its simplicity, a powerful message emerges.

Equally strong and poignant is her work titled *Cartas* (1986) in which sharp, clear lines form a three dimensional figure. It is a contemplative piece which carries the viewer into deep thought along with her character. Elizabeth Catlett diminishes or eliminates any objects which may interfere with the strength of her characters. In the case of *Cartas,* a single figure in pensive thought muses over the contents of some letters. To avoid possible monotony of shapes, the artist has maintained the linear nature of the letters, thus creating noteworthy compositional unity.

**Elizabeth Catlett.** *Madonna* (1982). **Lithograph on paper, 16¹⁄₈×21 in. Courtesy of the artist.**

One must consider *Cartas* as an unfinished work, but the applied technique is well conceived and worthy of note. It also draws the viewer's attention to the letters' contents, which remain unknown and consequently, a mystery.

In a similar vein, *Celie* (1986) reflects the significance of a letter. The strong female figure grasps pieces of the letter in both hands, thus creating a sense of action. The facial expression is one of profound thought, focusing on the letter thus activating the space between the female and the letters on the pages.

*Celie* is an expression of anticipation. One can only wonder what thoughts will stem from the letter. Compositionally, Catlett presents a traditional, classic figure, but by focusing on the head of the subject, the artist has created a shroud of light which acts both as a compositional device and a symbolic halo. The circle of light surrounding the head blends gradually into a background of lines which tend to agitate the environment. This subtle technique avoids a totally mute background which when set adjacent to the sharpness of the female's pure white attire, would have caused too great a contrast for a unified composition. A similar cloud of light surrounds the left hand of the figure thus diminishing the contrast between hand and background while allowing the use of line to excel in appropriate areas.

*Madonna* (1982) equals the compassionate appeal of her other works. The strong circular composition is made more powerful by the singular oval shapes which reside within the whole. Each figure's head delivers a message, a sermon of humility and peace. It becomes a matter of survival. The Madonna cradles the two youngsters; love of family is unmistakable. Catlett's use of darks and lights is powerful and elicits an undeniable plea for understanding and love.

Catlett is a remarkable composer. The oval shape with strong vertical and horizontal shapes is an ingenious use of opposing geometric planes. The rounded upper portion, which shaves off a major portion of the background, adds to the compact intensity of the trio. Intimate messages, although unknown, speak through the eyes of the two children and the consoling mother.

The semi–Abstract nature of the lower portion, although contrary to the general rules of composition, is compatible with the upper Realistic appearance. Catlett's works are highly subjective and *Madonna* is no exception. Immediate attention is payed to the trio of heads, and unaffected by adjacent areas, the focus remains upon the Madonna and children. In fact, to ensure concentration on them, the embracing arms force any meandering glance into the fold.

Elizabeth Catlett believes in the purpose that art should serve mankind beyond the visual pleasure of sensuous design and manipulative shapes in space. Art is one of the strongest forms of communication between peoples, and to waste it on individual pleasures or to cater to the rich and famous is totally wrong. And yet, Abstract art is not always understood by the masses. Thus, Catlett's work is Realistic, powerful in its simplicity so that her message is readily acceptable to all social classes. Catlett believes in total freedom, and she works to liberate her people. *Sharecroppers* (1970) is a portrait of the past but the message is current. In spite of its simple composition, its technical aspects are intricate and complex revealing the mastery of her craft. Textures prevail throughout the linocut. Yet, contrasts are formed by color rather than by technical means. But it is the pensive nature of Catlett's subjects that is first noticed, along with the strong physical features that reveal not only physical resiliency but reflect an inner spiritual strength that seems to sustain her work.

In another linocut titled *Homage to the Panthers* (1971), an opposite technique is used. Instead of the detailed, intricate textures found in *Sharecroppers,* one sees in *Homage to the Panthers* a comparatively flat pattern of human images which when singly isolated exhibit individual expres-

**Elizabeth Catlett.** *Mother and Child* (1962). Mahogany wood carving, 18×8×9 in. Courtesy of the artist.

sions. Six separate geometric shapes cradle the portraits of civil rights activists.

This linocut promotes what Catlett has called an aid to survival. The stark contrasts formed from a limited palette account for the dramatic appearance, and in spite of a simple layout, *Homage to the Panthers* makes a powerful statement. It is this simplicity of content, composition or technique which continues to emit a strong message. Catlett persists in direct, honest and simple portrayals.

Catlett is a noted painter and sculptor as well as a graphic artist. Her sculptures are simple in structure and design. *Black Unity* (1968) is a powerful piece and incorporates two works, two separate expressions, each literally viewed from opposite directions.

The standing rule is that a three-dimensional image should appear artistic from all angles, that compositionally the piece should retain its wholeness and that each slight shift of position should guarantee a visual completeness.

Catlett goes beyond. Not only has she fulfilled the above criteria, but has exploited two ideas within a single sculptural form in *Black Unity*. The front view exhibits two female heads—simple, direct, honest. The back view is the symbolic fist of black power. Each survives on its own merits. Yet, what a delight to have both in a single expression.

*Mother and Child* (1962), a remarkable sculpture of compassion and humility, is a plea for freedom and understanding. Aside from its foundation in the African-American culture, its simplicity of form tends to contradict its true complexity. A simple pose is manipulated into an intricate composition of overlapping shapes forming an embodiment of mankind. The mother's powerful hands are counterbalanced by the rigid stance of strongly chiseled feet, again conveying absolute determination.

The child is not lifelessly posed to suit photographic portraiture. Rather, Catlett's child is at once struggling for freedom from the mother's grasp and restful and at peace in the assuring security of maternal love. There is a power in the sculpture due partially to the simplicity of technique and lack of details, and also to Catlett's awareness of essential aspects of a given idea. The mother's straightforward gaze and the child's profile create a three-dimensional relationship coinciding with the general rules of sculpture in that one is challenged to accept a dual view from a single perspective. The curvature of the mother's lap affords an ideal place for the child both compositionally and literally.

The same simplicity that enlivens her graphic work also enhances her sculptures. There is a feature common to many of her sculptures—beseeching eyes turned heavenward. In her small statuette simply titled *Negro Woman* (1938), a headpiece becomes a prayer of thanksgiving, a plea for continued divine support. Again, the strength of her sculpture lies in the simplicity. Lack of details enables a full and intimate view of the subject without disruption.

*Negro Woman* is traditionally classic; its slightly raised head hints at a spiritual beckoning and a reliance on divine intervention. And it is this spirituality of the artist that creates a similar response from those who view her work.

Catlett's sculpture *Negro Girl* (1939) is an exquisite example of sorrow. It is not a joyous image of young life. Perhaps that is its strength. The simple, direct modeling of facial features allows for strong shadows.

A second version of a mother and child lacks in detail as a strong mother cradles her child with love and security. It differs from an earlier sculpture of the same theme by shifting the balance of the mother image. The artist has placed emphasis upon the lower torso in the second version, while in the first version, stress is balanced by equally spaced legs. In both sculptures there appears a fear, a fear of the future which has created a stronger bond than usual between mother and child.

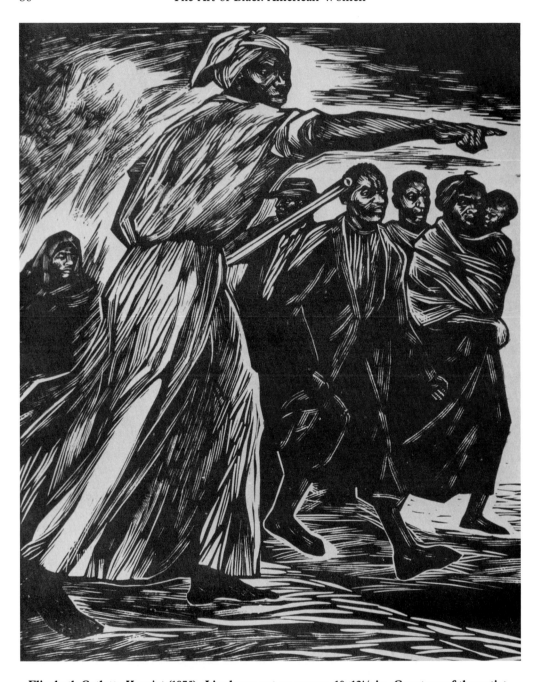

**Elizabeth Catlett. *Harriet* (1975). Linoleum cut on paper, 10×12¼ in. Courtesy of the artist.**

Catlett's life has been a catalogue of artistic achievements in both three-dimensional and two-dimensional media. Her lithograph *Harriet* (1975) is an exquisite example of her own personal fight for artistic freedom. Her disregard for society's schools of thought and approaches to life has strengthened personal concerns for the welfare of her own culture and of those groups ignored by the greed of the capitalistic world.

This dynamic lithograph shows a black leader spurring her followers to freedom. Aside from its dramatic appeal,

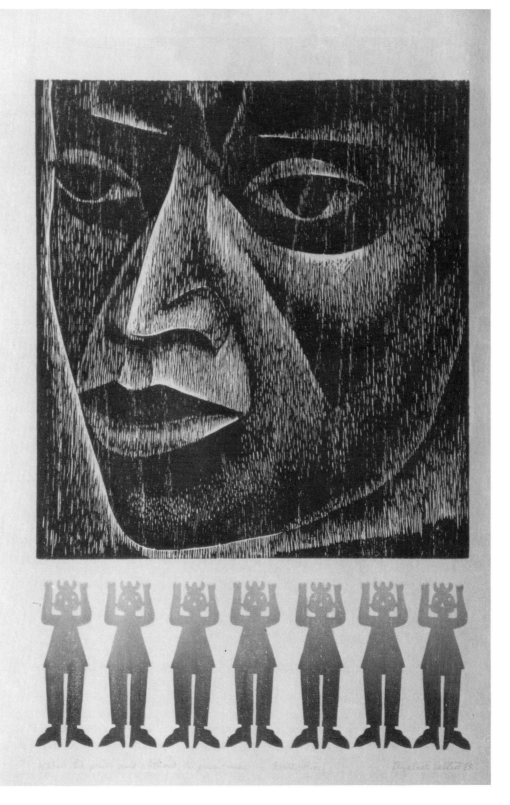

**Elizabeth Catlett.** *Man* (1975). Linoleum cut and woodcut on paper, 11³/₄×17¹/₂ in. Courtesy of the
artist.

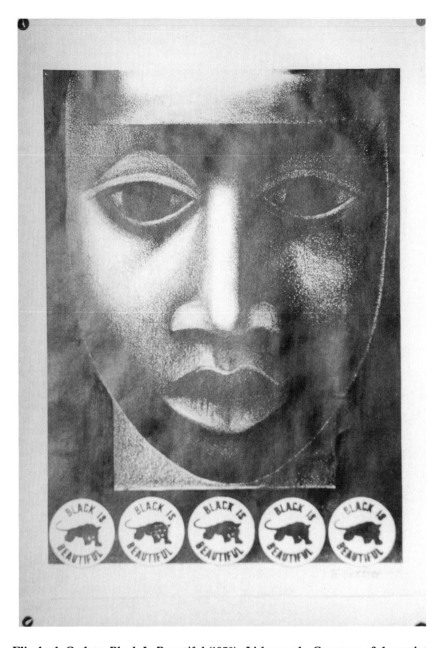

**Elizabeth Catlett. *Black Is Beautiful* (1970). Lithograph. Courtesy of the artist.**

the force of the outstretched arm of the female leader, which would ordinarily point the viewer out of the picture plane, retains the viewer's attention within the confines of the work. The painting urges the viewer to look beyond the work's mere technical aspects, and yet, one hesitates to focus on the individual expressions etched into the faces of the tormented.

*Harriet* could survive as a self-portrait, as Catlett is a leader for the rights of all individuals to explore without interference one's own potentials, particularly in the field of the fine arts. *Harriet* is a simply conceived composition, but the artist's dramatic use of line enhances it, creating a lithograph depicting several events. The appropriate dis-

tribution of darks and lights activates the work in dramatic fashion.

Switching from the dramatic to the tender was never a problem for Elizabeth Catlett, as in the case of *Negro es Bello* (1968). A strong composition because of its simplicity, the result is a charming rendition of a young child. The simple facial expression is contrasted to the scribbly background. This is a highly subjective expression, a personal love for a young child. What appears to be a routine portrayal, a photographic image is really a superb use of an artistic medium resulting in a qualitative work.

Equally proficient in the linocut and woodcut media, Catlett's style is exemplified in one work of the Black Heroes series titled *Malcolm Speaks for Us*. This linoleum illustrates her versatility. The precise composition and precise placement of images contrasts considerably to the dramatic, spiralling linear complexity witnessed in *Harriet* or in the smoothly rendered lithograph *Negro es Bello*.

*Malcolm Speaks for Us* (1969) is another example of Catlett's devotion to her own heritage and culture. By proclaiming the leadership of others she has proclaimed her own leadership. Her ability is to relate to the world at large in terms that not only the artist understands but the viewer can grasp and appreciate. Because of her training she is comfortable with most schools of art. *Malcolm Speaks for Us* has strains of the Op and the Pop movement along with echoes of Realism and Photorealism.

Catlett's dramatic woodcut titled *Man* (1975) is a highly personal rendition of the universality of man. The technical execution of the medium represents a patient yet persistent artist whose talents lie quietly undercover until the precise moment of creation. The arrangement of darks and lights reveals the strength and determination of the black culture. The unusual inclusion of seven figures at the base of the work adds to the intellectual and emotional strength of *Man*. Catlett is a powerful painter and printmaker as

well as sculptor. Her direct and unwavering commitment to her racial heritage ranks her high among America's finest artists.

In a work titled *Black Is Beautiful* (1970), Catlett introduces an all consuming close-up view of a young face mysteriously emerging to the surface from an uncertain environment. Anchoring this beautiful face are five circular logos inscribed with the words, "Black Is Beautiful." A black panther centralizes the slogan. The direct, simple, honest portrayal illustrates the magical sense of security of a powerless yet powerful force in American society. The repeat of the slogan, "Black Is Beautiful," illustrates the need to reiterate one's cultural origin.

The five balanced logos reinforce the formal balance of Catlett's subject. The arbitrary source of light enables the artist to adjust dark and light areas for the sake of emotional effect. A haunting sense of the unknown remains a concern, if not a fear of humanity. Even though a pensive mood is recorded, there are gaping eyes caught in disturbance, a sensuous mouth which illustrates an awareness, and yet a cautionary decision remains to be made.

Without the logo symbolism, the head form could provoke numerous interpretations, and its strength could well have survived without the assistance of the symbols. Catlett's recording of the human face features a bit of Surrealism, a Utopian view of the African culture. Catlett's use of shadows and reflections in the face and the horizontal cut of the forehead suggests a mask covering an underlying beauty.

*Chile I* (1980), a linoleum cut, reveals the frustration and despair of a jail term. Catlett has placed three prisoners behind bars, victims of an unjust aggression. Coupled with the intricate linear workings of the linocut are vast areas of black and white. Caged within each of three strategically positioned barred cells is a single figure whose life appears in danger.

The bewailing figure in the center of the work pleas in agony for humane

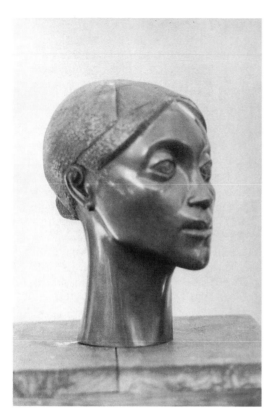

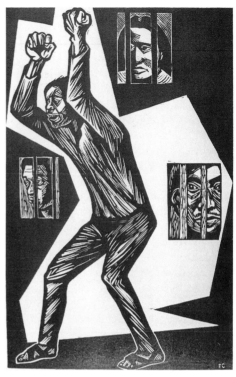

*Left:* **Elizabeth Catlett.** *The Embrace* **(1989). Black marble carving, 33¹/₂×11¹/₄×7¹/₂ in. Courtesy of the artist.** *Right:* **Elizabeth Catlett.** *Singing Head* **(1983). Black Monterrey marble, 19¹/₂×11³/₄×14 in. Courtesy of the artist.**

assistance. With clinched fists, angry facial expression and tense body actions, the man begs for his plight to be noticed and for fair legal action. Although the figure is encased within a white shape, there is a bit of symbolic freedom as well as a compositional technique in the extension of the victim's feet outside the limited white surface.

The dramatic effect of *Chile I* is created by the stark contrast of black and white. In a sense, *Chile I* is a four-fold expression. Each of the enclosed victims have personal experiences and if allowed to express their thoughts, their stories would create individual works of art.

Another atrocious event is witnessed in Catlett's linoleum cut titled *Central*

*America Says No* (1968). An unjust war which killed thousands of civilians as well as thousands of military troops has been a concern for artists since the invasion began. Catlett has shown in dramatic fashion the Central American's determination to thwart military attacks. The financial waste of war is registered upon the skeletal invader's helmet.

An exquisite rendering in bronze is a portrait titled *Glory* (1981), in which the lustrous finish matches the velvety flesh tones of the young face. The hairdo texture is a subtle contrast to the smooth finish of the portrait bust. The delicately modeled facial features reveal Catlett's versatility not only in the use of contrary media but in her variety of subject matter.

*Opposite, top left:* **Elizabeth Catlett.** *Glory* **(1981). Bronze, 13³/₈×9¹/₂×10¹/₂ in. Courtesy of the artist.** *Top right:* **Elizabeth Catlett.** *Chile I* **(1980). Linoleum cut on paper, 7×10¹/₄ in. Courtesy of the artist.** *Bottom:* **Elizabeth Catlett.** *Central America Says No* **(1968). Linoleum cut on paper, 20³/₈×15¹/₂ in. Courtesy of the artist.**

*Left:* **Elizabeth Catlett.** *Homage to Black Women Poets* **(1984). Mahogany carving, 15×13×69 in. Courtesy of the artist.** *Right:* **Elizabeth Catlett. "Untitled" (date unknown). Glass sculpture. Courtesy of the artist.**

Whether the delicate and elegant rendition of *Glory* or the grotesqueness of *Chile I,* Catlett has revealed her mastery of both media and established a sensitivity to the extremes of emotional reactions. *Glory* is a highly sensitive portrayal of a young life yet to be tested.

With a 1983 rendition in black marble, Catlett has produced a remarkable negative/positive response in the distribution of space. In *Singing Head,* cheek bones recede dramatically creating an obvious focus on the nose and slightly opened mouth. *Singing Head* is a handsome variation of receding and advancing spatial effects.

A black marble carving titled *The Embrace* (1989) is a marvelous example of interpenetration. Catlett has created openings in appropriate areas allowing a psychological freedom. Curved lines coupled with strong verticals and hori-

zontals make for a statuesque, masterful marriage of figure and form.

The two figures are so thoroughly engrossed in the embrace that a oneness results both in the literal sense as well as an artistic sense. There is a singularity of form without losing the presence of two in love engaged in a romantic affair. Furthermore, the simplicity and deliberate lack of details makes for a powerful image. Shapes are diversified but blend into one. The exquisite finish adds to the sincerity and innocence of the portrayal.

*Homage to Black Women Poets* (1984), executed in mahogany wood, has the same combination of curved, vertical and horizontal lines as *The Embrace.* Viewing it from the rear, one is treated to the artist's mastery. Normally of less interest than the front or side view, the rear view of *Homage to Black Women Poets* is alive with various undulations of curves,

indentations and open spaces. Lifesize in stature, the female has hoisted high her left arm. With left hand clinched and right hand grasping the left arm, the gesture is the symbol of power.

The body of the female is varied in negative and positive aspects. In an area that normally provokes a negative response, Catlett has introduced long strands of flowing hair reacing from the base of the figure's head to her lower torso. Not only is its presence an attractive addition but it serves a significant compositional need.

Because of the unusual attractiveness of the rear view, the viewer would naturally anticipate an even more exciting experience viewing *Homage to Black Women Poets* from the front or the side. The sensuous flow of wood grain and the subtle interruptions of that flow makes for pleasant viewing and aesthetic experience.

The translucence of glass has made Catlett's sculpture "Untitled" a reflective and contemplative piece. The posture of the subject adheres to the theory of interpenetration in which space and shape coexist within a single work. Negative and positive thought is seen in the equal distribution of open and closed areas. Shadows are reflected and everchanging as light dictates the dramatic effects of transparency.

The photo of the sculpture doesn't allow for full appreciation of its beauty. Three sides of the work are open for view, the fourth remains a mystery. The medium of glass introduces the element of shifting highlights and shadows which in turn create varying degrees of anticipation and wonder.

Catlett has executed several other seated figures in wood, bronze and marble. A 1979 version titled *Seated Figure* (see color insert) in mahogany wood excels in negative and positive aspects. There is a rather rigid pose, feet firmly anchored to a base and in perfect formal balance with elbows resting on similarly balanced kneecaps. Hands rest musingly alongside the cheeks of the face.

A 1986 version titled *Seated Woman* is informally balanced. Rendered in wood, it also relies on open spaces to forward the interpenetration theory. Strong verticals, horizontals and diagonals dominate the sculpture. Even though the figure is in a seated position, it remains a monumental structure. Although extremely simple in design, its unusual posture makes *Seated Woman* an exquisite example of Elizabeth Catlett's mastery.

The passing years only seem to add to Catlett's achievements. As late as 1990 she has revealed an uncanny use of the interpenetration theory. In her masterful work titled *Maternity* (1990) (see color insert) she has enclosed the unborn child within the mother's womb in such a manner that the sculpture is exciting to view from all angles.

# Career Highlights

Born in Washington, D. C., in 1915.

## Education

B.A. degree from Howard University, 1936; M.F.A. degree from the University of Iowa, 1940; Art Students League, New York; Art Institute of Chicago; studied under Ossip Zadkine and Grant Wood.

## Awards

Sculpture Award, American Negro Exposition, 1940; Acquisition Award, National Print Salon, 1960; Olympic Village Award, 1968; Rosenwald Fellowship, 1969; Sculpture Award, Golden Jubilee Exhibition, 1972; Print Award, Latin American Print Exhibit, Havana, Cuba, 1975.

## Selected Exhibitions

University of Iowa, Iowa City, Ia., 1939; Downtown Gallery, New York, 1940; American Negro Exposition, 1940; Atlanta University, Atlanta, Ga., 1942, 1943, 1951; Museum of Modern Art, New York, 1943; Baltimore Museum of Art, Baltimore, Md., 1944; Newark Museum, Newark, N.J., 1944; University of Chicago, 1944; Albany Institute of History and Art, Albany, N.Y., 1945; Museum of Modern Art, Mexico City, Mexico, 1956; Brockman Gallery, Los Angeles, Ca., 1967; City College of New York, 1967; La Jolla Museum of Art, La Jolla, Ca., 1970; James Porter Gallery, New York, 1970.

# *Bibliography*

## Books

Bontemps, Arna. *Forever Free: Art by African-American Women.* Alexandria, Va.: Stephesan, Inc., 1980.
Dover, Cedric. *American Negro Art.* Greenwich, Conn.: New York Graphic Society, 1960.
Driskell, David. *African American Artists: Selections from the Evans Tibbs Collection.* Washington, D. C.: Smithsonian, 1989.
_____. *The Barnett-Aden Collection.* Washington, D. C.: Smithsonian, 1974.
_____. *Two Centuries of Black American Art.* New York: Alfred Knopf and the Los Angeles County Museum of Art, 1976.
Fax, Elton. *Seventeen Black Artists.* New York: Dodd, Mead & Company, 1971.
Lewis, Samella. *Art: African American.* New York: Harcourt Brace Jovanovich, 1978.
_____. *The Art of Elizabeth Catlett.* Los Angeles: Alan S. Lewis Associates, 1991.
_____, and Ruth Waddy. *Black Artists on Art.* Los Angeles: Contemporary Crafts, 1971.
Rubinstein, Charlotte Streifer. *American Women Artists.* Boston: G. K. Hall, 1982.

## Periodical Articles

Catlett, Elizabeth. "The Negro Artist in America." *American Contemporary Art* (April 1944).
_____. "A Tribute to the Negro People." *American Contemporary Art* (April 1944).

## Catalogues

Barnett-Aden Gallery. "Elizabeth Catlett: 1948—The Negro Woman." Washington, D. C.
Fisk University. "Elizabeth Catlett." An Exhibition of Sculpture and Prints, Nashville, 1973.
Jackson State College. "An Exhibition of Sculpture and Prints by Elizabeth Catlett." Jackson, Miss., 1973.
Studio Museum in Harlem. "Elizabeth Catlett." New York, 1972.

# SEVEN

# *Jewel Simon*

Born in Houston, Texas, in 1911, Jewel Simon studied under such notables as Hale Woodruff and Alice Dunbar and at the famous Tamarind Institute. Early in her career, the classic still life and the natural landscape were her subjects but the unique diversionary *Apparition* (1969) with its exotic and compelling appeal has made Simon a master of her craft. The eerie, dreamlike figures of *Apparition*, rendered in flames of reds and oranges, celebrates the sensuous nature of the female. Intermingling figures erupt in an endless upswing while adjacent cool colors inhabit similarly rendered female forms.

This Abstract Expressionist approach results in a highly suggestive painting. Facial features remain unknown and undefined. The unique paradox of a vertical subject onto a horizontal surface adds to the unpredictability of the final product.

Unlike her earlier works, *Apparition* is intuitively executed. Color moves in spontaneous action as images are formed both in the positive and negative areas. Although the central spiral of color is prominently featured and assumes the positive aspect, secondary figures emerge from the two adjoining areas to form the negative aspects. However, similarities in all three sections of the painting blend into a total composition. Unlike Lucille Roberts whose purpose with her art is to promote the black culture, Simon prefers the quietude of the social scene.

A painting in point is her spring theme titled *The Early Birds* (1962) which depicts picnic treats in the park. Amid the vibrant trees are the family members celebrating an early spring festivity. The interlocking and overlapping of trees blocks the sky and partially hides the celebrants whose family activity becomes the focal point. The serenity of the sky is in contrast to the trees which seem alive with their new spring buds.

Although barren, the foreground is furnished with sharp angular shapes of color thus avoiding a monotonous display of green grass. *The Early Birds* is a celebration of quietude, an expression of solitude, perhaps even a resignation to the calm surrounding the storm.

In *The Early Birds*, the background is actually formed by the piercing and protruding tree branches. In other words, the positive aspects of nature have dictated the negative shapes, which in essence no longer remain negative but coexist with the positive aspects.

Simon is a classicist, a firm believer in the nature of divine creation and thus believes that attempts to duplicate nature would be futile. Instead, Simon has hoped to re-create the natural on her own terms but with a spiritual insight. The injection of figures onto the landscape adds dimension, and it capitalizes on the human element of communication.

**Jewel Simon.** *Apparition* **(1969). 40×30 in. Courtesy of the artist.**

In *The Eternal Hills,* Simon suggests eternal life by painting a natural landscape tempered with a spiritual purpose. A classical landscape of trees and mountains is transfigured into an image of secluded beauty. God's creation becomes the stimulus for a spiritually minded expression. Simple in its composition, the painting relies upon mood and atmospheric embellishment. The mist hovering above the mountainous background presents an ethereal format.

In spite of complexity of design, Simon's compositions allow for rest areas. In *The Eternal Hills* (1960), the sky becomes the rest spot even though naked tree branches against the sky make a jungle of angular shapes. Lack of foliage not only sets the mood of the painting but allows the background sky to act in contrast to the lines of the nude trees.

Aside from the academic landscapes, the routine still life becomes a favorite theme. *The Yellow Rose of Texas* (1944) is

such a painting. Although objectively and deliberately arranged, an intimate relationship between subject matter and artist accompanies a unique intuitive response to a popular stimulus. A poetic charm stems from a sensuous palette.

Space is allowed to remain negative in her work *The Yellow Rose of Texas,* in spite of attempts to do otherwise. The placement of an almost circular ashtray onto a vacant spot avoids a compositional blend. It accentuates a positive aspect which would be better left unattended. Rather than allow the negative space to enhance the total composition, the addition of the rounded object demands attention beyond its worth.

*The Yellow Rose of Texas* is a classical painting in the traditional sense. Its concentration on the frontal plane is a typical use of space, and additional objects are conceived as afterthoughts. The oval shape of the ashtray echoes the oval base of the vase, and the four books

**Jewel Simon.** *The Yellow Rose of Texas* **(1944). Oil on canvas. Courtesy of the artist.**

placed neatly between bookends reinforces the vertical panels of the window drapes. *The Yellow Rose of Texas* is a pleasant picture and should be considered in those terms.

*The Outing* (1981) is a joyous scene of a family fishing, picnicking and strolling around a pond amid an autumn setting. Trees become a haven for family activities, playing host before the seasonal change. Trees in the near foreground overlap the distant scenery and create a contrast of advancing and receding elements. An arc of autumn foliage lines the edges of the pond whose water echoes the splendor in blurred reflections. *The Outing* surrounds the occupants with trees which serve as a place of quietude as well as a compositional necessity.

An unusual painting, *Madonna of the Ghetto* (1952) reflects the need for mercy rather than the granting of it. The title suggests the presence of Christ and His mother, Mary. Reminiscent of the flight into Egypt, Mary protects her son from the threats of the ghetto, paralleling the threats of King Herod. Whatever Simon's intent, one questions the relationship between the typical mother and child and that of the Christian culture. Wrapped in the purity of white, one assumes an immaculate conception. The addition of the ghetto scene is non-essential to the literal meaning for it could identify any major city.

As a compositional device, its architecture is incompatible with the swirl of the white robes of the Madonna and child. Swirling robes are carried to the fullest extent in Simon's unusual work *Emergence* (1987). A sense of prayer and idolatry occurs in the folds of the white draperies. A somber face emerges from the maze of ribbonry. Although the figure is stationary, the composition moves in rhythmic patterns of smooth flowing circles. A halo adds to the purity of the figure. Three dimensional effects occur as gradation of color takes place. Again, the maternal instinct prevails.

**Jewel Simon.** *Pestilence* **(1972). Black ink on paper. Courtesy of the artist.**

*Emergence* beckons the viewer to contemplate not only the contents of the painting, but one's own inner personality. In an unusual display of emotion, Simon portrays an eeriness of circumstance, a stillness which seems to prevail in spite of the swirling movement of undulating shapes.

One is reminded of purity, an emergence of holiness amidst the evils of the day. There is a certain gentleness in her work, and a compassionate love of life is witnessed in her paintings of nature's commonplace. And yet, in *Emergence,* one is treated to a mystery, a speculative trek toward the unknown.

One assumes there is an objective portrayal underneath the swirling swishes of color enveloping the entire working surface. The only remains of an initial composition is the head of the emerging female figure.

In *The Mask of the Violin* (1944), Simon has applied the European influence of Cubism to the head and the upper torso of the female. The semi–Abstract face occupies the central portion of the work which is surrounded by shapes resembling office furniture. The mask and the violin hold adjoining positions as each relies upon the other.

The African shaped head is delicately etched with attention to facial features unlike the surrounding habitat. There are four different spatial planes none of which interpenetrate, but which advance and recede by virtue of overlapping shapes. Throughout her career, Simon has encountered and successfully mastered several styles.

Simon is noted for her paintings of quietude, for her series of paintings of peaceful scenes. Her seemingly sudden departure from the serene to the unusual Abstraction of *Emergence* strongly suggests a need for a jolting of the creative process. From the semi–Abstraction of *Emergence* to the total Abstraction of *Involvement* (1961), one witnesses a similarity of movement although

the latter painting reveals a deliberate placement of lines while the former relies upon an intuitive display of lines.

*Involvement* requests human participation, but not human communication. The interpenetration of opposing shapes revolving in circular movements entices the viewer to become involved. The intermixture of shape and color is accentuated with dynamically etched lines which not only define the linear direction of the painting but assist in the compositional structure. The Abstract painting maintains the element of unpredictability. It communicates emotions with color and shape. Its sweeping movements strongly suggest an eternity, a non-ending cycle of life, that in spite of tragedies, life continues to flourish.

An even more radical departure from the quiet, peaceful scenes of her early production is a loosely rendered but calculated expression titled *Pestilence.* The sharp contrast between the two concepts is peculiarly questionable. The love, compassion, humility and charity revealed in the works of Jewel Simon seem suddenly alien to her personality in *Pesti-lence.* The claw-like structure of an insect creature on an apparently slimy surface brings to mind a far-reaching plague. The application of pigment upon a wet surface is an appropriate technique for such an intuitive work.

The Abstract Expressionist rendering of *Pestilence* is indicative of the unpredictability of an insect attack. One is never sure of directional movements during such impulsive attacks of the canvas, and it is the intellect that determines the moment that the creative process has reached its goal.

More insects are inconceivable unless of course if one were to totally consume the canvas with claw-like creatures. However, without the benefit of negative space or an environment or habitat upon which to exist, Simon's portrayal may well have resulted in an all-over pattern of nothingness. The positioning of the creature, furthermore, adds to a spread of the disease. The placement midway upon the working surface allows for a continuous journey upward while leaving germs of destruction in the lower segment of the canvas.

# Career Highlights

Born in Houston, Texas, in 1911.

## Education

B.A. degree in Art from Atlanta University, Atlanta, Ga.; B.F.A. degree in Art from Atlanta University, Atlanta, Ga.; postgraduate work in painting under Hale Woodruff; postgraduate work in sculpture under Alice Dunbar at Spelman College.

## Awards

American Association University Women's Award; NAACP's James Weldon Johnson Art Award; The Bronze Jubilee Award; A.K.A. Golden Dove Heritage Award.

## Selected Exhibitions

Howard University Invitational, Washington, D.C., 1960; Xavier University, 1963; High Museum of Art, Atlanta, Ga., 1964, 1971; UCLA Art Galleries, Los Angeles, Ca., 1966–67; Oakland Museum of Art, Oakland, Ca., 1966; West Virginia State University, 1968; Atlanta Jewish Community Center, Atlanta, Ga., 1968, 1971; Stillman College, Tuscaloosa, Al., 1970; Mississippi State University, Jackson, Ms., 1970; Carnegie Institute, Pittsburgh, Pa., 1971; Georgia Institute of Technology, 1972.

## Solo Exhibitions

Atlanta Jewish Community Center, Atlanta, Ga.; Atlanta Artists Club, Atlanta, Ga.; Adair's Art Gallery, Atlanta, Ga.

# *Bibliography*

## Books

Atkinson, Edward. *Black Dimensions in Contemporary American Art.* New York: New American Library, 1971.

Chase, Judith. *Afro-American Art & Craft.* New York: Van Nostrand Rinehold, 1971.

Davis, John. *The American Negro Reference Book.* New York: Educational Heritage, 1966.

Dover, Cedric. *American Negro Art.* New York: New York Graphic Society, 1960.

Driskell, David. *Two Centuries of Black American Art.* New York: Los Angeles County Museum of Art, 1976.

Huggins, Nathan. *The Harlem Renaissance.* New York: Oxford University Press, 1971.

Lewis, Samella. *Art: African American.* New York: Harcourt Brace Jovanovich, 1978.

_____, and Ruth Waddy. *Black Artists on Art.* Los Angeles: Contemporary Crafts, 1969.

Simon, Jewel. *Flight: Preoccupation with Death, Life and Life Eternal.* Orangeberg, S.C.: Williams Associates, 1988.

Woodruff, Hale. *The American Negro Artist.* Ann Arbor: The University of Michigan Press, 1956.

## Exhibition Catalogues

Acts of Art Gallery. "Black Women Artists 1971." New York.

Baltimore Museum of Art. "Contemporary Negro Art." Baltimore, Md.

Downtown Gallery. "American Negro Art: 19th & 20th Centuries." New York.

Harlem Cultural Council. "The Art of the American Negro: Exhibition of Paintings."

Herbert F. Johnson Museum of Art. "Directions in Afro-American Art." Cornell University. Ithaca, N.Y.

La Jolla Museum of Art. "Dimensions of Black." La Jolla, Ca.

Whitney Museum of American Art. "Contemporary Black Artists in America." New York.

## EIGHT

# *Faith Ringgold*

Faith Ringgold, a political activist during the sixties and seventies, has used the American flag as a motivating force in engineering her ideas into artistic accomplishments. In her unusual portrayal of American democracy, the flag becomes a playground for rebellion. *The Flag Is Bleeding* (1967) represents the falsehoods of the American Constitution. Loopholes reflect the injustices cast upon the black race in America. Not only is the flag bleeding, but according to Ringgold it is leaking inequities that occur among the African-American culture.

The bloodshed suffered by the African American is a profound concern of Faith Ringgold. Thus, she has used the flag as the backdrop for three Americans who are interwoven with the flag. In spite of the disintegration of parts of the figures, the eyes of each individual clearly peer through the flag's fabric and into the unknown future. Arms interlocked, the three Americans stand steadfast against the bloody events experienced by the unfortunates of a greedy capitalistic society. Forty-eight stars representing forty-eight states fit favorably into a balanced composition. Aside from its political statements, *The Flag Is Bleeding* is an exciting blend of Op and Pop art.

In *Flag for the Moon: Die Nigger* (1969), Ringgold has included the fifty states of America instead of the forty-eight as painted in her 1967 rendition. The thirteen stripes representing the thirteen American colonies have been altered to read "nigger." The word "die" is superimposed upon the fifty stars.

Ringgold is stating that the flag does not represent black America, and that its existence as the symbol of democracy and freedom is a mirage which seems to appear for privileged audiences and disappear for the underprivileged.

Ringgold's statement is an intellectual and sophisticated one. The message is strong and a strong message is at times a protest. Yet, a protest of an artistic nature demands more than an emotional response. Ringgold combines an emotional protest with artistic means creating in the process an aesthetic experience.

*Die* (1967) illustrates the brutality resulting from racial strife and discontent. Ringgold has utilized realistic human figures interlocked with an Abstract environment. There is no visual perspective such as an established baseline or receding and advancing aspects of nature. Rather, the figures overlap to form an active scene of fear and anguish.

Distorted bodies, focusing on body parts that experience the torture and agony of innocent victims, is the stimuli for Ringgold. Although panoramic in scope, the artist has respected the limited working surface by reversing the parade of victims at the left of the canvas. White and black alike suffer from the ethnic struggles. *Die* is more than an emotional expression of anger and hatred; it is an

intellectually conceived and executed work. The figures, although complete, hint at decapitation by the manipulation of the foreground/background frontal plane. It is this Realism within an Abstract habitat which makes *Die* such an intriguing expression. Aside from its obvious message, it incorporates the rudiments of a masterful work.

In a completely different vein is a sculpture titled *Aunts Edith and Bessie* (1974) which proclaims the rights of women. Attired in African dress and masks, the open mouths of aunts Edith and Bessie symbolize the need to speak out for the guaranteed rights of women especially that of the ethnic groups. It lacks the powerful message of her flag series, but nonetheless calls for a long awaited solution.

Faith Ringgold's vicious protests of the sixties are drastically changed in her charming quilt paintings of the eighties. Of particular eloquence is her highly decorated work titled *Bitter Nest Part V: Homecoming* (see color insert). The merging of the quilt designs with the decorative painting is an amazing blend of compatibles.

*Homecoming* is a charming piece, a depiction of an intimate celebration. The usual refreshments are pictured on a three-legged table which corresponds with the childlike approach of a multi-view; that is, the showing of a still life from both front and top views. But perhaps most delightful are the decor of the room and its occupants.

Flatly painted, three dimensional effects occur because of receding and advancing colors within each individual pattern. Only the faces of the four characters indicate shading techniques. The flatness of the painting concurs with a similar flatness within the quilt designs. And since *Homecoming* is best seen by hanging on a wall, it naturally presents a frontal format.

A similar piece titled *Bitter Nest Part I: Love in the School Yard* (1988) strays somewhat from the highly decorative subject matter of *Homecoming*. The contents present a different challenge, one in which contrary elements blend into a total composition.

Early during her career, Faith Ringgold revealed a true strength of expression in such works as *God Bless America* (1964), and *The American Dream* (1964). The bold contrasts coupled with symbolic irony reveal a power of the images. As she has often claimed, art is freedom. It is one activity that allows self-expression free of reprimand. In her powerful *God Bless America* (see color insert), one witnesses a woman entangled in the stars and stripes. But the woman is not proud. One sees instead a foreigner, an immigrant of sorts, an American citizen but not with the freedom guaranteed under the Bill of Rights.

There is a sense of defeat in the face of the female victim. There is interpenetration between foreground and background, and the positioning of color maintains visual movement.

A similar painting titled *The American Dream* reveals an elegantly attired, attractive woman of an upper social class sporting an elaborate diamond ring. Again the emphasis is upon the pseudo-trappings of the American democratic society in the name of greed. The materialistic success associated with the American dream is not about what Ringgold paints. It may be the American pursuit for those who wish it, but for Ringgold the American dream is the precious sense of freedom to be oneself without penalty, to live in order to fulfill the will of the Divine Being whose purpose was not to sacrifice for lost causes.

*The American Dream* is a strong painting. The simple planes of color gracefully meander about the canvas surface and bring into focus an example of

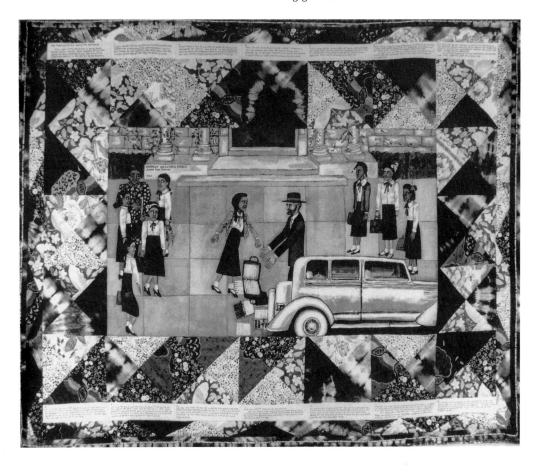

**Faith Ringgold.** *Bitter Nest Part I: Love in the School Yard* **(1988). Acrylic on canvas, dyed and pieced fabric, 92¹/₂×75¹/₂ in. Courtesy of the Bernice Steinbaum Gallery, New York City.**

success. And yet, the isolation, loneliness and despair that exists in spite of success recalls the need for a spiritual reawakening.

The semi–Abstract approach opens wide the field of speculation and interpretation. It is difficult to scan an artist's inner sensations and to reveal what often eludes the artist herself. What Ringgold intended is not always received by the viewer. And yet, regardless of the message of *God Bless Ameica* and *The American Dream,* both works are judged on their artistic merits. However, without a message with which to awaken one's senses, the works fall short of a lofty goal. Ringgold's later works prove that a magical charm can circumvent the aggressive messages of the sixties.

The viewer unaccustomed to Ringgold's mixture of paint and quilt could readily question her combination. In *The Winner* (1988), the quilt tends to act as a border design for an exciting painting titled *The New York Marathon.* The combination of runners in motion against a skyscraper environment creates an emotional painting.

It is important to note the female runner leading the pack, and the quintet of runners jamming the bridges. The quilt adds an architectural flavor to the work, and by enlarging the working surface, it adds to the immensity of the

*Opposite:* **Faith Ringgold.** *Die* **(1967). Oil on canvas, 96×72 in. Courtesy of the Bernice Steinbaum Gallery, New York City.**

endeavor. Ringgold has tied the quilt design to the architectural design of the painting with color balance and a linear format.

*Double Dutch on the Golden Gate Bridge* (1988) is a monumental rendition in which the expanse of skyscrapers is heightened by the additional bordering of the quilt designs. The danger of preoccupation with the technical process and the very possible loss of emphasis to the care of the piece are everpresent. The need to match an alien material with the medium of paint in order to maintain a unified composition makes for a perilous journey. There is no question that Ringgold blends technical processes that seem contrary. By transporting the double dutch rope jumpers to the Golden Gate bridge instead of habitual neighborhoods suggests a superiority or a recognition of a noteworthy feat, yet that theme reduces the strength of the mixed media.

A single message, not unlike those of her works of the sixties, would engage the viewer in serious thought and possibly would motivate action. Painting is a compromise but only in adjusting to maintain an artistic product. Frequently the original idea is challenged by physical limitations. Rather than succumb to unforgivable concessions, a different medium of expression may be essential.

Ringgold's intentions are unclear. There seems to be an obsession to incorporate the quilting process and when combined with the paint medium, it affords a unique and novel approach which leans dangerously toward the decorative. Instead of painted marvels, her works become gorgeous tapestries. But the nature of a tapestry by necessity slackens the process, creating in turn a less dramatic portrayal. Were one to concentrate on the joyous celebration which her works strongly suggest, then her message becomes incidental, or at best, a clue to total understanding.

Several detail segments of *Double Dutch on the Golden Gate Bridge* could be major paintings. The whole composition is a unique work which survives on its own merits. To rely upon fringe benefits such as the mixed media for a total expression may expand an audience participation while losing the significance of the original idea.

The use of media simply for the sake of having that media in the work frequently stalls an artist from deeper penetration into his or her own environment. Ringgold's drawing and painting talents extend far beyond her current retrospective showing. To be versatile does not free one's self. Ringgold's indulgence with the quilting process sidelines the more exigent needs of her talents. To awaken society by the shock of her easel paintings or by the glamorous contents of her attached quilting becomes a disturbing question. As beautiful as her paint/quilt creations are, they serve a lesser purpose. However, it *is* Ringgold who is the artist. What purpose does a multimedia expression serve? Is it to garnish and enhance or to diminish the initial intent of the artist?

It is indeed conceivable that in the case of Ringgold, her entire career may be a continuing creative process. It is probable that the quilt painting process is a segment of a total experience, a technique which will one day give way to a new and more dramatic approach. It is possible that Abstract Expressionism may enter her agenda. She has already dealt with Op and Pop, Realism and Surrealism, and Abstract. Perhaps a single medium will again reign supreme and depict her ultimate expression.

In the meantime, one is thankful for her quilt paintings. A few survive the perils of over-decoration and the dual media succeed as a single entity. In the case of her work titled *Sonny's Quilt* (1986), Ringgold has incorporated the quilt material into the painting itself thus creating an interpenetration of the two materials, whereas before, the quilt material served as a border design only. The overlap of the two materials actually enhance the total expression.

Visual perspective is diminished as the background and foreground coincide

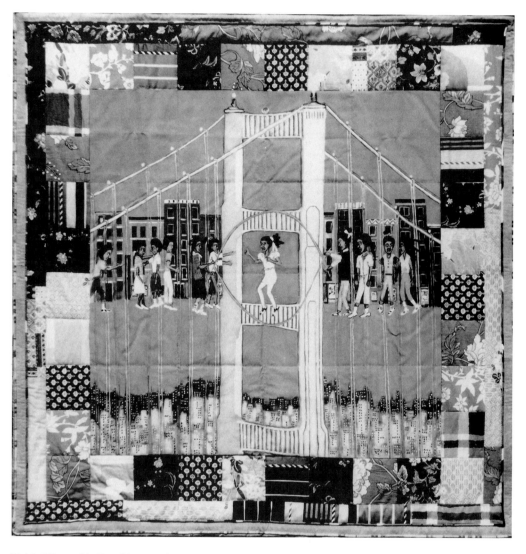

**Faith Ringgold.** *Double Dutch on the Golden Gate* **(1988) from the Women on a Bridge Series. Acrylic on canvas, printed, dyed and pieced fabric, 68×68½ in. Courtesy of the Bernice Steinbaum Gallery, New York City.**

in color and tone. Similarly the skyscrapers on the near and far sides of the river reveal identical spatial distances. Visual perspective is partially established by the receding elements of the bridge. Ringgold has again utilized the quilt design for bordering her painting. The brilliant colors reflect the happy times which are transmitted to the audience.

The same exuberance is shown in *Groovin' High* (1986), in which several dancing couples are dressed in material matching that of her quilted borders.

Males and females dance feverishly in splendid fashion as they collide upon a limited dancing surface.

The lustrous colors of the quilt border complement the fun and the excitement of the event. The painting has its own strength without added ornamentation. In this case one must evaluate the painting and not the whole work. Several single episodes occur within the work. Joined together they form a team of overlapping figures thus creating a visually subjective expression. *Groovin' High* is

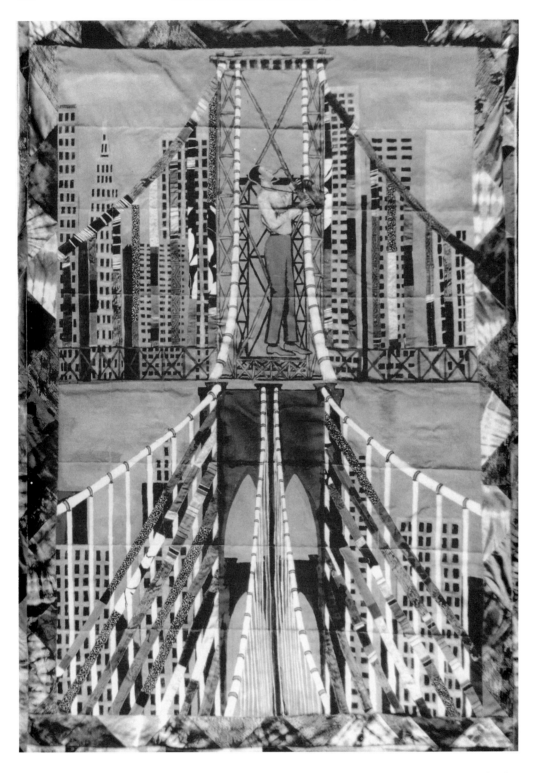

**Faith Ringgold.** *Sonny's Quilt* **(1986). Acrylic on canvas, tie-dyed, printed, and pieced fabric, 60×84½ in. Courtesy of the Bernice Steinbaum Gallery, New York City. Collection of Barbara and Ronald Davis Balser, Atlanta, Georgia.**

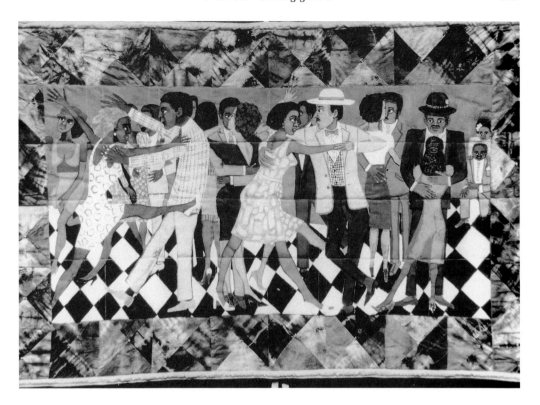

**Faith Ringgold.** *Groovin' High* **(1986). Oil on canvas, tie-dyed, printed and pieced fabric, 92×56 in. Courtesy of the Bernice Steinbaum Gallery, New York City. Collection of Barbara and Ronald Davis.**

an intricate composition. Even though the lower half of the painting's design coincides with the geometric shapes of the quilt pattern, the quilting becomes a secondary addition when not compositionally needed.

Depending on purpose, a single medium is the best means of a direct, honest expression and is the strongest form of communication. In some instances, Ringgold's dual media is marvelously executed and with artistic purpose. In other cases, the additional quilt pattern may have overplayed its role. *Groovin' High* is a powerful painting and needs no embellishment. It is the medium that best suits an idea that should be used. And there is always the possibility of overkill; excess activity confuses an audience.

On the other hand, the effectiveness of Ringgold's *The Purple Quilt* (1986) and *Echoes of Harlem* (1980) relies upon the total work. *Echoes of Harlem* utilizes the rectangular shapes of the quilt to incorporate human heads, and thus the architectural pattern is fulfilled. It is interesting to note the childlike display of heads, the formation appearing to rely on the tactile experience of the child. And the additional fold-over manuever makes the quilt painting similar to the child's fold-over picture.

*Echoes of Harlem* is made to be viewed from a vertical or horizontal angle. The use of fabric is essential to the uniformity of the product, although it is at times difficult to focus on the faces that inhabit the canvas/quilt expression.

Facial expressions are subtle; eyes wide open and set lips reflect a closed society. Ringgold has followed a formula for placement with each rectangular head equal in size but varied by a tilt or a nod to the left or right. But there is a leaning toward a calculated balance of images

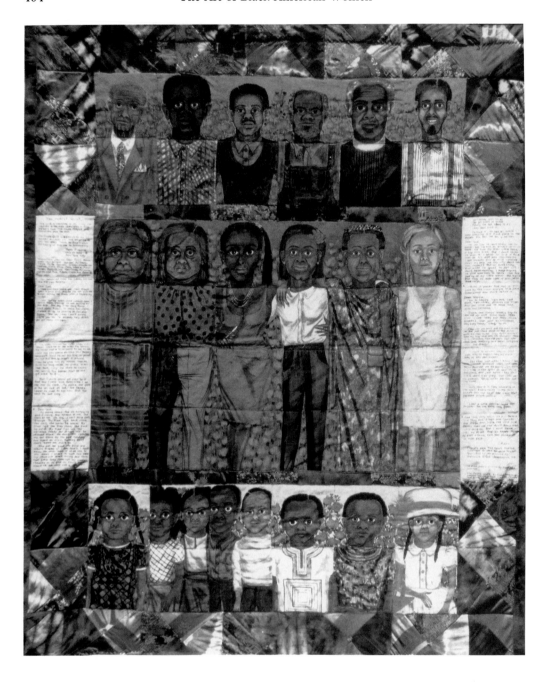

**Faith Ringgold.** *The Purple Quilt* (1986). **Acrylic on canvas, tie-dyed, printed and piece fabric, 72×90 in. Courtesy of the Bernice Steinbaum Gallery, New York City. Collection of Dr. and Mrs. Harold Steinbaum, New York City.**

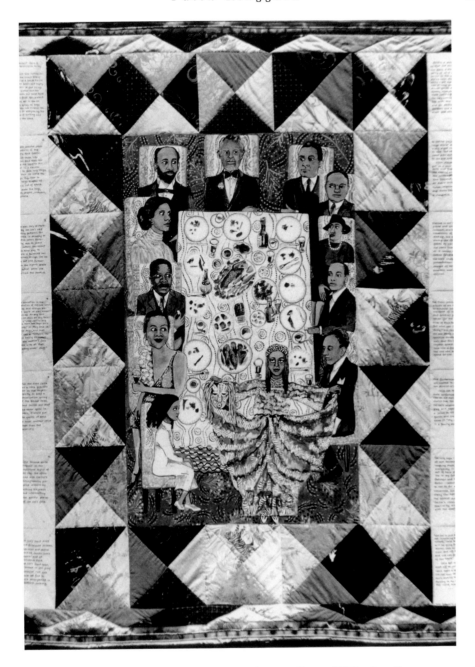

**Faith Ringgold.** *Bitter Nest Part II: Harlem Renaissance Party* **(1988). Acrylic on canvas, tie-dyed, printed and pieced fabric, 82×94 in. Courtesy of the Bernice Steinbaum Gallery, New York City.**

that tends to confuse the viewer. Heads positioned at each of the four corners of the rectangular product are tilted in a fashion resembling one "turning the corner." There are twice as many women as men pictured in the produc-tion, which may suggest the power of womanhood.

Another work, *The Purple Quilt* (1986), expands the use of human figures by including the upper torso, and in some cases, the total figure. The title stems

from the book *The Color Purple*. In her quilt painting she pays homage to the story's characters, giving them a visual identification as well as literary. The figures represent all walks of life and include all ages. The upper tier of humans comprises a male population, the lower segment incorporates children, while the center panel features women who are deliberately enlarged, again suggesting female power.

Each tier of individuals represents personal tragedies as well as victims of a national catastrophe. The children, innocently portrayed, appear alert, yet hesitant to encounter the social problems facing them in the future. The middle section is reserved for the women who bear the brunt of the social dilemmas by nurturing the children while accepting their own uncertain future.

In each of the rectangular tiers of human pride and fear is a decorative environment which serves to coincide with the quilted background. There is a strong bond among these survivors. The similarity of expression, physical stance and rigid but formal balance serve to maintain an integrity and inner fortitude. To avoid monotony, Ringgold has doubled up the human characters thus avoiding a sterile formation of images.

The narrative episodes of her Bitter Nest series are without question colorful and intriguing. However, again the viewer might concentrate on the pictorial aspect and ignore the narrative aspect. In *Bitter Nest Part II: Harlem Renaissance Party* (1988), Ringgold delights her audience with the colorful table setting and wondrous looks of her dinner guests. There is an excitement; one is tantalized by the inquisitive looks and the questioning ogles of both the men and the women. It is the mystery that lies behind the facial expression of each guest that creates audience reaction.

The dancing girl no doubt appeals to the gentlemen. The artist has depicted more men than women for the gala affair. The festive table setting adds to the delightful ceremony. To the viewer

the reason of the celebration matters little, for it is the visual appearance that motivates the viewer into action.

The combining of visual pleasures with the narrative is indeed noteworthy and a definite must for other artists who may wish to follow in Ringgold's path of achievements. Ringgold has remarkably adjusted the decorative nature of the quilting process with the essential aspects of her paintings. The tablecloth, dress attire and the placement of the food confirm her obsession with the decorative nature of life.

Again, Ringgold's use of the front/ top view of her subject matter allows for a full and complete look of each essential object. Although realistically impossible to witness front and top views simultaneously, this child-like form of naturalism is indeed logical, and for centuries adult artists have utilized the natural instincts of the child artist.

The rectangular format of her portraits coincide with similarly arranged quilt squares. It is the extreme complexity of design that warrants a detailed study of her individual works, not so much to read her biographical sketches, but more to study the pictorial aspects.

There is much to discover and uncover, and time becomes a factor. One is initially drawn into the work as a whole and each new discovery adds to the anticipation of further discovery. *Harlem Renaissance Party* is such an expression.

*The Letter* (1988) is another example of Ringgold's ingenuity. Again, one is intrigued with the intricate design and the numerous possibilities of interpretations. To engage in a quick response to *The Letter* would be inconceivable. One is overpowered by the intensity of color which creates an initial shock, followed by a rest period for reflection and assimilation. Then the slow process of viewing begins.

The painting blends into the quilted background while the biographical narratives serve as left and right borders. Ringgold's Bitter Nest series is a sort of

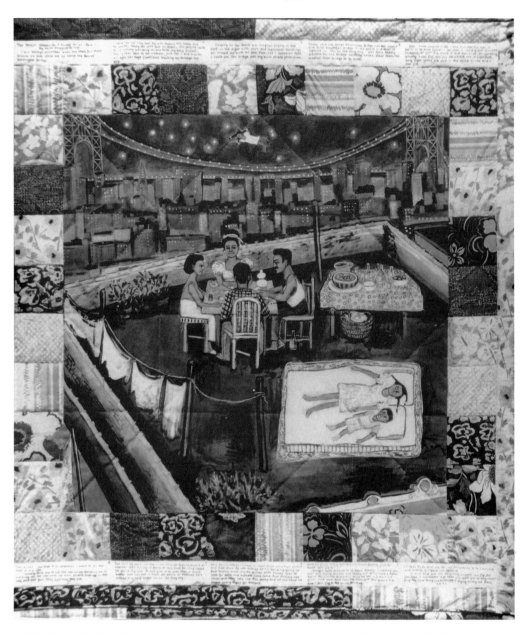

**Faith Ringgold.** *Tar Beach* (1988). Acrylic on canvas, pieced, printed and painted fabric, 69×74 in. Courtesy of the Soloman R. Guggenheim Museum. Photo courtesy of the Bernice Steinbaum Gallery, New York City.

illustration except that unlike the general definition of illustration, Ringgold's approach is that of the writing becoming the illustration for the painting, an unusual technique to be sure, but Faith Ringgold is indeed an unusual artist.

Ringgold's biography is altered in her famous quilt painting titled *Tar Beach* (1988). The interpretation of her painting is more clear than earlier quilt biographies. In fact, city dwellers, especially those of tenement buildings, had free open air entertainment. The Great Depression forced neighbors to entertain each other, and during hot, humid nights the rooftop became the scene of human

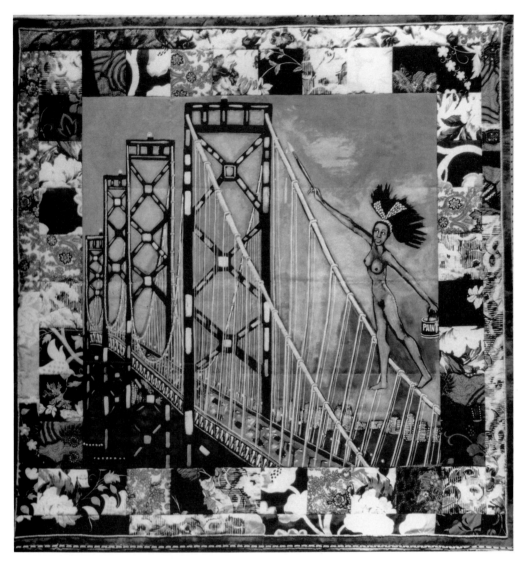

**Faith Ringgold.** *Woman Painting the Bay Bridge* **(1988). Acrylic on canvas, tie-dyed, printed and pieced fabric, 68×68 in. Courtesy of the Bernice Steinbaum Gallery, New York City. Collection of Mr. and Mrs. John Spohler, New Jersey.**

activity where entire familes ate, drank and relaxed.

In Ringgold's *Tar Beach,* a primitive portrayal becomes a fascinating mixture of realism and child-like picturization. The quaintness and charm of the rooftop event is at times overshadowed by the quilt pattern. Although exquisitely related to the core of the painting, one becomes unsure of which medium supercedes the other. The two media, although successfully melded together in a technical

sense, do not automatically create a sense of oneness.

However, as mentioned earlier, initial reactions become superficial responses. The viewer participates in a full scale review of a Ringgold tapestry which demands more than a cursory glance. And yet, it is easy to hold in esteem her painting as an honest, direct display of human conduct innocently and magically portrayed.

Adding to the charm and magical

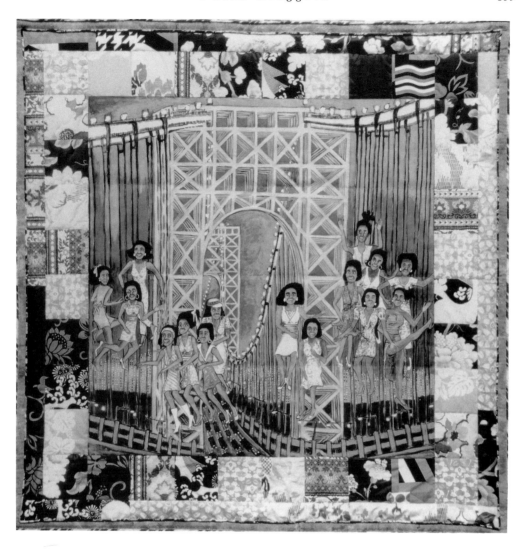

**Faith Ringgold.** *Dancing on the George Washington Bridge* **(1988) from the Women on a Bridge Series. Acrylic on canvas, tie-dyed, printed and pieced fabric, 68×68 in. Courtesy of the Bernice Steinbaum Gallery, New York City. Collection of Roy Eaton, New York City.**

innocence are childhood fantasies of freedom and dreams of wishful thinking: conquering the unconquerable and pretending to accomplish the impossible. *Tar Beach* pictures the artist as a child soaring over Manhattan's skyscrapers in angelic fashion.

The child's image appears again in *Woman Painting the Bay Bridge* (1988), in which her fondness for the bridge has freed her to explore artistic privileges. The female spreads joy with red paint while far below hordes of automobiles cross the famous bridge toward the city's nightly activities. Ringgold has chosen the evening for painting. A rich purple sky contrasts sharply with the bright lights of the bridge, its occupants and the fully lit skyline of New York's buildings. Rectangular shapes of color painted onto the bridge by the flying female are echoed by similarly colored quilt patches surrounding the painted canvas.

A more joyous celebration occurs in *Dancing on the George Washington Bridge* (1988), in which several groups of

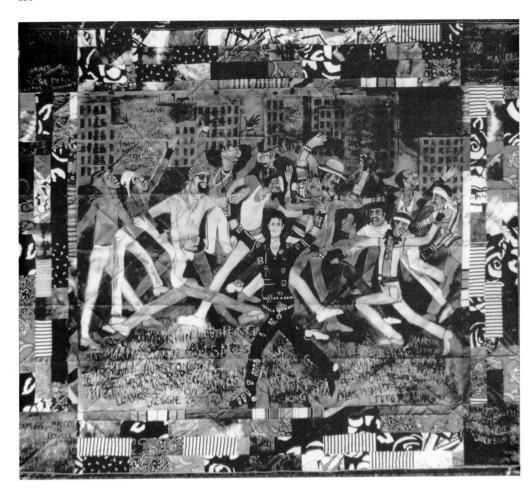

**Faith Ringgold.** *Who's Bad?* **(1988). Acrylic on canvas, pieced fabric, 92½×70 in. Courtesy of the Bernice Steinbaum Gallery, New York City.**

dancers enhance the entire canvas/quilt with their smiling faces and active bodies. The everpresent skyscraper skyline lies partially hidden behind the towering bridge. There are four separate dancing groups superimposed upon the frontal planes of the bridge. All are female, again revealing a feminist stronghold.

*Dancing on the George Washington Bridge* is a victory dance. Whether it be fantasy or reality, it is indeed a glorious sight. Specks of light in the skyline and the bridge's own light system correspond to the environment of the quilt border. The designs on the dancing girls' clothes also relate to the patchwork designs of the quilt.

In an unusual male dominated work titled *Who's Bad?* (1988), Ringgold depicts a celebration of the achievements of the black race. Headed by a formidable dance team of energetic gymnastic dancers and featuring the most popular entertainer of the current decade, Michael Jackson, Ringgold has succeeded in answering her satirical question in the title with the names of worldwide newsmakers such as Martin Luther King, Jr., Jesse Jackson, Malcolm X, Clayton Powell, Baldwin, Mandela and others.

*Who's Bad?* is another example of a powerful painting which would fit well with her achievements of the sixties. The embellishment of environmental borders is unwarranted. The strength of this piece lies in the seemingly chaotic dance for-

mations which in spite of its frenzied intermingling of forms sustains an orderly display of overlap and interpenetration.

*Who's Bad?* is a powerful testimony to the accomplishments of American black leadership. Tenement buildings consume the background segment of the painting while the forefront features names of African-American leaders. Since fabric borders are utilized, Ringgold has succeeded in relating the dancers with the quilt patterns outside the painted canvas surface.

By using a single hero figure to illustrate black achievement, Ringgold is allowed to incorporate several other figures by names alone. *Who's Bad?* is a forceful painting, one which proclaims noteworthy contributions to the American culture.

*Baby Faith and Willi Series #5* (1982) is an Abstract work which succeeds completely as a multimedia expression. There is no conflict between the inner painting and its surrounding fabric. Because both segments are Abstract, its compatibility is readily seen and thus readily accepted. The Abstract Expressionist version of the inner painting coincides with a similarly executed tie-dyed pattern in the quilt border. Since both are Abstract, there is no conflict.

Even earlier than her 1982 quilt work, in 1967 Ringgold painted a large canvas titled *U.S. Postage Commemorating the Advent of Black Power.* It followed her dual canvases, *God Bless America* and *The American Dream. U.S. Postage* became a fixture of the sixties. It was more symbolic than other works of the torrid decade, and it subscribed to the Op and Pop movements. The repetitive facial leers are reminiscent of George Tooker's famous mummy-like, sterile glances of his robot civilization.

Despite being greatly outnumbered in the general population, blacks are shown as obviously significant in American society by their presence upon the United States postage stamp. Ringgold's works of the sixties are powerful and forceful and have awakened some elements of the democratic process. But as with all fine artists who move on to incorporate more of the inner self and personal desires, and to express a sheer love of painting and creating, political themes recede in the total scheme of things. Nearing the golden years, Ringgold has instilled charm and magic in her works of the eighties in order to delight her viewers without the shock of the works of the sixties.

# Career Highlights

Born in New York City in 1930.

## Education

B.S. degree in Fine Art from New York City College, 1955; M.A. degree in Art from City College of New York, 1959.

## Awards

National Endowment of the Arts in Sculpture, 1978; Honorary Doctorate of Fine Arts from Moore College of Art, Philadelphia, Pa.; Candace Award, 1986; Guggenheim Memorial Foundation Fellowship; Public Art Fund Award from the Port Authority of New York and New Jersey; Honorary Doctorate from College of Wooster, 1987; New York Foundation for the Arts Award, 1988; NEA Arts Award for Painting, 1989; La Napouli Award, France, 1989; The Mid Atlantic Arts Foundation Award, 1989.

## Solo Exhibitions

The Museum of Modern Art, New York, 1968; Spectrum Gallery, New York, 1970; Voorhees Gallery, Rutgers University, 1973; Studio Museum in Harlem, New York, 1984; Bernice Steinbaum Gallery, New York, 1987; Bernice Steinbaum Gallery, New York, 1988; Thomas Center Gallery, Gainesville, Fl., 1988; Simms Fine Art Gallery, New Orleans, La., 1989; University of Washington, Seattle, 1989; James Madison University, Harrisburg, Va., 1989; University of Massachusetts, Amherst, 1989; Fine Arts Museum, Long Island, N.Y., 1990; The High Museum of Art, Atlanta, Ga., 1990; Arizona State Art Museum, Tempe, Az., 1990; Miami University Art Museum, Oxford, Oh., 1991; Albright-Knox Art Gallery, Buffalo, N.Y., 1991; Pensacola Museum of Art, Pensacola, Fl., 1991; Davenport Museum of Art, Davenport, Ia., 1991; University of Michigan Art Museum, Ann Arbor, 1992; Mills College Art Gallery, Oakland, Ca., 1992; Tacoma Museum of Art, Tacoma, Wa., 1992.

# *Bibliography*

## Books

Atkinson, Edward. *Black Dimensions in Contemporary American Art.* New York: New American Library, 1971.

Boning, Richard. *Profiles of Black Americans.* Rockville Centre, New York: Dexter & Westbrook, 1969.

Butcher, Margaret. *The Negro in American Culture.* New York: Alfred A. Knopf, 1971.

Chase, Judith. *Afro American Art & Craft.* New York: Van Nostrand Reinhold, 1971.

Dannett, Sylvia. *Profiles of Negro Womanhood.* Yonkers, N.Y.: Educational Heritage, 1966.

Davis, John P. *The American Negro Reference Book.* Yonkers, N.Y.: Educational Heritage, 1966.

Dover, Cedric. *American Negro Art.* Greenwich, Ct.: New York Graphic Society, 1969.

Fax, Elton. *Seventeen Black Artists.* New York: Dodd, Mead & Company, 1971.

Fine, Elsa. *The Afro-American Artist.* New York: Holt, Rinehardt & Winston, 1973.

Gayle, Addison. *The Black Aesthetic.* Garden City, N.Y.: Doubleday, 1971.

Grigsby, Eugene. *Art and Ethnics.* Dubuque, Ia.: William C. Brown, 1977.

Locke, Alain. *Negro Art: Past & Present.* New York: Albany Historical Society, 1933.

————. *The Negro in Art.* New York: Hacker, 1968.

Porter, James. *Modern Negro Art.* New York: Arno, 1969.

Roelof-Lanner. *Prints by American Negro Artists.* Los Angeles: Los Angeles Cultural Exchange Center, 1965.

Rubinstein, Charlotte Streifer. *American Women Artists.* Boston: G. K. Hall, 1982.

Woodruff, Hale. *The American Negro Artist.* Ann Arbor: University of Michigan Press, 1956.

# NINE

# *Freida High W. Tesfagiorgis*

Artist Freida High W. Tesfagiorgis is an activist whose concern for the African American is dynamic and provocative. She exhibited paintings of racial injustices which originated with the early lynchings of the South and included the hidden sophistication of the Northern political system.

Tesfagiorgis is a noted scholar in the field of African and African-American studies and a historian of renown. Her consistently compassionate paintings project her knowledge and devotion to the welfare of the African American, and in particular to the African-American artist.

In her work titled *Hidden Memories* (1985), remnants of the Southern lynchings are seen. It is a highly symbolic work reflecting the martyrdom of Mary Turner, who in the year 1918 was a victim of lynching in Georgia. In the well-planned composition, the sole subject is Mary Turner, but she has been disguised as an object rather than a person. Perhaps by so doing, the victim's imagery becomes universally acceptable. In *Hidden Memories* the subject becomes Abstract, an elongated, columnar structure. Female symbols give the work human nature but in an impersonal way. The symbolic presence of Mary Turner resides comfortably within a vertical white band which in turn is surrounded by dark luminous structures parallel to the white band. There is a sense of mystery created by the pulsating bands of darks and lights. There are delicate moments of visual pleasures as if the initial intent was graced with pleasurable events.

*Hidden Memories* is an attractive painting. If one were to ignore its literal message, one would be treated to a complex, meticulously rendered extravaganza of visual beauties. Hidden memories remain hidden from the unfamiliar critic as their individual identity is transformed to an Abstract awareness. The scene has become highly personalized.

There is both regimentation and freedom; some segments are cemented in place, while other areas vibrate with dynamic tensions. There is activity and inactivity. *Hidden Memories* has been described as life and death, and the literal message of Turner's lynching was indeed death, but the martyrdom has created life in a sense of an eternal search.

Several African-American artists have used the Aunt Jemima theme as a springboard for dynamic paintings. Tesfagiorgis is no exception. A pastel titled *Aunt Jemima's Matrilineage* (1982) focuses on a legendary, fictional personality which emerged during slavery. As a domestic servant to families of all races and ages, Aunt Jemima was highly regarded, in fact, a household name which exists today and whose image remains on supermarket shelves throughout the nation.

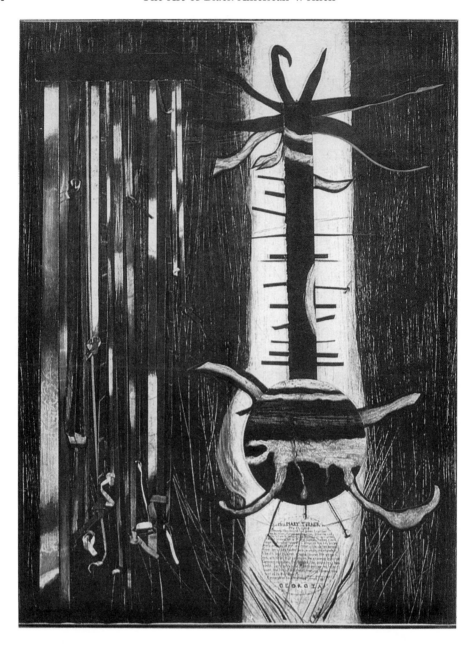

**Freida High W. Tesfagiorgis.** *Hidden Memories* **(1985). Pastel, 30×40 in. Courtesy of the artist.**

Even though the Aunt Jemima stereotype remains, its image is subordinated in Tesfagiorgis's pastel. The introduction of the Zulu doll of South Africa, which symbolizes female participation in African and African-American societies, dominates much of the right foreground. The background is of African textiles and patchwork quilts creating a rhythmic pattern of color and textures. African sculptures reside opposite Aunt Jemima, whose figure is somewhat fused into the background of textiles and in the foreground dance of the Zulu doll.

The artist has captured the ritualistic atmosphere of the African society while incorporating American racist stereotypes. But even more important is the

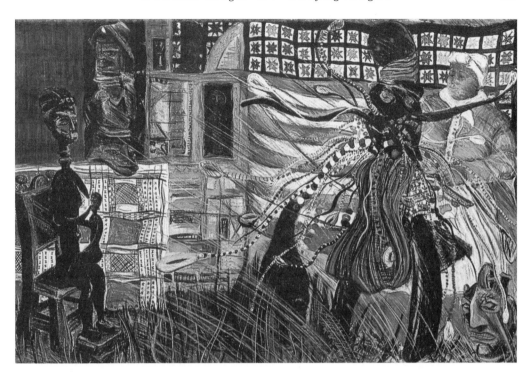

**Freida High W. Tesfagiorgis.** *Aunt Jemima's Matrilineage* **(1982). Pastel, 45×32 in. Courtesy of the artist.**

result in terms of artistic achievement. Regardless of social systems and racial injustices, the artist has utilized the elements of the artistic process in rendering in flawless technical manner a superb compositional unity. The introduction of Realistic images onto a frontal plane while proceeding to overlap and interpenetrate them into an Abstract expression has resulted in a masterful display. Tesfagiorgis has injected color into an otherwise objective work, and the result is *Aunt Jemima's Matrilineage.* Various kinds of brushstrokes represent numerous styles blended in total harmony.

There is a mysterious yet poetic charm about Tesfagiorgis's work. This is especially true in her pastel titled *Transformation* (1985). Although she claims that the work refers to the ascension of her first husband, it is reminiscent of the Renaissance masterpieces of the Christian ascension attributed to El Greco, Tintoretto and others.

The portrayal of the spirit is difficult without the use of symbols. Since the spirit is invisible, the artist has introduced earthy items and the skull of a human being. The movement of color in a totally Abstract way may convey an upward surge, a heavenly journey, an ascension. The transformation of a human body into a spiritual invisible soul can only be a form of speculation in terms of the artistic process. Tesfagiorgis has succeeded in projecting a spiritual feeling. It is now up to the viewer to accept the artist's interpretation in the spirit that it was created.

Tesfagiorgis believes in revenge, in attacking those who plague the innocent, and she believes in art as a tool for overcoming the injustices inherent in today's society. She is a feminist who believes that women have been unjustly subjected to abuse and harassment. In the exhibition catalogue "Keep Your Soul" (Alverno College, Milwaukee, Wi., 1990) she describes her painting titled *Witch Wench*

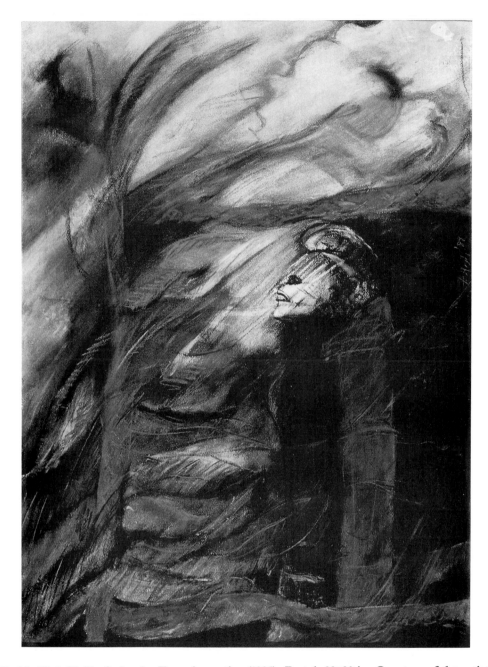

**Freida High W. Tesfagiorgis.** *Transformation* **(1985). Pastel, 22×30 in. Courtesy of the artist.**

*Witch Wench* (see color insert), and claims that the work

> exemplifies an idea of victory over victimization. Its subjective and didactic character informs the spectator of the universal violence mitigated against women whose knowledge and powers

threaten male hierarchies. It recalls the identification and execution of witches and wenches who were burned, hung, raped and/or defiled.

Here the woman subject struggles to survive as the symbolic bird releases her spirit up toward the feminine moon and out into the universe. The

metaphysical association of the bird with witchcraft especially among the Yoruba in Nigeria, confirms the continuity of women's power. In reality, the recognition of women's victimization empowers would-be-victims by stimulating in them a consciousness of power and a plan of action to claim it.

There is a hint of ascension in *Witch Wench Witch Wench* (1989), a form of a resurrection, a transformation, so to speak, of the real to the unreal.

Tesfagiorgis is a master at orchestrating opposition. Her arrangement of opposites involves colors and techniques; objectivity and subjectivity reside within the same expression; intellect and intuition coexist; two dimensional surfaces blend with three dimensional; definitive contours compete with suggestive gestures. There seems to be a tension between these opposites, and yet a compatible relationship occurs. It is this consistent opposition that intensifies the expression and activates an otherwise commonplace composition. It is this unpredictability that the artist has created and demands of her audience.

The artist speaks of contemplation, the serious consideration of the consequences of an act and its eventual solutions. Indeed, the viewer is dramatically involved in her work. Not only does the artist contemplate, but the viewer is forced to do likewise. Thus, the work itself becomes a stimulus. Not only is the work itself studied, but the work acts as a springboard for the resurgence of neglected or ignored memories.

Tesfagiorgis speaks of dualism as if opposite forces are in combat, but in fact the duality works with a single purpose. One element has to do with ideas while the other deals with the technical means of conveying those ideas. The sociopolitical subject matter involves the African-American issues of womanhood, and the second half of the dualism refers to the style of portraying such issues. The artist allows historical isms and symbols of African culture to enlarge her artistic vocabulary in the final product. In her work *Witch Wench Witch Wench,* her overall theme concerns the universality of women.

The artist admits being tempted into Abstract portrayals in order to avoid the pain of enduring, recording and expressing the continuous and everpresent bigotry and discriminatory practices toward the African-American society. However, to do so would negate her own artistic existence. Tesfagiorgis needs to acknowledge and express the obvious and disguised methods of racial injustices.

In a mixed media work titled *Hidden Memories Contained in the Crevices of the Forest* (1990), the artist has painted what appears to be a mutilated body of African descent. The artist succeeds in shocking the viewer, but the purpose of the shock may not readily be understood. Speculation is common especially when the uninitiated are involved. But in a personal manner she has succeeded, which becomes the initial step toward communication. Artistic integrity is fulfilled the moment the message is complete upon the canvas. The message has been sent; now it must be received. And the reception relies upon the readiness of the audience. A certain segment of society will always remain indifferent. Another segment has closed minds, but this is not the problem of the artist. In the case of Tesfagiorgis, she must remain true to her current style of expression. In time and among certain peoples her message will be received and acted upon.

Tesfagiorgis speaks as if the audience who resides outside the artistic experience is the target of the attack. She claims to share the agony of her message with her viewers. And yet, does the spectator participate in the message to the same degree of intensity that the artist did in creating it? Probably not, and perhaps it matters not. The artist is not responsible for the actions of her audience. She can only set the stage for action to occur, and she has done so.

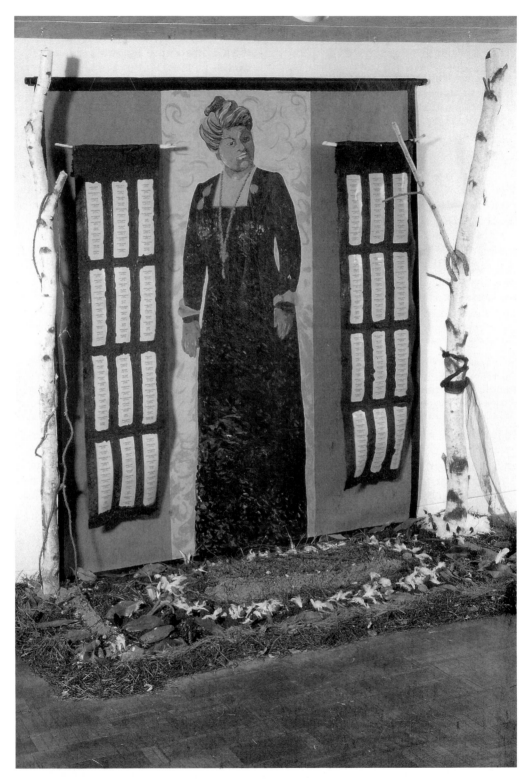

**Freida High W. Tesfagiorgis.** *Homage to Ida B. Wells* (1990). **Mixed media, 96×84 in. Courtesy of the artist.**

In another mixed media work titled *Homage to Ida B. Wells* (1990), the artist creates a monument to the activist who fought against racial lynchings in America. The natural wood branches, symbolizing the executioner's tool, are hoisted adjacent to the two sides of the image of Ida B. Wells.

# *Career Highlights*

Born in Starkville, Mississippi, in 1946.

## Education

A.A. degree in Art Education from Graceland College, Lamoni, Ia., 1966; B.S. degree in Art Education from Northern Illinois University, DeKalb, Il., 1968; M.A. degree in Graphics & Painting from the University of Wisconsin, Madison, Wi., 1970; M.F.A. degree in Graphics and Painting from the University of Wisconsin, Madison, Wi., 1971; postgraduate work as CIC scholar in African Art, Indiana University, and academic research in African and African-American Art History, University of Wisconsin.

## Awards

University of Wisconsin Art Fellowship, 1969–71; Ford Foundation Fellowship, African Studies, University of Wisconsin, Madison, Wi., 1971; Knapp Bequest, 1975; Wisconsin Arts Board Grant, 1977; Dane County Cultural Affairs Grant, 1977; University of Wisconsin Graduate School Art Grant, 1979; Office of the Mayor, Madison City Arts Grant (Mural), 1981; Chancellor's Award in the Creative Arts, 1983–88; Wisconsin Arts Board Grant, 1986; Vilas Award, University of Wisconsin Contemporary African Art Rsearch, 1989 and 1990; Graduate Research Award, University of Wisconsin, 1991.

## Selected Exhibitions

Mid States Art Exhibition, Evansville Museum of Arts and Sciences, Evansville, In., 1970; Museum of Science & Industry, Chicago, Il., 1972; Susan B. Anthony Gallery, University of Wisconsin, Madison, 1972; Gallery Toward the Black Aesthetic, Milwaukee, Wi., 1972; Malcolm X College, Chicago, Il., 1972; San Francisco Bay Area Civic Center, San Francisco, Ca., 1972; Centennial Building, Illinois State University, Normal, Il., 1973; Depauw University Art Center, Greencastle, In., 1973; Ethnic Heritage Center, University of Wisconsin, Green Bay, Wi., 1973; Concours International de la Palme D'or Des Beaux Arts, Palmares, Monte-Carlo, 1974; Burpee Art Museum, Rockford, Il., 1975; Studio Museum, New York, 1975; Art Gallery, Bradley University, Peoria, Il., 1976; Performing Arts Center, Milwaukee, Wi., 1976; South Side Community Art Center, Chicago, Il., 1976; Wright Art Center, Beloit, Wi., 1976; Alabama A & M University, Normal, Al., 1978; Schenectady Museum, Schenectady, N.Y., 1982; National Center of Afro-American Art, Roxbury, Ma., 1982; City Municipal Building, Prichard, Al., 1983; Cudahy Galleries, Milwaukee Art Museum, Milwaukee, Wi., 1985; Governors State University, Park Forest South, Il., 1985; Trisollini Gallery, Ohio University, Athens, Oh., 1985; National Afro-American Museum, Ohio Historical Society, Columbus, Oh., 1986; Art Gallery, University of Louisville, Louisville, Ky., 1986; Rosenthal Gallery, Fayetteville State University, Fayetteville, N.C., 1986; Fine Arts Museum of the South, Mobile, Al., 1986; Union Art Gallery, Madison, Wi., 1987; Alverno College, Milwaukee, Wi., 1990; Cudahy Art Gallery, Milwaukee Art Museum, Milwaukee, Wi., 1990.

## Solo Exhibitions

Cartwright Center, University of Wisconsin-LaCross, 1973; Afro-American Cultural Center, Purdue University, Lafayette, In., 1973; Wisconsin Academy of Arts, Letters & Science, Madison, Wi., 1973; Art Gallery, Kentucky State University, Frankfurt, Ky., 1975; Studio Museum, New York, 1976; Grand Rapids Art Museum, Grand Rapids, Mi., 1988.

# *Bibliography*

## Journals

Tesfagiorgis, Freida High. "African-American Women Artists." *Women's Studies Encyclopedia Project Literature and the Arts* 2 (Fall 1990).
_____. "Afrofemcentrism: The Work of Elizabeth Catlett & Faith Ringgold." *Sage: A Scholarly Journal for Black Women* 4, no. 1 (Spring 1987).
_____. "Contemporary African Women Artists." *Women's Studies Encyclopedia Project Literature and the Arts* 2 (Fall 1990).

## Catalogues

Burpee Art Museum. "Annual Greenwich Village Art Exhibition." Rockford, Il., Sept. 1975.
Elvehjem Museum of Art. "Traditional African Art: A Female Focus." Madison, Wi., June 20–July 26, 1981.
Gallery, University of Wisconsin. "Traditional Art of Sub-Saharan Africa." Madison, Wi., October 2–29, 1972.
Memorial Union Gallery. "Pattern and Narrative. An Exhibition of Contemporary African Art." University of Wisconsin, Madison, Wi., June 22–July 23, 1990.
_____. "The Wisconsin Connection: Black Artists Past and Present." University of Wisconsin, Madison, Wi., Jan. 16–Feb. 15, 1987.
Milwaukee Art Center. "Second Annual Inner City Arts Council Exhibition." Milwaukee, Wi., Sept. 1975.
_____. "Third Annual Inner City Arts Exhibition." Milwaukee, Wi., July 1976.
Old Niger House. "Personal Stages." Lagos, Nigeria, March 28–April 12, 1975.
Performing Arts Center. "Mid-Western Black Artists." Milwaukee, Wi., February 1976.
Studio Museum. "Contributor to Catalogue, Faith Ringgold: Twenty Year Retrospective." New York, April 1984.
Susan B. Anthony Gallery. "Prints and Paintings." University of Wisconsin, Madison, Wi., Feb. 7–25, 1972.
Union Gallery. "Black Expressions." University of Wisconsin, Madison, Wi., March 5–15, 1973.
_____. "Contemporary African Art." University of Wisconsin, Madison, Wi., March 16–31, 1977.
_____. "Creations from Africa." University of Wisconsin, Madison, Wi.: Sept. 29–Oct. 10, 1971.

# TEN

# *Emma Amos*

Emma Amos does not point toward her use of different media as proof of artistic development; rather she sees her progress in the changes in subject matter. She continues to explore and exploit a single idea in several works of art. Even though each painting in a series is complete in and of itself, Amos has continued to utilize similar elements in each painting in order to draw the series together. In the group of paintings called Water Series (1985–87), the artist has used a single figure as in *Diver* (1985), and created a dramatic yet refreshingly beautiful display of human flesh.

Amos has placed a human in a watery environment as a symbol of freedom. Her painting displays her belief in abandonment, a loosening of one's physical faculties. There is a sense of the intuitive process, coupled with objective rendering of the human so that a satisfying blend of the objective and subjective occurs.

There remains a tension in *Diver;* one thinks of the underwater pressure, but nonetheless the water is a pleasant environment into which the diver will eventually plunge. But it is this suspension in space, the last moment before the diver hits the water, which attracts the viewer into participation. The positioning of the aquatic female is compositionally ideal in relation to the space below the plunge. It allows for the lower space to remain activated in spite of its lack of figures.

Mentioned earlier is the use of color to create a combination of objective and subjective. In *Diver,* the objectively portrayed figure is immersed in brisk, subjective brushstrokes of color. Amos develops a compatibility between the two opposite techniques by overlapping the objective figure with brushstrokes of splashing color while maintaining the objectivity of the aquatic figure. One is unsure of the identity of various streaks of color which dominate the diver's habitat. The background is enriched with colors of a non-water nature which could be caused by sources outside the picture plane.

Amos's aquatic forms are not *in* the water, but remain just outside the watery surface. The wet appearance of the background acts as a compositional essential, halting the motion of the roleplayer, namely, the diver. One becomes excited by the anticipation of an event.

In a similar fashion, *Diagonal Diver* (1985–87) creates the excitement of anticipation. In both *Diver* and *Diagonal Diver,* Amos has brought a subject into an appropriate habitat. There is no visual perspective, only a frontal plane in which recession or advancement of the subject remains constant, and the subject is suspended in space but anchored to a chosen spot upon the canvas. It is as if the painting were turned on end so that the audience is given a close-up view of the diver while the artist abolishes any surrounding

**Emma Amos.** *Tumbling After* (1986) from the Water Series. Acrylic painting with hand weaving, kente borders, 48×72 in. Courtesy of the artist.

objects, freeing the background of inter-
ruptions. Were such disruptions to occur,
the viewer would be forced to withdraw
full attention from the dominating figure
of the diver.

By enlarging the figure, the artist is
forced to activate the figure's environ-
ment in order to avoid a disunity be-
tween the diver and her surroundings. In
*Diver,* the downward movement is
quickly established, but in order to slow
the direct plunge and thus eliminate the
dramatic tension between the act of do-
ing and the result of that doing, Amos
has extended the arms of the diver out-
ward. In so doing, she has moved the
viewer's attention from the eventual
plunge into the water to the aquatic
figure itself.

Amos has deliberately eliminated a
natural visual perspective. Horizons and
baselines are purposely avoided, and in
their places reside frontal planes.

However, in her work titled *Tum-
bling After* (1986) and a subsequent work
titled *The Raft* (1986), three similar ele-
ments reside in a single environment.
And yet, the three figures maintain
different postures. Thus, each aquatic
form is its own artistic composition, but
since each background is similar in color
and technique, a single composition
evolves. Amos has used aquatic figures to
develop a trio or team.

In *Tumbling After,* Amos has applied
colors that are contrary to nature. Instead
of the expected blues and greens of a
water scene, the viewer is treated to col-
ors of sunrise and sunset. *Tumbling After*
is split into three segments, each contain-
ing its own figure, and each segment
qualifies as a single painted composition.
However, Amos combines the segments
into one.

The artist has allowed a separation
of the three segments in order that each
of the three can be appreciated as singu-
lar expressions and simultaneously en-
joyed as a single unit.

A similar approach is witnessed in
*The Raft,* another work in the Water
Series. Although similar in style, *The Raft*

supports a slightly different environment.
The raft, upon which a female rests, con-
sumes much of the working surface of
the canvas. The remaining space is iden-
tified as a watery surface, but the raft is
positioned in such a manner as to split
the canvas into three individual areas.
Each area includes a human form so that
three separate compositions are united
into one. A fourth image, a huge fish,
hovers over a segment of the raft.

Again, visual perspective is totally
abolished since *The Raft* is witnessed from
above. Amos incorporates strokes of paint,
or literally streaks of color, which serve to
enhance and reinforce the compositional
organization. What appear to be nonsen-
sical intrusions upon the working surface
are actually compositional necessities.

It has been this artist's firm belief
that a medium or technique should
justify an idea and that the idea should
never cater to a medium. According to
her critics, Amos is aesthetically chal-
lenged by the manipulation of materials
and techniques, and it raises the concern
of service to an idea. It is essential that
the artist use the most appropriate
medium and technique to effectively ex-
press an idea, which Amos has done.

Through the fantasy of life, the art
process becomes a therapeutic device for
the creator. In the exhibition catalogue
"Water Series" (Parker/Bratton Gallery
of New York City, 1987) Amos describes
the process as follows:

> The first water canvases were *Diver*
> and *Diagonal Diver.* Floating, soaring,
> controlled descent, the kindness of
> water as a cushion, being able to swim
> like a fish (I can't swim at all), the
> anxiety of child's play *(Tumbling
> After),* released tension by the back-
> bend and diving arch, the sexiness of
> sun on wet bodies, the mystery of un-
> derwater creatures: these are the sym-
> bols of the water paintings. . . . These
> pictures represent freedom to me, a
> definite letting go. Still a water
> chicken, I like to imagine the thrill of
> the snorkler among coral reefs, and the
> high speed joy-ride of two underwater
> explorers riding the back of a giant

Emma Amos. *Water Baby* (1987) from the Water Series. Acrylic painting with fabric collage, 22×28 in. Courtesy of the artist. Collection of Sylvan Cole.

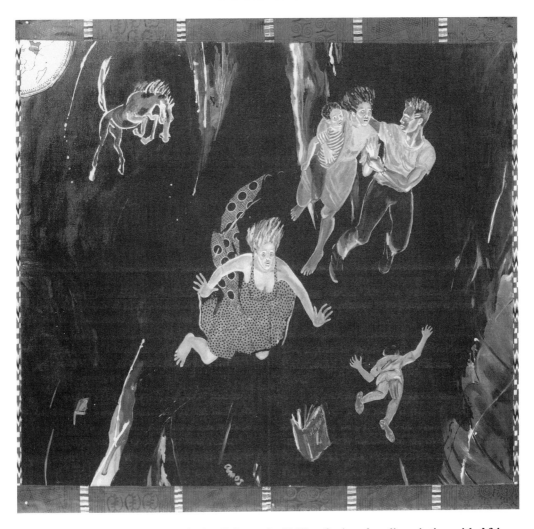

**Emma Amos. *The Heaven's Rain* (1990) from the Falling Series. Acrylic painting with African fabric collage, 84×80 in. Collection of the Newark Museum. Purchase 1990 Eleanor Upton Bequest Fund and The Links, Inc., North Jersey Chapter.**

manta ray, a wild improbability reported and photographed in National Geographic.

In *Water Baby* (1987), Amos indeed revealed that abandonment. Even though intuition plays its usual role in an Abstract Expressionist work, the artist has reluctantly surrendered total freedom in order to more accurately identify the central figure. The smoothly curved female body diving into open waters swings into the picture like an Olympic gold medalist. A deliberate opposition is created by forming a diamond shape around the figure. The swish of color surrounding the figure is swift and dramatic, counterbalancing the serene rhythmic flow of the diver.

*Water Baby* is both objective and subjective. The initial design concept is objective, but becomes intimate with its instinctive brushwork. It avoids the title of Abstract Expressionism because the figure is separate in technique from its surroundings. However, the directional movement of the brushstrokes that reside in those areas surrounding the figure is similar to that of the figure itself thus maintaining a circular rhythm compatible to the whole.

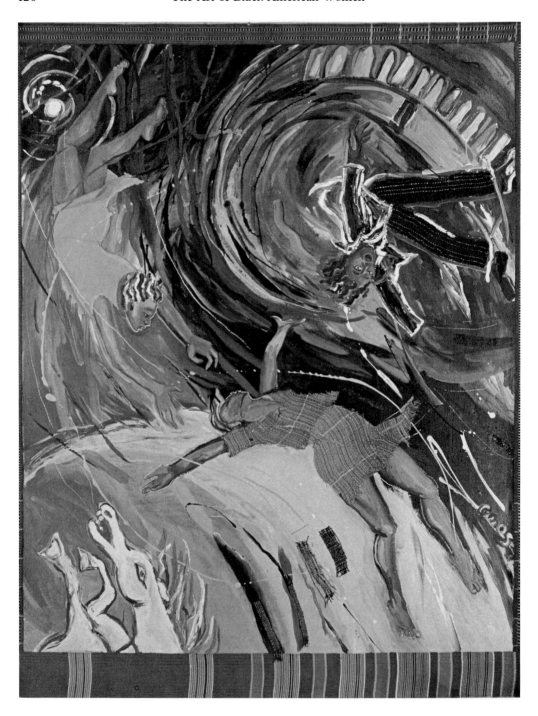

**Emma Amos.** *Catching My Mother in the Grand Scheme of Things* (1988) **from the Falling Series. Acrylic painting with woven fabric collage and kente cloth borders on linen canvas, 58×73 in. Courtesy of the artist.**

There is that abandonment of spirit that Amos has claimed in all her work, and the spirit of freedom can be zealously overstated in some segments of the work and understated in others. In *Water Baby,* the splashes of water dramatically overshadow the swan dive and yet, in spite of it, the central figure overcomes the odds.

In a group of paintings titled the Falling Series, Amos pays tribute to the fears and frustrations of American society. The fear of dying is dramatically portrayed. The fears of people around the world are exhibited in such works as *The Heavens Rain* (1990), a remarkable display of fallen dreams and anxious fears.

The fear of falling stems from a lack of security, having nothing to which to anchor oneself. Amos's figures fall into nothingness. There is no earth upon which to land, there is only limbo. But the fear of not knowing the future and or the loss of the past that no longer can serve the present or the future are the concerns of Amos.

Man has neglected to serve mankind, and this greed, selfishness and inhumanity are of interest to Amos. These are the real causes of the universal fear that invades the world. Amos makes no mention of the spiritual in a religious context, and yet one is drawn toward an omnipotent Being as the sole source of salvation. Amos is making this known, and as an artist, she is doing her share to fill that spiritual drought.

In her famous work *The Heavens Rain,* humanity itself is falling into unknown paths and uncertain fates, and there is no hint of a conclusion. As the figures indicate, anxiety and fear is ever-present. When does it end and where does it end? For this Amos has no answers, but she had dramatically made known the fear so that perhaps in time, such fears will no longer exist.

In *Catching My Mother in the Grand Scheme of Things* (1988), Amos has continued to create images of falling victims of society. Three compositions blend into a terrifying but fascinating portrayal of fear and the unknown. Her swirling style of adapting color to her concepts relives the nightmares of yesteryears. In *Catching My Mother in the Grand Scheme of Things,* the artist reveals an acrobatic-like team of females floating in space, one figure desperately trying to save the life of another who seems lost.

Another part of the work depicts a human figure dropping down a stairwell, a bottomless pit, with the fear of the unknown registered on the face of the potential victim. The swirling brushstrokes of color avoid touching the females who are formed with a more controlled application of pigment. But the fear remains.

Aside from the conceptual concerns, the viewer is treated to a dazzling display and dramatic movement of color. There are streams of color which appear erratic when viewed alone, but when witnessed as a reinforcement to the general composition, their presence proves essential to the whole.

There is less of a sense of despair in *Catching My Mother* than in the other paintings of this series. Figures are positioned closer together suggesting a security that eludes the participants in *The Heavens Rain.* To the viewer, it may suggest hope for the future.

In another work of this series, *Birds Fly* (1988), Amos has drastically removed the sense of falling. A powerful image dominates the lower portion of the painting reflecting a continual concern for humanity's fight for survival. There are invisible baselines anchoring both figures and buildings suggesting that falling occurs within known destinations and locations. Birds flying can be found anywhere in the world, augmenting the viewer's belief that the background of this painting is normal and not otherworldly as in the other works of this series.

In concept, Amos is an Abstract Expressionist. In spite of her combination of media, she has maintained that loose but highly organized look that characterizes the Abstract Expressionist school of

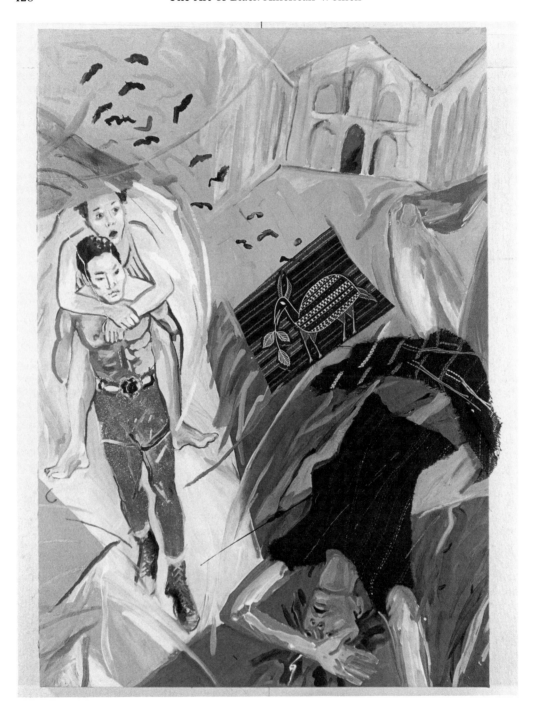

**Emma Amos.** *Birds Fly* **(1988) from the Falling Series. Acrylic and woven linen with African fabrics on linen canvas, 36×51 in. Courtesy of the artist.**

thought. At first glance her work looks chaotic, but after further study, one recognizes an inner structure that relates to compositional balance and unity. Even in her masterful *A Reading at Bessie Smith's Grave,* in an obviously objective positioning of the roleplayers, Amos has introduced the swishing brushstrokes of the Abstract Expressionist movement.

Emma Amos is an artist in the truest sense; she does more than record a site, an event or a figure. She emotionally expresses a message of worth, and in so doing forces her audience to emotionally respond. She has selected an appropriate style of expression that excites the viewer and creates an atmosphere of anticipation.

# Career Highlights

Born in Atlanta, Georgia, in 1938.

## Education

B.A. degree from Antioch College, Yellow Springs, Oh., 1958; B.F.A. degree from London Central School, England, 1960; M.A. degree from New York University, 1965.

## Awards

National Endowment for the Arts Fellowship, 1983; Skowhegan School of Painting & Sculpture Award; New York Foundation for the Arts Fellowship, 1989.

## Selected Exhibitions

Minneapolis Institute of Art, Minneapolis, Mn., 1969; Boston Museum of Fine Arts, Boston, Ma., 1970; Huntsville Museum of Art, Huntsville, Al., 1979; Studio Museum, New York, 1979; Douglass College Art Center, New York, 1980; Elaine Benson Gallery, Bridgehampton, N.Y., 1982; Kenkeleba House, New York, 1983; The Schomburg Center for Research in Black Culture, New York, 1984; Skandinaviska Enskilda Bankn, Stockholm, Sweden, 1985; The Studio Museum, New York, 1985; Associated American Artists Gallery, New York, 1986; Montclair Museum of Art, Montclair, N.J., 1987.

## Solo Exhibitions

Alexander Gallery, Atlanta, Ga., 1960; Davis Fine Arts Gallery, West Virginia State College, 1974; Gallery 62, National Urban League, New York, 1980; Galleri Oscar, Stockholm, Sweden, 1986; Parker/Bratton Gallery, New York, 1987; Jersey City Museum of Art, New Jersey, 1988; Isobel Neal Gallery, Chicago, 1988; Ingred Cusson Gallery, New York, 1989; Zimmermann Saturn Gallery, Nashville, Tn., 1990

# Bibliography

## Periodical Articles

"Emma Amos at Gallery 62." *Grafica,* March 22, 1981.
Morrison, Allen. "A New Surge in the Arts." *Ebony Magazine* (August 1967).
Siegel, Jeanne. "Why Spiral?" *Artnews* (September 1966).
"TV Craft Series Gets Big Hand from Boston Viewers." *Craft Horizons* (December 1977).
"What Is Black Art?" *Newsweek,* June 22, 1970.

# Catalogues

Montclair State College Gallery. "Black Women in the Arts." 1990.
The New Museum. "The Decade Show: Frameworks of Identity in the 1980's." New York, 1990.
Wilson, Judith and Moira Roth. "Autobiography: In Her Own Image." 1988.

# Reviews

"Black Arts Festival Gathers Strength." *Art Business News* (October 1990).
Colby, Joy Hakanson. "Exhibits: Through Women's Eyes." *The Detroit News,* February 15, 1991.
"Contemporary Black Artists Featured in Exhibit." *Marietta Daily Journal,* February 1, 1991.
Fox, Catherine. "A Festival Group Show That Adds Up." *The Atlanta Journal* and *Constitution,* August 3, 1990.
Grant, Daniel. "Black Artists at Williams." *The Berkshire Eagle,* June 7, 1989.
Green Hortense. "Montclair Museum Spotlights." *Suburban News,* February 4, 1987.
Langer, Cassandra. "Women at the Cutting Edge." *Women Artists News* (Fall 1988).
Navarra, Tova. "Intaglio Prints Are Prized for Enduring Impression." *Asbury Park Press,* January 12, 1991.
Raven, Arlene. "Colored." *The Village Voice,* May 31, 1988.
_____. "Emma Amos: The Falling Series." *The Village Voice,* May 7, 1991.
Smith, Roberta. "Art: Committed to Print." *The New York Times,* February 5, 1988.
Viksjo, Cathy. "Exhibits." *The New York Times,* February 18, 1990.
Watkins, Eileen. "Black Women's Sorority Sponsors MSC Exhibit." *The Sunday Star Ledger,* July 1, 1990.

# *Robin Holder*

The world I live in is very complex. The mainstream society does not address my needs or adequately appreciate my concerns. We no longer have a clearly defined, all-encompassing agreed-upon system for life, growth and death. The procedures for birthing, naming, becoming an adult, choosing a livelihood are lost or ignored. I've found more support in the structures of ancient civilizations. In the past, we had priestesses, wise men, medicine women, seers and adepts to guide us. Time was when we could seek solace and training in the temple. Oracles were consulted. Our vision quests became part of the family's collective memory and the town would talk story, making legend of our struggle. If you passed examination by the forty-two accessors with a feather-light soul on the Scales of Tahuti, people rejoiced. As each challenge was resolved, we were renamed, our achievements added to the Akashic records and the village celebrated.

Robin Holder made the above statement in a letter to this author, and it sets the stage for an exciting series of works, a battle between the forces of nature and the forces of a man-made system of law and order. According to Holder, mankind has traveled backward, and instead of enriching the lives of the human race through intellectual and technical advances, greed and power have replaced love and compassion.

Holder wishes to ignore the abuses of the past by creating within womanhood the power and dignity that has long been gone from the earth. With Holder that power and dignity comes to surface on paper laden with an ideal blend of the three worlds of the plant, animal and human kingdoms.

Holder is a firm believer in divine creation, in the purity and devotion of nature to its own needs. Man's neglect and sheer destruction of nature with little or no concern for the habitats of God's smaller creatures is unforgivable according to Holder. Instead of condemning such action, Holder has chosen to laud the power and perfectness of nature. She has placed mankind in a secondary position in God's kingdom, and yet in another sense, she has used the animal (particularly the bird) kingdom to enrich and amend the spiritual structure of man.

Holder employs the theory of interpenetration in order to simultaneously utilize the three worlds. The animal, plant and human phases of life succumb to each other as each world permeates the other. The use of interpenetration to consider and express the three worlds simultaneously on a single working surface is ideal for Holder's notions. To otherwise interpret her theme as in Chagall's topsy-turvy method or Picasso's Cubist technique would result in misleading intentions and eventual confusion.

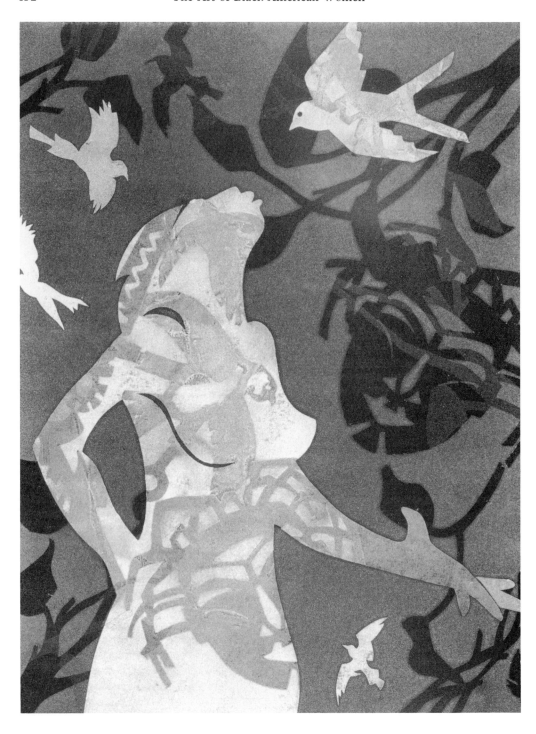

**Robin Holder.** *Show Me How III* (1990). **Acrylic on canvas, 32×35 in. Courtesy of the artist.**

Actually, nature is the sole source of motivation for the artist. Whether depicted consciously or subconsciously and whether or not the natural elements are visually realized in the product itself matters little so long as the process continues to celebrate the original intent. In time nature will conquer. As proof, Holder's versions of the interrelationship of plant, bird and female figure are obviously compatible.

In a statement regarding her pledge to rectify the human negligence in supplying her needs, Holder has introduced the Warrior Women Wizards: Mystical Magical Mysterious Series.

In it, the women represent phases, roles, attitudes and states of consciousness in a never-ending battle to balance often conflicting realities in accordance with Natural Law. My work is motivated by my multi-cultural background in which layers upon layers of various racial, economic, cultural and spiritual worlds exist within one family. I claim them all and strive to collage them into a wholesome statement of power and integrity.

According to writer Veronica Mitchell, Holder utilized her talents to foster and promote a non-violent protest against the ignorance and bigotry that has festered within American society, that her inner spiritual, emotional, social and intellectual promptings have inspired others to establish a direct course of action for the betterment of society and all mankind.

Holder's work is a biographical study. She becomes the focal point of the universe. In her work titled *Show Me How III* (1990), she beseeches the aid of the flying birds of the universe who surround her nude body with obvious ecstasy. Her naked body is transparent, showing symbols of her spiritual and cultural growth. African masks and tribal designs appear as tattoo marks along with images of tree branches and winged

birds. Interpenetration flourishes as plant and animal life co-exist with the human figure. Birds fly with total freedom, and Holder, through the means of her artistic expressions, satisfies her own lack of mobility. There is an obvious intermingling of racial, cultural, philosophical and spiritual images. The interpenetration of figures transcends the two-dimensional surface. Images recede and advance, reliant totally on the use of color. The intensity of the work fades and then regains strength as if the images are hallucinations that appear and then suddenly disappear.

Is the use of plants, birds and humans an attempt to satisfy a realistic desire, or is it a fantasy of the art process? The complete use of the working surface suggests activity beyond and outside the limitations set by the artist. The artistic ingredients suggest a panoramic view of the worlds in which Holder claims to have lived.

In *Show Me How III,* the biographical figure pleads for knowledge of the proper road for survival. It appears utopian in essence, ideal as a visual pleasure, and a solution because it reflects the very success that has been sidelined. The creation of art is an accomplishment, an achievement that is granted to a comparatively few. The very process of creation is a lofty way of life, a procedure that stirs the imagination of others.

Holder has proven herself as an artist of integrity and forthrightness. Her works such as *Show Me How III* are a delight to behold. The granting of pleasure to thousands is indicative of an unusual childhood. It seems that Holder has strengthened her own position in life with the giving of pleasure to others.

Closely related in theme and composition is Holder's remarkable bird and human. The trust that her female figure portrays is unique and reminds the audience of the need to transform the human race into one that uses power appropriately and that has humility and a dedication to life.

In *Trusting in You III* (1991), Holder

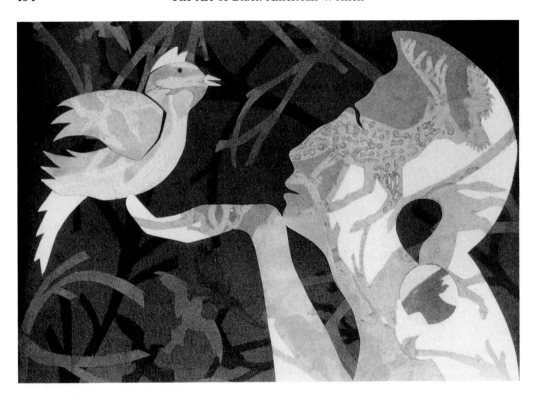

**Robin Holder. *Trusting in You III* (1991). Stencil monotype, 28×22 in. Courtesy of the artist.**

has presented for closer scrutiny a mo-
ment of intimate communication be-
tween a person and a bird of beauty. In
fact, the intimacy is so close, the outline
of the human head encompasses images
similar to those in the outline of the bird.
Tree branches and animal legs merge;
the similarity of the two forms a oneness.
This oneness is expanded to include the
human and the bird. Again, the focus is
centered on the human but connected
with it to form a single idea is the bird.
The negative space or the space sur-
rounding the central image is brought
into focus as a secondary plane. It acts as
the habitat of both the animal and
human kingdoms. The background en-
vironment remains mute so that its
secondary role strengthens the intent or
purpose of the painting. Bird images are
located in both the foreground and the
background, and the flight of the bird in
and out of the darkness represents the
freedom of entrances and exits.

Holder believes that form, discipline
and structure are crucial to freedom of
expression, movement and communica-
tion. *Trusting in You III* is a marvelous
example of nature's compatibility. As-
pects of nature recede and advance in ac-
cordance with the spatial elements re-
quired to form a unified composition.
Holder's *Trusting in You III* presents a
quiet life style, a stillness that is iden-
tified with the wise animals and the
human being who are forced to ac-
knowledge and trust their structure of
life.

One need not believe in Holder's
premise in order to enjoy her work. Art
remains speculative, suggestive and often
misunderstood. In spite of its highly per-
sonal approach, Holder has presented an
Abstract work which frees the observer
from an objective assessment, and thus
appreciation stems from color, composi-
tion and individual style.

In an eerie portrayal of female form,

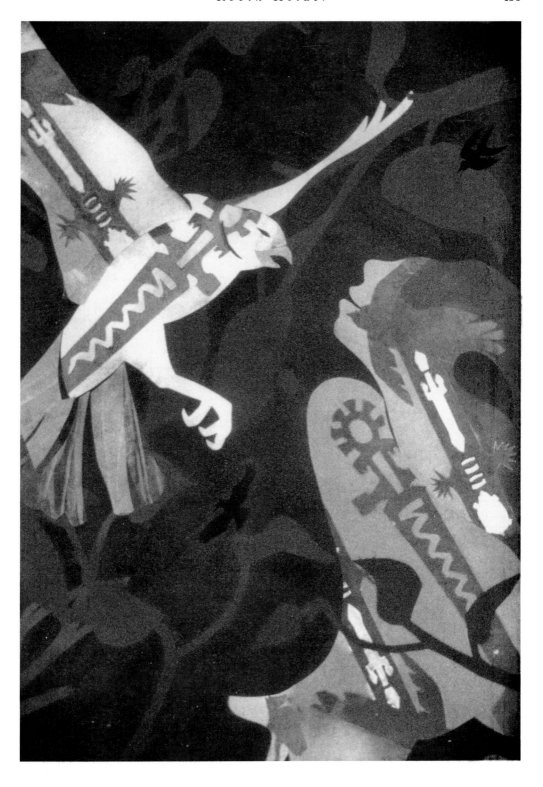

Robin Holder. *Message II* (1989). Stencil monotype, 22×28 in. Courtesy of the artist.

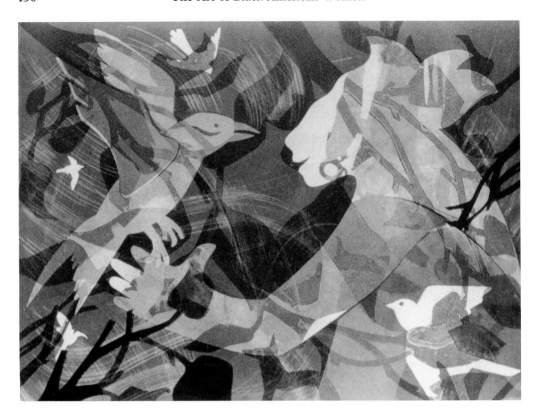

**Robin Holder.** *Birdwizard II* **(1989). Stencil monotype, 28×22 in. Courtesy of the artist.**

in *Message II* (1989) Holder duplicates identical markings and similar body actions in the shapes of an eagle-like creature and a human female. Again, Holder becomes the female transformed into a creature with a strong survival instinct, a calculated flight pattern, a ferocious strength and the dignity to come and go in total freedom.

*Message II* is less transparent and less Abstract. A deliberate separation of the eagle and the female creates an anticipation of an eventual encounter. The approaching and inevitable contact creates a tension between the two and as long as the spatial distance prevails, the anxiety remains. The anticipation of an event is frequently more exciting than the event itself. Holder has used this theory to her advantage.

Because of the detail of the markings which seem tattooed upon the two bodies, the viewer is apt to lose sight of

the two images which occupy the major portion of the canvas. The background is dark thus highlighting the presence of the eagle and the female.

Perhaps her most important work is *Birdwizard II* (1989) in which a montage of images overlap and interpenetrate to create an exciting interchange of plant and animal life. The bird image is distributed in appropriately selected spots, and the female form, distinct in other works, has lost its identity. Instead, one is treated to a gradual transformation. The everpresent tree branches weaving throughout unite the elements of color and shape into a complex composition. There is no distinction between negative and positive space. The positive elements are eventually overshadowed by elements of the past. Holder has superimposed images of the past with those of the present and the future.

*Making Time II* presents a pensive

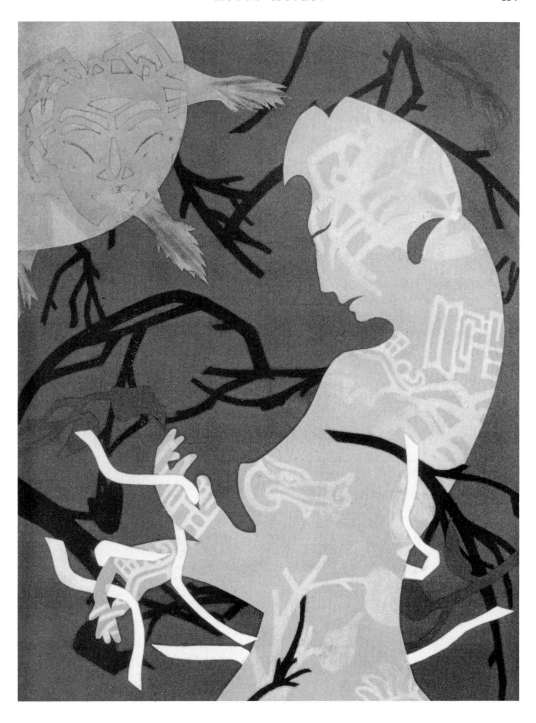

**Robin Holder.** *Making Time II* (1990). **Hand colored stencil monotype, 30×44 in. Courtesy of the artist.**

mood, created by the motionless female, and a sense of hesitation, in spite of the careful planning of image positions and spatial relationships. Interweaving and overlapping of plant, animal and human forms evoke eerie performances from all participants. A gigantic turtle moves toward the female as her fingers twist and hold branch-like objects. Tree branches provide a natural environment.

Aside from its literal content, *Making Time II* (1990) is an impressive display of magic parts which have personal and intimate connections with the artist. Holder has demonstrated a remarkable adherance to a cause, and it has been the creative process that has been her salvation.

In a letter to this author, Holder has explained her philosophical position as follows:

> The Warrior Women Wizards: Mystical Mysteries series is an expression of the quest for power with dignity, truth and harmony. By creating the Warrior Women, I am developing a visual language of symbolic images that reflect the process of self-determination within Universal Natural Law. Archetypal symbols from Africa, Native North and South America and Pharaonic Egypt fade in and out of the primary image. I use the spears, shields, vessels, masks, magical wands, birds, pyramids and temples as symbols of rituals and tools used in the battle for wisdom, strength, tolerance, balance and spiritual growth.

Robin Holder's work reflects a profound attachment to the wisdom of animals. Holder continues:

> Animals live on earth in accordance with the natural order of things. They know their purpose. They quickly learn how to develop their characteristics. Each species understands its power, its weakness. They make shelter, live in communities, raise families, provide food, mobilize themselves, transport resources, collaborate, laugh, sing, dance, make love. They also know how to die. From what I fathom they live with dignity, utilize their strength appropriately, and respect one another. Animals are honest and direct.

The natural world has become her guide through life. This unusual arrangement has led her through life both as a human being and as a successful artist. An example of her thinking is captured in the following quote:

> I watch birds watching me. They walk on the ground, swim in the water and they fly. Their vision is broader than mine. I always feel that if I can become airborne I'll gain a more balanced view, a better perspective of my reality. I can see from here to the end of the road. A bird can see the road, around the bend, and two miles away all at once.

# Career Highlights

Born in Chicago in 1952.

## Education

Art Students League of New York; studied under artists Marshall Glasier, Vaclav Vytlacil, Rudolf Baranik, Morris Kantor and Richad Mayhew; Werkgroep Uit Het Amsterdam Grafisch Atelier, Amsterdam, Holland.

# Awards

Purchase Award, Atlanta Life Insurance Co.; Grant Recipient, Manhattan Graphics Center; Juror's Award, University of Hawaii; Martin Luther King Scholarship, Art Students League.

# Selected Exhibitions

Kennesaw State College, Marietta, Ga.; McIntosh Gallery, Atlanta, Ga.; Artists Space, New York; Art Institute of Boston, Boston, Ma.; Hera Gallery, Wakefield, R.I.; University of Michigan, Ann Arbor, Mi.; Kenkeleba Wellspring Gallery, New York; Ponder Fine Arts Gallery, Benedict College; Harding and Landing Sts, Columbia, S.C.; The Chicago Museum of Science & Industry, Chicago, Il.; Gallerie Elva, Stockholm, Sweden; Theatre Arts Gallery, Design Center, Los Angeles, Cal; Columbia Museum of Art, Columbia, S.C.; Miami-Dade Library, Miami, Fl.; Castillo Gallery, New York; Schomburg Center for Research in Black Culture, New York; Purdue University, Lafayette, In.; California State University, Stanislaus, Ca.; University of Tennessee, Knoxville, Tn.; Museum of African Culture, Dallas, Tx.; Essex County College, Newark, N.J.; Jazzonia Gallery, Detroit, Mi.; Brooklyn Arts & Culture Association, New York; Hamilton College, New York; Baruch College, New York; Museo Municipal, Guayaquil, Ecuador; Casa de la Cultura, Esmeraldas, Ecuador.

# Solo Exhibitions

Isobel Neal Gallery, Chicago, Il.; Womens Studio Workshop, Rosendale, N.Y.; Langston Hughes Library, New York; Ward-Nasse Gallery, New York; ITC, Delft, Holland; ACBAW Center, Mount Vernon, N.Y.

# *Bibliography*

## Periodical Articles

Briggins, Angela. "Style of the Nile." *The City Sun*, May 11, 1988.
Falco, Jody. "Variety at Ward-Nasse." *Manhattan Arts* (March 1985).
Folliott, Sheila. "Expanding Powers." *Artweek* (March 1983).
Holder, Robin. "Animal Totems." *Woman of Power: The Living Earth* (Spring 1991).
Kelley, Caffyn. "Wild Things: The Wisdom of Animals." *Women Artists Monographs* (March 1991).
Kresge, Ann. "Descent to Common Ground." *Binnewater Tides* (Spring 1990).
Leary, Jack. "With Art They Feel Printsly." *New York Daily News*, March 10, 1978.
Lyons, Harriet. "The Art Biz." *Ms.* (November 1985).
Mitchell, Veronica. "Robin Holder's Mystical Magical Mysteries." *Black American Literature Forum* (Spring 1985).
Van Allen, Suzanne. "Contemporary Black Artists." *Attraction Entertainment Guide* (February 1, 1991).
York, Hildreth. "Bob Blackburn and the Printmaking Workshop." *Black American Literature Forum* (Spring-Summer 1986).

## Catalogues

"Art Works in City Spaces." City of New York, 1985.
"Artists Liason." Santa Monica, California, 1986.
The Brooklyn Museum. "A Tapestry of Fine Threads: Black Women Artists." 1983.
The Center for Art and Culture of Bedford Styvesant. "New American Art." 1983.
"Choosing: An Exhibit of Changing Perspectives in Modern Art and Art Criticism by Black Americans 1925–1985." Hampton University, Virginia.

Columbia Museum of Art. "Through a Master Printer: Robert Blackburn and the Printmaking Workshop." Columbia, South Carolina, Spring 1985.
Flossie Martin Gallery. "Coast to Coast." Radford University, 1990.
Hera Educational Foundation. "Homes/Homelessness." Rhode Island, 1989.
Ponder Fine Arts Center. "A Visual Heritage." Benedict College, South Carolina, 1987.
Ramapo College. "New Horizons in Printmaking." New Jersey, 1986.

# TWELVE

# *Cynthia Hawkins*

In reviewing the paintings of Cynthia Hawkins, one must conclude that negative and positive space is one and the same. It is only space that exists. Hawkins suggests that one consider the results of positioning a shape upon a rectangular canvas because negative and positive space must co-exist.

The life of nature and man is not recognized as artistically significant by Hawkins. Realistic images are absent in her work. She is a proponent of the Abstract Expressionist school of thought evidenced by her color-field rendition. Color floats in color, space in space; limitations occur only when the edge of the canvas is reached. She has purposely avoided a linear composition. This suggests she is concerned about volume and mass but not shape. The occurrence of a shape without any apparent perimeters is indeed difficult to envision.

Hawkins fell heir to the reductivist process of the Abstract Expressionist school and specifically of the color-field process of expression. Recognizable images were never a part of her production. To interpret her work is to attempt to examine her conscience. From those who ignore or condemn the works of the Abstract Expressionist school, a highly and deeply personal response to concepts that are totally alien cannot be anticipated.

Hawkins does not care. Her profound personal approach can be appreciated for its dramatic, poetic or spiritual compositions of color in space.

There are several points at which the creative process will end for the artist. The intuitive forces which pierce the working surface end when the intellect dictates the results. Hawkins is an intuitive painter, an Abstract Expressionist who deals with the unknown. If an idea exists before the plunge onto canvas, it may soon be abolished or sidelined in favor of a more recent urge to contradict the initial act.

Hawkins has preconceived ideas; she does not rely on accidental meanderings of the brush. By the same token, she has not ignored the possibilities of discovering and exploring unknown territories. Hawkins's work is exciting, not because of its color or composition but because of the unpredictability of the process.

When does the end occur? How many times does the artist reach the end during the creative process? Answers occur at the discretion of the artist. They cannot be predicted. However, as Hawkins explains it, compositional planning occurs at the outset of the painting. In a letter to this author, she has stated,

> My work differs from others by way of focusing on the inference of symbols and signs, and of linear calligraphic marks, and in addition, the use of static marks together with geometric symbols and geometric configurations. These varied marks and forms when

*Left:* Cynthia Hawkins. *Currency of Meaning #5* (1988). Oil on canvas, 56×76 in. Courtesy of the artist. *Right:* Cynthia Hawkins. *Currency of Meaning #6* (1988). Oil on canvas, 56×76 in. Courtesy of the artist.

**Cynthia Hawkins.** *Currency of Meaning #10 Ruby, Ruby* **(1989). Oil on canvas, 50×68 in. Courtesy of the artist.**

strung together imply a sentence or a passage of text. An important aspect of the marks or configuration of marks is the nature of the line. Whether a brush or an oil stick, the lines must allude to a human behind the mark; that is, the gesture embodies both, a sign/symbol which possesses an implied meaning by its very configuration, as well as a physicality of the gesture. Physicality, through the vitality of the hand/movement, whether the mark is hard edge

*Left*: Cynthia Hawkins. *Currency of Meaning #9* (1989). Oil on canvas, 50×68 in. Courtesy of the artist. *Right*: Cynthia Hawkins. *Currency of Meaning #11* (1989). Oil on canvas, 56×70 in. Courtesy of the artist.

and flat, or determined and roughly described. The roughly described configuration is an engagement of intimacy with the viewer. The fact that the line may be in some places incomplete only engages further and becomes, even a sub-text, and the conversation continues as the nuances of language are recognized and are come to terms with.

This describes the intuitive process that Hawkins applies to her work. There is even a strong suggestion that the intuitive process may bridge several productions. In other words, if newly discovered directions occur as a painting nears completion, that discovery may find its place within an ensuing painting, or it may even be a motivation to initiate a new series of works totally different from preceding ones.

According to Hawkins,

the intuitive use of color within particular boundaries has produced conditions where the range in color value and chroma are quite close, particularly in the larger more expressive passages of each painting.

That is not applicable to all intuitive processes. Color contrast is a choice the artist makes before the application of paint. The choice does not always result in a satisfying conclusion.

Hawkins wishes that diverse interpretations would occur among a wide audience. She has stated that

the way in which color is used can also be perceived as the gesticulations that, along with the overall expressiveness of my work, adds to the visually discursive nature of the works, thereby increasing the levels or shades of inference, interpretation and meaning attributed not only by myself, but the viewer as well.

The very nature of Abstract Expressionism opens wide the avenue of various interpretations, and it seems to be to Hawkins's advantage that several different meanings occur to her audience.

Hawkins is not aware of all her actions; that is, she is not accountable for all that exists within the framework of her paintings. It is a fact that subconscious images emerge upon the surface of the canvas that are purely coincidental.

The intent of the artist is seldom the intent interpreted by her audience. The artist sends a message via the painted expression and the viewer moves in to receive the message. One must realize that for each viewer receiving the message, there will exist an equal number of interpretations. Thus, in order to understand Hawkins's message, one needs to understand the creative process and particularly, the intuitive process.

The language of Hawkins is Abstract. In her Currency of Meaning series, she refers to divisions of space, the splitting of her canvas into three different passages. Other artists refer to such passages as environments or habitats. Interestingly enough, each division or environment has its own language or inhabitants. And yet, each of the three environments contribute to the totality, thus creating a single unit or composition. Most artists at one time or another, consciously or subconsciously, have utilized the theory that Hawkins has prescribed. Incorporating single aspects of nature into separate habitats that constitute a whole is not a new technique. The approach dates back to medieval times. However, Hawkins approach is definitely Abstract, leading to diverse and unusual meanings and interpretations. According to critic Thelma Golden (in *The International Review of African-American Art*, v. 9, no. 2) in describing *Currency of Meaning #5* (1988),

the top, large half of #5 speaks directly to her earlier large canvases. In huge, flat swatches the shadows of triangles are evident. Their yellow white points pierce through the darker, equally sharp expanse which covers the uppermost part of the canvas. Within her characteristic tactile surface, she has incorporated a more graphic brushwork. The bottom half of the canvas,

separated from the top section of the painting by a blue line with irregular bright orange circles, is a fence-like grid of squares. Irregular in a way that reveals the indisputable characteristics of their medium, the squares cover what could be another painting. With its marbleized, wet-into-wet effect the surface highlights neither one or the other color, but the symbiotic merger of both.

In spite of critic Golden's remark that both passages merge into one, the fact that the two passages are contrary leaves doubt as to their compatibility. They exist as a single unit but more on a physical basis than a literal or spiritual one. And yet, the artist does not object to possible misinterpretations because of the diversified responses open to the viewer. Those are the merits of Hawkins's series of paintings. It is difficult enough to finalize a painting in the Abstract Expressionist manner because of the intuitive urges that intrude upon the process, and then to deliberately extend the process onto a second, third and fourth painting makes the possibility of failure even greater. But as Hawkins has explained, the failure results in a new direction. In other words, errors became opportunities for new adventures.

What appears as an overlay in *Currency of Meaning #5* becomes a passage in and of itself in *Currency of Meaning #6* (1988). It is a habitat without an inhabitant whereas in *#5*, two environments overlap while remaining separate, each with its own function. Were one of the environments to be removed, the remaining one would unite with the upper environment resulting in a totally different message.

Hawkins is careful to meander only within boundaries so that the message is not prolonged to the point of obscurity. Even though there are limits, the language differs with each work.

In *Currency of Meaning #6*, the top half varies in shades of blue, and because the color blue identifies with the sky, one would assume that the dark and light are aspects of nature residing in their natural habitat. As clouds, they are interchangeable and movable so that the message or language is everpresent and everlasting. The narrow horizontal band of triangular shapes reaching from left to right across the canvas separates the two passages while uniting them as well.

Hawkins has introduced a grid with doodles that speaks a different language from that witnessed in *#5*. It has an irregular pattern. As a patchwork of several rectangular units, each unit becomes an environment of its own as well as a single aspect of a total environment.

*Currency of Meaning #10* (1989), subtitled, *Ruby, Ruby,* is described by Thelma Golden as follows:

> Unlike #5 and #6, *Ruby, Ruby* is divided into three parts. The top third is a verdant green field populated with both full and empty squares. Their disjointed nature makes them seem like scattered pebbles. With an unintentionally deliberate hand, Hawkins fills in some of the squares rendering them a wash-like white, leaving others merely outlined with no system beyond their obvious variation.

There are occasions when the artist subconsciously paints an area, not realizing until the area becomes part of the expression that the action was not intended. And yet, because of such action, an unintended creative act, although deliberate in a subconscious sense, alters an original intent into one of total satisfaction.

Critic Golden says,

> the middle *Ruby, Ruby* passage is again the familiar, liberated abstract scape which partially obscures the presence of a grid. This passage, like most of Hawkins' works, revels in its own painterly purity. This dominant, middle expanse is hemmed in at both top and bottom by thin dividing lines, both a diversion and a constraining device for the painter.

There is a certain beauty that exists not only in the pigment itself but in the

manner in which it is applied to the surface of the canvas, especially in the middle passage.

Golden calls the lower third of *Ruby, Ruby*

the most unusual. On a black ground, Hawkins draws six determinative triangles, perhaps related to those which have been heretofore partially or totally obscured. Surrounding the triangles are luminescent half-moon shaped marks. As seemingly unrelated as this passage is, it also brings us closer to newer, more untried concerns in Hawkins' work. With a variation of approaches, Hawkins sets an unavoidable temper for the experience of divulging meanings which the paintings in this series demand.

*Currency of Meaning #9* (1989) reveals both the intuitive and non-intuitive approach within a single expression. Totally instinctive in nature is the middle passage in which an explosion of color occurs and which acts in total contrast to the upper and lower passages. The calculated spacing existing in the two outlying passages is equal to the variety of geometric shapes that occur. However, in the lower passage, a mosaic-like pattern consumes the spatial surface. Irregularities exist since both the rectangular shapes which constitute the positive aspects and the remaining environment unite to form a preconceived pattern. The opposing forces of technical application of pigment seem compatible since the intuitive middle ground is balanced on top and bottom.

A reversal of procedure is evident in *Currency of Meaning #11* (1989). However, instead of three different passages, five exist. The top and lower passages are intuitively expressed while the middle one is conceptualized by four floating triangular shapes. Narrow horizontal shapes separate the upper and lower passages from the central one. Circular shapes equally distanced from one another are carefully positioned to fit snugly within the prescribed area.

The lower band separating the middle passage from the bottom passage relies on hieroglyphic messages. The beauty of *Currency of Meaning #11* lies in the combination of intuitive, semi–Expressionistic and non-objective techniques within a single expression. One will continue to speculate upon the abstractions of Hawkins. Her work may be misinterpreted, but often it is the beauty of the search that is most satisfying.

# Career Highlights

Born in Queens, New York in 1950.

## Education

B.A. degree from Queens College, CUNY, New York; M.F.A. degree from Maryland Institute, College of Art; postgraduate work from Art Students League, New York; postgraduate work from Brooklyn Museum Art School, New York.

## Awards

Brooklyn Museum Art School, Provincetown Workshop, 1985; Artist-in-residence Fellowship, Studio Museum in Harlem, 1987; Patricia Roberts Harris Fellowship, 1990–91, 1991–92.

## Selected Exhibitions

Queens College, New York, 1973; Emily Lowe Gallery, Hempstead, N.Y., 1979; The Jamaica Art Center, New York, 1980; Bronx Museum, New York, 1980; James Szoke Gallery, New York, 1984; Mississippi Museum of Art, Jackson, Ms., 1984; Augusta Savage Gallery, University of Massachusetts at Amherst, 1984; Grace Borgenticht Gallery, New York, 1986; Kenkeleba Gallery, New York, 1986; Studio Museum in Harlem, New York, 1988; Aljira Gallery, Newark, N.J., 1989; PepsiCo Gallery, Purchase, N.Y., 1989; Dome Gallery, New York, 1990; Montclair State College, Montclair, N.J., 1990; The Hudson Guild Gallery, New York, 1990; Decker Art Gallery, Baltimore, Md., 1991

## Solo Exhibitions

Queens College, New York, 1974; Midtown/Downtown Gallery, New York; 1981; Miami-Dade Community College, Miami, Fl., 1986; Cinque Gallery, New York, 1989.

# *Bibliography*

## Periodical Article

Golden, Thelma. "African-American Women Artists: Another Generation. Cynthia Hawkins." *International Review of African American Art*, Vol. 9, no. 2 (January 1991).

## Exhibition Catalogues

Artist Space. "Selections." New York, 1987.
Gallery at the Mechanic Theatre. "Cynthia Hawkins & Page Fleming." Baltimore, Md., 1991.
The Harlem School of the Arts. "Manifestations & Influences." New York, 1990.
The Jamaica Art Center. "Three Episodes. Afro-American Art." New York, 1980.
Jamie Zsoke Gallery. "Paper, Clay & Steel." New York, 1984.
PepsiCo Gallery. "From the Studio: Then and Now." Purchase, New York, 1989.
Queens College Gallery. "Ten Women." Queens, New York.

## Catalogues

"Black Women in the Arts, 1990." Montclair State College.
"The Fifth Annual Atlanta Life Insurance Company National Art Competition." Atlanta, Ga., February 1985.
"Four Views." Augusta Savage Gallery. University of Massachusetts, 1984.
Goode-Bryant, Linda. "Remains." Emily Lowe Gallery. Hofstra University.
Henry, Janet. "Cynthia Hawkins." *Black Current*, 1982.
Jones, Kellie. "The Regional Question." School 33 Gallery, June 1991.
Wilson, Judith. "Cynthia Hawkins." Francis Wolfson Art Center, February 1986.

## Reviews

Dorsey, John. "Spring 1991 Juried Exhibition." *The Baltimore Sun*, June 5, 1991.
Raynor, Vivian. "Cynthia Hawkins." *New York Times*, July 20, 1984.
Wilson, Judith. "Cynthia Hawkins." *Art in America* (October 1980).

*Top:* Howardena Pindell. *India: Suttee* (1986–87). Acrylic, paper, polymer photo transfer on sewn canvas, 90×56 in. Courtesy of the artist. *Bottom:* Howardena Pindell. *Autobiography: Through the Looking Glass* (1988). Acrylic, paper, oil stick, cattle markers, tempera, gouache, polymer photo transfer on sewn canvas. Courtesy of the artist.

*Above:* Norma Morgan. *Friends and Sisters* (1984). Watercolor. Courtesy of the artist. *Opposite, top:* Vivian Browne. *Two Men* (1966). Oil on canvas, 52×48 in. Courtesy of the artist. *Opposite, bottom:* Vivian Brown. *Dancer* (1968). Oil on canvas, 48×56 in. Courtesy of the artist.

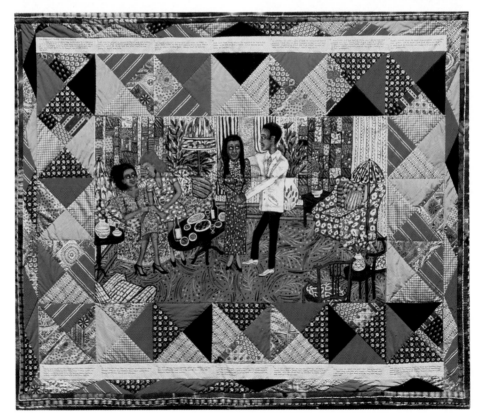

*Above:* Faith Ringgold. *God Bless America* (1964). Oil on canvas, 19×31 in. Courtesy of the Bernice Steinbaum Gallery, New York City. *Opposite, top left:* Elizabeth Catlett. *Seated Figure* (1979). Mahogany wood, 20½×13¼×16 in. Courtesy of the artist. *Opposite, top right:* Elizabeth Catlett. *Maternity* (1990). Mahogany wood, 19½×14½×5 in. Courtesy of the artist. *Opposite, bottom:* Faith Ringgold. *Bitter Nest Part V: Homecoming* (1988). Acrylic on canvas, printed, tie-dyed and pieced fabric. Courtesy of the Bernice Steinbaum Gallery, New York City.

Freida High W. Tesfagiorgis. *Witch Wench Witch Wench* (1989). Pastel on paper. Courtesy of the artist.

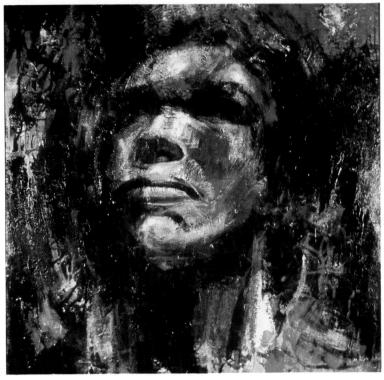

*Top:* Yvonne Catchings. *Dogwood.* Watercolor. Courtesy of the artist. *Bottom:* Malika Roberts. *Spectrum* (1972). Acrylic on canvas, 42×40 in. Courtesy of the artist.

**Mary Reed Daniel.** *Carnival #3* (1989). Handmade paper. 12×15 in. Courtesy of the artist.

# THIRTEEN

# *Camille Billops*

Camille Billops courageously reminds us of the evils of racial stereotypes that prevailed during the Depression of the thirties and the decade preceding it. And although the songs, dances and minstrel shows of the past are presumably forgotten, Billops continues to remind her audience of their acid characterizations, suggesting that one must be aware of ugliness in order to appreciate beauty, or that one must know evil in order to practice goodness.

In a comic strip style like that of Roy Lichtenstein but without the dialogue, Billops uncovers the demeaning character of racism and its equally devastating form of cruelty.

Billops portrays those prejudiced people who fostered racism with their ridiculous characterizations of black-faced performers. And yet, hers is a non-violent protest, a reminder of one's sins so that eventual goodness may emerge. The unearthing of racial stereotypes is never an enjoyable experience, but it is essential to remind oneself so that one can be strengthened within. Such a reaction may become a spiritual experience. In other words, it widens one's inner focus, but remains a gnawing confirmation of one's need to succeed.

In spite of Billops's quiet protest, there exists a whimsical display of symbols as witnessed in her work titled *Old Black Joe* (1991). Billops has combined highly distorted figures with musical notes into an exciting composition. And yet, her message is deliberate and forthright. It acknowledges greed that finds satisfaction at the mercy of racial stereotypes. In *Old Black Joe,* the exaggerated smiles of white performers cavorting as black minstrels exemplify the insidious concern of the minstrel show owner. The portrayal of slavery was never more ludicrous and the real tragedy was labeled as smart showmanship. And yet, there is a guilt that resides within the performer's actions as if one's conscience is affecting each musical note or dance step.

Artistically, the overlapping of musical symbols with the figures adds to the unity of the expression.

Where other artists have fused collage materials with paint, Billops has overlapped symbolic forms with layers of pigment. In *Old Black Joe,* the artist has avoided a collage temptation which Romare Bearden, for example, would have welcomed.

In a *Newsday* art review, critic Karen Lipson has written,

> the work of Camille Billops is so funky, funny and stylish it's surprising that it hasn't made its way into a gallery. Billops creates cartoonlike male and female painted ceramic figures, about four feet high, and drawings of similar characters in colored pencil on paper. Smiling lasciviously or peering seductively through lowered lashes,

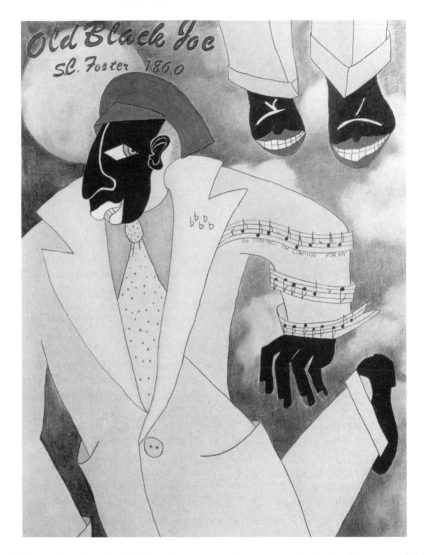

**Camille Billops.** *Old Black Joe* **(1991). Colored pencil on paper, 22×30 in. Courtesy of the artist.**

they have the stylized tension of couples in a tango parlor. Their slightly decadent look may also make us think of "Cabaret" or some other appropriately seedy scenario.

With Billops's ceramic sculpture *Remember Vienna III* (1988), one is reacquainted with the decades of the twenties and thirties. The cartoons of those yesteryears are vividly recalled when viewing Billops's funky but flashy display of a routine flirtation or an invitation to dance.

Aside from her pleasant and yet un-

orthodox approach, Billops has conquered compositional demands in such works as *Remember Vienna III*. Even though each piece is executed to exist as single sculpture, there are compositional elements found in both. The spacing between the two figures is ideally suited to the circumstances. The invitation becomes an allurement, and to alter the space between the two figures would alter the emotional attachment. The activity to which Billops refers has yet to occur. Thus, the viewer becomes attached to the anticipation of what has yet to exist.

To emphasize the similarity of the

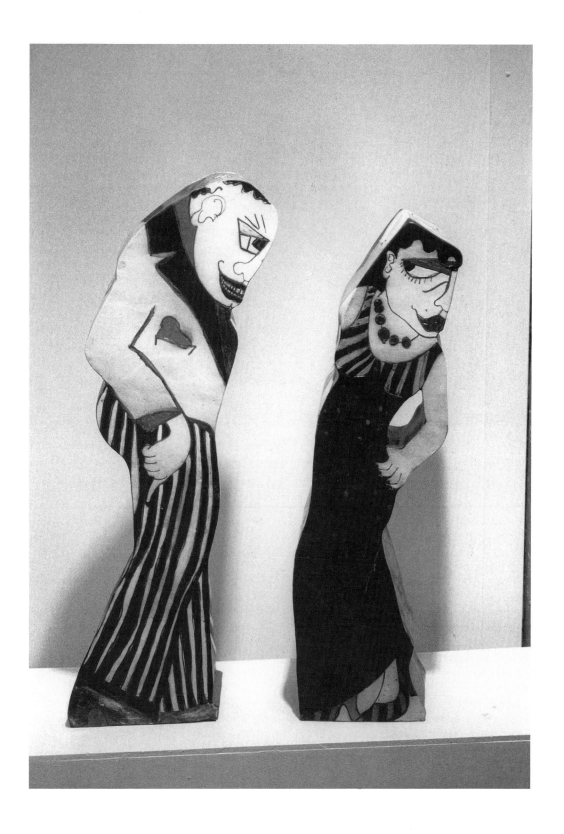

**Camille Billops.** *Remember Vienna III* (1988). Ceramic sculpture, male 40¹/₂×11¹/₄×5¹/₄ in., female 37×9¹/₂×7 in. Courtesy of the artist.

**Camille Billops. *#2 Kaohsiung Series* (1982). Colored pencil on paper, 21×15 in. Courtesy of the artist.**

two, Billops has repeated the striped trousers design in the female dancer's blouse. The male's black lapel matches the black formal gown of the female. Pieces of the man's hair resemble the female hairstyle. The shape of the eye sockets and the sensuously contoured facial features add to the anticipation of the event.

As one moves around the figures, the space between the two shifts and a different scenario exists. With each turn of the viewer, the spatial distance between the two diminishes until one reaches the back side where again the ideal spatial relationship occurs. There is tantalizing communication between the figure's eyes, but the slope of individual bodies also add to the flirtatious characterizations.

A close-up, more intimate view of Billops's romantic couple is witnessed in *#2 Kaohsiung Series* (1982), and one senses a cartoonist approach as the sole purpose for establishing a unique style.

Billops has repeated symbols which identify her work as a series of approaches to one couple, a unit whose existence relies upon each of the members. The viewer is drawn into the conversation, the invitation, the anticipation of an occurrence. The female to the left seems to refuse the advances of the male. And yet, in the foreground an unidentified couple dance furiously as their shadows duplicate their actions onto the background. The two major subjects watch excitedly as Billops exercises her freedom to express her most inner feelings.

Stripes are regularly applied to the characters' attire in Billops's work, and this is again witnessed in the background of *#2 Kaohsiung Series*. Deliberate distortion exists throughout as recognizable symbols are used. The female's three fingers and the male's four are not symbolic but they do serve compositional needs. The obviously exaggerated and distorted facial features become compatible with body segments.

*Left:* Camille Billops. *Prisoners* (1987). Ceramic sculpture (side view), 10¼×15×32½ in. Courtesy of the artist. *Right:* Camille Billops. *Prisoners* (1987). Ceramic sculpture (back view), 10¼×15× 32½ in. Courtesy of the artist.

There exists perhaps a dual meaning depending on the viewer's emotional or intellectual status. One moment there appears a sense of peril, an aggressiveness on the part of the male and fear on the part of the female. Another moment a feeling of anticipated intimacy prevails in which a loving, caring couple playfully tease one another. Of course, viewpoints will differ, and although as distasteful as the facial features may appear, they nonetheless serve to accent a Pop approach to a commonplace situation.

In another review of Billops's exhibition of works, critic Beth Monin had the following to say:

**Camille Billops.** *The Story of Mom* **(1981). Ceramic sculpture, 47×11×7 in. Courtesy of the artist.**

Artist Camille Billops aims to wipe the paint off the blackface minstrel and with a touch of humor reveal him for what he is: a white man making vicious fun of a race of people about whom he knows little or nothing.

Camille Billops invites you to peek behind the minstrel mask and to speculate who was hiding there and why.

Even though this quote specifically relates to *Old Black Joe,* there remains a sense of acidity hidden within Billops's drawings and sculptures, especially in her Prisoner Series.

Billops twists and turns facial features until a suitable angle is achieved. In *Prisoners* (1987), she offers the viewer the left side of the body, but includes

**Camille Billops.** *From the Story of Mom* **(1986). Colored pencil on paper, 22×15 in. Courtesy of the artist.**

the right side of the head, an impossible physical feat but one which was essential to the composition. The back view is of a regular rectangular shape but includes an intricately painted composition within the simple form. A pair of chairs are painted to accommodate two figures whose single cause seems to be the exchange of secrets. Because the work is a personal and intimate expression, misinterpretations can occur, but nonetheless, curiosity, anticipation and amusement are seldom absent from Billops's portrayals.

Even though the side view of *Prisoners* is not as captivating as the back view, its message is obvious with the broad black and white stripes of the figure's attire. The unusual posture of the prisoner is more a sculptural necessity than a symbolic gesture. Billops's ability to create four different compositions from a single sculpture and yet maintain a flowing design throughout the whole is what separates her work from other ce-

ramic sculptors. The back view of *Prisoners,* for example, becomes a two-dimensional painting on a three-dimensional surface. The figures remain unknown thus adding to the mystery of the secret.

*The Story of Mom* (1981) offers an unusual use of linear definition. The female figure clutched frantically by a youngster is not only theoretically mysterious, but also becomes an authentic sculpture which challenges one's intellect and arouses one's emotions.

Similar optical effects occur in *From the Story of Mom* (1986), a close-up view of "mom" at the wheel. The striped character recalls other linear applications in such works as *Prisoners* and *Remember Vienna III.* In a view through the side window of the vehicle, anxiety identifies the driver, and amid the series of black and white lines, a religious symbol adorns the sleeve of the female. The black crucifix allows for a myriad of speculations. Whether intended as a spiritual symbol or as a compositional need, its very

**Camille Billops. *Dancer Collage #4* (1980). Collage, 22×15 in. Courtesy of the artist.**

presence alerts the viewer of a spiritual message.

*Dancer Collage #4* (1980) is of a dance complete with musical notes and vibrations reminiscent of a Kandinsky score and a whimsical Miró painting. The colorful dancing couples, intensely involved in outdoing each other, prove a delight for the viewer. It is interesting to note the directional movement of the dancers, each turning the viewer's attention to areas outside the picture plane.

The comic strip image has diminished in *Dancer Collage,* although distortion of figures continues to define Billops's concepts. The background with its musical elements makes an appropriate habitat for its occupants. The musical score, so well distributed, is echoed in the designs of the clothes of the dancers. Billops has managed to depict a refreshing, airy atmosphere for an exhilarating activity.

Billops has exaggerated the segments of physical action. Body parts that are motivated to move by the music are dis-

torted. Even though the artist's figures are flatly handled and the background is lacking in recessive treatment, there exists a sense of spatial depth. Billops has positioned her figures onto the working surface from the foreground to the background assuming that a differentiation exists. Although placed onto a frontal plane, there remains the illusion of depth. And finally, the blackness of the figures creates a solidified subject matter against a less intensive background.

*Franco and Tessa I* (1990) is a delightful return to the flat treatment and distorted physical features appearing in work by an early elementary child. However, Billops's unique style and bits of flirtatious sophistication make for a momentous expression. Even though Franco and Tessa occupy center stage, three engaging couples treat the viewer to added amusement. It is the flatness of the celebrated couple and the recessive nature of the environment that makes *Franco and Tessa* such an unusual portrayal. The voluptuous Tessa assumes a

**Camille Billops.** *Franco & Tessa I* **(1990). Colored pencil on paper, 22×30 in. Courtesy of the artist.**

three-dimensional character produced by Billops's manipulation of her contour line. The mammoth shoes which might be considered clodhoppers add to Franco's whimsical yet serious intentions directed to his dancing partner.

The element of subjectivity enters the scene. In spite of the objective portrayal of three shadowed couples in the background, initial and sustained focus remains on the central dancing team of Franco and Tessa. The viewer indeed acknowledges the other couples but only incidentally. Therefore, the other

couples, who could objectify the viewer's approach to Franco and Tessa, are not a serious threat to derailing the personal, intimate relationship Billops has created with her two main subjects. Billops's work is indeed highly personal and the viewer is treated to unforeseen pleasures and unpredictable moments of enjoyment.

In spite of Billops's calling and her dedication to racial justice, her art work possesses forces that extend beyond this worthy cause, and even infrequently suggests spiritual overtones. After the initial shock, the viewer should temper his/her beliefs, relax and enjoy her unusual interpretation of life.

# Career Highlights

Born in Los Angelos in 1933.

## Education

B.A. degree from California State College; M.F.A. degree from City College of New York.

## Selected Exhibitions

Friendship House, Moscow, Russia, 1971; El Museo De Arte Moderno, La Tertulia, Cali, Columbia, 1976; St. Peters College and Art Center, Jersey City, N.J., 1976; Dreyfuss Gallery, Ann Arbor, Mich., 1978; Schnectady Museum of Art, Schnectady, N.Y., 1978; The Los Angeles Museum of Contemporary Art, Los Angeles, Ca., 1979; Israel Museum, Jerusalem, 1979; Yolisa House, New York, 1980; Martin Luther King Library, Washington, D.C., 1980; New Orleans Museum of Art, New Orleans, La., 1980; Center for Visual Arts, Illinois State University, 1981; Joslyn Art Museum, Omaha, Ne., 1981, Montgomery Museum of Fine Arts, Montgomery, Al., 1981; Indianapolis Museum of Art, Indianapolis, In., 1981; Westbeth Gallery, New York, 1981; Museum of Science & Industry, Chicago, Ill., 1985; Portsmouth Center for the Fine Arts, Portsmouth, Va., 1985; University of Maryland Art Gallery, College Park, Md., 1985; The Chrysler Museum, Norfolk, Va., 1985; Studio Museum in Harlem, New York, 1985; Soho 20 Gallery, New York, 1985; The Print Club, Philadelphia, Pa., 1986; Associated American Artists, New York, 1986; The Squibb Gallery, Princeton, N.J., 1987; Robeson Gallery, Rutgers University, Newark, N.J., 1987; Mountclair Museum of Art, Mountclair, N.J., 1987; Bernice Steinbaum Gallery, New York, 1989; Snub Harbor Cultural Center, Staten Island, N.Y., 1989; Atlanta College of Art, Atlanta, Ga., 1989; St. Laurence University, Canton, N.Y., 1989; Benton Gallery, South Hampton, N.Y., 1989; Zimmerman/Saturn Gallery, Nashville, Tn., 1990; Holman Art Gallery, Trenton State College, Trenton, N.J., 1990

## Solo Exhibitions

Gallerie Akhenaton, Cairo, Egypt, 1965; Winston-Salem State University, Winston-Salem, N.C., 1974; Amerika Haus, Hamburg, West Germany, 1976; Foto-Falle Gallery, Hamburg, West Germany, 1976; Rutgers University, Newark, N.J., 1977; The Bronx Museum of Art, New York, 1981; American Center, Karachi, Pakistan, 1983; American Cultural Center, Taipei, Taiwan, 1983; Otto Rene Castillo Center, New York, 1983; Calkins Gallery, Hofstra University, Hempstead, N.Y., 1986; Clark College, Atlanta University, 1990.

# Bibliography

## Periodical Articles

"American Artist to Hold Exhibit in Kaohsiung, Taipei." *China Post*, May 24, 1983.
"Art: Billops and Moody." *Arab Observer*, May 24, 1965.

"Art Notes." *Little Rock Arkansas Gazette,* 1984.

"Artist Camille Billops to Exhibit." *China Post,* June 14, 1983.

"Billops Art Works Displayed." *Pine Bluff News,* 1984.

"Camille Billops." *Crafts Horizons* (April 1974).

"Camille Billops." *Encore Magazine,* June 23, 1975.

Cook, Joan. "Truth Triumphs on a Harlem Stage." *The New York Times,* May 12, 1966.

"Eye on Art & Entertainment." *New York Age News,* September 14, 1974.

Goodman, George. "Tombs Arts Show Life and Fantasy." *The New Times,* February 8, 1973.

Lippard, Lucy. "Color Scheming." *The Village Voice,* April 22, 1981.

Lipson, Karen. "Unaffiliated Artist Show at C. W. Post." *Newsday,* June 14, 1986.

Lubell, Ellen. "Perception and Deception." *Soho Weekly News,* October 26, 1978.

Monin, Beth. "Billops Sees Hidden Face of Black Faces." *Nashville Banner,* October 30, 1990.

"My Life in Art." *Black Art Quarterly* (Summer 1977).

"Power Exchange: Camille Billops." *Heresies Magazine* 1979.

Raven, Arlene. "Colored." *Village Voice,* May 31, 1988.

Robertson, Marcia. "Black Females Defy Odds and Succeed." *The Atlanta Journal-Constitution,* July 7, 1988.

"A Sculptured Reality." *Essence Magazine,* (July 1972).

Shepard, Joan. "Prints of the City & World in Queens." *New York Daily News,* September 23, 1989.

Tapley, Mel. "About the Arts." *Amsterdam News,* April 11, 1981.

Wallace, Michele. "Daring to Do the Unpopular." *Ms. Magazine* (September 1973)

Whitfield, Tony. "Vigilence." *Art Forum* (September 1980).

Wolfe, George. "Camille Billops." *A Journal for Artists* (Spring 1986).

# FOURTEEN

# *Delilah Pierce*

Born in Washington, D. C., in 1904, Delilah Pierce has served America as educator, artist, and human being. Pierce has altered her style considerably over the years. Her works of the fifties focused on the problems caused in efforts to achieve social justice and integration. She uses people in her works as in such paintings as *Tradermen-Khartown, Sudan,* a 1962 work, and *Supplication,* a 1960 title.

In the former work, overlapping figures of Africans gather together for a common cause. The close proximity of forms suggests a far bigger crowd than in reality. *Tradermen* is intensified by the intimate nature of the gathering. Its vertical, rectangular shape adds drama to the portrayal. The figures create activity and a subjective expression although objectively conceived and executed. Brushstrokes are applied convincingly in creating highlights and shadows. Sources of light are arbitrary and visual reality is ignored in favor of compositional needs.

Facial features are less pronounced than in her other works, perhaps to enforce the nature of anonymity. The common cause of the gathering is highlighted by a similarity of personalities. And yet, the likenesses make for an intriguing subjective expression.

In a similar vein is a dramatic 1960 portrait of a single female in the act of beseechment. With *Supplication,* Pierce has focused on the uplifting spirit of prayer as the figure seeks divine guidance. The formidable figure looms large in the foreground as a handsome face tilts heavenward, and elongated fingers stretch in the pleading fashion. A peaceful sky contrasts to the tilted rows of buildings which intensifies the visual perspective by eliminating the horizon.

The inward slant of buildings not only acts as a compositional device but creates an emotional tension and may in reality add to the stressful nature of the plaintiff. Surrounded by an urban environment, the female pleads for mercy, not for herself but for the urban population.

A decade later, the Pierce style changed considerably along with the subject matter. A piece titled *Daffodils* (1958), reveals a blend of foreground and background in which the shapes of the flowers are echoed throughout the work. The switch from the human figures of earlier works to traditional content reflects not only a style change but an attitude change.

Contrast is subtle and tends to rely upon texture rather than color. The crevices of paint created by both brushstroke and palette knife are not contrasts in color but caused by shadows. *Daffodils* is indeed a highly personal depiction of a common theme. The background, which resembles a window frame, is subdued in brushwork forcing the flowers to advance to the forefront in spite of placement and color.

160

 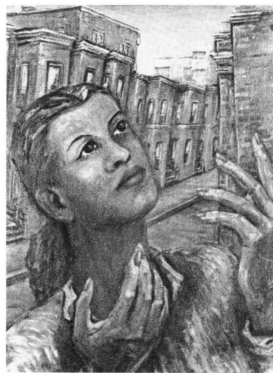

*Left:* **Delilah Pierce.** *Tradermen-Khartoum, Sudan* **(1962). Oil on canvas, 24×42 in. Courtesy of the artist.** *Right:* **Delilah Pierce.** *Supplication* **(1960). Oil on canvas, 18×24 in. Courtesy of the artist.**

An exact duplication of style is seen in *Waterfront* (1958), a more complex piece of images. Boats are moored in a congested harbor; the horizontal boat images are interrupted by diagonal and vertical masts reaching upward to sky level. Buildings similar to those seen in *Daffodils* anchor the background. Again, foreground and background become a single unit of expression. Only the narrow layer of sky presents a rest area. It is the crevices of paint that create the contrast between the numerous floating objects and the lineup of fisheries and canneries.

A brief scan of Pierce's everchanging style is further witnessed in a 1982 painting titled *Nebulae,* an Abstract Expressionist version of a flower-like subject which is loose and exuberant. An explosion of pastel colors reveals a solar system of light. Particles of a sun-shaped formation break from their origin as sparkling bits of color.

Drenched in a watercolor medium, *Nebulae* introduces a freedom of expression heretofore unknown to Pierce's. Speckles of color advance and recede in a jubilant fashion. Its focal point, although centralized, is spread across the working surface so that a subjective expression results.

Gone are Pierce's pleas for mercy and her calls for aid. *Nebulae* introduces art on a universal scale, although less personal and less dramatic than her work of the fifties. There is strength in a painting if its execution is not rigid or pressured into existence. *Nebulae* is a pleasant portrayal of color and shape; there is no inner drive to resolve racial inequalities or injustices, but rather a momentary freedom from personal obligations. The spirit is uplifted, resulting in a joyous celebration.

It is not always possible to account for an artistic style change. The decision

to deliberately avoid the creation of recognizable images automatically results in Abstract forms alien to the artist's current concepts.

In peaceful seclusion is a remarkable painting titled *Guardian of the Shore* (1958). This seascape combines the ruggedness of the shore cliffs with the serene sky and waters. The focal point is the cliffside, positioned in the upper left corner of the painting and offset by the quiet solitude of the still waters. The horizon line in the distance adds to the stillness. Rock formations settle at the base of the cliffside while the endless sea is compositionally halted in the foreground while the shoreline is partially lost from view. Lines accent and sharpen the divisions between similar rock formations. Vertical wharf poles highlight the foreground and heighten the broad sweeping areas of the cliffsides.

Pierce's works speak of her compassion and devotion to her calling as an artist. She has purposely avoided the ugly and the violent because hope does not dwell in the unpleasant. According to the art critic Judith Means,

> The way she perceives the world, with joy and optimism, and the stunning clarity of her finely-developed aesthetic sense are integral not only to her character but also to the vivid visual textures of her work.

Pierce was equally adept at depicting European and Asian themes as well as those of the United States. Her painting *Sudanese Tradesmen* (1964) is an example of her concern and compassion for the peoples of strange lands. There is a fluidity about her work, but it is calculated in terms of composition. Direct focus is on the players who demand center stage, while the background includes the essentials of their travels. Pierce has arranged a vertical composition within which are circles representing the heads of the Sudanese tradesmen and the round drums occupying the foreground.

*Sudanese Tradesmen* is objectively conceived and arranged upon the canvas, and yet in spite of the assumed rigidity, the six figures are relaxed and seemingly content with the day's sales. To reinforce the vertical display of the figures, Pierce has positioned two vertical pillars to stop the viewer's attention from wandering beyond the picture plane. Visual perspective is all but eliminated as the background is blurred in order to dramatize the appearance of the tradesmen. *Sudanese Tradesmen* is a recording of an event, but Pierce's sympathetic approach to her theme adds that artistic touch which separates an artistic expression from a mere recording.

Another dramatic vertical image is found in *Nature's Symphony/Martha's Vineyard—Legacy* (1980). A rocky foreground anchors the expression, and except for a lone boulder snuggled between the towering trees in the distance, the work would have been divided into two distinct paintings. *Nature's Symphony,* a segment of a triptych, is a daring but successful attempt to unite two opposing forces by the placement of a single image.

The dramatic upward movement of naked trees, offset by the rugged, circular structure of the rocks, is a deliberate technique of unbalancing a composition in order to eventually balance it. Pierce has established a horizontal mesa of circular images at the base of the painting and with a subtle approach neatly repeated the horizontal movement while simultaneously lessening the strength of the upward movement of the vertical environment.

*Harborside Mosaic* (1979) reveals Pierce's quiet, yet strong approach to seemingly empty areas of canvas. Open segments of sea and sky which occupy one half of the canvas maintain the natural stillness but suggest a sort of muted activity. The use of several smoothly blended colors suggests a controlled emotional force underlying a potential sensuous activity.

A circular painting on a rectangular

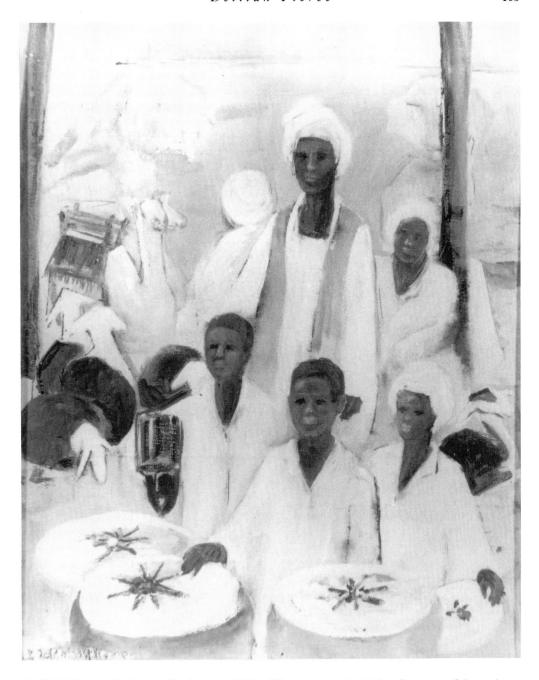

**Delilah Pierce.** *Sudanese Tradesmen* (1964). **Oil on canvas, 14×16 in. Courtesy of the artist.**

surface is a compositional risk. And yet, the similarity of color of both the circular painting and its surrounding negative space allows both segments of the painting to coexist.

The convincing brushwork suggests that the artist has been there before. In *Harborside Mosaic,* Pierce has combined the three basic directional movements by placing horizontal planes within a circular form which in turn has been positioned onto a rectangular vertical surface.

The word mosaic defines the juxtaposition of shapes representing the dwell-

**Delilah Pierce.** *Nature's Symphony/Martha's Vineyard—Legacy* **(1980). First section of a trip-tych, each section 36×40 in. Courtesy of the artist.**

ings of the coastal community. The painting deals with the close proximity of abodes by using linear brushstrokes. The porthole view is reminiscent of Wayne Thiebaud's city series which focuses on unusual viewing angles.

Pierce's technique reflects the joy of painting. In spite of her naturalistic portrayals, there appears the master's touch accumulated through years of experimentation and exploitation of pigments. She uses nature as a springboard to newly discovered techniques and media, and yet she relies on her thorough experience to

**Delilah Pierce.** *Harborside Mosaic* **(1979). Oil on canvas, 24×30 in. Courtesy of the artist.**

ward off temptations to indulge in accidental meanderings of the pigment.

Throughout her career, Pierce experimented only with ideas, trying not to merely record a scene or event but to expand or deepen the theme's expression.

She ignored the attempts of other artists to test various media for the sake of discoveries. Rather, she mastered a single medium and then pursued variations of techniques within that medium.

Her techniques are solidly founded

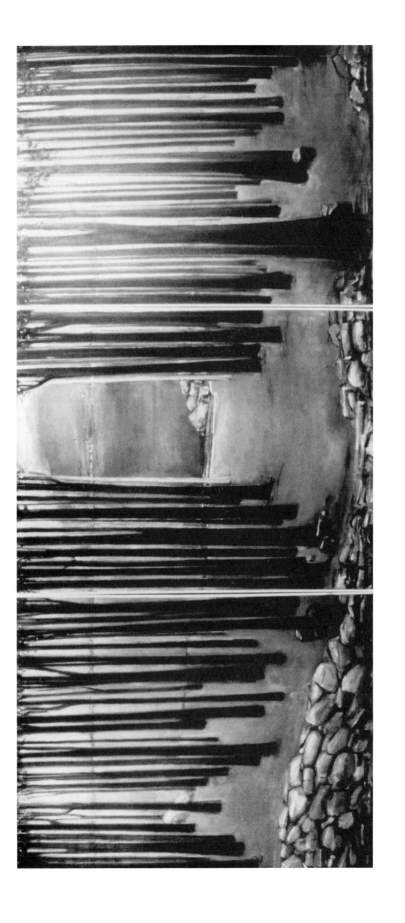

Delilah Pierce. *Nature's Legacy/Symphony* (1980). Acrylic on canvas, each panel 36×40 in. Total triptych 108×40 in. Courtesy of the artist.

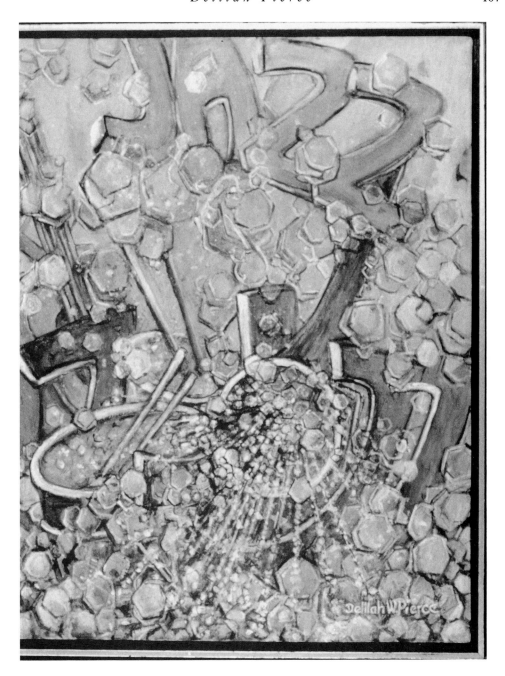

**Delilah Pierce.** *Jazz Vibrations* **(1988–89). Acrylic on canvas, 20×24 in. Courtesy of the artist.**

in the rigid rules of her predecessors such as Lois Mailou Jones, Ralph Pearson and Vaclav Vytlacil.

Sometimes one may question the theory of triptych paintings. In the case of *Nature's Legacy/Symphony,* the additional two panels expand and broaden the single panel *Nature's Symphony.* There is strength in repetition, but in the case of *Nature's Legacy/Symphony,* the repeat pattern of trees is slightly altered to avoid monotony.

Each of the three panels are worthy of individual study. Pierce arranges the

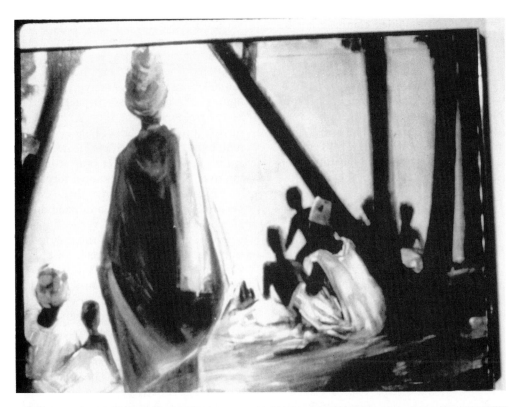

*Top:* Delilah Pierce. *On the River Niger* (1963). Acrylic on canvas, 36×48 in.  Courtesy of the artist.
*Bottom:* Delilah Pierce. *Vineyard Haven Harbor* (1957). Oil on canvas, 25×37 in. Courtesy of the
artist.

panels to form a unified composition. Interchanging the three panels would upset the current sequence, and yet this in turn would cause a need for further intellectual and emotional responses.

The central panel symbolizes exaltation, an enlightenment of the human condition. The left and right panels similarly show light in nature's forests so that each panel serves as a plea for acceptance. There is a feeling of the eternal, an everlasting presence of life. Pierce has used a horizontal surface for the strong vertical images to send her message.

A reverse approach to nature is *Jazz Vibrations* (1988–89). Totally subjective, it suggests the gyrations of segments of various mechanical devices. The word "jazz" is amid irregular overlapping shapes which interpenetrate, giving the painting a sense of depth.

Recession and advancement of space are recognized in the contrasting shapes of darks and lights. There is a solidity of forms which is absent in *Nature's Legacy/Symphony,* and this allows for intervals of space which are three-dimensional in appearance.

Similar to *Sudanese Tradesmen* is *On the River Niger* (1963) in which acrylic washes are used to create movement even though the subjects are painted in still positions. The major figure occupying the center of the work coexists with several figures. The large areas of space created by the trees match the shapes created in the main figure's attire. There is a contemplative mood which permeates the entire scene. Figures peer outwardly onto the river Niger to an unknown future.

*Vineyard Haven Harbor,* like *Nature's Legacy/Symphony,* works a horizontal surface by the application of vertical images. The tall, vertical masts of the sailing ships line the harbor as streaks of blue slash in horizontal fashion across the sky. The heavily applied pigment flashes in brilliant colors as the ship's masts are reflected in the watery foreground.

Impressionist in appearance and Cubist in technique, *Vineyard Haven Harbor* is an emotional transformation of a tranquil harbor scene. The quietude of the scene is broken by the color.

Delilah Pierce's remarkable career continues to show bursts of artistic enthusiasm. Her work reflects her concern for the American populace and nature.

# Career Highlights

Born in Washington, D. C. in 1904.

## Education

B.S. degree from Howard University, Washington, D. C.; M.A. degree from Teachers College, Columbia University, New York; postgraduate work from the University of Pennsylvania, the University of Chicago and New York University; studio work under Lois Mailou Jones, James Wells, Ralph Pearson, Jack Perlmutter and Vaclav Vytlacil.

## Awards

The Agnes Meyer Traveling Fellowship, 1962; National Sorority of Phi Delta Kappa Award, Washington, D.C., 1963; American Federation of Arts Award, 1964; Delilah Pierce Day for Cultural Contributions, 1980; National Conference of Artists Award, 1981; Washington, D. C. Federation of Civic Association, Inc. Annual Award, 1983; Washington, D. C. AAUW Professional Achievement Award, 1984; Howard University Art Department Alumni Award, 1989.

## Selected Exhibitions

Atlanta University, Atlanta, Ga., 1952, 1953; Smithsonian Institution Area Show, Washington, D. C., 1952, 1953, 1955; Corcoran Gallery of Art Area Show, Washington, D. C., 1957, 1958, 1959; Barnett Aden Gallery, Washington, D. C., 1958, 1959, 1960; Baltimore Museum of Art Area Show, Baltimore, Md., 1959; Georgetown University, Washington, D. C., 1960–74; American Art League Show, 1960; Howard University, Washington, D. C., 1960, 1963, 1964, 1966, 1976; 20th Century Gallery, Williamsburg, Va., 1964; Hampton Institute, Hampton, Va., 1968; Catholic University, Washington, D. C., 1969; New Jersey State Museum, Trenton, N.J., 1970; University of Pennsylvania, 1972; United States Embassy in Cairo, Egypt and Zaire, Africa, 1973–80; National Museum of American Art, Washington, D. C., 1982; Montpelier Cultural Arts Center, Montpelier, Vt., 1982; Schenectady Museum, Schenectady, N.Y., 1983; Evans-Tibbs Gallery, Washington, D. C., 1983; United Nations Conference on Women, Nairobi, Kenya, Africa, 1985; Kenkeleba Gallery, New York, 1986; Anacostia Museum, Smithsonian Institution, Washington, D. C., 1989.

# *Bibliography*

## Books

Atkinson, Edward. *Black Dimensions in Contemporary American Art.* New York: New American Library, 1971.
Dover, Cedric. *American Negro Art.* New York: New York Graphic Society, 1960.
Driskell, David. *African American Artists.* Washington, D. C.: Smithsonian and University of Washington Press, 1989.
Kinard, John. *The Barnett-Aden Collection.* Washington, D. C.: Smithsonian, 1974.

## Periodical Articles

Andrews, Benny. "On Understanding Black Art." *New York Times,* June 21, 1970.
Langston, Hughes. "The Negro Artist and the Racial Mountain." *Black Expression,* 1969.
Locke, Alain. "American Negro as Artist." *American Magazine of Art* 23 (Sept. 1931).
Means, Judith. "Delilah W. Pierce." *Art Voices/South* (May-June 1980).

## Exhibition Catalogues

Acts of Art Gallery. "Black Women Artists." New York.
Agricultural and Technical College of North Carolina. "Fifteen Afro-American Women." Greensboro.
City College. "The Evolution of Afro-American Artists." New York.
Harmon Foundation. "Exhibition of Fine Arts by American Negro Artists." New York.
Minneapolis Institute of Arts. "Thirty Contemporary Black Artists."
Newark Museum. "Black Artists: Two Generations." Newark, N.J.
Studio Museum in Harlem. "Afro-American Artists." New York.
————. "Harlem Artists 69." New York.
University of California. "The Negro in American Art." Los Angeles.
Whitney Museum of American Art. "Contemporary Black Artists in America." New York.

# FIFTEEN

# *Yvonne Catchings*

After the Martin Luther King, Jr., assassination, protesters throughout America became so outraged and angry that civil rights riots occurred. The ultimate was the Detroit riot in which lootings, arson, destruction and killings resulted.

With a few collage materials and red paint, artist Yvonne Catchings has portrayed the essence of destruction. The fiery red background becomes a perfect symbolic environment, and the charred wood material illustrates the depth of arsonry. In spite of its vastness the particles of collage materials pierce it to interject a series of interruptions. Thus, a compositional rest area never becomes a haven for peace. Even today, her collage painting *The Detroit Riot* (1968) would apply in a cold war situation.

Catchings's work reflects total destruction. In reality, entire neighborhoods were obliterated. Sheer anger and frustration engulfed the black community. The tragic murder following the two Kennedy assassinations was more than citizens could endure. Catchings's portrayal does not involve human figures. Instead, she has revealed the material damages of a chain of events that erupted after years of slavery and discrimination. A resolution to portray the human suffering and anguish incurred from years of struggle and despair becomes the credo of Catchings's production.

In a painting titled *The Chains Are Still There* Catchings hints at the continuing impeding of freedom by picturing a mere symbol. How much stronger and provocative would the painting be if the human personality were included? Without its title would the painting not be mere decoration suggesting several images, the least of which would be a symbol of slavery?

Catchings's favorite expressions are paintings, and she uses several techniques. She is equally adept in oil, acrylic, watercolor and mixed media. In the more transitory and temporal medium of watercolor, Catchings adheres to a lucidly technical approach to commonplace themes. However, her fluid technique enhances her subjects to an advantage.

In a simple, desolate environment revealed in *Wash Time* (1974), Catchings explores and exploits the capabilities of the watercolor medium. The combination of wet and dry surfaces is accented by defining the subject matter with outlines. Thus, explosions of color are surrounded by lines for identification. This technique, often referred to as brushless painting, is ideal for the discovery of themes or subject content. By the theory of visualization or accidental meandering, ideas emerge from the numerous clusters of color floating in space. Thus, by suggestion one discovers and strengthens that discovery into a total idea and a unified composition.

**Yvonne Catchings.** *The Detroit Riot* (1968). **Oil and mixed media on canvas, 24×36 in. Courtesy of the artist.**

In *Wash Time,* both well-defined and vague elements exist within a given expression. Likewise, a sense of looseness and one of tightness coexist. Executed in a similar fashion is the intuitive work *Down in the Bottom* (1975). Not unlike the primitive style of Doris Lee, the results of the watercolor medium are Realistic and yet Abstract, thus inviting the viewer to speculate as to its meaning. The airy atmosphere lends a sense of eternal belonging to a particular environment, not necessarily a desirable site but one swelled with childhood memories. The shanty, the clothesline, the outhouse and the tire swing become integral segments of the composition as well as a biographical sketch of earlier years. Again, the combination of solidity and transparency delivers an equal balance of techniques.

In *Hope Tree in the Valley* (1974), Catchings avoids the spatial meanderings of subject matter by relying on solid forms anchored to secure environments. Transparencies exist only in the sky. The painting is arranged in four tiers or horizontal partitions. Each is dependent upon the preceding segment as the horizontal terrain in the forefront overlaps a second environment, which in turn extends into the third segment. The final horizontal plane is pierced by an object originating in the forefront plane.

Close-up views in such works as *Flowers and Pearls* (1974) and *Clothes Line* (1974) exhibit opaque qualities which are absent in the previously discussed paintings.

*Flowers and Pearls* exhibits both the opaque and the transparent qualities. Colors representing various types of flowers blend together and overlap to create an abundance of color, identifying and suggesting the varieties of flowers. Contour lines define particular objects otherwise unidentifiable. A single strand of pearls lies in the forefront adjacent to what appears to be a summer purse. *Flowers and Pearls* is subjective in approach, since the negative space is minimal. There is a certain looseness which prevails in spite of the objective arrangement.

Both unusual in its theme and in its composition is the painting *The Clothes Line.* Having already established vertical boundaries with the working surface, Catchings has reinforced the vertical panel with strong upright trees extending the height of the painting. The vertical strength of the trees is lessened by the horizontal stretch of clothesline tied securely to each tree. Five individually chosen bits of clothing hang vertically though to compensate for the horizontal clothesline.

Catchings is partial perhaps to the nude aspect of the tree because it avoids the danger of superficiality. The truth resides in the tree's basic structure rather than outer trimmings which tend to cover up the truth more than to expose it. Too often the superficiality of an outer appearance disguises the inner strength and beauty.

Catchings's choice of clothes is again a reminder of the past, of earlier years. The simple theme of a commonplace incident becomes a spur for the creative process. The artist Loren MacIver was made famous by such inane topics as a crack in the sidewalk, windshield wipers during a rain, or a window shade. *The Clothes Line* has that touch of class which makes a daily routine or an unattractive scene one of charm and beauty.

Catchings's primitive *Country Madonna* (1975) is an amazing tribute to the birth of Christ. It is a simple work with a profound message. The Christian atmosphere is evidenced through the halos surrounding the heads of the mother and child nestled in the country rocking chair. Christmas trees peer through two of the three windows. The star that guided the Magi to the blessed event is silhouetted in the spacious sky. *Country Madonna* is a modern version of the birth of Christ but placed in a poor country setting. The outdoor cook pot, the scrubboard and the clothesline establish the economic level of the celebrated couple.

In spite of its sharp contrast, there

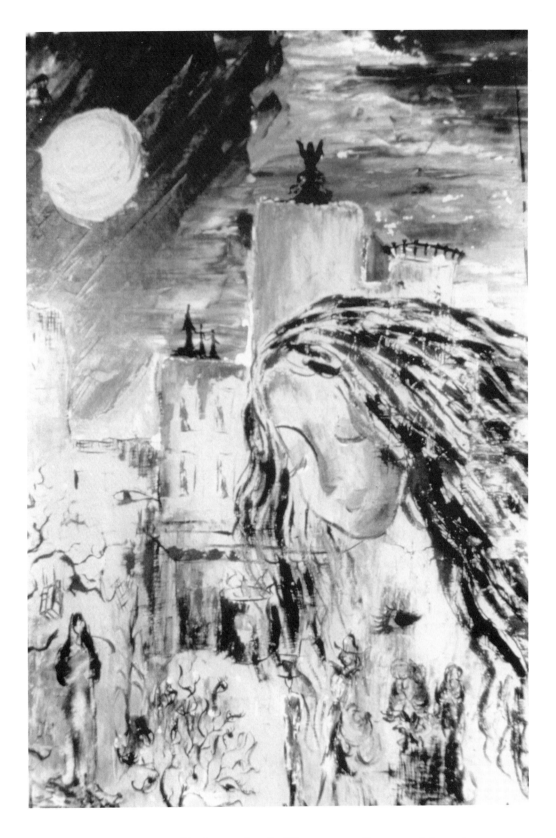

**Yvonne Catchings.** *The Dream* (1975). Oil on canvas. Courtesy of the artist.

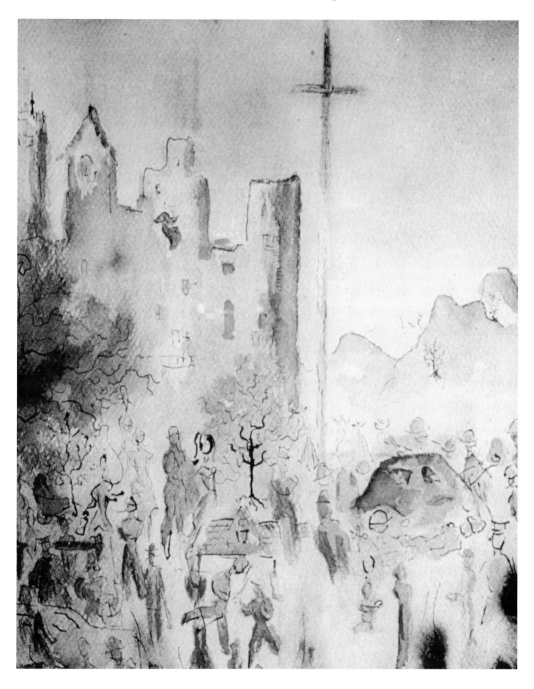

**Yvonne Catchings.** *Search for Peace* (1974). **Watercolor, 14×21 in. Courtesy of the artist.**

**Yvonne Catchings.** *Washer Woman* (1974). **Mixed media, 8×19¹/₂ in. Courtesy of the artist.**

exists a quietude, a stillness attributed partially to the theme itself and secondly to the regimented technique. The idea was totally outlined before work was initiated. Textures followed the established boundaries thus avoiding any technical disturbances that may have resulted from emotional changes in the artist's makeup.

There is an informal balance of contrasting darks and lights along with the varied textured areas which constitute the middle portion of the work. Textures are simple and direct and fulfill the need without overplaying their roles.

Catchings has used different media to forecast her message. Her fluid and transparent watercolors convey a freedom from life's problems and dilemmas. The medium of watercolor has been referred to as non-permanent, a medium of fleeting glances, a temporary recording of nature insufficient to serve the more permanent status of oil or enamel. In a similar vein, Catchings has treated her watercolor approach as a temporary solution to life's shortcomings. It is a short jaunt of a long journey.

Other watercolor landscapes have such titles as *Backyard* and *Through the Columns*. The fluidity of pigment witnessed in *Backyard* (1975) communicates a panoramic view of not a single backyard but those of adjacent surroundings. Totally different in composition is an unusual landscape titled *Through the Columns* (1975), in which the viewer focuses upon a landscape of trees interrupted by monumental columns.

Like most artists, Catchings has altered her style several times throughout her career. She is at her best with such works as *The Detroit Riot* (1968) and *The Dream* (1975). The latter painting in brilliant color reveals a lovely woman in ecstasy, but it is the Expressionist style that arouses Catchings's audience. There is a melodramatic atmosphere created by the golden colors of the female and adjacent buildings and the exciting blue of the skies. Catchings has blended a limited palette with a provocative theme, and a balance between an objective and subjec-

tive approach makes for an austere portrayal. The brilliant sky blue is echoed in the diminutive female figures dotting the foreground.

Similar subjectivity exists in Catchings's painting titled *Dogwood* (see color insert). Details are repeatedly portrayed and consume the entire working surface resulting in a team of individual flowers. Brilliantly colored flowers sparkle against a dark background. *Dogwood* has an all-over pattern of shapes and colors which pleasantly record a segment of nature unfortunately avoided by most artists.

By painting a close-up view of nature, the artist has projected an Abstract version of a realistic or natural aspect of nature. Because space is taken by the images of the dogwood flower, negative space becomes a rarity. The rendering of the flowers, although precise in its initial intent, does not relinquish the Abstract Expressionist notion. There is a sense of the Abstract created by the approach to the painting rather than an intentional attempt to abstract an idea.

In a different vein, but continuing her plea for freedom and peace amid a racist society, is Catchings's watercolor *Search for Peace* (1974), focusing on the cross motif as the symbol for fashioning one's lifestyle. Human figures flourish in the foreground; they are diminutive in stature perhaps to emphasize the insignificance of the human or his reliance upon the omnipotent God. A cathedral-like structure occupies the left of the canvas while the cruciform protrudes into the sky area. Mountain ranges also reside in the background indicating the location of the event.

Catchings admits that a change in style is inevitable and that the presence of several media is both a challenge and a menace. The search for truth is at times sidelined by an introduction of a medium heretofore unused by the artist. It is common knowledge that the appropriate medium is essential to a successful expression. Catchings has utilized several different media to express her notions of life. The medium of watercolor paint

seems to be her most successful means of communication. Yet, it is a small part of the whole in *Washer Woman* (1974). The word "Octagon" is used as an anchor, both in a literal sense and a compositional one. The upper part of the mixed media production pictures a clothesline draped with several items of newly washed clothing. The middle section of the work includes the washer woman positioned in front of the old fashioned scrubboard, and anchoring the entire composition are two rectangular shapes representing cleansing soap. Thus, compositional unity is performed by the elements of art as well as words and letters.

Although adept in the use of differ-ent media, Catchings has excelled in her fluid, Expressionistic use of the oil medium as seen in *The Dream,* which is direct, immediate and deliberate but which reflects the instincts of the intuitive process.

In spite of her comparatively short span of artistic creativity, Catchings has ventured in and out of various styles and approaches. Rather than exploit various media to satisfy artistic needs, Catchings would do well to concentrate on her fluid watercolor style or her Abstract Expressionism in the oil medium. The ability to control one's emotional reaction and transfer it onto a limited working surface as Catchings can is the mark of a masterful artist.

## *Career Highlights*

Born in Atlanta, Georgia, in 1935.

## Education

A.B. degree from Spelman College, Atlanta, Ga., 1955; M.A. degree from Columbia University, New York, 1958; M.M.P. degree from the University of Michigan, Ann Arbor, Mi., 1970; additional graduate study at Wayne State University, 1960, 1963, 1968, 1973.

## Awards

Jerome Award, Spelman College, 1955; Delta Sigma Theta Fellowship, 1968–69; Fellowship, University of Michigan, 1968–70; Honorable Mention (Paintings), Atlanta University Art Exhibition, 1954, 1955, 1958, 1959; Jewelry Award, Scarab Club, Detroit Art Teachers Club, 1964; First Award for Print, Delta Sigma Theta Sorority (Arts & Letters), 1975.

## Selected Exhibitions

Faculty Art Show, Marygrove College, Detroit, Mi.; Northwestern High School with Sculptor Oliver Lagrove, Detroit, Mi.; Festival of Fine Arts, Ebenezer A.M.E. Church, Detroit, Mi.; Columbia University, New York; Wayne State University, Detroit, Mi.; Art Teachers Club, Scarab Club Galleries, Detroit, Mi.; Contemporary Studio, Detroit, Mi.; Piedmont Park Art Festival, Atlanta, Ga.; Beaux Art Guild, Tuskegee, Al.

## Solo Exhibitions

Hilton Hotel, Detroit, Mi.; Plymouth United Church of Christ, Detroit, Mi.

# *Bibliography*

## Books

*Black Personalities of Detroit.* Detroit: Detroit Board of Education, 1975.

Bontemps, Arna. *Forever Free: Art by African-American Women.* Alexandria, Va.: Stephesan, Inc., 1980.

Catchings, Yvonne. *You Ain't Free Yet: Notes from a Black Woman.* Chicago: DuSable Museum of Art, 1976.

Dover, Cedric. *American Negro Art.* New York: New York Graphic Society, 1960.

*The International Directory of Distinguished Leadership.* The American Biographical Institute, 1987/88.

Lewis, Samella, and Ruth Waddy. *Black Artists on Art.* Los Angeles: Contemporary Crafts, 1970.

Matney, William. *Who's Who Among Black Americans.* 1976, 1977, 1980.

*A Print Portfolio by Negro Artists.* Washington, D. C.: National Conference of Artists, 1963.

*Who's Who of American Women.* 13th edition. Chicago, 1983–89.

*The World's Who's Who of Women,* Sixth Edition. Cambridge, England. International Biographical Centre, 1979, 1989.

## Periodical Articles

*Arts and Activities.* January 1960.

*The Instructor.* May 1960.

*The Michigan Chronicle.* March 1971.

*The Instructor.* April 1961.

*The Michigan Reading Journal.* Fall 1984.

*The Instructor.* December 1962, 1984.

*The Detroit Society for Genealogical Research.* Spring 1975.

*Black Art: An International Quarterly.* Spring 1978.

# SIXTEEN

# *Gilda Snowden*

An abstractionist is one who views the world idealistically, transforming the imperfect into something perfect.

The extract (*Arts Midwest,* Oct. 1990) illustrates Gilda Snowden's intent and dissatisfaction with an art form falling short of the mark. Snowden explains her work as "descriptions of how I feel and what I sense about the world around me." The key words are "feel and sense," words especially important to the Abstract Expressionist school of thought. "The world around me" becomes a direct influence on the world within herself. There is no separation of the inner and outer worlds; they are one and the same. Snowden does not distinguish between the two worlds. It is the outer environment that will forever remain uncontrollable and unpredictable. Snowden has learned to see the two different worlds so that the outer world (disasters, floods, cyclones, tornados) serves the inner world. According to Snowden, the joining of the two forces is essential to survival. She has learned to arouse emotions and transfer them to her audience. Her technique of impulsively applying pigment coincides with the unpredictability of natural forces upon the human race.

Nature is both temporary and permanent. It is permanent but its state is everchanging, and it is this unpredictableness that Snowden portrays. What Snowden has accomplished with her sev-eral versions of a single idea is a series of imperfections and perfections: each work may be perfect but by opening the work to further exploration, the perfect rendition gives way to an imperfect continuance.

Snowden has transformed the devastation of the tornado into art by expressing her emotional reactions to it in the most appropriate manner. After several versions, she then has intermixed the tornado image with a self image thus blending the inner and outer worlds into a single expression.

It is through the Abstract Expressionist technique that Snowden is able to perfect a given expression because she may halt the painting process at any given moment. Since the process is the product in the sense that only it has a beginning and the end occurs only at the discretion of the artist, several options become available.

Only Snowden could predict the perfection of her work. In her series of paintings titled *Self-Portrait,* any one painting of the group may be perfect in the opinion of the artist but regardless of its rating, Snowden considers each painting a complete expression.

In each of three versions, nightmarish images vaguely representing a human figure consume the canvas. Snowden has deliberately muted the background in order to fully and completely shock the viewer. Although her self-

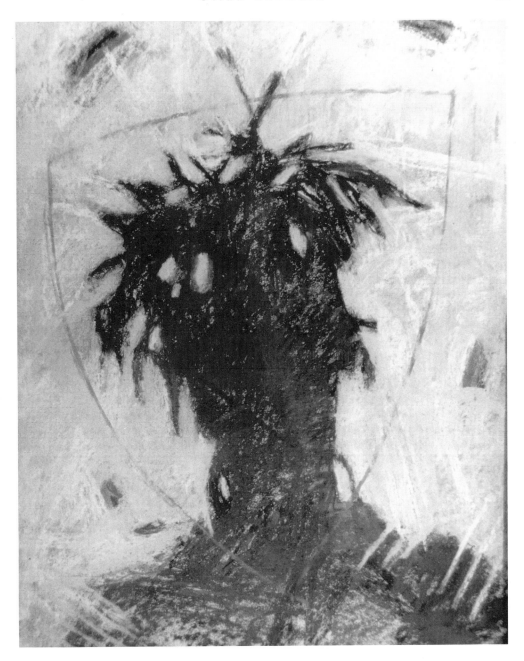

**Gilda Snowden.** *Self-Portrait* **(1991). Pastel, 22×30 in. Courtesy of the artist.**

portraits are personal statements, Snowden wants the world to recognize the effects of the outer world upon the inner world. Even though she represents herself as a human nonentity, she has succeeded in her goal to transform personal tragedies into artistic successes. In other words, she has not fallen victim to circumstances beyond her control, but rather has turned loss into triumph.

The turmoil of childhood is symbolized by the destructive forces which seem to have torn to shreds the artist's existence. The upward swing of brushstrokes reflects a spiritual guidance, and a triangular shield is barely visible but still

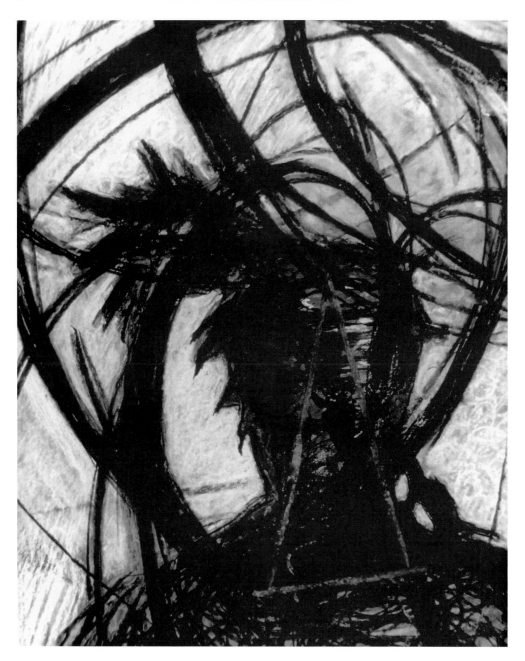

**Gilda Snowden. *Self in Storm* (1991). Pastel, 22×30 in. Courtesy of the artist.**

warrants significant notice. The invisible shield surrounds only the head, suggesting a three-dimensionality by surrounding the image instead of setting in front or behind it. It is a protective shield harboring the childhood memories of a tragic past.

The pastel medium enables the artist to manipulate ideas instinctively while maintaining an authoritative command of the process. Sharp strokes of color moving in different directions create an unpredictability. There is evidence that the artist reconsidered her work during the process; colors overlap as if to correct an existing situation by altering the color

scheme. It is a matter of impulsively using color to justify an emotional need.

The Abstract in art is that which is unidentifiable, that which does not exist as an object or figure of definition. Thus, shapes which are merely shapes, nonrepresentational, are described as nonobjective. Thus, the term nonobjective art, meaning art without objects, defines that which is without a name or title or that which is nonidentifiable as a thing.

In a sense, Snowden's paintings are nonobjective. Although her images are identified by names, their appearances are nonobjective. In other words, without the titles for identification, they would exist as nonobjectives by the layperson.

Snowden admits to being an Abstractionist, but she is not a nonobjectivist. Her works rely on emotionalism based on impulse and instinct.

Referring once more to her series of self-portraits, forms vaguely resemble the head and shoulders. Remnants of the self-portraits are scattered about the canvas as if by a tornado. They appear as impromptu discharges of color satisfying a series of impulses which relate directly to an alarming childhood.

Although Snowden declares herself an Abstractionist, she is rightly classified as an Abstract Expressionist. The intuitive process is evidenced in the accompanying photographs of her paintings. Her *Self-Portrait* series reflects the dramatic episodes of Snowden's childhood. The sharp, thorny strokes of color piercing the portrait create a Surrealistic world. The extremely distorted self-portraits are incorporated in her series of pastels titled *Self in Storm*. In separate works, Snowden has transposed the tornado images atop the self-portraits to form a single tragedy. The tornado has become a personal tragedy, not of a natural cause, but of a symbolic one.

Snowden has superimposed one tragedy over another, an outer environment over an inner environment. The artist has joined the forces of nature and man and manipulated color and space into a frightening artistic experience. The muted negative space becomes an intense, fiery environment, created by energetic swoops of color. The swirling swatches of color representing the tornado resemble the tragic event of a Grünewald crucifixion. Snowden has crucified herself, has crowned her brow with piercing thorns as she pictures herself intertwined with the onrushing winds of the tornado.

Each of the three versions places the self-portrait as the stabilizer upon which the forces of nature act. And it is only with the Abstract Expressionist technique that Snowden could successfully blend two intense images into a single unit.

Snowden's drawings and paintings are deeply personal and consequently alien to the average art patron. And yet, Snowden welcomes speculation and even misinterpretation. The message is never totally ignored. One responds to color, composition and technique if unable to discover the meaning.

Snowden's paintings are essential to her well being. And because of the biographical significance attached to the paintings, the audience is welcome to participate. If accepted by an audience, Snowden then feels that not only is her art being appreciated but her memories and dreams as well are being considered as a universal possibility.

In doing her *Self-Portrait* series and her versions of *Self in Storm*, Snowden cannot account for her creative process. One can only assume that her actions mimic the general procedure of the gesture painter. In order to maintain, over a short span of time, the intensity of action demanded by the artist, the intellect must be alert to impulses so that an alternate route can be selected.

Painting intuitively demands a total coordination of the intellect and physical action along with the emotional control essential to the positioning of the expression upon a limited working surface in a given period of time.

Color that proves disturbing to the artist is generally eliminated by a second

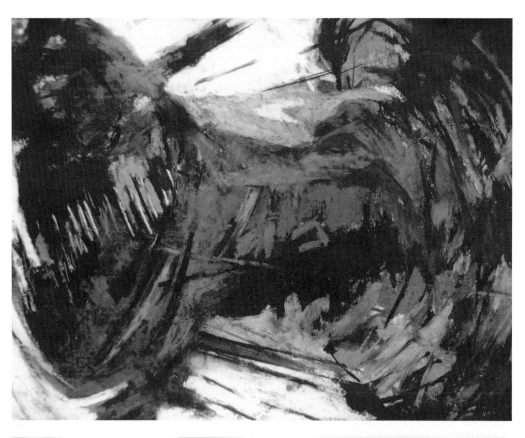

color overlapping the first, or by blending a second color with the first thus creating a third color. It is frequently a trial and error experience which includes both frustration and exhilaration. Goals set in advance are seldom met because the process is halted in midstream, and to anticipate the finished product is futile because of the impulsive nature of the Abstract Expressionist style. There is a completeness to Snowden's work, and yet a sense of an unfinished symphony resides within her *Self-Portrait* series and those works titled *Self in Storm*. It is as if a twist of the brush could alter entire compositions.

Snowden's invitation for her audience to participate in her work is appropriate when regarding her series of tornado drawings and paintings. Snowden fully believes that a sensitive audience can receive her message. Because the devastation created by a tornado is generally well known, the intensified reaction to it by Snowden in her work is not shocking.

Snowden pursued her tornado series as a continuous and uninterrupted event, an everpresent threat and a tragic disturbance of nature. But Snowden had to concern herself with the placing of the natural event into a surface limited in size and shape. In other words, she had to stop the action, and yet, suggest its continuous journey in the form of an artistic expression.

Perhaps her numerous works on this theme account for her attempts to maintain the force of the tornado. Snowden's preoccupation with its devastating forces could account for her several versions, even though each expression is regarded as a total and complete recording. The fact that Abstract Expressionism is a continuous process and the fact that Snowden is rated as an Abstract Expressionist may account for the continuous series of tornado drawings and paintings.

Snowden's pastel drawings are here numbered for convenience. Thus, in *Tornado* XII (1991) Snowden struggles to activate the strong, swirling winds and the destructive funnel with personal tragedies and childhood memories and dreams.

Totally subjective in its occupancy of space, *Tornado* XIII (1990) is an extraordinary display of the power of an earthly phenomenon. Snowden has succeeded in recording the unrest and anxiety of a society engulfed in the torrid onrush of destruction. In *Tornado* XIII, the artist has allowed a segment of sky to surround the tornado funnel. Her palette has also shifted dramatically from yellowish greens to crimson and deep purples. All signs of humanity are swallowed up by swirling masses of the earth's surface. Again Snowden has utilized the entire canvas. The frontal plane has no visual perspective or spatial dimensions. Instead, one witnesses a churning upset of color splashed upon the canvas representing an entangled figure unable to escape.

*Tornado* XIV (1991) retains elements of the first composition, yet they are made all but invisible by the overlapping bodies of color which seem to create a separation of earth and sky. A mixture of reds, blues and purples contrast sharply to the extremes of black and white. Colors are impulsively applied. Others are scratched into the surface. There is a quietude about the scene; colors no longer clash but blend and mesh into a serene atmosphere. Even though reds and blacks shoot upward and pierce the environment with sharp attacks of the brush, there is a serenity, a calm before the storm. Yet there is evidence of the storm as well.

Remnants of her *Self in Storm* series occur in the tornado series. In *Tornado* XV (1991), the initial swooping lines, which resemble a crown of thorns in *Self in Storm*, are partially obliterated by a shroud of yellows and reds.

Snowden's series of tornado drawings differ from each other but still retain

*Opposite, left:* **Gilda Snowden.** *Tornado* **XII (1991). Pastel, 30×40 in. Courtesy of the artist.** *Right:* **Gilda Snowden.** *Tornado* **XIII (1990). Pastel, 30×40 in. Courtesy of the artist.**

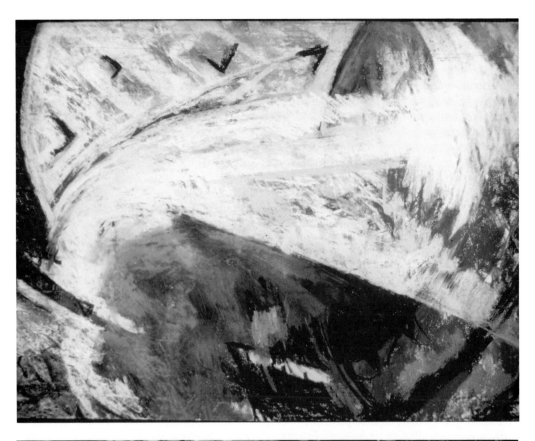

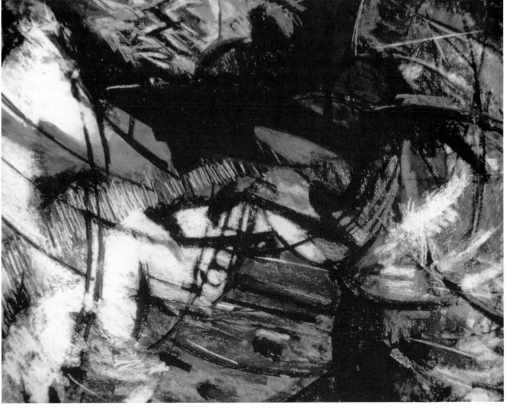

major similarities. It is as if an element is neglected in one version but adopted for another. *Tornado* XVI (1991) reverts back to the swirling winds, cloud funnels and threatening skies. A return to previously depicted images is a typical act of the artist, especially the Abstract Expressionist. *Tornado* XVI could have been titled *Typhoon.* The dynamic swirls of color in the foreground remain a mystery. What do the coiling, elongated, colorless shapes represent? To Snowden, literal translation remains insignificant. The releasing of one's emotions is foremost. The resulting artistic expression is a bonus, and if the art product is a success, then one has a celebration. Each succeeding pastel drawing of the tornado series seems to add another dimension.

*Tornado* XVII (1991) includes different tones of sienna, symbolic of the human anatomy, and coupled with gushes of red creates a terrifying resemblance to the Crucifixion that Christians remember annually with Good Friday services. The tornado is no longer a cloud, funnel or a whirlwind; instead, Snowden shows the effects of the tornado upon humanity. There is an upward surge of color which could apply to several concepts. Knowing the title does not necessarily guarantee understanding a painting.

And in numbers XVIII and XIX of the tornado series, Snowden has returned to the funnel cloud as the focal point of interest. The flashes of red pigment evident in *Tornado* XVII remain in *Tornado* XVIII (1991), but are repositioned to serve a different compositional need. The swirling dark clouds contrast sharply with the lighter sky creating visual depth.

As mentioned earlier, the use of recurring objects and symbols is a familiar practice of the Abstract painter. Even though a common denominator threads its way through this thematic series, each pastel drawing and painting exists on its own merits. One can ignore the title and

appreciate each expression as a singularly conceived and executed portrayal.

*Tornado* XIX (1991) delves slightly into the color-field aspect of Abstract Expressionism. Split in half by a piercing dagger-like diagonal, *Tornado* XIX resembles a huge concrete sculpture anchored at its base by swirling strands of color. There are bits of the tornado theme, but the powerful work leans toward the eradication of any tornado remembrances.

Again, one speculates on the presence of the human being found in what was initially conceived to be a whirlwind. The unusual form resembles a rocket positioned for take-off instead of a destructive tornado.

Finally, *Tornado* XX (1991) has relinquished all aspects of the original tornado drawing. Instead, one witnesses a dynamic display of the overlapping and interpenetration of solid blocks of color. It is a superlative array of the destructive forces of a tragic natural phenomenon. And yet, the cause of the tragic event remains unidentified so that the viewer has the pleasure of individual interpretation. Snowden has always favored audience participation and *Tornado* XX is ideal for such involvement.

The inner world of the artist and the world outside the artist are seldom brought together in unison. The artist possesses the unique opportunity of engaging in a compatible blend of experiences resulting in an aesthetic experience and its ensuing product. This artistic product, in turn, permits society en masse to enjoy the union of two opposites, sometimes in direct conflict, in the form of an artistic product.

Snowden has resolved personal problems by uniting the cause of the inner problems with the natural tragedies of the outer world which affect the inner worlds of others. And her drawings and paintings reveal the agony and the anguish by sustaining the action which

*Opposite, left:* Gilda Snowden. *Tornado* XIV (1991). Pastel, 30×40 in. Courtesy of the artist. *Right:* Gilda Snowden. *Tornado* XV (1991). Pastel, 30×40 in. Courtesy of the artist.

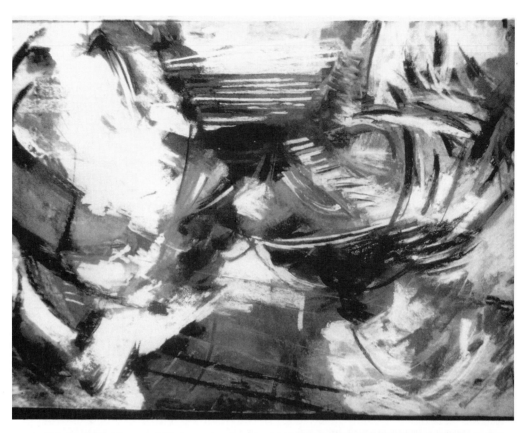

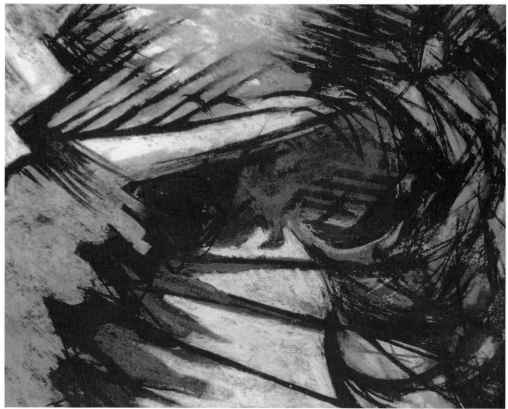

created the problems in the first place.

Abstract Expressionism continues to flourish because it allows the artist the freedom to alter directions in midstream. By the same token, this freedom to change is a difficult way of painting. In spite of Snowden's seemingly random expression, her placement of color demands an intellectual response to the very things that appear reckless and abandoned.

In a sense, the process of serializing her work sets the three stages of development. First, the self-portrait image of extreme distortion becomes the result of outside influences—the outer environment. Secondly, the cause of the self-portrait, namely, the tornado, is depicted. And finally, the cause and the effect are pictured in a single portrayal titled *Self in Storm.* One can only marvel at Snowden's approach to Abstract Expressionism and hope for continued exploitation and advancement of her inner and outer associations.

In a directed statement to this author, Snowden regards her work as autobiographical.

My work at this time (1990) runs along three parallel, yet related tracks. I have chosen the tornado, the self-portrait, and the album as the constants as far as image or concept is concerned. These themes manifest themselves physically as large oil paintings, pastel drawings and construction/ assemblages. Basically they all refer to my nightmares (tornado); my personal identity (silhouetted self-portraits); and the environment I live and work in (assemblages).

In doing these works it is my goal to explore and illustrate universal feelings, as well as my own personal view as a black female artist. It is my wish that my work creates dialogue and discussion.

I have chosen the tornado as a symbol for the experience that shatters, without warning, the equilibrium that

is precious to the human psyche. It speaks to the recklessness of life and the unpredictability of nature. The figure, being a part of this nature, is buffeted and bounced, but the strength of her convictions, both artistic and personal, keeps her standing despite the power of the storm.

I am intrigued with the idea of the portrait, the album as repository, and exploring diaristic concerns through drawing. My portraits are not obvious representations of a person, but are an attempt to capture the essence of that person through their favorite shapes, lines and colors.

Snowden has harnessed her autobiographical energies and in the process of her intuitive approach to art, has exploded them upon canvas with a control of her medium. The result is not a mass of apparent confusion or a chaotic environment, but a rhythm of visual poetry. The tornado images symbolize the unpredictable storm that shatters one's future dreams and the confidence that parallels those dreams.

Snowden's tornado series seems everpresent and eternal in its stubborn drive to upset any equilibrium nature might offer. It is this realization that Snowden recognizes in life, that nothing is certain and that one should forever be alert to nature's devastating effects on mankind.

A change of medium is always difficult for the artist. The medium of oil paint, for example, cannot be approached with the same temperament as one would utilize the watercolor medium. The switch from pastel to oil paint, similarly is alien enough to cause a bit of consternation. Snowden's switch, although cumbersome, has nonetheless retained the vibrancy of her pastel drawings of the same theme. The spontaneous linear work was replaced with exuberant blocks of color which ideally suited her medium change.

Snowden has spoken frequently of

*Opposite, left:* **Gilda Snowden.** *Tornado* **XVI (1991). Pastel, 30×40 in. Courtesy of the artist.** *Right:* **Gilda Snowden.** *Tornado* **XVII (1991). Pastel, 30×40 in. Courtesy of the artist.**

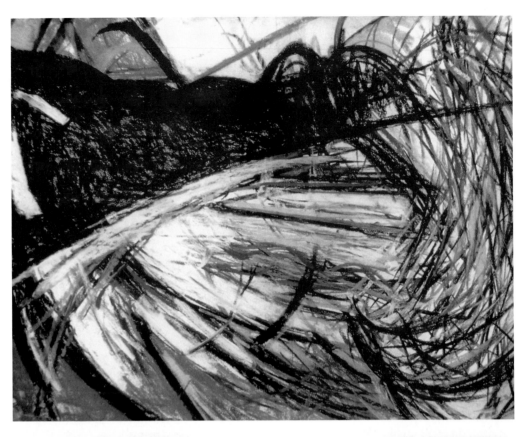

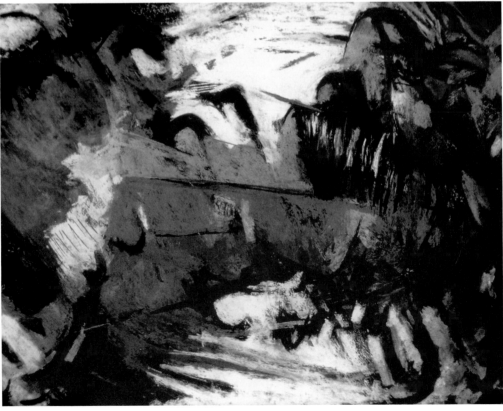

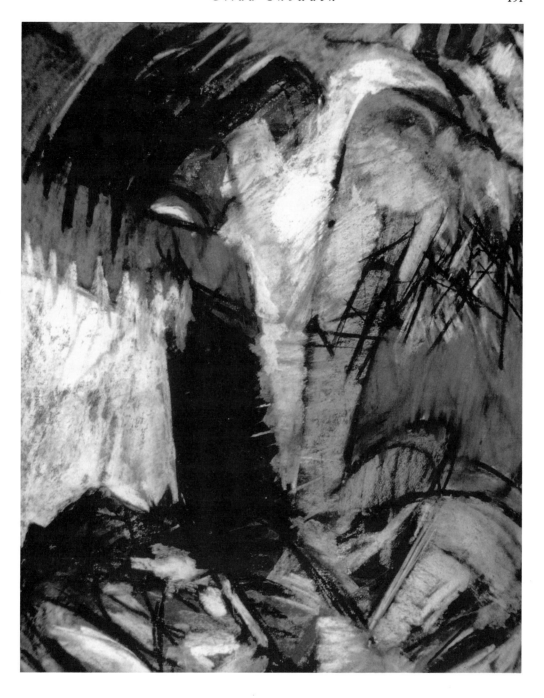

**Gilda Snowden.** *Tornado* **XX (1991). Pastel, 30×40 in. Courtesy of the artist.**

*Opposite, left:* **Gilda Snowden.** *Tornado* **XVIII (1991). Pastel, 30×40 in. Courtesy of the artist.**
*Right:* **Gilda Snowden.** *Tornado* **XIX (1991). Pastel, 30×40 in. Courtesy of the artist.**

the exploitation of art media. of being a Renaissance person of the arts. She has already proven herself capable with several art media and techniques. One only hopes that the single medium which best expresses her innermost thoughts and emotions will deepen and expand her work beyond its current limitations. Currently her pastel drawings create a dramatic appeal far superior to her oils and her constructions. Even though her sculptures draw upon an unlimited spatial environment, they lack the dramatic effects of her boisterous, intuitive pastel renderings which are limited only by the artist. But being a more permanent medium, her eventual venture into oil painting is assured, and because of Snowden's seemingly endless energy and enthusiasm, success will soon be bountiful.

Little word has been said of her constructions even though they comprise one-third of her thought processes and her production. Called the *Album Series,* this work preceded her more Expressionistic work in pastel drawing and oil painting. In a *Metro Times* article by Manon Meilgaard, she has described her *Album Series* in the following manner:

> The constructions start from a fairly flat base and then are built up in order to have a form that projects out into space. They are then painted with a paint called encaustic, which is an ancient Greek technique using beeswax as a base. The paint is applied hot and

cools immediately upon contact with the surface, so the resultant layer of color looks as if it grew along with the piece.

> The names of the constructions are derived from the identities of close friends. Somehow I want to imbue my work with the personalities of the people I know and love. I feel very uncomfortable with the idea of numbering art objects; this is too impersonal a procedure. Usually during the course of the creation of a piece, I begin to get feelings or clues about the relationship between that piece and the personality of a friend. What is happening is that I am projecting those qualities myself. Thus I see the creation of a work of art as being a dialogue between myself and nature, the particular nature being a more personal one.

It is not uncommon for artists of Snowden's intellectual and emotional drive to experiment early during their artistic career. Frequently it takes a lifetime to accommodate the several attempts at experimenting with and exploiting different media. However, it seems that in the case of Snowden, that achievement has been reached with her mastery of the pastel drawing technique. Her graduation to the medium of oil is further proof of her advancement into the more permanent media. Gilda Snowden has a wealth of experiences to share with others. Let us hope that her audience is receptive to her offerings.

# *Career Highlights*

Born in Detroit, Michigan, in 1954.

## Education

B.F.A. degree in Painting, Wayne State University, Detroit, Mi., 1977; M.A. degree in Painting, Wayne State University, Detroit, Mi., 1978; M.F.A. degree in Painting from Wayne State University, Detroit, Mi., 1979.

# Awards

Graduate Professional Scholarship, Wayne State University, 1977–79; Michigan Council for the Arts Individual Artists Grant (Painting), 1982; Michigan Council for the Arts Individual Artists Grant (Painting), 1985; Michigan Council for the Arts Individual Artists Grant (Sculpture), 1988; Tannahill Faculty Grant, Center for Creative Studies, 1990; Arts Midwest NEA Regional Fellowship, 1990; Michigan Council for the Arts Individual Artists Grant (Painting), 1990.

## Selected Exhibitions

J. L. Hudson Gallery, Detroit, Mi., 1982; Park West Gallery, Southfield, Mi., 1982; Artcite Gallery, Windsor, Ontario, Canada, 1984; Cranbrook Academy of Art, Bloomfield Hills, Mi., 1984; Race Street Gallery, Flint, Mi., 1984; Wayne State Community Arts Gallery, Detroit, Mi., 1985; Detroit Institute of Arts, Detroit, Mi., 1985; Mt. Clemens Art Center, Mt. Clemens, Mi., 1985; Artemisia Gallery, Chicago, Il., 1986; Cranbrook Academy of Art Museum, Bloomfield Hills, Mi., 1987; Laundale Art Center, University of Houston, Houston, Tx., 1987; Nawara Gallery, Walled Lake, Mi., 1987; The Museum of Science and Industry, Chicago, Il., 1987; University of Michigan Museum of Art, Ann Arbor, Mi., 1988; Diverse Works Gallery, Houston, Tx., 1988; Michigan's African American Artists, a traveling exhibition sponsored by the Art Center of Battle Creek; Meadowbrook Art Gallery, Oakland University, Rochester, Mi., 1989; Slusser Gallery, University of Michigan, Ann Arbor, Mi., 1989; Pontiac Art Center, Pontiac, Mi., 1989; Detroit Artists Market, Detroit, Mi., 1989; National Conference of Artists Gallery, Detroit, Mi., 1989; Broadway Gallery, Detroit, Mi., 1989; Artemisia Gallery, Chicago, Il., 1990; Eubie Blake Center, Urban Services Cultural Arts Program, Baltimore, Md., 1990; Flossie Martin Gallery, Radford, Va., 1990; Wayne County Council for the Arts, Wayne County Building, Detroit, Mi., 1990; Ford Gallery, Eastern Michigan University, Ypsilanti, Mi., 1990; Art-in-General Gallery, New York, 1990; Western Michigan University, Kalamazoo, Mi., 1990; Mark Masuoka Gallery, Las Vegas, Nv., 1990; Islip Art Museum, Long Island, N.Y., 1991; Detroit Institute of Art, Detroit, Mi., 1991.

## Solo Exhibitions

Willis Gallery, Detroit, Michigan, 1981; Detroit Artists Market, 1982; Detroit Council for the Arts, Detroit, Mi., 1984; 55 Peterboro Gallery, Detroit, Mi., 1985; Paint Creek Center for the Arts, Rochester, Mi., 1987; Broadway Gallery, Detroit, Mi., 1988.

# *Bibliography*

## Periodical Articles

Brown, Jocelyn. "Creative Artist/Instructor Seeking to Encourage Others." *Michigan Chronicle*, September 12, 1982.

Colby, Joy Hakanson. "Art by Committee: Local Artists Draw Battle Lines Over DIA's Michigan Program." *The Detroit News*, April 23, 1989.

––––––––. "Is Black Art Booming in Detroit?" *The Detroit News*, August 27, 1986.

––––––––. "The Last Frontier: Commitment from Black Collectors Sparks Renaissance of African American Art." *The Detroit News*, January 9, 1989.

DeRamus, Betty. "Ugly Reality Takes Walk in Shoe Sculpture." *The Detroit News*, March 6, 1990.

Dunmore, Gregory and Monica Morgan. "About Town—Culture Break." *Michigan Chronicle*, September 24, 1988.

Gibbs, Michelle. "A Rumbling Inside." *City Arts Quarterly* (Fall 1989).

Grannum, Hugh. "Blacks in Detroit. Making Inroads in the Art World." *Detroit Free Press*, December 16, 1990.

Griffin, Jo. "Display Combined Old, New Cultures." *Jackson Citizen Patriot*, February 18, 1988.

Gustafson, Jim. "Working: She Stretches the Boundaries of Her Art." *The Detroit News*, March 15, 1987.

Hansel, Betsey. "Her Challenges in Art Has Layers of Secrets." *Detroit Free Press*, December 4, 1986.

Jones, Dawn. "Catalyst: Gilda Snowden." *Arts Midwest Monthly Magazine* (October 1990).

Mannisto, Glen. "Artspace—The Year in Review." *The Metro Times*, December 19–25, 1990.

Meilgaard, Manon. "An Artist in the Family." *The Metro Times,* May 13–20, 1986.
_____. "Local Artists and the DIA." *The Metro Times,* December 18–26, 1988.
_____. "The Year in Review." *The Metro Times,* December 18–26, 1988.
Miro, Marsha. "Blacks in Detroit. New Bursts of Creativity." *Detroit Free Press,* December 16, 1990.
_____. "Commitment Ties Collector Robert Perkins to Detroit Artists." *Detroit Free Press,* February 15, 1991.
_____. "Diversity and Unity Mark New Cranbrook Exhibition." *Detroit Free Press,* 1986.
_____. "Framing a Life Around Art." *Detroit Free Press,* October 1981.
Ollivierra, Neil. "Hot Dates: Luchs and Snowden Exhibition." *The Metro Times,* October 24–30, 1990.
Puls, Mark. "Interview: Gilda Snowden." *The South End,* October 5 and October 12, 1985.
Roth, Karen. "Painting Surfaces: The Work of Snowden & Sharpe." *Detroit Focus Quarterly* (August 1982).
Sinclair, John. "Artist Calling." *The Metro Times,* January 18–24, 1984.
Sterling, Keith. "Five Detroit Artists." *City Arts Quarterly* 4, no. 3/4 (Spring/Summer/Fall).
_____. "Gilda Snowden: A Whirlwind of an Artist." *Michigan Chronicle,* March 10, 1990.
Teasley, Marie. "NIFTA Highlights & Builds Bridges for Black Artists." *Michigan Chronicle,* January 21, 1989.
Wheaton, Marilyn. "October Exhibit Depicts Michigan Experience." *Detroit Market for Artists Newsletter* (Winter 1988).
Woodson, Shirley. "The History of Black Art in Michigan." *City Magazine* (March 1987).

# Reviews

Acosta, Dan. "No Brand Art." *Health Care News,* December 15, 1982.
Cantu, John Carlos. "Dreams Hold Fast in Afro-American Exhibition." *Ann Arbor News,* February 21, 1988.
Colby, Joy Hakanson. "Art for Life." *The Detroit News,* May 10, 1990.
_____. "Fit for a King: Artists Pay Tribute to Martin Luther King." *The Detroit News,* February 4, 1988.
_____. "Form of Color." *The Detroit News,* May 17, 1988.
_____. "Gilda Snowden/Chris Whittey at the Michigan Gallery." *Detroit News,* November 11, 1985.
_____. "Gilda Snowden Gives Tornadoes a Good Image." *The Detroit News,* September 7, 1988.
_____. "Invitational at Feigenson Gallery." *The Detroit News,* March 23, 1986.
_____. "Metro Detroit Shows Celebrate Black Heritage." *The Detroit News,* February 17, 1989.
_____. "Nine Lives Give Food for Thought at Focus Gallery." *The Detroit News,* October 19, 1990.
Kirchner, James. "Currents—Jazzonia Group Show." *New Art Examiner* (December 1982).
McCoy, Antoine. "Artscape Detroit." *City Arts Quarterly* 1, no. 3 (1985–86).
Malinowski, Marianne. "55 Peterboro Gallery." *The South End,* April 2, 1986.
Mancewicz, Bernice. "Six Explore Ritual, Myth and Symbol." *Grand Rapids Press,* February 5, 1984.
Meilgaard, Manon. "Update: Detroit Artists—Rich, Diverse." *The Eccentric Newspaper,* February 10, 1986.
Miro, Marsha. "Aids Benefit Arouses Local Artists' Generosity." *Detroit Free Press,* May 4, 1990.
_____. "Artists Offer Exhibit of Culturally Rich Variety." *Detroit Free Press,* October 30, 1990.
_____. "Detroit's Energy and Tension Reflected in This Artist." *Detroit Free Press,* July 5, 1981.
_____. "Michigan Artists Mix Ethnic, Contemporary." *The Detroit Free Press,* January 29, 1989.
Shannon, Helen. "One Person Show at 55 Peterboro Gallery." *Detroit Focus Quarterly* (December 1985).
Slowinski, Dolores. "Black Perspectives in Art." *New Art Examiner* (May 1985).
Williams, Peter. "Gilda Snowden/Broadway Gallery." *Detroit Focus Quarterly* (Winter 1989).
Yolles, D. Sandra. "Gilda Snowden." *Art News* (December 1988).

# SEVENTEEN

# *Malkia Roberts*

Malkia Roberts has combined the pleasant things of life with a quiet and subdued emotional response, reflecting a sincere joy of process. And yet, in her poignant portrayal *Black Is Beautiful* (1975), she has dramatically exposed the black image in a compelling and compassionate manner. Her commitment to her heritage is beautifully expressed. It is a work of art which not only enhances the creative process which she proudly represents but praises the content of her subject. She is proud of her heritage and her deliberate inclusion of the obvious joys of life speaks for an artist truly dedicated to the cause of humanity.

Roberts has used the vertical panel for *Black Is Beautiful,* a format that lends itself to an automatic drama. The black image is realistic in style, however it is nestled in a troubled background.

The tense human figure is positioned amid an abstract, emotionally charged environment which is at times unidentifiable. Thus in spite of economic and social circumstances, the black figure is proud to engage in whatever tactics are available to further the cause of the black race. This is a matter of conscience. Thus, although personal in choice, Roberts's execution of her idea results in a product on a masterful level.

Emotions need not always be dramatic as proven by Roberts's approach. The subtleties of her work place her style midway between intellectualism and emotionalism. This unique balance, however, hinges on the perilous flip-flop of emphasis. One tends to accept a greater responsibility for either approach.

*Black Is Beautiful* combines a realistic subject matter with an Abstract Expressionist environment. The artist avoids a contradiction and confusion of styles by uniquely blending the two techniques with a natural flow of color. The realistic subject matter leans toward subjectivity as the background is of images of recognizable objects. Each style invades the territory of the other, but the intrusion is subtle and hardly discernible.

Roberts's personal attachment to her black heritage is expanded and deepened in *Black Madonna* (1969). Roberts's title has nothing to do with theology; rather, it is chosen as a reinforcement of the black race. It is customary to celebrate international holidays in one's own cultural setting. Aside from the American tradition, Roberts has extended the notion into an ethnic environment. And her choice, her personal choice, may remain a mystery perhaps even to herself, for the artist is not always accountable for subjective beckonings which occur in spite of oneself.

Regardless of the titles, Roberts's work is vital and it exists in an atmosphere of controlled explosiveness. Although Abstract Expressionist in style, her interpenetratory environment is pleasant and subtle in its emotional response.

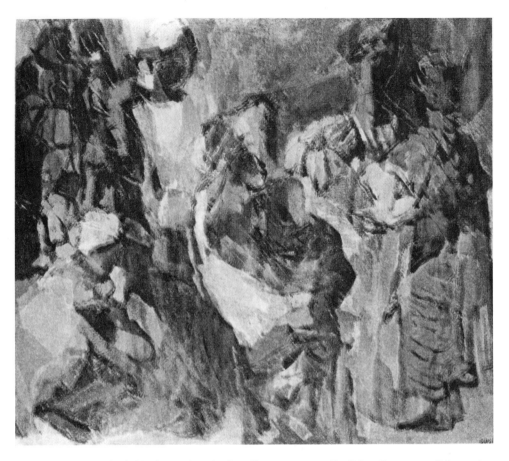

**Malkia Roberts.** *Black Madonna* **(1969). Acrylic on canvas, 48×42 in. Courtesy of the artist.**

*Black Madonna* is beautiful to behold, not because of its content but because it is a fine painting. Roberts maintains a balance of color refreshing in its choice and its application.

The subject of *Black Madonna* illustrates and reaffirms her loyalty to the continuous efforts of blacks to justify their existence not only as creative individuals but as free to pursue any course worthy of their talents.

Her purpose of expressing the plight of the black man in a materialistic society compliments her and places her above those artists whose sole purposes are commercial gain or ego satisfaction. Roberts's use of a God-given gift in response to an age old problem fulfills the demands of a personal conscience. Even her subject in *Black Is Beautiful* pensively envisions the future while ques-

tioning his fate. The subject stands firm amid emotional turmoil. Even though Roberts professes that her work is absent of intellectual pursuance, its presence is obvious. The intermingling of abstract shapes of color is not happenstance; the intellect is indeed at work. The complexity of design and its attractive blend of parts is proof. Perhaps her reference while creating is the exploits of the non-objective artists whose fates rely upon the juxtaposition of sterile shapes of color. It is Roberts's blend of intellect, emotions and message that is her strength as an artist.

In order for black art to be mainstreamed, it needs first to be identified. According to Roberts, it needs to be liberated from slavery.

In her painting titled *Black Heritage* (1969), Roberts incorporates the same

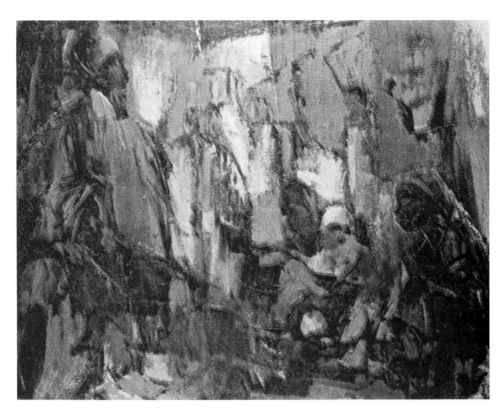

**Malkia Roberts. *Black Heritage* (1969). Acrylic on canvas, 48×42 in. Courtesy of the artist.**

sinister shapes of color witnessed in *Black Madonna*. The interior scene exudes suggestive abstract images which lack definition, and yet, *Black Heritage* resembles an African scene. Shades of a color lie adjacent to each other. Black figures emerge from a semi–Abstract environment.

The subjectivity of the work makes intrigue the potent force of *Black Heritage*. Mysteriously secretive images roam the canvas treating the viewer to an exciting journey. Roberts's insistence upon black definition is tempered by her semi–Abstract approach. Her process, considered to be Abstract Expressionism, becomes significant to the product that follows.

Roberts's powerful message is again seen in her provocative *Natural Woman* (1970). Brilliant colors sweep across the canvas in Abstract Expressionist fashion. One is reminded of de Kooning's Woman Series although Roberts's version is refined to a tonal clarity.

Visual depth is created unusually as colors recede and advance in a parade of undulating images, undefined and yet clear in their spontaneity and illumination. Fiery reds and yellows blaze in unison in an upward sweep of the vertical plane. The title may be a bit illusive but it matters little. The strength of the painting is found in technique. Colors erupt to form a powerful statement not unlike her semi–Abstracts *Black Madonna* and *Black Is Beautiful*.

Throughout her career, Roberts has experimented in the Abstract Expressionist movement which is characterized by its freedom from tradition and its exclusion of representational content. Since Abstract Expressionism is based on the intuitive response to a given idea or a natural event without respect to visual representation, the intellectual or visual senses are utilized prior to the act of drawing. Mind, spirit and body work simultaneously. Throughout the process,

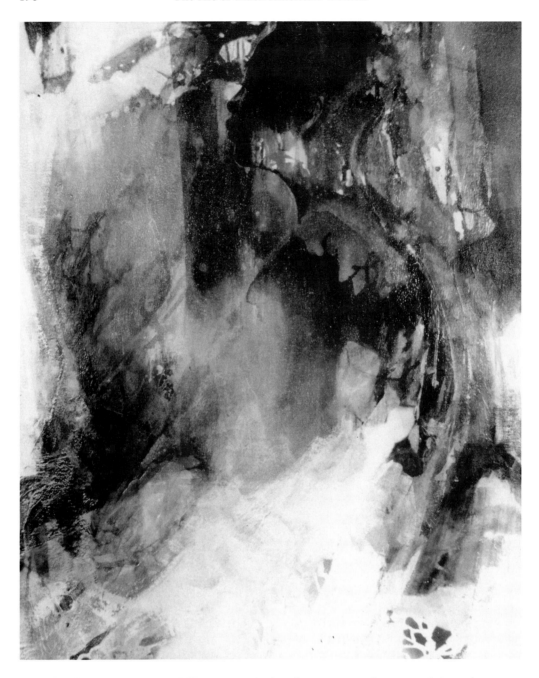

**Malkia Roberts.** *Natural Woman* **(1970). Acrylic on canvas. Courtesy of the artist.**

intervals of disruptions are reflected in the final outcome. The emotional flow of line or space, if halted by intermittent results caused by intellectual assertions, continues after the emotional stage is once again set.

Roberts relies upon individual emo-tions, subjective reactions to life which are unlimited except for the physical con-finement of the working surface. Apparent disorganization and irrational composition, if so viewed on canvas, resemble similar factors in human nature. Nature is not predictable and it is this

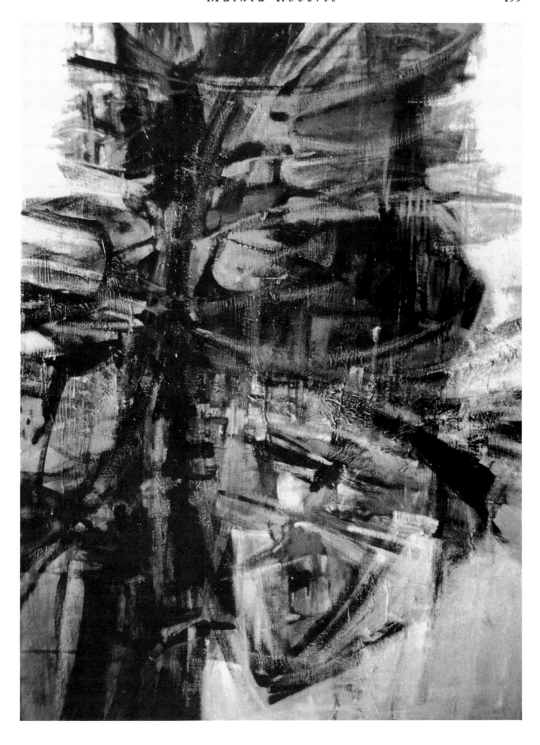

**Malkia Roberts.** *Aquarians Can Fly* (1984). Oil on canvas, 48×52 in. Courtesy of the artist.

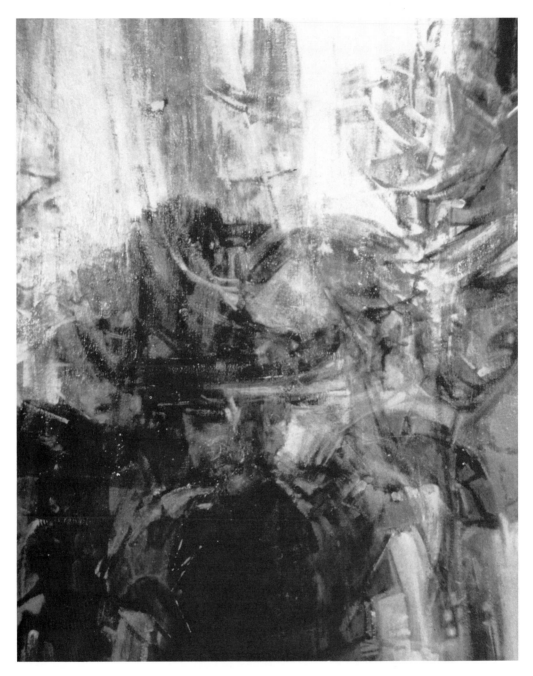

**Malkia Roberts.** *My Lord, What a Morning* **(1981). Acrylic on canvas, 36×54 in. Courtesy of the artist.**

uncertainty that has beckoned Roberts to the Abstract Expressionist school. Mechanical images, whether artistically expressed in the form of streamlined, geometric, non-objective paintings or in the form of subjective stimuli, are avoided in favor of personalized statements in accordance with emotional needs.

Acutely aware of personal uncertainties caused by intense emotional reactions to the future of mankind, Roberts

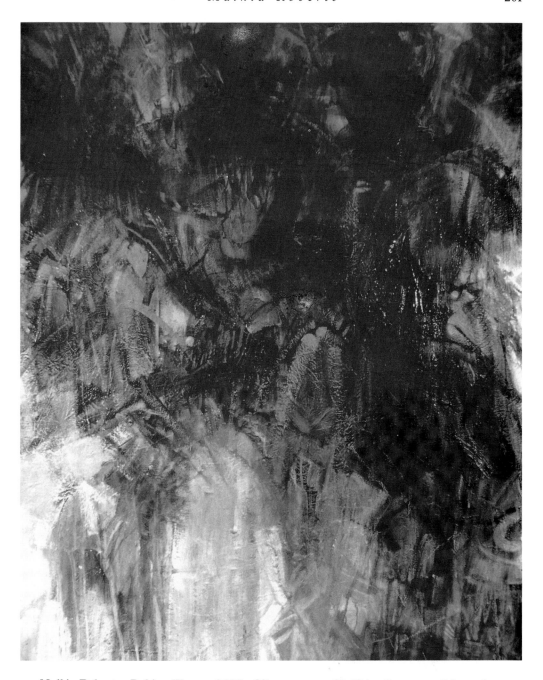

**Malkia Roberts.** *Bahian Women* **(1989). Oil on canvas, 50×58 in. Courtesy of the artist.**

has abolished traditional and acceptable premises and has welcomed the instinctive, the emotional, the unprepared and the accidental—all forms of expression that lay bare the inner emotions of the artist who has bewailed the ultraorganized portrayal of visual identities.

Roberts has spoken of the reliance on the past, the acceptance of the present and the anticipation of the future. She expressed this belief in her work titled *Spectrum* (see color insert). The female form is a reflection of the past. The present is evidenced in the Expressionistic

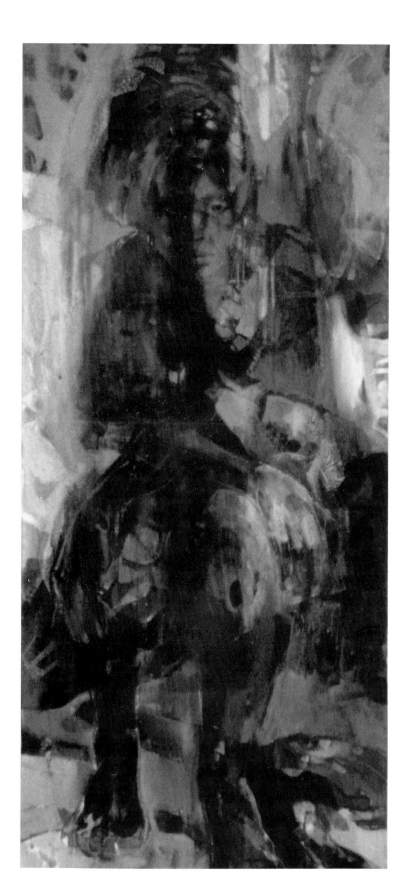

style, and the anticipation of the future is reflected in the upward tilt of the head and the eyes peering heavenward. The entire expression is consumed in a fiery spread of shades of a single color which automatically eliminates the possibility of negative space and ensuing objectivity.

Roberts and other Abstract Expressionists rely totally on intuitive responses, not necessarily to an idea but to the process itself. A brushstroke of color presupposes a counter reaction, and succeeding applications of paint progress toward an eventual conclusion. The process of painting becomes the product of painting. Its eventual outcome is uncertain just as each brushstroke becomes an adventure into the unknown.

In the case of *Aquarians Can Fly* (1984), the artist has combined intellect and emotion in creating a compelling display of intuitive brushstrokes. The result is an exciting interweaving of geometric shapes which have no definitive identities. Instead, a loose, suggestive combination of colors overlap and interpenetrate into an exotic display. The viewer is allowed to utilize the title in a speculative manner, but the pleasing array of color composed in a satisfying manner is reason enough to accept it as a marvelous example of the Abstract Expressionist movement.

Roberts has been regarded as both a gesture painter and an action painter. The action painter considers the total body in the creative process. The size of Roberts's canvases suggest that indeed the total body participates in the artistic expression. It is conceivable that Roberts's body moves with the distribution of the paint in order to guarantee a unified composition. Whether the working surface stands vertically upon an easel or lies flat upon a horizontal surface matters little. Regardless of the physical posture, Roberts's style is difficult to master because it relies completely on the total union of mind and spirit. Interruption of the process not only alters the expression, but destruction may result leading to a new beginning.

Such paintings as *My Lord, What a Morning* (1981) and *Bahian Women* (1989), rely on the point of interruption of the creative process. In *My Lord, What a Morning,* a single color is exhausted throughout the canvas before a second or third color is applied. After the initial charge of blue on white, a second color is considered in terms of its compatibility with the two extremes of blue and white. The interpenetration method creates color change and affects the original color. As different colors are added to the painting, emotional and intellectual changes occur warranting anticipated conclusions.

As colors unify and intensify the canvas, linear qualities give way to solidified areas. *My Lord, What a Morning* has arrived at that point. It seems like a war of lines and swirling shapes, jabbing, overlapping and interpenetrating. A constant battle for space occurs in which lines are identified, disguised, obliterated and re-inserted in a flow of energy which recedes and advances according to emotional reactions. The danger of over-indulgence is forever present in Roberts's work. Instinctive responses coupled with intellectual precision, therefore, must be primed for immediate interaction. The ability to stop is as essential as the ability to start, and the element of change from free flowing rhythmic patterns to piercing, jagged intersections presents a dramatic panoramic view of an idea in the abstract.

Perhaps more dramatic is her painting titled *Bahian Women*, which leans toward images which emerge amid scrawling, scribbling areas of varying degrees of widths. Fluidity of line is less prominent, and human images seem to enhance the curious distortion. Portions of the human body penetrate the surface, difficult to discern, but nonetheless, appropriate to the highly suggestive expression.

*Opposite:* **Malkia Roberts.** *Mother of All Mothers* **(1974). 38×60 in. Courtesy of the artist.**

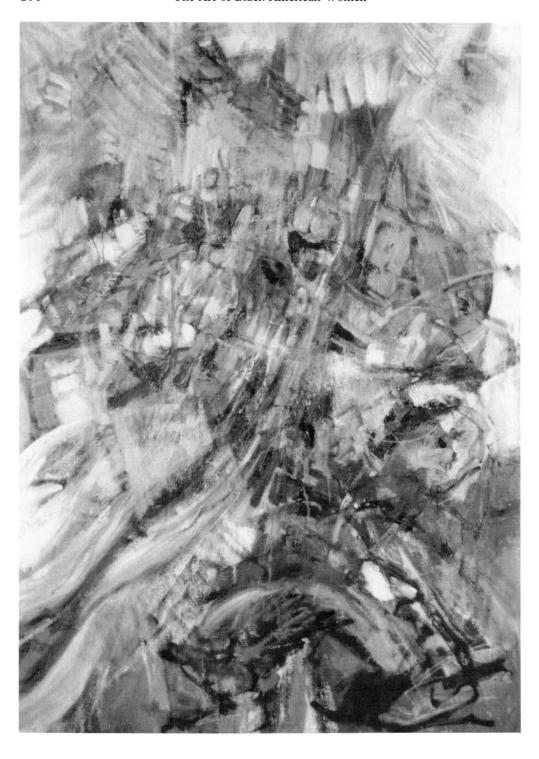

**Malkia Roberts.** *Celebration* **(1991). Oil on canvas, 45×50 in. Courtesy of the artist.**

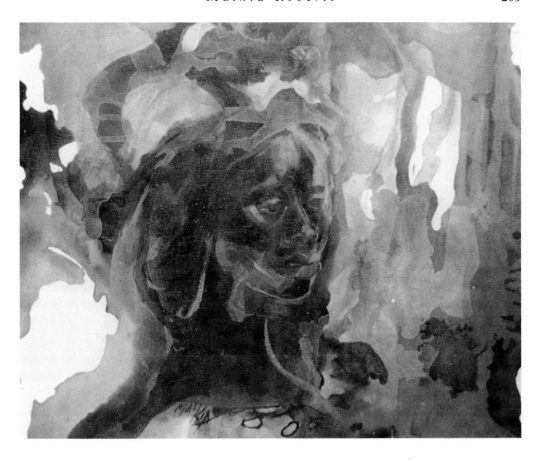

**Malkia Roberts.** *Yoruba Blue* **(1973). Acrylic on canvas. Courtesy of the artist.**

Roberts's unpredictable style seems appropriate for the spiritual qualities and compassionate emotions of her experiences. In *Bahian Women,* Roberts insists upon brushwork, scraping and reassertion which enables points of intersection to be more intentional, and consequently more dramatic than the casual meanderings of accidental crisscrossings.

Concern for the painting's existence determines ingredients, which according to Roberts are resolved through the satisfactory expression of the idea. Decisions are made and executed seconds after initial statements are made. A smear, scrape or overlay suddenly opens wide or shuts off interpretations of new ideas. Dissatisfactions will occur and this state is obvious as Roberts struggles with the arrangement of color contrasts and

spatial identities. It is common to change an image several times within a given expression, and the insertion of new ideas over a single area may occur as frequently as the artist deems it necessary for the successful completion.

Roberts's ideas have much to do with technique. Her style of painting wavers little as different ideas are introduced. A feminine object treated by such artists as Rubens, Renoir and others is smooth, sensuous, lush and rich in color, as is the works of Roberts. Woman is sometimes symbolized as a hurricane, a ship at sea or a steaming locomotive. The femininity of objects plays havoc with the mind in terms of proper identification. Roberts has not expressed womanhood in the traditional sense, but with spiritual and mysterious insights.

Strange that the seemingly disorgan-

ized splashes of color witnessed in Roberts's painting *Mother of All Mothers* (1974) is in essence a highly suitable array of organized parts which create a detailed arrangement. Intuitive responses to an idea are not readily executed; they emerge only after a considerable exchange of intellect and emotion at the moment of execution that coincide to formulate order at its highest peak. The highly explosive emotional discharge is governed only by the limited surface of the canvas.

In *Celebration* (1991) Roberts has visually created the sensation of a celebration. Contour and gesture lines of varying widths provoke dynamic tensions while promoting optical illusions. Roberts seems to have drawn the image before the application of paint in order for the original drawing to dictate the follow-up. There exists little opportunity for change of attack since limitations were set in the original approach. The addition of color within the prescribed lines establishs a predictable goal.

Free flowing, almost accidental in procedure but spirited in appearance is Roberts's painting *Yoruba Blue* (1973). *Yoruba Blue* reeks with nostalgia reminiscent of an early morning garden tour in which the flowers develop wildly but are touched with human care and love. It is Abstract Expressionism at its peak where emotion and intellect collide with ease and compatibility. The pigment is limited to the dictates of the mind. Yet, the emotions are allowed to forge a powerful image upon a comparatively small surface.

*Yoruba Blue* also reminds one of the color-field paintings of the Abstract Expressionist school although Roberts's arrival on the scene developed from the gesture action approach. Roberts's broad brushstrokes seem to explode beyond set boundaries, and the upward movement tends toward the exaltation of an idea, as if a sacrifice to the heavens above were

being offered. Roberts has discreetly halted the upward climb of particular forms, and equally severed tips of other forms suggesting a continuous ascent outside the picture plane. The artist allows the viewer to join her journey, a slow journey that exhibits a touch of reward at the end.

Other works such as *And Still I Rise* (1990) and *Festival* (1989) seem turbulant, like avalanches or flood waters breaking loose. *And Still I Rise* exploits a negative surface with explosive bursts of color which at first glance resemble a giant ogre with fantastic anatomical features.

The protrusion of negative areas of space suggests divisions of content without an actual separation. Thus, one is left to speculation and individual interpretation. In other words, emotional reactions created by the artist are now hopefully experienced by the viewer.

The same speculative forces occur when viewing *Festival.* An imaginary figure seems to move skyward. There is a diagonal, arc-like swing of color which resembles the ascension of a spiritual being.

*Deep River* (1985) and *This Little Light of Mine* (1985) are more precisely controlled than works already discussed. *This Little Light of Mine* is more tightly knit by its circular structure. Even though a figure emerges from a sea of blue, its compositional structure is unified from all viewpoints.

Roberts has not spoken of the process of creating a painting, but it is possible that the working surface is dampened at the initial application of paint. As colors are brushed onto the surface, their appearance and positions are determined by the wetness of the canvas and the simultaneous control of hand and intellect. The painting is not preconceived; no certainty is linked to placement of color; intuitive forces gather for the unique experience of chance.

*Opposite, left:* **Malkia Roberts.** *And I Still Rise* **(1990). Oil on canvas, 50×52 in. Courtesy of the artist.** *Right:* **Malkia Roberts.** *Festival* **(1989). Oil on canvas. Courtesy of the artist.**

**Malkia Roberts.** *This Little Light of Mine* **(1985). Oil on canvas, diameter 34 in. Courtesy of the artist.**

Seconds before the application of color, the decision is made as to color, position, shape and size of the area to be filled. Additional colors offset, reconstruct, strengthen or weaken the expression. The painting is complete at several stages. The result of the artistic move is not necessarily the end of the creative process. Several results constitute the complete act. It is during the process of painting *This Little Light of Mine,* for example, that certain conditions were met, satisfactions were fulfilled which dictated the uniformity of the whole. Results which are contrary to the original or preceding determinants cause an eventual downfall of the painting.

Roberts's initially blurred style bordered on the conceptual in which calculation became a major force. No longer did chance determine progress, and although Abstract Expressionism appeared to be at full strength for Roberts, she nonetheless fell victim to a conscious preparedness which heretofore was unacceptable. Even though Roberts's divisions of space lack the hard edge structure of a Mondrian, nevertheless, they are objectively calculated for size, shape, color and position on the canvas.

Exploitation of a single color becomes beauty in the hands of Roberts in *Deep River.* Flooded in shades of blue, *Deep River* is speckled with spots of vibrant colors which tend to enhance the soothing blues by disrupting the security

of the imagery. It is the positioning of these specks, daubs and smears of color in appropriate areas that not only maintains the intuitive process but which completes the painting as a total expression.

In spite of all that has been said, Abstract Expressionism demands an idea on the part of the artist, a notion of a sort that the ego feeds upon or is humbled by, a notion to which emotional forces are applied. The idea itself can be abstract so long as a point of departure is established.

Malkia Roberts has summed up her personal philosophy in a statement issued in several of her catalogue brochures. It reads as follows:

> At the root of art we find magic—and faith in the power of images. I see my painting as a spirit flow of images—a journey from the me to the you—a communion with those who have gone before—a sharing with those who are yet to come.

# Career Highlights

Born in Washington, D.C., in 1923.

## Education

B.A. degree from Howard University; M.A. degree from the University of Michigan, Ann Arbor; B.F.A. degree from Howard University; M.F.A. degree from the University of Michigan, Institute of African Studies; postgraduate work at New York University, Catholic University and Parsons School of Design.

## Awards

Agnes Meyer Fellowship, 1963; Evening Star Award, Society of Washington Artists, 1966; paintings on loan to the United States State Department.

## Selected Exhibitions

Teachers College, Washington, D.C., 1968; College Museum, Hampton Institute, Hampton, Va., 1989; Society of Smithsonian Institution, Washington, D.C., 1989; The High Library, Elizabethtown College, Elizabeth, Pa., 1990; Mayor's Mini Art Gallery, Washington, D. C., 1990; Anacostia Museum, Smithsonian Institution, Washington, D. C., 1990.

# Bibliography

## Books

Atkinson, Edward. *Black Dimensions in Contemporary American Art.* New York: New American Library, 1971.
Bontemps, Arna. *Forever Free: Art by African American Women, 1862–1980.* Alexandria, Va.: Stephesan, Inc., 1980.
Driskell, David. *Two Centuries of American Art.* New York: Los Angeles County Museum and Knopf, 1976.
Fine, Elsa. *The Afro American Artist: The Search for Identity.* New York: Holt, Rinehart & Winston, 1973.
Gaither, Barry. *Afro American Artists: New York & Boston.* Boston: The Museum of the National Center of Afro-American Artists, 1970.

Igoe, Lynn. *Two Hundred & Fifty Years of Afro-American Art: An Annotated Bibliography*. New York: R. R. Bowker, 1981.

Kinard, John. *The Barnett-Aden Collection*. Washington, D. C.: Smithsonian, 1974.

Lewis, Samella. *Art: African American*. New York: Harcourt Brace Jovanovich, 1978.

_____. *Art: African American*. Los Angeles: Alan S. Lewis, 1991.

_____, and Ruth Waddy. *Black Artists on Art*. Los Angeles: Contemporary Crafts, 1969.

Locke, Alain. *The Negro in Art: A Pictorial Record of the Negro Artist and of the Negro Theme in Art*. Washington, D. C. and New York: Hacker Art, 1979.

Porter, James. *One Hundred Fifty Years, Afro-American Art*. Los Angeles: UCLA Art Galleries, 1966.

## Periodical Articles

Bearden, Romare. "The Negro Artist & Modern Times." *Opportunity* (December 1934).

Burroughs, Margaret. "The National Conference of Negro Artists." Atlanta University. Atlanta, Ga., 1959.

Lowenfeld, Viktor. "Negro Art in America." *Design Magazine* (September 1944).

## Catalogues and Brochures

Anacostia Museum, Smithsonian Institution. "Gathered Visions. Selected Works of African American Women." Washington, D. C.

Gallerie la Taj. "Malkia Roberts Paintings." Alexandria, Va. October 21, 1990–November 11, 1990.

The High Library—Elizabethtown College. "The Spirit Moves: The Art of Malkia Roberts." Elizabethtown, Pa. February 11–28, 1991.

The King-Tisdell Cottage. "Odyssey: Malkia Roberts' Paintings." Savannah, Ga. October 18, 1987–November 21, 1987.

Mayor's Mini Art Gallery. "Creative Threads." Washington, D. C. August 1, 1990–October 6, 1990.

# EIGHTEEN

# *Ann Tanksley*

Fascinating is the word that describes the work of Ann Tanksley. Disregarding the visual rules of perspective and proportion, the artist has deliberately distorted physical features for psychological reasons, flatly painted areas that possess three-dimensional measurements, and created compositions which bear upon immediate needs rather than concern for formal balance.

Aside from compositional essentials, Tanskley covers the range of social injustices in a direct, simple and honest approach. Her work reflects the influence of her travels, the residential colors, the simple work habits, the loneliness, and the love and devotion to one's spiritual beliefs.

In *Canal Builders* (1986), one witnesses the physical toil of the black man; figures are flatly painted, but physically distorted to portray the immense pressure under which they are placed. Visual perspective is created with the recession and advancement of figures and the landscape itself rather than the intensification of color. In spite of the obvious flatness of landscape and figures, there exists a realism that is formidable. There is a slight overlapping of figures, thus avoiding an objective rendition and promoting a subjective portrayal. Tanksley has created a team of humans rather than isolating individual aspects.

*Canal Builders* is a pleasant painting and it depicts a dedication of life both to the immediate cause and to a greater goal. The acceptance of one's status in life as determined by a divine source is a greater blessing than "all the riches in China."

Tanksley believes in the inner spirit, the freedom to be oneself, and holds that beauty resides not in the accumulation of riches, but in the spiritual strength and inner determination to remain true to oneself and one's Maker.

Tanksley incorporates certain child-like characteristics into her work. Besides the flat pattern, the outlining of figures and the psychological distortion, visual perspective is exaggerated. However, this is overcome by the intervention of the canal diggers. Although slightly sophisticated, the uphill horizon prevails.

In another painting, *Black Dancers* (1985), the simplicity of design is its strength. Again, Tanksley positions single aspects into a team of dancers, thus transforming an objective painting into one of total intimacy. The observer becomes no stranger. It is a familiar event but presented in an unusually artistic manner. The brilliant colors of red and yellow celebrate the dance event, but the color blue, worn by the trained athletes, suggests a bittersweet feeling among the performers striving for cultural satisfaction. The environment surrounding these superb athletes is as simple and undisturbed as the dance itself.

An unusual departure from the flatly

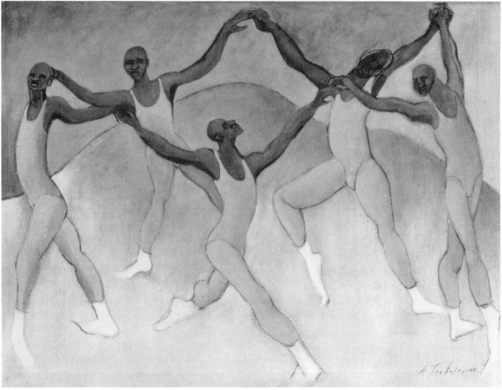

painted figures in *Canal Builders* and *Black Dancers* is the Abstract Expressionist version rendered in *Hibiscus Pickers* (1984). Its action is heightened by the vacillating brushstrokes which seem to define the action of the pickers rather than the pickers themselves. This versatility in style seems to suggest an experienced background in technical application of media. She applies the appropriate technique to suit an idea. Too often the reverse is true, which sacrifices the intended message.

Instead of the well-defined figures of *Canal Builders* and *Black Dancers,* Tanksley integrates the hibiscus pickers with the environment, thus creating a oneness. The figures and the crop are one, and yet, Tanksley knows that in *Hibiscus Pickers* humanity no longer exists; Tanksley shows no mercy. The pickers become slaves to the soil, not a soil that they love but rather an earth that is merely tolerated.

The blurry or windblown effect created by Tanksley is exciting. The audience immediately responds emotionally to a dramatic painting. And yet, the event itself is commonplace for those inhabitants who toil for their livelihoods.

Visual perspective is ignored as Tanksley places her occupants onto a frontal plane. Horizontal planes are suggested with a dark, turbulent sky and a lower horizontal layer of earth. The wind-swept atmosphere fails to diminish the three horizontal planes, but does create a subjective expression of oneness.

The same blurry effect is witnessed in *Going Home* (1973), but here the figures are clearly defined. The shapes of the two humans create a whimsical contrast with the delicately rendered fence in the background. The wrought iron fence also separates the formidable subjects from nature's garden of flowers.

There is excitement in the air, a pleasant anticipation that usually accompanies a return home. To counteract the strong movement to the right, the artist has constructed the fence to automatically halt the viewer's visual journey. The two, although individually created, are a unit, and in spite of a controlled environment, the personality transmitted from artist to canvas is reflected in the bodily gestures of the subjects.

There is a oneness of artist and concept. Her love of life in spite of social barriers and frustrations is promoted in her work for audiences to witness and accept, for there is little to reject in Tanksley's world of art. Her paintings evoke a spiritual awakening. One is drawn to the intensity of color that prevails and identifies the moods of feasts and celebrations. Where muted colors appear, there also appears the brightness of the future.

Life is full of anticipation and dedication, of acceptance and hope, of faith and survival. These are all present in the works of Ann Tanksley. There is pride within the midst of turmoil, a determination toward survival against the odds.

Tanksley makes a statement with a single line. Her figures lack detail but in a strange way manifest a total gesture with a mere twist of a line. Two-dimensional surfaces develop into three-dimensional images. Suggestive motions occur which anticipate future actions. In a sense, Tanksley's method is not unlike that of the Abstract Expressionist. By suggestion, a gesture registers and simultaneously dictates a future gesture. This ability to predict the future while preserving the present is evidence of Tanksley's remarkable talent.

The artist communicates through the figures of the painting, a rare commitment of the contemporary artist. In the abstract sense, color and movement may transmit emotions, but an immediate emotional and intellectual reaction is created by the figure. Artist and spectator

*Opposite, top:* **Ann Tanksley.** *Canal Builders* **(1986). Oil on canvas, 24×30 in. Courtesy of the artist. Collection of Dr. and Mrs. Edward James.** *Bottom:* **Ann Tanksley.** *Black Dancers* **(1985). Oil on canvas, 30×40 in. Courtesy of the artist.**

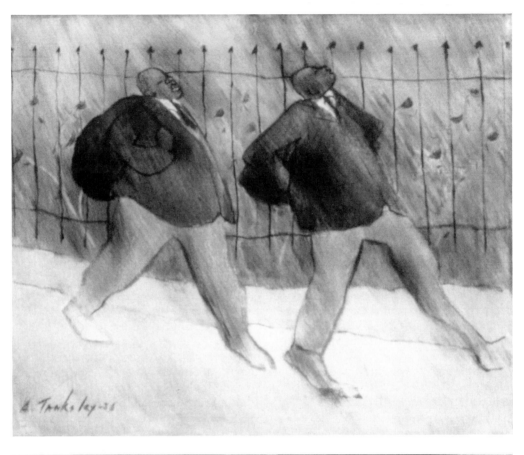

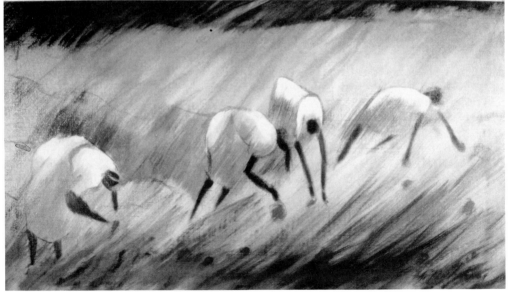

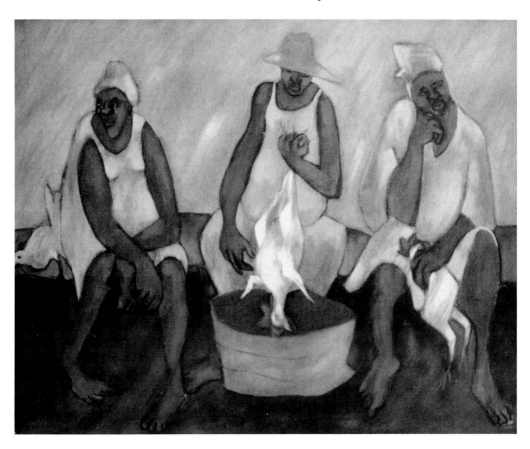

**Ann Tanksley.** *Pickin Chickens* **(1986). Oil on canvas, 30×24 in. Courtesy of the artist.**

communicate through the painting. At times the message of the artist is not received by the viewer in its original form.

However, common ground can help make for immediate understanding. In her famous painting *Pickin Chickens* (1986), Tanksley again portrays a commonplace incident, one that is not always a pleasant task for the participants. The artist exploits the physical and emotional actions of the roleplayers. The unpleasantness is registered on the faces of the subjects. The trio reflect a strong intimate approach to her theme because of their engagement in a single chore, the formally balanced composition, and the singularity in dress and disgust with their chore.

The vertical figures overlap three horizontal planes, the lower plane resting at the feet of the trio, the middle section anchoring their bottoms and the upper portion acting as a backdrop. There is no romance in *Pickin Chickens*, but Tanksley illustrates perfectly the characters' acceptance, although reluctant, of day to day activities. Each figure's posture is different in order to personalize the subjects.

The viewer responds subjectively because of the nearness of the subjects; in other words, the three have become one. The brushwork, delicately applied, is consistent in its character and distribution. The muted background allows for full focus on the chicken pickers, and because it is a front view, the spectator engages in the action head on.

*Opposite, top:* **Ann Tanksley.** *Going Home* **(1973). Oil on canvas, 16×20 in. Courtesy of the artist.**
*Bottom:* **Ann Tanksley.** *Hibiscus Pickers* **(1984). Oil on canvas, 18×32 in. Courtesy of the artist.**

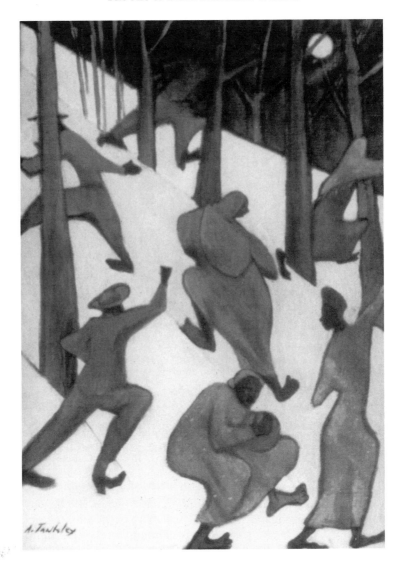

**Ann Tanksley. *Running to Freedom* (1987). Courtesy of the artist.**

To some viewers this event would be one of yesteryear, to others it is a daily occurrence. But again, the simplicity and humility of Tanksley's subjects and the pride with which she attacks her themes are indeed noteworthy.

A festive occasion is the subject of *Juneteenth II,* an unusual title for a depiction of a gala affair. It pictures children playing, men and women dancing, resting and enjoying the brilliant sunlight. It differs considerably from her other works like *Going Home* and *Black Dancers,* because of the total overlap of figures.

Again outlining becomes an integral part of the painting as does flatness of color. Tanksley repeatedly employs the tools of the primitive artist whose choice to define images with outlines reminds one of children's art.

Figures in *Running to Freedom* (1987) are similar to those witnessed in *Canal Builders* but the dramatic appeal of *Running to Freedom* is found in its theme of the everpresent and seemingly everlasting attempt to free oneself from racial discrimination. Tanksley illustrates how this fight is sometimes an uphill battle. The

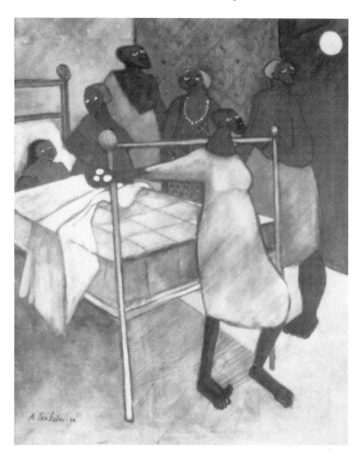

**Ann Tanksley.** *Night Visitors* **(1985). Oil on canvas, 24×30 in. Courtesy of the artist.**

artist displays a truly unique approach by using a forest of trees as a barrier to social justice. During the drive toward freedom, one can feel that success is inevitable only to stumble when nearing victory. There is this sense of frustration as well as the initial exuberance. Body gestures suggest various degrees of enthusiasm, and physical movement is also varied among individuals.

Compositionally, the artist has avoided overlapping the figures, but as a schematic tool, she has overlapped naked trees with the fleeing prisoners of social injustices; this stops their trek to freedom, but it also aids in compositional unity. A full moon pierces the darkness, and although insignificant in its size and placement, it plays an important role in the distribution of color.

*Night Visitors* (1985) includes the same full moon, and its compositional effect is noteworthy, but speculating as to its symbolic meaning could be misleading. The objective painting depicts a bedridden victim helplessly invaded by a roomful of visitors. The unusual environment is composed of three vertical panels, strengthening the background environment. The shadow under the victim's bed acts as an anchor to the foremost figure. Tanksley again introduces several figures that overlap to form a unit. Individual personalities disappear into the mass, and similarity of facial expressions and body gestures reinforces the integrated group.

The viewer becomes a spectator, a member of the group. This invitation is created by the direction of the lines of the victim's bed and its shadow. There are inquisitive expressions on the faces of

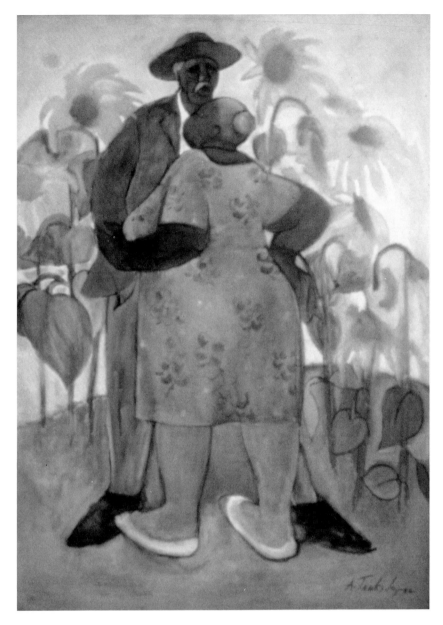

**Ann Tanksley.** *Sunflowers* **(1986). Oil on canvas, 30×40 in. Courtesy of the artist.**

the visitors. One is haunted by the presence of the full moon. Does it identify with the title? Is it essential to the composition? Or is it symbolic of a future act? The artist stimulates the viewer and creates an atmosphere of inquiry and wonder in *Night Visitors*.

*Sunflowers* (1986) is a painting of an intimate relationship between a man and a woman, and the viewer remains a specta-tor. The audience can only speculate on the conversation. The artist has used the environment as the title so the viewer has immediate contact with the habitat. The central figures become secondary in significance. *Sunflowers* is a simple picture of a daily occurrence according to Tanksley.

As in all of her works, the contour line suggests three-dimensionality. The

slowly curved hill in the background is also seen in *Black Dancers*. It is a simple technique of joining together the strong verticals into a unit. A fluidity of color is evidenced in the most remote flower images. They seem to vanish into the environment in a deliberate attempt to deemphasize them in favor of the male and female. A further blend of the couple and the surrounding background is witnessed in the flowery pattern of the woman's dress. It is a subtle rendering, one over-looked at first glance, but indeed compatible with the total environment.

*Sunflowers* is a whimsical display of an occurrence in human life, and the viewer is left to speculate on several delightful conclusions. In spite of the pleasantness of Tanksley's work, her message is strong and clear. She has fought for human rights and she enlists this theme in many of her works, but never in a terrifying manner. And yet, one observes and does not forget.

# Career Highlights

Born in Pittsburgh in 1934.

## Education

B.F.A. degree from the Carnegie Institute of Technology; further study at the Art Students League of New York; attended the Parsons School of Design, New York; studied at the New School for Social Research, New York.

## Selected Exhibitions

Kenkelaba House, New York; Christie's, New York; Brooke Alexander, New York; Isobel Neal Gallery Ltd., Chicago, Il.; Samuels's Gallery, Oakland, Ca.; American Women in Art, Nairobi, Kenya; Purdue University, Lafayette, In.; Union Theological Seminary, New York; Indianapolis Museum of Art, Indianapolis, In.; University of Maryland, College Park, Md.; Salmagundi Club, New York; Carnegie Institute, Pittsburgh, Pa.; Hudson River Museum, Yonkers, N.Y.; Mount Holyoke College, South Hadley, Ma.; Great Neck Library, Great Neck, N.Y.; Nassau Community College, Garden City, N.Y.; Fordham University, New York; University of Connecticut, Storrs, Ct.; Norfolk State College, Norfolk, Va.; Queens College, Queens, N.Y.; Bratten Gallery, New York.

## Solo Exhibitions

AC-BAW Center for the Arts, Mt. Vernon, N.Y.; Barnes-Little Gallery, Washington, D. C.; Spiral Gallery, Brooklyn, N.Y.; Jamaica Art Center, Jamaica, N.Y.; Campbell Gallery, Sewickley, Pa.; Dorsey Gallery, Brooklyn, N.Y.; Spectrum IV Gallery, New Rochelle, N.Y.; Acts of Art Gallery, Mt. Vernon, N.Y.; Black History Museum, Hempstead, N.Y.

# Bibliography

## Books

Cedarholm, Theresa. *Afro-American Artists*. Boston: Boston Public Library, 1973.
Chase, Judith. *Afro-American Art & Craft*. New York: Van Nostrand Reinhold, 1971.
Schatz, Walter. *Directory of Afro-American Resources*. New York: R. R. Bowker, 1970.
*250 Years of Afro-American Art*. Edited by Lynn Moody. New York: R. R. Bowker, 1981.
*Who's Who in American Art*. 19 ed. New York: R. R. Bowker, 1990.

## Catalogues

AC-BAW Center. "Ann Tanksley." Mt. Vernon, New York, January 15, 1991.
At Act of Art. "Tanksley Art Exhibit Pictures the World of the Black Woman." May 15, 1991.
Kenkeleba House, Inc. "Ann Tanksley." New York, May 12, 1991.

## Reviews

"Artist Comes Home." *Pittsburgh NB News,* January 28, 1987.
Bryant, Jean. "Standing Out: Artist Puts Pointed Ideas in Soft Hues." *The Pittsburgh Press,* February 10, 1987.
Herron, Clara. "In Celebration of Black History." *Living North,* February 5, 1987.
Steiner, Raymond. "Ann Tanksley at the AC-BAW Center." *Art Times* (March 1991).

# NINETEEN

# *Alma Woodsey Thomas*

Alma Woodsey Thomas, an accomplished artist, has traveled the roads of experimentation. Born in 1895, Alma Thomas survived decades of turmoil as she struggled to maintain her artistic balance while the art world struggled to survive. It was the tragedies that motivated the artist to initiate a regional art during the Great Depression of the thirties and World War II. And yet, for Thomas, art has a feeling of timelessness. She feels that art is for all time, for all ages and for all lands. Her career has focused on several schools of thought ranging from the magical Realism of *Still Life* to the Abstract Expressionism of *Tenement Scene, Harlem* to her optical illusion paintings.

*Leaves Outside a Window in Rain* (1966) seems more a gesture toward a total painting than a finished product and becomes a lead into a distinctly different style. A developing style is not always welcomed by the artist. Circumstances warrant a renewed look at life necessitating a new approach. Other times a style becomes matter of fact and demands a renewed effort of the artistic urge.

One needs to recognize the trend of the individual artist. One must grow but such development entails several avenues of embarkment. One such alteration is in technique, another is in subject matter, and a third is in the idea itself. Thomas chose the technical means of executing a painting. In another sense, the choice of subject matter demands a change in style. *Leaves Outside a Window in Rain* could not have been painted with the same approach as that used for another work titled *Still Life*.

The subject matter, the idea and the technique are essential changes. Thomas has met that demand and isolated the singularity of idea by avoiding the introduction of other aspects.

Thomas's erratic *Tenement Scene, Harlem* (1959) has all the marks of an emotional discharge of hatred and anger. Its slashing brushstrokes and knife marks record the anxiety and fear that accompany uncertainty and the unknown. The eruption of opposing forces tends to express the disillusionment of life and the difficulty of day to day living, daily hardships and continuous sacrifice.

*Tenement Scene* is an examination of life in the ghetto, a home for the unfortunate and the underprivileged. Thomas's expression is a strong declaration, a moving statement both in its literal translation and in its artistic accomplishment.

There are bruising conflicts between humanity and its environment. The warm colors of earth occupying the central areas of the vertical plane and representing the human element wrestle with the cooler blues and purples representing the conditions of the ghetto. Thomas has allowed certain elements of the ghetto to escape into the human

environment to satisfy compositional needs. Spurts of red color create a habitat of pain and agony.

*Tenement Scene* subscribes to the Abstract Expressionist school of thought and is well conceived and executed. It is an emotional painting, instinctively portrayed. To explode color upon a limited working surface and sustain the strength of Thomas's portrayal is indeed a difficult task.

An additional merit to *Tenement Scene* is the journey that continues beyond the confines of the canvas. The suggestive nature of action or gesture painting allows for the statement to reside outside the limits set by the canvas. The edges of the canvas constrain the power and strength to the point of near combustion. And it is this abstract power of slashing colors and jagged shapes that commits the artist to the intuitive nature of the creative process.

Less dramatic than *Tenement Scene* but nonetheless as compelling in its appeal for recognition is Thomas's *Study of a Young Girl* (1960). Expressionistic in style, its layers of seemingly briskly applied pigment blend into a compatible relationship. The image of the young girl is defined with roughly textured brushstrokes. Thomas has adhered to the Abstract Expressionist school as she responds intuitively to the young girl. The nature of this school of thought disallows identities. In fact, interpretations vary considerably in attempts to literally translate the artist's intent.

Frequently the title is altered after completion of the painting because during the creative process intuitive responses are often aimed not at the original stimulus but at an urge to change in midstream toward an ensuing idea. It is this unpredictability of the result that creates an uncertainty. This is a difficult method of painting since the emotional, intellectual and physical faculties function simultaneously. Thomas has succeeded with *Study of a Young Girl.* Not only has the young girl's

personality emerged but so too has the artist's personality.

Thomas's brushstrokes are not only convincing, they are dynamically positioned and intellectually controlled, but applied emotionally. Her transformation from the Realistic still life set-ups to the Abstract Expressionist tenement and figurative scenes is remarkable.

In total contrast to *Study of a Young Girl* in concept and execution is a charming painting simply titled *Still Life* (1955). Visual perspective, technical dexterity, recession and advancement of color and proper attentiveness to detail describe *Still Life.* A symbolic smoothly finished sculptured head contrasts nicely with the textural nature of the flowers that reach upward from a tall, slender vase. Thomas's use of the horizontal tabletop anchoring the vertically placed still life objects allows for an additional environment as a backdrop.

One senses her still life works are disciplinary tools, a return to the basics in order to strengthen different technical approaches. The overlapping of objects in *Still Life* brings together the essential images. Thomas was wise to allow for a rest area in the foreground, and yet it is rescued from being an area of emptiness by the shimmering reflections of positioned objects.

As a realistic portrayal, *Still Life* is an intricately charming painting exuding a sense of poetry. The combination of line and shape is in equal balance. There is a sense of the Abstract in appropriate areas along with deliberate objectivity as if the need to emotionally portray reactions to a given notion had to be fulfilled.

Objective placement of details is diminished in lieu of extreme compatibility. Single aspects become units blended into the whole; the background becomes the foreground; the habitat and its occupants become one. Although aspects of the painting were carefully positioned to create an objective portrayal, the background draped behind and under the selected objects unites the two forces.

Thomas has turned a commonplace

theme into a poetic, charming display of pleasant things. In a sense she has resurrected a still life into a moving, exciting panorama of utilitarian objects. Of course, the choice of subject matter is a factor as are technique and color selection.

Similarly executed is Thomas's boat scene titled *Georgetown Barge* (1968) which retains the elegance of her earlier works in addition to the crusty, suggestive nature of Abstract Expressionism. Set upon a triple plane system of horizontals, the focal point includes several positive aspects such as the boats moored along the shore. The upper and lower levels of sky and water have colors intuitively brushed or knifed in place. The suggestive nature of the painting abolishes the defined structure underlying the initial composition.

Color strengthens the structural appearance of the painting as well as correcting any errors caused by the erratic application of paint. Details are created with quickly applied lines. The intuitive process of creation is the ideal procedure for those who wish to emotionalize. Thomas's classical training has proven invaluable for her later style changes.

A major change directly related to her exposure to Abstract Expressionism is seen in her field color painting titled *Etude in Color* (1970), a painting best viewed from all angles, upward, downward or from either side. Its all-over pattern travels beyond the limits of the canvas. The movement in any direction is interrupted by slight jabs of paint to form their own pattern. The highest intensity of color splits the canvas while adjacent colors add to the delight as optical illusions occur throughout the painting.

Thomas's latest style is seen in her painting *Light Blue Nursery* (1968) in which rows of pastel colors are intricately placed in an Impressionistic fashion. Relying on the white of the working surface to be the stabilizing color, small rectangular marks are painted in successive order on a horizontal plane. The colors black and white become the divisional

colors that pull together the entire painting. There is no attempt to fuse the colors although there is a rainbow resemblance that emerges when viewed from a distance.

Two years later a similar painting titled *Snoopy Sees Earth Wrapped in Sunset* (1970) was painted in identical fashion. Rather than a rectangular shape, Thomas uses a circular shape. Rows of colors are vertically arranged and juxtaposed to create a crescent shape within the central core of the circle. A cleavage, created by the insertion of lighter colors than those of adjacent areas, disrupts the circular movement. In spite of an obvious leaning toward monotony, *Snoopy Sees Earth* is a pleasant recording of colors and shapes.

Thomas avoided the sixties' and seventies' theme of black protest and embraced the Abstract Expressionist approach to art. Gesture paintings such as *Tenement Scene, Harlem* and *Study of a Young Girl* diminished in number as her color-field paintings increased in production. *Wind and Crepe Myrtle Concerto* (1973), a fine example, is peaceful, the Swan Lake version of painting. Visually pleasing and a fantasy of sorts, it transports one from the cruelties of life to a land of enchantment. Thomas's ability to retain the viewer's attention with simple adjustments of the color plane marks her as a master of her craft.

The simple design comes dangerously close to monotony, but it avoids such by slight manipulation of her color swatches. The vertical concept upon a horizontal plane is in itself a contradiction. She has avoided the usual single color background evident in her earlier color fluid impressions. The environment in *Wind and Crepe Myrtle Concerto* varies in color tones to form a union with positive tonal qualities keeping with the concerto theme.

Thomas became educated in the mainstream of American art. Experiencing magical Realism, Abstract Expressionism and color field expressionism resulted in the mastery of all three schools of thought.

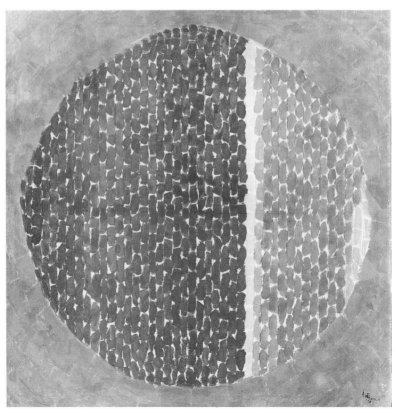

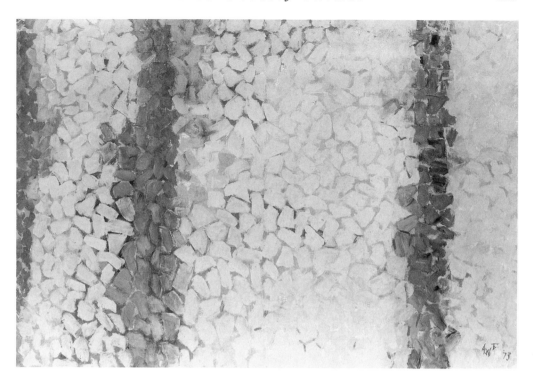

**Alma Woodsey Thomas.** *Wind and Crepe Myrtle Concerto* **(1973). Acrylic on canvas, 52×35 in. (132.2×89.0 cm.). Courtesy of the National Museum of American Art, Smithsonian Institution, gift of Alma W. Thomas.**

Similar in technique to her other works is *The Eclipse, March 1970* (1970). Impressionistic in approach, the painting is a dazzling display of color. The circular movement is enhanced by the repetitive pattern of negative spaces of noncolor. These spaces, which are allowed to remain between the series of colors, create their own design. Without the allotted spaces, *The Eclipse* would appear as a tightly knit colored shape.

*The Eclipse* represents an endless journey, a trek across an unlimited working surface. It is a small segment of a panoramic view which radiates endlessly from a central core. However, as a painting, the off-center placement of the core creates the uncertainty of its journey. Its position avoids the danger of monotony.

An expansion of the technique utilized in *The Eclipse* is witnessed in a 1973 work titled *Autumn Leaves Fluttering in the Breeze.* It is a reverse technique in which the positive aspects of the painting are light in intensity, and the negative environment is dark in contrast. Suggestive images occur as leaf motifs emerge from the dark habitat. The fluttering of autumn leaves, as in the title, is present and seen in the position of dabs of color which adhere to the theory of Impressionism. Coupled with the illusional radiation of color, the resulting display has a fascinating visual effect upon the observer.

Visual perspective is absent but there does exist spatial recession and advancement of color. There is a sense of visually

*Opposite, top:* **Alma Woodsey Thomas.** *Light Blue Nursery* **(1968). Acrylic on canvas, 48×50 in. (121.5×124.4 cm.). Courtesy of the National Museum of American Art, Smithsonian Institution, gift of Alma W. Thomas.** *Bottom:* **Alma Woodsey Thomas.** *Snoopy Sees Earth Wrapped in Sunset* **(1970). Acrylic on canvas, 47⅞×47⅞ in. (121.6×121.6 cm.). Courtesy of the National Museum of American Art, Smithsonian Institution, gift of Alma W. Thomas.**

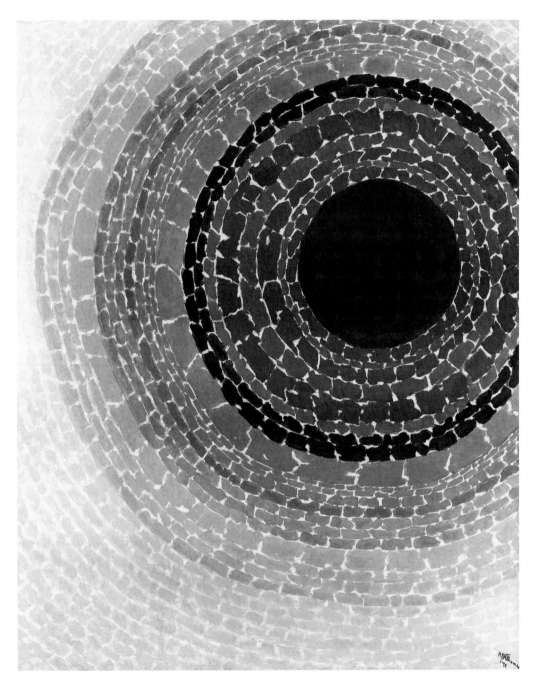

**Alma Woodsey Thomas.** *The Eclipse, March 1970* (1970). Acrylic on canvas, 49³/₄×62 in. (57.5×126.5 cm.). Courtesy of the National Museum of American Art, Smithsonian Institution, gift of Alma W. Thomas.

*Opposite, top:* **Alma Woodsey Thomas.** *Autumn Leaves Fluttering in the Breeze* (1973). Acrylic on canvas, 50×40 in. (127.0×101.5 cm.). Courtesy of the National Museum of American Art, Smithsonian Institution, bequest of Alma W. Thomas. *Bottom:* Alma Woodsey Thomas. *Snow Reflections on Pond* (1973). Acrylic on canvas, 54×68 in. (137.2×172.7 cm.). Courtesy of the National Museum of American Art, Smithsonian Institution, bequest of Alma W. Thomas.

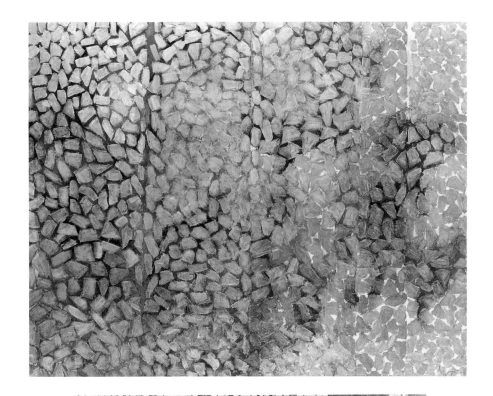

**Alma Woodsey Thomas.** *Breeze Rustling Through Fall Flowers* **(1968). Acrylic on canvas, 50×58 in. (127.0×147.3 cm.). Courtesy of The Phillips Collection, Washington, D. C., gift of Franz Bader, 1976.**

moving in and out of the painting. And yet to remove any one of the numerous bits of color would alter the total composition.

*Snow Reflections on Pond* (1973) contains the dark background seen in *Autumn Leaves.* Although highly objective, its totally exclusive use of a single geometric shape suggests a totally subjective appearance.

Snow reflections are not only difficult to portray but impossible to realistically record. Although Thomas's recording is Abstract in approach and execution, one is reminded of Loren MacIver's renditions of mud puddles, rain-

drops on a sidewalk and pebbles on a sandy beach. *Snow Reflections on Pond* resembles more a woven placemat than what the title suggests. Open spaces, representing the negative space of the background (the pond), actually determine the compositional balance or focus. Without the open spaces, the painting would be nothing more than a repeat pattern resembling that of a decorative wallpaper design. However, throughout her career, Thomas has faithfully adhered to the theory of the color-field exponents of the Abstract Expressionist school of painting. She has assured herself of a high place in the annals of American art, especially in the field of Abstract art.

Similar in title to *Autumn Leaves* but considerably different in technique is Thomas's work *Breeze Rustling Through Fall Flowers* (1968). A mosaic-type approach and execution, it relies upon an optical/Impressionistic appearance for viewer approval. It communicates no humanist statement, nor does it arouse one's inner emotions; rather it appeals to one's intellect. Color is adjusted to provoke both recession and advancement in space. Thomas's knowledge of the Abstract Expressionist school of painting is revealed in her color-field approach, and *Breeze Rustling Through Fall Flowers* is such an example.

# Career Highlights

Born in Columbus, Ga., in 1896.

## Education

B.S. degree from Howard University, Washington, D. C.; M.A. degree from Columbia University, New York; postgraduate work at American University, Washington, D. C.; postgraduate work at Temple University, Philadelphia, Pa.

## Awards

Corcoran Gallery of Art Traveling Exhibition, 1970; State Department Award, 1970; Howard University Purchase Award; George Washington University Art Award.

## Selected Exhibitions

Boston Museum of Fine Arts, 1970; Nordness Galleries, New York, 1970; La Jolla Museum of Art, 1970; Whitney Museum of American Art, 1971; National Museum of American Art, Smithsonian Institution, 1972; Ringling Museum of Art, 1973; Baltimore Museum of Art; Corcoran Gallery of Art; Carnegie Institute, 1973; Wesleyan University; Jackson State College; Anacostia Museum of Art, Smithsonian Institution.

## Solo Exhibitions

Howard University Gallery of Art; Franz Bader Art Gallery; American University.

# *Bibliography*

## Books

Atkinson, Edwin. *Black Dimensions in Contemporary Art, American.* New York: New American Library, 1971.
Dover, Cedric. *American Negro Art.* New York: New York Graphic Society, 1960.
Driskell, David. *African-American Artists: 1880–1987.* Washington, D. C.: Smithsonian and University of
    Washington Press, 1989.
Lewis, Samella, and Ruth Waddy. *Black Artists on Art.* Los Angeles: Contemporary Crafts, 1969.
Patterson, Lindsey. *The Negro in Music and Art.* New York: Publishers Company, 1968.
Rubenstein, Charlotte. *American Women Artists.* Boston: G. K. Hall, 1982.
Von Studnitz, Rosemarie. *Prints by American Negro Artists.* Los Angeles: Cultural Exchange Centre, 1965.

## Periodical Articles

McIlvaine, Donald. "Art and Soul." *Art Gallery* 13 (April 1970).
Mellow, James. "Black Community, The White Art World." *New York Times,* June 9, 1969.
Neal, Larry. "Any Day Now: Black Art & Black Liberation." *Ebony* (August 1970).
Pincus-Witten. "Black Artists of the Thirties." *Artforum* 7 (Summer-Fall 1969).
Porter, James. "Afro-American Art at Flood-Tide." *Arts & Society* 5 (Summer-Fall 1968).
Rose, Barbara. "Black Art in America." *Art in America* 58 (Sept.-Oct. 1970).
Schuyler, George. "The Negro Art Hokum." *Nation,* January 16, 1926.
"Symposium: Black Art, What Is It?" *Art Gallery* 8 (April 1970).
"What Is Black Art." *Time,* July 1, 1970.
Winslow, Vernon. "Negro Art & The Depression." *Opportunity* 19 (February 1941).

# Clementine Hunter

Primitive art is closely related to the art of children. Because of the tendency to associate ideas with physical movements, both the child and the primitive painter rely upon the physical form of being rather than the visual form of seeing.

Visual perspective is alien to the primitive artist's mental processes. Clementine Hunter has recorded nature as if she were acting out the moves. And yet, even if visual perspective became a concern, it would have been ignored until the baseline theory had become a reality.

Hunter is concerned only with the expression of ideas. And yet, she retains the earliest forms of pictorial portrayal. The baseline, the familiar anchor to which all aspects of life are positioned, is a repeated image of Hunter's work. So too are such innocent childlike symbols as the inside-outside picture, the X-ray picture and the fold-over portrayal.

Much of Hunter's work also relies upon the psychological significance of an idea: a flower may emerge in her picture larger and taller than a human being; a house may appear smaller than a baby animal; facial features become blotches of color often within the contours of an oversized head.

In several of her works, Hunter has utilized not only a single but double or triple baselines within a single painting. It is this direct disregard of reality that creates the innocent charm of Hunter's world. Its honesty, its singularity and

directness of purpose gives her audience a statement that cannot be misconstrued. This approach differs little from that of the child except that Hunter's simplicity of approach and her philosophy is backed by years of living the simple life. There appear in her work bits of sophistication that come about only with the wisdom of a human being who is faithful to the wishes of a divine being.

Clementine Hunter paints the commonplace. She adds no thrills, distorts no facts, or propagandizes no statements. Rather, she presents the usual with sincerity. Her colorful paintings, nonetheless, project an honesty and intimacy seldom exhibited in museums or galleries today. Hunter has used the childlike techniques in a sophisticated manner that discards the cumbersome drips and blotches that accompany the young child's painting.

In her painting *Saturday Night at the Honky Tonk* (1975), Hunter has used the double baseline to record two separate incidents. Anchored to the lower baseline are several couples engaged in antics ranging from dancing to fighting. In her 1955 exhibit catalogue from the Delgado Museum of Art, Hunter describes the scene as "so much noise at that honky-tonk down the road that I used to couldn't sleep. Now it don't bother me no more."

A second baseline is established upon which to place the honky tonk it-

*Top:* Clementine Hunter. *Saturday Night at the Honky Tonk* (1975). Courtesy of and from the collection of Thomas N. Whitehead. *Bottom:* Clementine Hunter. *In Grandma's Yard* (1973). Courtesy of and from the collection of Thomas N. Whitehead.

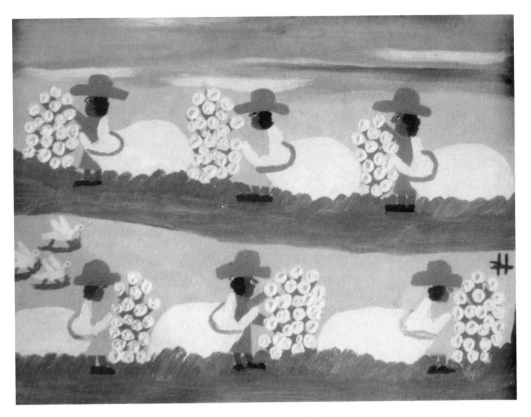

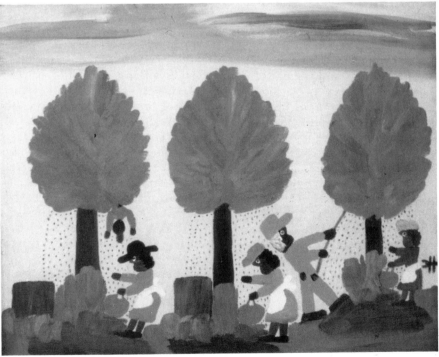

*Top:* Clementine Hunter. *Cotton Pickin'* (1975). Courtesy of and from the collection of Thomas N. Whitehead. *Bottom:* Clementine Hunter. *Pecan Pickin'* (1973). Courtesy of and from the collection of Thomas N. Whitehead.

self. Hunter's building pretends to be a one-sided affair; that is, the rectangular shape appears to lack depth and volume and thus is likely to fall over. The honky tonk building is centrally positioned and flanked by lollypop shaped trees constituting a formally balanced composition, another characteristic of a young child's art work. Billowy, light clouds hover overhead. Hunter's statement is direct, honest and humble.

Hunter adheres to a frontal plane. Even though visual perspective is greatly diminished, the baseline technique tends to establish the ensuing composition. In another charming rendition with a double baseline, *In Grandma's Yard* (1973), Hunter doubled the story line by stacking an event upon another in order to avoid a continuous event.

Instead of a horizontal painting with a single baseline, the artist has halved the painting and placed the tail end of the idea atop the initial baseline. Thus, the painting includes two ground lines and two skylines. Yet it is a single painting, only altered to shorten the length and heighten the vertical aspect.

The child may paint a picture from left to right and upon "running out of room," continue the story by placing the next part of the story above the first. According to nature, such a phenomenon is impossible, but with art the unreal can be artistically envisioned and rendered.

The flatly painted figures and objects show signs of sophistication by the lack of secondary colors. The characteristic use of pure color is replaced with shades of single colors and color blends unlike the pure color palette of the child. Hunter has also relinquished the flatly painted sky in lieu of shaded areas of moving clouds. Lollypop trees continue to line the baselines.

Hunter throughout her career has been a simple person with the humility of a young child. She paints joyously as if God has blessed her with the ability to see life through the hearts of innocent children.

Unlike others discussed in this book,

Hunter has no educational or artistic training. She is self-taught and speaks her mind in simple terms. In questioning her purpose in painting, she responded, "I wanted something to take up my mind, so I kept on painting. It got so if I had something in my head, I had to paint it." Such simple words of communication are reflected in her paintings. However, there is charm in the words she spoke and in the works she paints.

Similar in structure to *In Grandma's Yard* is a charming work titled *Cotton Pickin'* (1975). Both are in total contrast to the drunken brawls and violent action witnessed in *Saturday Night at the Honky Tonk*. In the painting *In Grandma's Yard*, one is treated to the simple, innocent acts of holding a baby, carrying a present, churning butter, smoking a pipe and holding a pet bird.

An interesting feature of *Cotton Pickin'* is the compositional structure. The dual baseline splits the painting into two halves, each segment containing three identically defined cotton pickers wearing similar red sombreros. Each figure is faceless, symbolizing the classification of the Southern plantation worker. Cotton is thrust into cotton bales which are equal in size to the workers themselves. Hunter has relied on the limited palette of primary colors and the color white. The division of the painting into two segments eliminates the traditional perspective one anticipates in a landscape scene. Hunter has used the baseline in an Abstract manner similar to the Abstract painter who defines visual perspective in order to incorporate receding and advancing images which would be impossible to record under traditional techniques.

Further charm is created by the inclusion of the trio of ducklings moving about in an adjacent stream. The ducks have little to do with the general theme, and yet, their inclusion is characteristic of the primitive artist's thought process: A vacant spot is seldom left vacant. Furthermore, Hunter's positioning of the ducks slows the viewer's exit from the picture plane by reversing the viewer's focus.

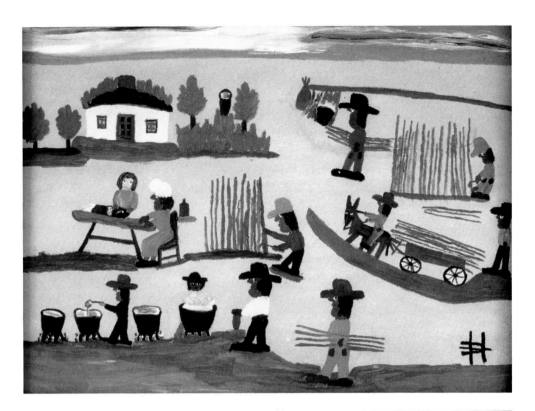

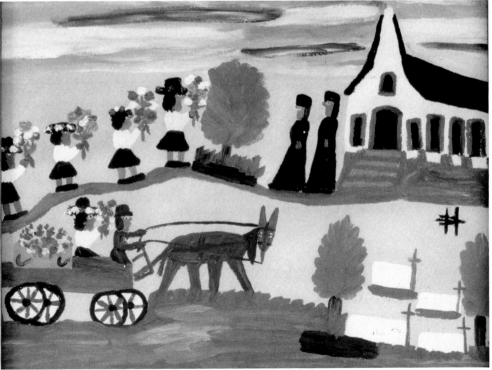

*Top:* Clementine Hunter. *Syrup Makin'* (1975). Courtesy of and from the collection of Thomas N. Whitehead. *Bottom:* Clementine Hunter. *Cane River Funeral* (1970). Courtesy of and from the collection of Thomas N. Whitehead.

The childlike philosophy is continued in Hunter's work *Pecan Pickin'* (1973). A simple composition, three lollypop trees are anchored to a baseline and neatly tucked under a blue skyline. The fact that the sky does not appear to "touch the ground" suggests that visual perspective is purposely avoided. In a traditional sense, one would consider the sky area painted behind the trees, but Hunter has painted the skyline to rest above the treetops and placed all colors and images on a frontal plane.

According to the child's theory, which could be applied to Hunter's work, were the sky painted to "touch the ground," the pecan trees and workers would be "buried alive" or "smothered to death." This thought is not realistic, but typical of a child's artistic thought process. Its relation to the primitive's approach varies with each artist. In the case of Hunter, its use applies more to a compositional need than a childlike technique.

*Pecan Pickin'* depicts the shaking of pecan trees as the pickers wait for the hundreds of pecan nuts to drop to the ground. Each of the three pecan pickers, sporting neatly pressed aprons, gather the nuts as the male workers shake the pecans from the trees. Hunter does not differentiate between types of trees; the Hunter tree remains a lollypop image. Again, the streak of sky is an attempt to fuse colors, suggesting a break from flatly painted areas which characterize the primitive approach to the artistic expression of nature.

The use of the baseline in a drawing or painting signifies the search for security or safety. The child uses it to anchor himself/herself to a personal environment. In a sense it represents the ground upon which one stands, or the sidewalk upon which one walks, or the earth from which a tree emerges, or the street upon which an automobile is driven. It is a priority of the child when painting a picture. It is also a need of the primitive artist. Hunter has used the baseline in the paintings discussed in this chapter. The

length of the baseline depends upon the number of images being anchored to it.

In Hunter's *Syrup Makin'* (1975) as many as eight variations of the baseline are utilized. Sandwiched between the horizontal sky above and the earth below is a sandy area upon which the process of making syrup occurs. Each individual segment of the process demands its own baseline. For each figure or object painted onto the sandy landscape, a baseline is painted under each image to secure it to its surroundings.

Hunter has recorded the entire process. Each segment of the process is an individual composition. The composition is unified by the close relationship between the activities. The six separate events of the syrup making process are placed in tiers upon a common environment. The narrow skyline serves as a balance to the horizontal strip of land anchoring the painting.

The commonplace themes communicate a sense of appreciation for the luxuries of this generation. The hardships involved in the early methods of producing our daily needs are duly recorded. And yet, Hunter's renditions of these commonplace chores are gems. Her naive manner of composition is convincing and consequently highly believable. She has defined visual perspective and it is this apparent lack of concern for visual reality that proves intriguing for the viewer.

Recording a daily chore became an act of relaxation. In spite of her lack of education and artistic training, Hunter is able to compose instinctively. Her compositions are simple and yet complex. She utilizes the canvas backgrounds by jamming activities onto the scene.

Hunter's compositions are similar to Doris Lee's renderings. In *Cane River Funeral* (1970), Hunter engages in a series of events which objectively portray sadness throughout the countryside. The funeral parade is led by a mule pulling an old fashion wagon with a colorfully decorated casket. Hunter has treated *Cane River Funeral* as a joyous celebration of recognizing eternal life. Four youngsters

*Top:* Clementine Hunter. *Cane River Wake* (1973). Courtesy of and from the collection of Thomas N. Whitehead. *Bottom:* Clementine Hunter. *The Melrose Auction* (1972). Courtesy of and from the collection of Thomas N. Whitehead.

resembling pom-pom girls carry bouquets of flowers while awaiting the arrival of the widow who is draped in black.

Again, as in other works, the bulk of activity resides within the middle plane. The lower baseline secures the casket, wagon and mule, then exits to the left and re-enters the picture plane to anchor the flower girls and the widow.

Hunter has jammed the middle plane with images. Her dense, objective portrayals are recordings of daily lives—the joys, the tragedies, the stillness, the noise, the chores, the acceptance of life, but most of all, the humanity of country people.

*Cane River Wake* (1973) is composed similarly to *Cane River Funeral.* Activity is confined to the middle plane as the viewer is treated as a spectator to the event. Hunter has placed her audience facing the altar site thus allowing spectators to move into the picture without notice. The spatial effects created by the wake formation are the result of positioning images in recessive order without diminishing the size of the occupants, or having the colors lessened in intensity.

Again, Hunter has created a celebration. Vases of flowers and decorated crucifixes face the mourners whose backs face the viewer. It is this technique which attracts the viewer as a participant to the mournful event.

Hunter has consistently simplified a complex situation without sacrificing the excitement, drama or hilarity of the event. *Cane River Wake* lacks the series of baselines present in the majority of her works. The lack (or inclusion) of particular symbols is unintentional. Hunter has seemingly without reason included an image which may or may not have had a relationship to other images within the picture plane.

Instinct governs Hunter's work as much as any preconceived notion does, and it is quite conceivable that the presence or absence of baselines never occurs to her. That is the nature of the primitive art process. And yet, after completing *Cane River Wake,* additional intrusions would have overplayed the intent and disrupted the composition.

Hunter has relied upon color and a direct approach to an idea to communicate the emotional reactions of the event. Hunter has avoided facial expressions and intimate close-ups of her subjects so that the viewer must rely upon the objective forces.

In *The Melrose Auction* (1972), Hunter has transformed the countryside into a marketplace. Again, the middle plane becomes the mecca of activity. Visual perspective is totally ignored, as auction items which were meant to lie upon the sandy surface of the countryside, appear to hang from the middle plane as if it were a wall of a room.

Furthermore, the artist has applied the front view/top view of images. Both views are essential for the primitive artist. It is important to expose the view of an object which best exhibits that object. So it is very common to see within a single painting three views of an object in order to find the most attractive view. The Realist painter would reveal a single view throughout and in most cases, the choice would be the front view. Aside from the plural views of objects witnessed in *The Melrose Auction,* one also encounters several baselines. The primitive painter does not acknowledge volume or material distance. Instead of the artist advancing objects in space by enlarging their size and intensifying their color, spatial matters are not considered.

Hunter assures her subjects' safety by placing each on an individual baseline. Similar to the child's security blanket, each of Hunter's figures are anchored to a baseline. The introduction of the baseline has little to do with composition. It has more to do with the security of the pictured images; it is the communication of one's own security which is transferred from the artist to those pictured in the painting.

*The Ladies in Calico Tour Time* (1970) is a delightful exposition of well dressed ladies. Throughout her lifetime of paint-

**Clementine Hunter.** *The Ladies in Calico Tour Time* **(1970). Courtesy of and from the collection of Thomas N. Whitehead.**

ing, a limited palette has been used. Aside from the three primary colors, only the colors black and white are added. Although the color green dominates the painting, the color itself is the result of primary colors.

Donned in festive gowns, the ladies entertain the viewers. Because of its personal nature, the theme in *The Ladies* seems to be showtime. It is a formally balanced composition with the tour building centrally located and flanked by a single lollypop tree. The gaiety is reflected in the brightly colored decorative gowns.

Particularly noticeable in her works is the singularity of images. An overlapping of figures is totally inappropriate for a Hunter portrayal. In *The Ladies,* like other Hunter paintings, images are so closely positioned that overlapping is not only nonessential, but by so doing, elements would be diminished. In other words, it is essential to the primitive painter that there is full view of painted images.

Hunter does not allow negative space to dominate her work. Intense activity is created by the placement of several images onto a broad negative surface. As each positive image is painted onto the canvas, positivism replaces negativism. Clementine Hunter has never disappointed her viewers. She has claimed that her heart dictates her ideas. The heart feels and the mind sees and this combination sets apart the works of this remarkable woman.

# Career Highlights

Born in Little Eva Plantation, La., in the year 1885. Died in 1988.

Unlike the other artists discussed in this book, whose educational and art training included graduate degrees and postgraduate work at some of the finest universities in America and abroad, Clementine Hunter attended school once, but as she stated, "I didn't learn nothing. I just went to play with other children."

The Delgado Museum of Art in New Orleans held a one woman showing of her work in the year 1955.

# Bibliography

Bontemps, Arna. *Forever Free: Art by African-American Women, 1862–1980*. Alexandria, Va.: Stephesan, Inc., 1980.

Dover, Cedric. *American Negro Art*. Greenwich, Ct.: New York Graphic Society, 1969.

Driskell, David C. *African-American Artists 1880–1987: Selections from the Evans-Tibbs Collection*. Seattle and London: University of Washington Press and Smithsonian Institution Traveling Exhibition Service, Washington, D. C.

_____. *Two Centuries of Black American Art*. New York: Los Angeles County Museum of Art and Knopf Publishers, 1976.

*The Evans-Tibbs Collection*. Washington, D. C.: The Evans-Tibbs Collection, 1988.

Fine, Elsa. *The Afro-American Artist: The Search for Identity*. New York: Holt, Rinehart & Winston, 1973.

Igoe, Lynn. *Two Hundred and Fifty Years of Afro-American Art: An Annotated Bibliography*. New York: R. R. Bowker, 1981.

Locke, Alain. *Negro Art: Past and Present*. Washington, D. C.: Associates in Negro Folk Education, 1936.

_____. *The Negro in Art: A Pictorial Record of the Negro Artist and of the Negro Theme in Art*. Washington, D. C.: The Associates in Negro Folk Education, 1940.

Porter, James A. *One Hundred and Fifty Years, Afro-American Art*. Los Angeles: U.C.L.A. Galleries, 1966.

# TWENTY-ONE

# *Viola Burley Leak*

Viola Burley Leak has developed a unique contemporary style for ancient themes such as the family and Adam and Eve and the Garden of Eden.

In her unusual semi–Abstract portrayal titled *Temptation: Adam and Eve* (1985), the artist has woven African symbolic images into a complex tapestry of soft sculpture. Overlapping shapes representing the seasons of the year have varying intensities of green. Interpenetration of the figures and the environment creates a totally unified composition.

The figures of Adam and Eve are in richly colored appliqué and are tempted by a third figure. The pleasant color scheme is further enhanced by a variety of shapes which seem to dance forward and backward creating in the process a visual depth unusual for a two-dimensional surface. The black figures, extremely distorted, perform in a contemporary fashion. As part of a series titled Ancestral Garden, the themes of her work generally reflect an African-American heritage.

The purpose of the Ancestral Garden series is to explore and exploit the myths and realities of man. Leak has taken liberties with her themes, a valid approach to the expression of ideas. In *Temptation*, the viewer is granted privileges of speculation which frequently lead to misinterpretations. If meaning eludes the viewer, the pleasantness of color and composition is still available for visual delight.

In *The Family* (1985), Leak has presented a beautifully designed image of the traditional mother and child theme. An environment of leaf-like shapes envelops the background while similar shapes overlap and interpenetrate to form the figures of the family. The child is cradled by the mother whose expression of tenderness is clearly seen. The father, of lesser significance, hovers to the left of the central figure, his presence identifiable only by outlines and elongated figures reaching to fondle the child.

The rhythmic color pattern fuses to bring the foreground and background into a oneness. There are balances and counterbalances as Leak weaves shape and color throughout her work. The cradled child image is repeated several times as if its imagery is essential to a universal message. Leak has warned the viewer that surprises occur in her work, surprises which result from exploitation and exploration. The artist has indeed utilized the geometric shape to her advantage. At times, literal translation is impossible because literal meaning is never intended. The essentials of composition become more important than any literal message.

*The Family* is a beautiful rendition on a devout theme. There is a sense of security and a substantial faith in a Being greater than oneself. Again, this is an in-

**Viola Burley Leak.** *Temptation: Adam and Eve* **(1985). Appliqué tapestry. Courtesy of the artist.**

terpretation, perhaps incorrect, but none-theless a viewer's option upon seeing the work.

An accomplished painter, Leak has blended painting techniques with collage and batik. Her prints are of the traditional approach but she has combined printmaking and painting and has finally arrived at a union of textile and printmaking to establish textile appliqué as witnessed in *The Family* and *Temptation*.

A third work of the Ancestral Garden series is titled *Village Figure* (1985). It focuses on a female standing in a habitat of bird and plant life. Bird and plant are similar in shape as Leak not only succeeds in creating a compatible relationship, but she also establishes a unity of compositional objects. Its circular rhythm is closely related to other works in this series. The female leers wonderingly at her audience residing outside the picture plane. Leak again utilizes the outline to accentuate essen-

tial aspects in both foreground and background. Claw-like plants match the female's talons with which she is embracing herself.

There is an intimacy that invites the viewer to simply enjoy the colorful display rather than speculate as to its meaning. Recession and advancement of positive aspects of nature are ignored in favor of maintaining a viewer's full focus by using a front view.

The subjectivity of the work is due to its uniformity and directional movement. There exists a singularity of motion, a movement radiating out from the sensuous look of the female, whose resemblance to Eve in *Temptation* and to the mother in *The Family* is evidently ancestral. The Garden of Eden is again depicted in *Village Figure*.

In *Together* (1985), Leak has applied a low-keyed palette, relying on the sharp contrast between black and white. The color lavender acts as a unifying force so that attention rests on the male/female

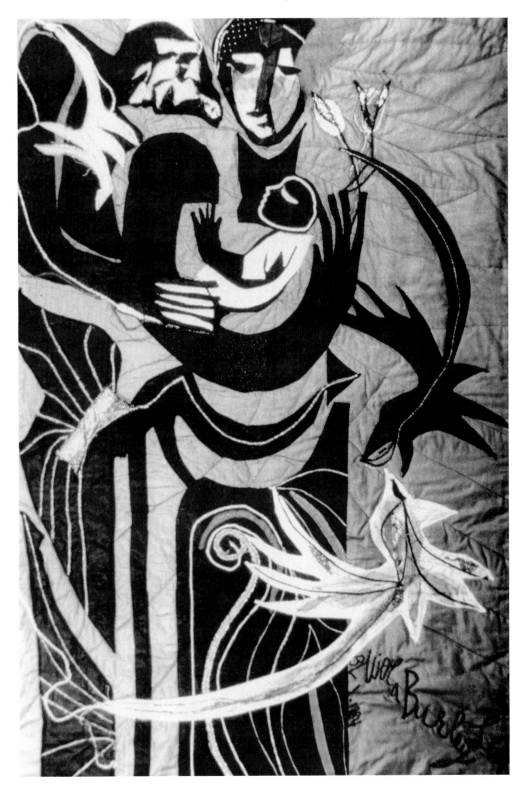

**Viola Burley Leak.** *Family* (1985). Appliqué, 36×60 in. Courtesy of the artist.

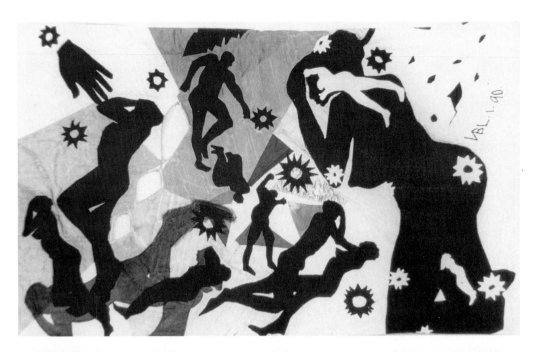

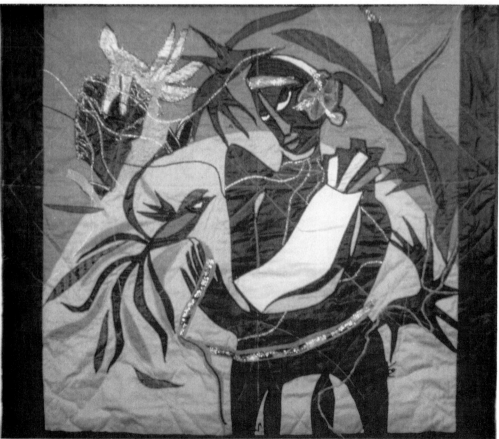

*Top:* Viola Burley Leak. "Untitled" (1985) from the Dream Series. Appliqué tapestry, 45×65 in. Courtesy of the artist. *Bottom:* Viola Burley Leak. *Village Figure* (1985). Appliqué tapestry, 31×41 in. Courtesy of the artist.

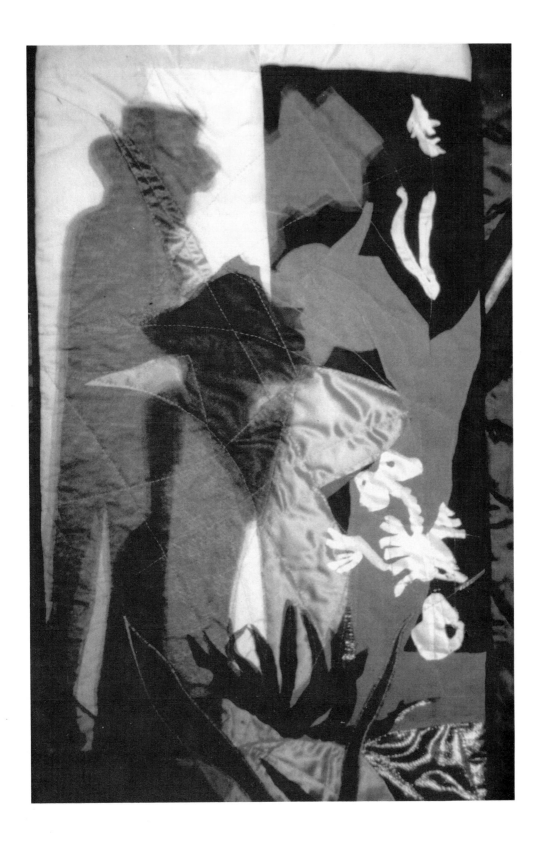

Viola Burley Leak. Detail of *Sunday Sunder* (1986). Appliqué tapestry. Courtesy of the artist.

couple. The togetherness reminds the viewer of Oscar Kokoschka's painting *The Tempest.* The strong geometric shapes, acting as space divisions, are considered both positive and negative in the areas that they serve. The thrust of a black shape upon a white surface creates a contrasting shape.

In one painting of her Dream Series, Leak has recorded a sequence of events which reflect reality in an unusual fashion. Although the painting is titled *Together,* elements of separation appear as well. Visual elements in a perspective relationship are diminished by the abstract order of things. The recessive nature of *Together* is retained by the size diminishment of figures as they appear in the background. Leak has used the overlapping technique to correlate positive aspects with their environment. The circular movements of the male and female bodies are opposed by the straightness of the background. This apparent contradiction is resolved by the straight lines employed as contours of the figures.

Another of the Dream Series is an untitled painting which exhibits several figures in combat. The work is split into five groups each depicting violent episodes, more of a nightmare than a dream. It is the background that unites each segment into a total composition.

The viewer may consider the work a silhouette of black figures placed upon a white surface except for the other colors which act as a backdrop. Leak has discreetly applied dabs of red symbolizing the blood results of violent encounters. Circles rimmed with dagger-like thorns are sprinkled about the environment. The pointed shapes are also within the figures themselves suggesting that threats become realities. Leak executed several silhouettes before introducing muted background colors.

There is no visual perspective or recessive qualities. Figures and shapes symbolizing the emotional states of anger, hate and anxiety occupy the frontal plane. The viewer does not visually journey through the environment, but instead faces a bombardment of violent affairs head-on.

*Sunday Sunder* (1986) is an unusually intimate rendition of the mysterious episodes of life which hinge upon divine intervention. Described as a detail of a larger work, *Sunday Sunder* is a series of related nightmarish events and is crowned with the supreme Christian symbol of the crucifix. In spite of the most dramatic and violent events, the need for spiritual guidance from someone greater than oneself is evidenced in the cross which hovers over the sinister happenings. Abstract figures which overlap and interpenetrate form a dreary and catastrophic portrayal of life. A shadowy figure to the left of the tapestry stands adjacent to a penitent, genuflecting figure with hands clasped in orison.

A shape resembling a satanic figure acts as a background for skeleton parts which are dropping into nothingness. *Sunday Sunder* is an eerie depiction of a fiery Hades. The tapestry, shaped like a cathedral stained glass window, is divided into two major vertical segments.

The left of the tapestry is white, symbolizing purity but still containing the sinister, shadowy figures of the underworld. To the right appears a dark environment with fiery red demons coupled with a series of skeletal parts.

It is interesting to note that particular shapes remain opaque while others overlap and interpenetrate to form Abstract images. Thus there are both recessive elements suggested by introducing secondary colors and advancing elements created by pure colors.

Because of the intimate nature of Viola Burley Leak's paintings, prints and tapestries, the viewer is left to speculate and possibly misinterpret Leak's work. Yet, the sheer joy of viewing her complex and spiritual work is satisfaction enough. Leak is a special artist who has met the special needs of her ever increasing audience.

## *Career Highlights*

Born in Nashville in 1944.

# *Bibliography*

## Catalogues

Anacostia Museum, Smithsonian Institution. "Gathered Visions: Selected Works by African American Women Artists." Washington, D. C.

Mayor's Mini Art Gallery, Stables Art Center. "Creative Threads: D. C. Commission on the Arts." Washington, D. C.

## Cover Jacket

Reproduction of Leak's *Sunday Sunder,* in *Momentum Magazine.* Journal of the National Catholic Educational Association (February 1987).

# *Mary Reed Daniel*

Born in East St. Louis, Illinois, in 1946, Mary Reed Daniel has exploited both the Realist and Abstract schools of thought. In one example of the Abstract Expressionist school she titled *Nature Study No. 20* (1980), Daniel intuitively responds to nature. There is a certain spiritual quality in the outdoors, a peaceful resignation to the natural elements of life. It is this spiritual identification one seeks through the simplicity of form and the purity of color. Daniel takes an approach to art that is like one's initial emotional response to things created by a divine being.

Instinctively applied, color becomes the vehicle of expression. To what extent does one expand a particular reaction? How intense must a color be? At what point does one stop is a question that Daniel has answered in her *Nature Study*.

Abstract Expressionism is a difficult technique because it avoids preconceived notions during the actual process of painting. When one relies on instinct, the application of paint cannot be reversed. Once paint is applied to the working surface, adjacent areas of space are automatically attacked.

One does not paint a well-defined object; rather one envisions an object and paints an image of that object. Daniel in *Nature Study* has painted an intuitive response to a natural scene. The landscape is not painted as a *visual* interpretation of what is but rather an emo-

*tional* response to what is. Brushstrokes are applied and details are ignored.

*Nature Study No. 20* is a restless painting. There are signs of haste, and yet its simplicity and directness is its strength. The brilliant colors are controlled within the confines of the limited working surface, but strongly suggest a continuation beyond its boundaries.

Not unlike other artists, Daniel's technical approach has changed with time. A painting eleven years earlier titled *A Friend* is executed in an objective fashion although it is hinged to a bit of emotional Expressionism. There is a look of abandonment; the portrait maintains an exuberance by virtue of the colorful environment. (The pink earrings fail to gladden Daniel's subject.) *A Friend* is truly a subjective painting across the entire canvas. The monochrome background assists in total focus upon the subject matter. The subject's glance is simple and direct and relies upon the simplicity that surrounds her face.

The powerful watercolor *Kena* (1990), although conceived as a well-defined figure, nonetheless prescribes to Daniel's initial Abstract Expressionist approach to painting. The wet-on-wet method is unpredictable in its results. An erroneous placement of color could create unwanted recessive and advancing elements as dark colors generally recede and light colors advance on the picture plane.

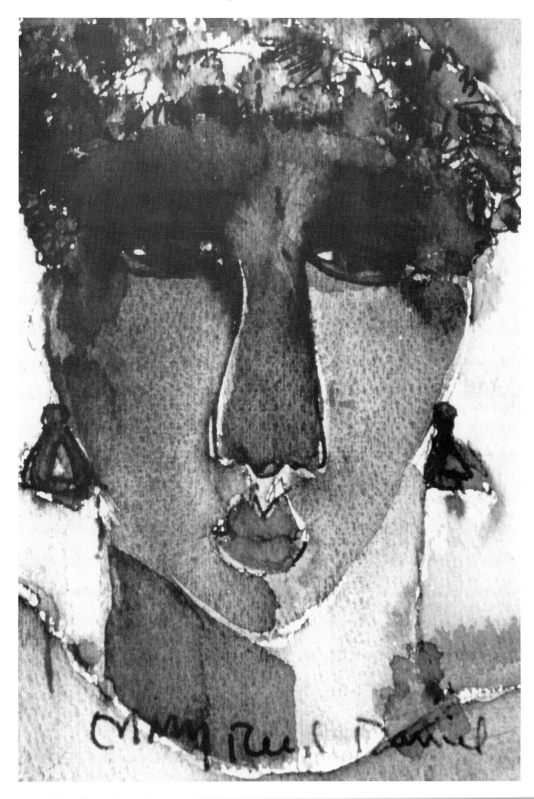

**Mary Reed Daniel.** *Kena* (1990). Watercolor and dye, 6×8 in. Courtesy of the artist.

Daniel has applied dark colors to the forehead and nose of the head while lighter colors are applied to the areas surrounding the nose, which, according to visual perspective, would create figure distortions. Instead of the brow and nose projecting forward as they should, these facial features recede.

The white of the paper acts as a highlight which accentuates the contours of particular segments of the face. As an Abstract Expressionist, Daniel creates a strong image. The dark eye sockets suggest a mood of depression or despair. Such emotional states are sometimes the result of Abstract Expressionism; that is, the very unpredictability of the intuitive approach allows for errant ways seldom corrected. Therefore, the suggestive nature of the expression leads to an incorrect analysis by the viewer. Yet, the net result is a strong display of the emotional relationship between the artist and her subject.

The intuitive approach to painting is a risk in terms of satisfactory results because of the uncertainties of paint application. Regardless of media (watercolor, oil, enamel) the looseness with which the medium is applied and the simultaneous aherence to the dictates of the physical, emotional and intellectual faculties, makes for the unpredictable results.

Daniel's paintings are quickly rendered, and the smallness of the working surface allows for an even quicker creation. Her painting *Odett* (1988) is executed in watercolor and reflects the quickness. Particularly noticeable is the background in which there is the application of a wet medium onto the wet paper. The suggestive nature of certain elements is created by the application of color onto damp color. This technique is compatible throughout. Individual contour lines, added for accent, are applied upon dry surfaces.

There are areas of instinctive application which tend to disrupt the unity of the whole. Such areas are generally diminished in significance by treating other areas with similar applications of the medium, and in so doing establishing a compatibility within the whole. Another approach would be to ignore the deviating area, introduce elements of a stronger nature and thus weaken the presence of the unsatisfactory.

*Odett* is a quickly rendered expression. That is the nature of gesture painting, the core of Abstract Expressionism. *Lue* (1986) is another example of the instinctive process. Daniel has presented a simple gesture drawing of selected lines defining the portrayed character. As a watercolor painting, the artist has allowed the white surface of the paper to act as the highlight and to accent those areas which demand definitive recognition. The drawing remains suggestive as watercolor washes fail to fully act as a backdrop. Even as a finished product, the painting appears unfinished. It could well be a preliminary approach to a more permanent medium.

Brushmarks are obvious in their placement; they are deliberate and final. This finality of position is significant in the intuitive process because its placement cannot be erased. Any erroneous positioning can be resolved only by focusing on other elements of the painting. Balance is witnessed in the jabs of dark inflicted into the foreground and the relatively smaller jabs piercing the upper portion of the figure. Because of the brushstrokes, *Lue* and other similar works are intriguing in their uncertainty and thus are open to viewer speculation. In other words, Daniel has created her own papers, which in and of themselves represent an exciting expression.

In *Carnival #3* (see color insert), an endless journey of color and texture is closely scrutinized. Brilliant colors fuse with muted environments and fade away before emerging once more. *Carnival #3* is a spattering of warm and cool colors intermingling with environments of varying intensities. One is reminded of Paul Klee and Joan Miró and their carnival paintings. It is also reminiscent of underwater excursions. Because of its extreme

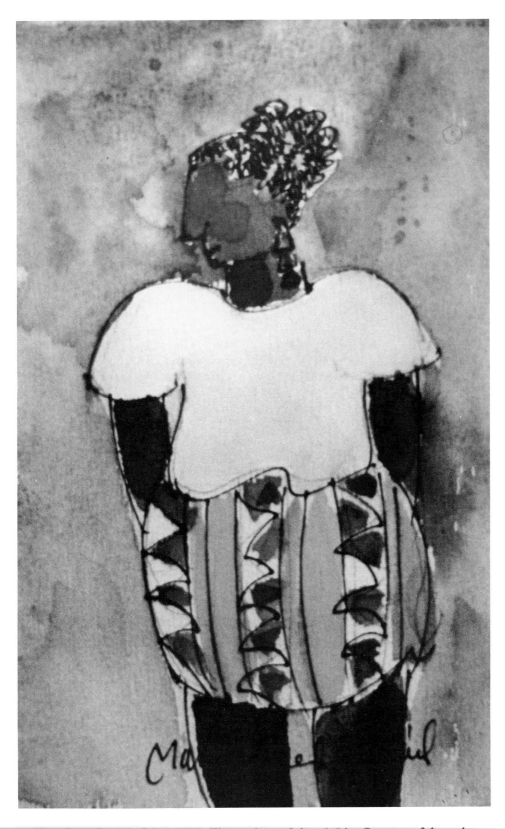

**Mary Reed Daniel.** *Odett* (1988). Watercolor and dye, 5×7 in. Courtesy of the artist.

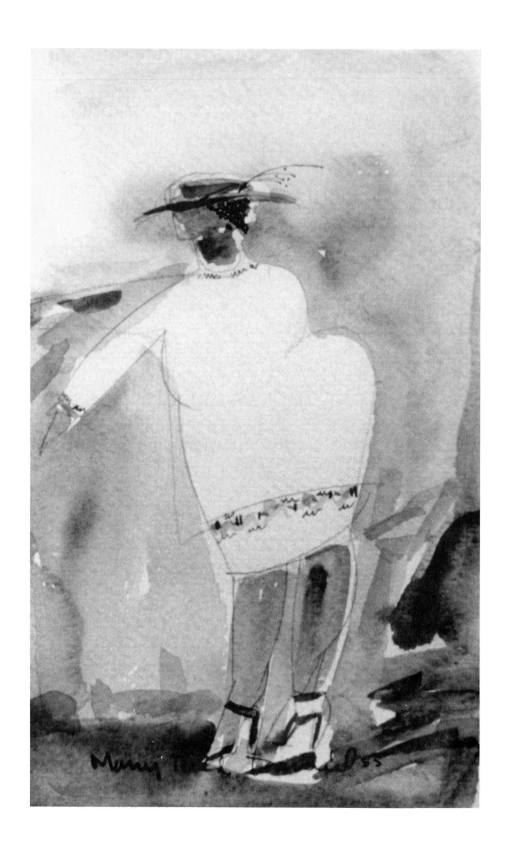

**Mary Reed Daniel.** *Lue* (1986). Watercolor and dye, 5×7 in. Courtesy of the artist.

Abstract nature, speculation may be in order. There is a sense of the eerie, a search for unknown species, a sense of the ethereal. Equally distributed shadows and highlights assist in the total unification.

Mary Reed Daniel is firmly entrenched as an exponent of the Abstract Expressionist school. Her emotional responses to life, although intuitive, are well conceived.

# *Career Highlights*

Born in East St. Louis, Il., in 1946.

## Education

Southern Illinois University.

## Selected Exhibitions

Art Institute of Chicago, Chicago, Il.; Lake Forest Academy, Lake Forest, Il.; Saks Fifth Avenue, Old Orchard/Skokie, Il.; Milliken Corp., New York; Earl Graves Publishing Co. (Black Enterprise Magazine), New York; Columbia College Gallery, Chicago, Il.; Lakeview Museum of Arts & Science, Peoria, Il.; State of Illinois Gallery, State of Illinois Center/Chicago; JB Speed Museum, Louisville, Ky.; Museum of Science and Industry, Chicago, Il.; Chicago Center for Prints, Chicago, Il.; Suburban Fine Art Center, Highland Park, Il.; Fine Art Center En Taos, Taos, N.M.: Diaspora 3, Paramaribo, Suriname.

# *Bibliography*

## Books

Bontemps, Arna. *Forever Free: Art by African-American Women, 1862–1980.* Alexandria, Va.: Stephesan, Inc., 1980.
Driskell, David C. *African-American Artists 1880–1987: Selections from the Evans-Tibbs Collection.* Seattle and London: University of Washington Press, 1989.
Jacobs, Joseph. *Since the Harlem Renaissance.* Lewisburg, Pa.: The Center Gallery of Bucknell University, 1984.
Lewis, Samella. *Art: African American.* New York: Harcourt Brace Jovanovich, 1978.
The Studio Museum in Harlem. *The Harlem Renaissance.* New York: Abrams, 1987.

# TWENTY-THREE

# *Adell Westbrook*

Negative space is nonexistent in the complex paintings of Adelle Westbrook. The inevitable question arises as to where is the point of departure and where is the point of destination. Westbrook's circular compositions are seemingly endless in execution. The injection of a circular shape demands additional similar shapes within already established areas or into the outer environment. Since Westbrook's work concerns itself with the solar system, the task of initiating new forms into the environment becomes a demanding one. Not only is the recession and advancement of color a challenging concern, but the danger of overloading the painting with shapes and objects is critical in terms of visual effects which may actually interfere with the creative process.

Westbrook's works seem highly calculated. As a circle of color is added to the working surface, it affects the entire composition. If an incompatible relationship occurs, color, shape and size are considered in an effort to establish a unity. Intensity of color is especially significant in determining the recession or advancement of color.

Westbrook and other members of the non–Objective school of painting are concerned with the illusion of space. The initial spot of color affects the remaining compositional efforts, but it is the intensity, size, shape and placement of that first color that determines subsequent efforts. The process becomes one of balance and counterbalance until the artist comes to the decision to halt the process, at which point the work is considered complete, or to continue the process until the space is exhausted to the point that any additions would only cause disruption to the union.

Since the artist is dealing in abstract shapes and human figures are ignored, communication relies upon the acceptance of the work. How does one accept the Abstract, non–Objective work of Westbrook? Colors evoke emotions and the combination of several colors may provoke emotions of joy, sorrow, mystery and laughter in varying degrees.

Westbrook has experimented with non–Objective painting at various stages of development, some works considered complete at certain points and others deemed incomplete. In the process that follows, it resembles the intuitive process of the Abstract Expressionist.

*Solar No. II* (1985) resembles an explosion of parts disintegrating into space. The circular shapes become crescent shapes as new forms are introduced. Although circles of color dominate the environment, rectangular shapes join the circular movement and in a sense disrupt the rhythm of Westbrook's work. The introduction of alien shapes, incompatible at first glance, forces the artist to reintroduce curved shapes in order to offset the unfamiliar. This process continues until Westbrook decides that the work is done.

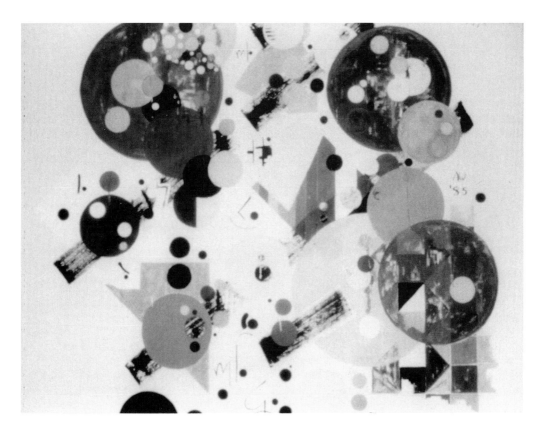

*Top:* Adell Westbrook. *Solar No. II* (1985). Acrylic on canvas, 60×60 in. Courtesy of the artist. *Bottom:* Adell Westbrook. *Solar No. I* (1985). Acrylic on canvas, 120×72 in. Courtesy of the artist.

**Adell Westbrook.** *Solar No. III* **(1985). Acrylic on canvas, 84×60 in. Courtesy of the artist.**

Although *Solar No. II* appears incomplete because of the space surrounding the majority of the positive aspects, one visualizes the additional parts that fill the negative environment. Yet, unless instinct dictates otherwise, the painting remains complete. With *Solar No. II,* one is reminded of the whimsical and fantastic images of Joan Miró and Paul Klee. Imaginary images emerge as one as if they were animated. Whether or not intended by the artist, speculation grows as forms remain abstract.

In *Solar No. I* (1985), a rectangle is formed by the accumulation of circles. Its presence amid a negative environment is diminished because of the circles floating beyond the rectangle. By such a positioning, the artist extends the viewer's vision upward and downward into the open environment, thus allowing for either further action or completion. Westbrook evidently chose the latter.

In *Solar No. III* (1985), circles overlap with rectangles, again permitting open spaces to act as the environment. There is also an unusual example of Impressionism. Centrally located is an irregular rose colored shape containing small circles of various colors. While the Impressionist technique was not employed, the results seem otherwise.

Westbrook's paintings as late as 1984 are forms of action painting à la Jackson Pollock. Colors are applied instinctively, wet on wet. Primary colors fuse to form secondary colors. The placement of colors adjacent to or within other colors is an instinctive act. Results are not always satisfactory and accidental meanderings of color frequently create undesirable effects. The process then either continues in an effort to diminish the presence of the unwanted colors or ceases and the painting is discarded.

Elimination of an "incorrect" color necessitates adding another color in order to draw attention away from the error. Thus, the "incorrect" color is never eliminated; it is simply overpowered by

**Adell Westbrook.** *Solar No. IV* (1985). **Acrylic on canvas, 36×50 in. Courtesy of the artist.**

other colors. Westbrook's arrival at a preplanned product is a prolonged journey. Several intuitive responses must occur before the artist will forsake an instinctive reaction in favor of the preplanned version.

Such works as *Solar No. II* and *Solar No. III* call for intellectual insight in the choice of placement. Even though the intellectual process functions adequately, it is at the moment that a decision is made that the intuitive urge responds. And thus, illogical as it may seem, intuition may follow the intellect.

In spite of the complexity of design, *Solar No. IV* (1985) is a remarkable rendition of overlapping shades of color that miraculously avoid interpenetration. Extremely ambitious in its use of space, the painting is totally devoid of negative space. Circles surround other images, tending to destroy the efficacy of the preplans. But because of the painting's multiplicity of shapes and colors, such images become compatible with their seemingly opposing neighbors.

*Solar No. IV* presents a circus atmosphere, a carnival of color. With imagination, the viewer may recognize clown images emerging in Abstract form, creating a sense of joy and laughter. This is an emotional reaction on the part of the viewer, and it is an immediate response. Further inquiry must be of an intellectually inquisitive nature. One is captured by the movement of one shape in relation to others and intrigued by the vacillation of colored shapes within the limited space.

There is a need to venture slowly from one shape to another in order to enjoy the journey. On the other hand, one may take in the entire expression at a single glance before enjoying its parts. The total working surface is utilized, and the beginning point of the painting remains a mystery. At what point has Westbrook considered its completion? It seems the journey could be infinite, and yet, there is a point of exhaustion. The journey may end several times during the process, but there is always that extra

spot of color that needs to become a part of the whole. In calculating the placement of a color, one needs to acknowledge its effects upon the total environment.

The thrill is in the unpredictable. There is anticipation before placing one color adjacent to another. Even if the artist knows beforehand the results of positioning colors, not until the work is realized can the emotional or intellectual reactions of the viewer be measured. Westbrook has created some color relationships by partially destroying others. Since interpenetration is lacking in her works, the overlapping of colors actually creates new shapes by abolishing segments of other shapes.

Interpenetration could form a third color by overlapping two others. For example, the color red placed over the color blue would create the color violet if there is transparency. It would also create the opposite of Westbrook's intention which is to create the illusion of space by positioning positive aspects within a negative environment.

Westbrook's isolated images are inactive. Each color reacts only to its immediate surroundings; there is no movement as each color is anchored solidly within another color. It is only with the inclusion of several such combinations that visual movement occurs. However, it is an optical movement, one created by the viewer. It is the viewer's eye that gives movement to Westbrook's paintings.

It is well known that the more objects included in a painting, the less attention is granted to each object. The amount of visual time spent on individual colors is determined by the size and intensity of each color and by the contrast formed by the color and its environment.

A color with no regard for the surrounding color is subjective in nature. Add a color to another color and the inserted color becomes subjective while the original color becomes the surrounding area. This process of painting shapes one

**Adell Westbrook.** *Renewal* **(1989). Acrylic on canvas, 48×72 in. Courtesy of the artist.**

upon another until all available space has diminished is both preconceived and intuitive.

In her painting titled *Renewal* (1989), negative space becomes positive. It is uniquely Westbrook, although it has tinges of Chagall, Kandinsky, Léger and other Abstract painters. Yet, such similarities are inevitable because they are basic to the Abstractionist. In *Renewal*, Westbrook has continued to utilize the entire working surface. There is both compositional completeness within the limited boundaries of the canvas and a panoramic sense of continuance beyond the prescribed surface of the canvas.

One can accept Westbrook's painting as a total expression and also consider it as a segment of a greater, unknown expression. One can only assume the continuance of *Renewal* beyond the picture plane. Because of its nonobjectivity, the viewer shuns all symbolic aspects in terms of the literal. Also because of its

nature, it is open to widespread speculation. The journey can be exciting if the concern is for color and movement rather than for a literal translation.

It was mentioned earlier that Westbrook's work is both subjective and objective, that the total is a summation of all its parts. The painting process is objective from the start as focus is placed upon individual shapes of color, but at the painting's completion, the artist looks upon it as a subjective work. However, the viewer is apt to look upon the work as a whole and thus subjectively experience it. It is only after this subjective experience that the viewer examines individual shapes of color.

A similar process holds true when considering the intellectual and emotional reactions. The artist first responds intellectually and later emotionally while the viewer will first react emotionally, and then intellectually. It is again the story of the artist sending a message which is often received by the viewer in a

manner quite contrary to the artist's intent. Nonetheless, any response, whether similar or not to that of the artist, is better than no response at all.

Westbrook has utilized geometric shapes to express her emotions and intellectual insights of the universe. Her work resembles the everchanging solar system in which atoms of the universe break away and form other entities. Her works such as *Solar No. IV* and *Renewal* are potential explosions in which the surface is bursting with activity, granting opportunity for expansion. It is this broader scope that creates the potential for departure of its parts.

The departing segments do not leave the universe. They merely change places with other parts which are also changing places. Westbrook manipulates shapes in space. As space slowly diminishes, Westbrook has simply placed one shape over another and in so doing, has diminished the positive strength of the original. This process creates difficulties in obtaining artistic satisfaction.

There are decisions made, and after months of idleness, the process begins anew. In other words, what appeared as a complete product months before, now demands further action. The intellectual or emotional process suggests a new direction in color structure or spatial relationship for the work. It is at this point during the process that an entirely different technical style or compositional structure would be best served by a clean working surface.

Westbrook has explored the universe and attempts to translate onto a limited two-dimensional surface the significance of her discoveries. She has conquered her personal reactions with satisfying conclusions.

# Career Highlights

Born in Little Rock, Arkansas, in 1935.

## Education

Studied at Traphagan School of Art, New York; B.A. degree from University of Maryland, 1977; M.F.A. degree from the Catholic University, Washington, D. C., 1981.

## Selected Exhibitions

University of Maryland, 1978; Salve Regina Gallery, Catholic University of America, 1980; The St. John Mall Festival, Catholic University of America, 1980; The National Museum of American Art, Washington, D. C., 1981; McMullen Library Annual, Catholic University of America, 1981; Montgomery College, Rockville, Md., 1981; Henri Gallery, Washington, D. C., 1985; Anacostia Museum of Art, Washington, D. C., 1990–91.

# Bibliography

## Reviews

Carter, Allen. "Gathered Visions: Selected Works by Arican American Women Artists." *Washington Review* (April/May 1991).
Douthis, Johnnie. "Discoveries/Varied Artistry of African American Women." *The Torch* (January 1991).
Thorson, Alice. "Common Bonds/Gathered Visions." *Gallery* (January 8, 1991).

# Catalogues

The Catholic University of America. "The Saint John Mall Festival." Washington, D. C., 1980.

"Gathered Visions: Selected Works by African American Women Artists." Text by Robert Hall. Washington, D. C., April 1991.

National Museum of American Art. "Women's Tools Group Show." Text by Linda Roscoe Hartigan. Washington, D. C., Feb. 24-March 21, 1981.

University of Maryland. "Hall Exhibition of Paper Paintings." Text by Sam Gilliam. College Park, Md., 1978.

# *Nanette Carter*

Nanette Carter uses the nonvisual perspective approach, ignoring the visual terms upon which landscapes are generally created. Instead, she has blended the three habitats while separating distinct aspects of nature; that is, separate habitats occur, each devoted to different subjects. Each environment becomes a single painting existing on its own while enhancing the other two.

Carter has purposely avoided the general view as seen in the receding and advancing of aspects of nature that normally exists in the commonplace. For example, her painting titled *Fire Water* incorporates three horizontal planes, the middle plane exhibiting the effects of a world catastrophe. The fiery red dominating the middle plane seems to envelop a circle symbolizing the world globe. The globe, infested with flame-like shapes, spills into the universe suggesting the final judgment.

All Abstract art is open to speculation and subsequent misinterpretation. *Fire Water* is no exception. The horizontal planes above and below the middle ground act as buffers to the turbulent central plane.

Carter is not the only artist who divides a vertical surface into compatible horizontal planes. Cynthia Hawkins's paintings are similar in their distribution of space, while Loren MacIver has utilized this divisional approach in a highly Realistic manner rather than in an Ab-

stract sense. Her famous paintings *Taxi* and *Window Shade,* executed a half century ago, illustrate an approach similar to Carter but from a Realistic viewpoint.

The use of different habitats with different subjects is not a new approach either. It stems from the most natural early childhood expressions of sky, land, and "space in between." One needs to understand the psychology of the child. The three divisions of space are not accurately recorded in a child's drawing. The child views the landscape in both the visual and psychological sense. To the child, the sky above and the earth below are the upper and lower divisions of space. The third division is the middle plane in which life itself exists. The horizon line common in naturalistic landscapes actually identifies with the middle plane which one might respectfully title the horizon space.

This childlike view of the world should not be confused with the frontal plane occurring in the Realistic works of MacIver. Carter has deliberately and judiciously divided her working surface into two or more segments. They do not necessarily follow the rules of visual perspective; they are more apt to track the trends of Abstract Expressionism.

There are those who relate the three divisional planes to the spiritual worlds of heaven and hell, with limbo or purgatory as the middle habitat. In spite of the artist's intent, the viewer is more likely than

**Nanette Carter.** *Fire Water #29* (1991). **Oil pastel on canvas, 11×18 in. Courtesy of the artist.**

**Nanette Carter.** *Calm Shores* (1991). Woodcut, 17×25½ in. Courtesy of the artist.

not to misunderstand the artistic purpose.

The Abstract Expressionistic nature of the painting invites a layman's misinterpretation. Some artists do not object to erroneous reviews so long as a response is forthcoming. Disregard is more of an indicator of an artist's decline than are opposing reactions. Even though the heaven and hell and limbo theory may not be acceptable, it is possible to accept such a proposal if the state of mind warranted this reaction. The state of mind of the viewer at the time of review may readily determine the viewer's acceptance or rejection of the artist's work.

Carter is not limited to the threesome approach, but has succeeded as well with the dual environmental approach. In her painting *Calm Shores* (1991), Carter has established two environments with each focusing a single aspect of nature. In order to maintain a unified composition, Carter has arranged the subject of each habitat into positions of isolation, yet near enough to each other to unite the whole.

The subjects also appear within the limitations of their environments so as to avoid forcing the viewer's glance outside the picture plane. The positioning of the individual subjects creates activity in an area which appears void of activity. In other words, the distance between the subject and its surroundings becomes activated by anticipation. One predicts forthcoming excitement because the subject not only intercepts a negative area but by so doing becomes a positive aspect and alters the entire focus of attention.

*Calm Shores* suggests in the literal sense a shore of land surrounded by water, represented by the negative space. Thus, in the lower portion of the painting, the peninsula, as a positive element, pierces the water as the second positive element, a seagull shape, resides within the negative space activated by its presence. The wings of the bird-like shape are curved inward to help hold the viewer's attention.

Each of Carter's subjects occupies space in such a manner as to maintain the compositional unity. The bird shape within the upper environment maintains a position near the edge of the canvas, thus preventing glances from traveling beyond the limits of the canvas. The positioning also creates a sense of anxiety or anticipated action within the entire area of the upper horizontal plane.

In a second painting titled *Fire Water #12* (1990), Carter has again used a two-division technique to compare the present with the past. A beautiful intermixture of color dominates the major portion of the canvas suggesting the brilliance of a peacock with its plummage.

Even though the artist has used an Abstract approach, the viewer's interpretation, erroneous as it may be, is important. One is never quite sure if a misinterpretation of the artist's intent creates for the viewer a loss of appreciation. The pleasure derived from an artistic work is sometimes more intense when misinterpretations occur. Whether this offends the artist or not really matters little because there will always be those who possess the receptive powers to discern the artist's message.

The personal nature of Carter's work supplies the viewer with several options. The natural ability to relate, if possible, the artist's expression to that of oneself is foremost. However, in the case of Abstract art such as Carter's, interpretations become personal. In order to receive a message sent by Carter, one needs to understand the artistic development of the artist prior to her current trend.

No school of thought occurs independent of preceding styles or circumstances. The arrival of Abstract Expressionism may have been due to an academic climate during the forties, but it still remained up to the individual to determine an appropriate route.

In Carter's painting *Untitled,* the viewer immediately reacts in an abstract manner since the artist gives no clue as to the subject matter. As one views the

**Nanette Carter.** *Fire Water #12* (1990). **Oil pastel on canvas, 29³/₄×45¹/₄ in. Courtesy of the artist.**

turbulent middle plane, one is attracted to the emotional environment, the swirling clouds of blue and grey which seem to complete with the bird-like creature circling an invisible assailant. Although symbolic in its imagery, the combination of creature and habitat form a satisfying composition.

# Career Highlights

Born in Columbus, Ohio, in 1954.

## Education

B.A. degree from Oberlin College; M.F.A. degree from Pratt Institute of Art; studied at L'Accademia di Belle Arti, Perugia, Italy.

## Selected Exhibitions

Elaine Benson Gallery, Bridgehampton, N.Y., 1978; Parrish Art Museum, South Hampton, N.Y., 1978; Wooster College, 1979; Hudson River Museum, 1980; Museum of the National Center for African American Artists, 1980; Brooklyn Museum, 1981; Studio Museum of Harlem, 1981; Miriam Perlman Gallery, Chicago, Ill., 1982; Albright-Knox Museum, 1983; Purdue University, 1984; Saginaw Art Museum, 1984; Mary Ryan Gallery of Art, New York, 1991.

## Solo Exhibitions

Ericson Gallery, New York, 1983; N'Namdi Gallery, Detroit, Mich., 1984; Cinque Gallery, New York, 1985; Montclair Art Museum, Montclair, N.J., 1988; June Kelly Gallery, New York, 1990; Jersey City Museum of Art, Jersey City, N.J., 1990.

# Bibliography

## Periodical Articles

Colby, Joy Hakanson. "Nanette Carter." *Detroit News,* October 16, 1984.
Cole, Harriet. "Nanette Carter." *Essence* (July 1986).
Ferren, Rae. "Nanette Carter." *Women Artists Newsletter,* 1978.
Simpson, Coreen. "Nanette Carter." *Flair* (November 1980).
Siwula, Barbara. "Nanette Carter." *Detroit Focus Quarterly* (December 1984).
Wallach, Amei. "Nanette Carter." *Newsday,* May 28, 1978.

## Reviews

Bass, Ruth. "Review: Nanette Carter." *Art News* (February 1991).
Colby, Joy Hakanson. "Review: Nanette Carter." *The Detroit News,* January 17, 1989.
Harrison, Helen. "Review: Nanette Carter." *New York Times,* February 5, 1979.
Jones, Lisa. "Black Art Today." *Daily News,* March 12, 1988, video.
Miro, Marsha. "Review: Nanette Carter." *The Detroit Free Press,* February 12, 1989.
Porter, Evette. "Art for Our Sake." *Essence* (May 1990).
"Review: Nanette Carter." *East Hampton Star,* February 15, 1979.
"Review: Nanette Carter." *Montclair Times,* October 18, 1984.
Wolff, Theodore. "Artist at Work: Nanette Carter." *The Christian Science Monitor,* September 11, 1986.
_____. "Review: Nanette Carter." *The Christian Science Monitor,* February 2, 1981.

# Index

*Numbers in **boldface** refer to pages with illustrated works.*